DESIGNING RUSSIAN CINEMA

KINO – The Russian and Soviet Cinema

Series Editors:

Birgit Beumers, Emeritus Professor of Film Studies at the University of Aberystwyth, Wales

Lilya Kaganovsky, Professor of Slavic, Comparative Literature, and Media & Cinema Studies, at the University of Illinois, USA

Advisory Board:

Richard Taylor, Swansea (Founding Editor)
Julian Graffy, University College London-SSEES
Jeremy Hicks, Queen Mary University of London
Denise Youngblood, University of Vermont

This series situates Russian, Soviet and post-Soviet cinema in its proper historical and aesthetic context, both as a major cultural force and as a crucible for experimentation that is of central significance to the development of world cinema culture. Books in the series strive to combine the best of scholarship, past, present and future, with a style of writing that is accessible to a broad readership, whether that readership's primary interest lies in cinema or in political history.

Published in the KINO – The Russian and Soviet Cinema series:

Alexander Medvedkin
Emma Widdis

Cinema and Soviet Society: From the Revolution to the Death of Stalin
Peter Kenez

Cinema in Central Asia: Rewriting Cultural Histories
Edited by Michael Rouland, Gulnara Abikeyeva and Birgit Beumers

The Cinema of Alexander Sokurov
Edited by Birgit Beumers and Nancy Condee

The Cinema of Tarkovsky: Labyrinths of Space and Time
Nariman Skakov

Dziga Vertov: Defining Documentary Film
Jeremy Hicks

Eisenstein on the Audiovisual: The Montage of Music, Image and Sound in Cinema
Robert Robertson

Forward Soviet!: History and Non-fiction Film in the USSR
Graham Roberts

Performing Femininity: Woman as Performer in Early Russian Cinema
Rachel Morley

Real Images: Soviet Cinema and the Thaw
Josephine Woll

'Russian Americans' in Soviet Film: Cinematic Dialogues between the US and the USSR
Marina L. Levitina

Russia on Reels: The Russian Idea in Post-Soviet Cinema
Birgit Beumers

Savage Junctures: Sergei Eisenstein and the Shape of Thinking
Anne Nesbet

Screening Soviet Nationalities: Kulturfilms from the Far North to Central Asia
Oksana Sarkisova

Soviet Cinema: Politics and Persuasion under Stalin
Jamie Miller

Ukrainian Cinema: Belonging and Identity during the Soviet Thaw
Joshua First

Vsevolod Pudovkin: Classic Films of the Soviet Avant-garde
Amy Sargeant

DESIGNING RUSSIAN CINEMA

The Production Artist and the Material Environment in Silent Era Film

Eleanor Rees

BLOOMSBURY ACADEMIC
LONDON • NEW YORK • OXFORD • NEW DELHI • SYDNEY

BLOOMSBURY ACADEMIC
Bloomsbury Publishing Plc
50 Bedford Square, London, WC1B 3DP, UK
1385 Broadway, New York, NY 10018, USA
29 Earlsfort Terrace, Dublin 2, Ireland

BLOOMSBURY, BLOOMSBURY ACADEMIC and the Diana logo are trademarks of Bloomsbury Publishing Plc

First published in Great Britain 2023
This paperback edition published 2024

Copyright © Eleanor Rees, 2023

Eleanor Rees has asserted her right under the Copyright, Designs and Patents Act, 1988, to be identified as Author of this work.

For legal purposes the Acknowledgements on pp. xii–xiii constitute an extension of this copyright page.

Cover design: Ben Anslow
Cover images: Brown paper texture background (© Katsumi Murouchi / Getty); Scene from the film *The General Line (Old and New)* (1929). Dir. Sergei Eisenstein (© Album / Alamy)

All rights reserved. No part of this publication may be reproduced or transmitted in any form or by any means, electronic or mechanical, including photocopying, recording, or any information storage or retrieval system, without prior permission in writing from the publishers.

Bloomsbury Publishing Plc does not have any control over, or responsibility for, any third-party websites referred to or in this book. All internet addresses given in this book were correct at the time of going to press. The author and publisher regret any inconvenience caused if addresses have changed or sites have ceased to exist, but can accept no responsibility for any such changes.

A catalogue record for this book is available from the British Library.

A catalog record for this book is available from the Library of Congress.

ISBN: HB: 978-1-3502-4636-2
PB: 978-1-3502-4635-5
ePDF: 978-1-3502-4638-6
eBook: 978-1-3502-4637-9

Series: KINO – The Russian and Soviet Cinema

Typeset by Integra Software Services Pvt. Ltd.

To find out more about our authors and books visit www.bloomsbury.com and sign up for our newsletters.

In loving memory of my grandparents

CONTENTS

List of illustrations	x
Acknowledgements	xii
Note on transliteration and translation	xiv
Introduction	1
Chapter 1	
EARLY RUSSIAN PRODUCTION ARTISTS: PROFESSIONAL PRACTICES AND CULTURAL CONTEXTS	19
Chapter 2	
THE RURAL ENVIRONMENT	50
Chapter 3	
THE DOMESTIC INTERIOR	80
Chapter 4	
THE WORKPLACE	113
Chapter 5	
ARTISTIC ARENAS	144
Conclusion	172
Appendix	182
Notes	196
Bibliography	240
Filmography	258
Index	261

ILLUSTRATIONS

1.1 Viktor Simov's interior set for the 1898 Moscow Art Theatre
 (MKhT) production of Anton Chekov's *The Seagull* (Chaika) 25
1.2 Simov's exterior set for the 1898 MKhT production of
 Chekov's *The Seagull* (Chaika) 25
1.3 Vladimir Egorov, 'The Artist of Theatre Stage Scenery and
 the Artist of the Cinema Picture... What's the Difference?'.
 RGALI f. 2710, op. 1, ed. khr. 59, 5 30
2.1 *Izba* interior. *The Dashing Merchant* (Ukhar´-kupets) directed
 by Vasilii Goncharov © Pathé 1909. All rights reserved 54
2.2 Peasant interior. *Who Ruined Her?* (Kto zagubil?) directed
 by Nikandr Turkin © Aleksandr Khanzhonkov & Co 1916.
 All rights reserved 60
2.3 'Architectural frames from the film *The General Line*
 (General´naia liniia). A Sovkino Production by
 S. M. Eizenshtein. Architecture by A. K. Burov',
 Sovremennaia arkhitektura 5–6 (1926): 136–7 73
2.4 The bus and village architecture. *A Major Nuisance*
 (Krupnaia nepriatnost´). 1930. All rights reserved 78
3.1 The widow's living room. *The Little House in Kolomna*
 (Domik v Kolomne), directed by Piotr Chardynin
 © Akcionernoe Obscestvo A.H.i.K./Khanzhonkov 1913.
 All rights reserved 83
3.2 Veranda. *The Kreutzer Sonata* (Kreitserova sonata), directed
 by Vladimir Gardin © Thiemann & Reinhardt 1914.
 All rights reserved 87
3.3 Interior, *The Kreutzer Sonata* 88
3.4 Natasha's father's dacha. *The Girl with a Hatbox* (Devushka s
 korobkoi), directed by Boris Barnet © Mezhrabpom-Rus´
 1927. All rights reserved 106
4.1 Zheleznov's office. *The Alarm* (Nabat), directed by Evgenii
 Bauer © Aleksandr Khanzhonkov & Co 1917.
 All rights reserved 118
4.2 *Aelita*, directed by Iakov Protazanov © Mezhrabpom-Rus´
 1924. All rights reserved. Photo courtesy of Photo 12/
 Alamy Stock Photo 122

4.3	*Strike* (Stachka), directed by Sergei M. Eizenshtein © Proletkult – Groskino 1925. All rights reserved. Photo courtesy of TCD/Prod.DB/Alamy Stock Photo	130
4.4	Factory corridor. *Strike* (Stachka), directed by Sergei M. Eizenshtein © Proletkul′t – Groskino 1925. All rights reserved	131
4.5	The journalists' office. *Your Acquaintance* (Vasha znakomaia), directed by Lev Kuleshov © Sovkino 1927. All rights reserved	134
5.1	Basil Hallward's studio, *The Picture of Dorian Gray* (Portret Doriana Greia), published in *Cine-Phono 21-22* (1915): 42	149
5.2	Vladimir Egorov, 'The Artist of Theatre Stage Scenery and the Artist of the Film Frame… What's the Difference?'. RGALI f. 2710, op. 1, ed. khr. 59, 8	151
5.3	The film studio. *The Cigarette Girl from Mossel′prom* (Papirosnitsa ot Mossel′proma), directed by Iurii Zheliabuzhskii © Mezhrabpom-Rus′ 1924. All rights reserved	161
5.4	Theatre performance. *The Last Act* (Poslednii attraktsion) © Sovkino 1929. All rights reserved.	170

ACKNOWLEDGEMENTS

I am grateful for the generous support of the Wolfson Foundation, which in part funded the research for this book with a three-year scholarship. I also thank the Design History Society and the School of Slavonic and East European Studies (SSEES) for additional contributions towards research trips to archives in Moscow. I presented material included in this book at seminars held by the SSEES Russian Cinema Research Group and the Cambridge Courtauld Russian Art Centre and at conferences hosted by the Courtauld Institute of Art, the Humboldt University and the Design History Society, the European Architectural Network and the Architecture, Space and Society Centre at Birkbeck University. Many thanks to those who were present for listening with interest and responding with useful questions and suggestions. Some of the material included in this book was originally published in articles in *Film History* and the *Journal of Design History* and as the chapter 'Comfort and the Domestic Interior in Early Soviet Cinema' in Pat Kirkham and Sarah Lichtman (eds), *Screen Interiors: From Country House to Cosmic Heterotopias* (London: Bloomsbury Academic, 2021). I thank the anonymous reviewers, who offered useful suggestions for improvement, and the publishers for granting me permission to re-publish the material here in a revised form. I am also grateful to the three anonymous reviewers for Bloomsbury Academic press who gave guidance for strengthening the argument of this book.

I thank Maria Mileeva for introducing me to Russian art and encouraging me to pursue research in the field. Special thanks go to Lee Grieveson and Emma Widdis, who provided helpful comments on and support for my doctoral research on the topic. I am grateful to Birgit Beumers and the five anonymous reviewers on the Bloomsbury editorial board for believing in the project. I have profited greatly from the input of Philip Cavendish, who commented on versions of chapters of this book and generously shared with me his knowledge of Russian and Soviet cinema. I also owe my gratitude to Julian Graffy, who offered valuable suggestions for improvement, particularly on the translations, which have benefited enormously from his clarifications and suggested approach. Throughout the research for and writing of this book, I have benefited enormously from the guidance of Rachel Morley, who read multiple versions of chapters and responded with thoughtful questions,

Acknowledgements

critical challenge and invaluable suggestions for improvement; she supported my research with enthusiasm and much patience, for which I am grateful. Any remaining errors and infelicities are, of course, my own responsibility.

This monograph has benefited from invaluable practical support from many individuals. In particular, Andrea Zsubori of SSEES library helped acquire much research material. I owe my gratitude to Alex Krouglov, Dmitrii Matchin, Svetlana Mcmillan and Maria Sibiryakova, who supported the development of my Russian language skills. During research trips to Moscow, Iuliia Belova and Oleg Bochkov of Gosfil′mofond Rossii and Kristina Iur′eva of Muzei kino granted me kind permission to view material and were helpful with my requests. I am also grateful to Aleksandr Lavrent′ev and Liudmila Miasnikova for sharing with me their time and knowledge. Additionally, I thank the Russian Archive of Literature and Art (RGALI) and Gosfil′mofond for granting me copyright permission to reprint images. The support of Ben Anslow, Rebecca Barden and Veidehi Hans at Bloomsbury Academic Press was essential for publishing this book.

I owe special thanks to those who befriended me and showed me great kindness during time spent in Russia, in particular Antonio Bernal, Ol′ga Yudina, Pavel Zvozin, Liana Mukhamedzianova, Dina Veriutina and Maria Vertiletskaia in Saint Petersburg; and Xavier Dreyfus, Denis Fedorin and Sergei Mikhailov in Moscow. While writing this book, I have profited greatly from the humour and comfort of many friends and colleagues. I thank them all, and especially Yoojin Choi, Oliver Coulson, Valentin Grukhin, Sofia Gurevich, Juan Herrero, Charlotte Hollihan, Matt Mason, Eleanor Sedgley, Sam Shin, Bence Tóth, Georgie Treacy, Aggie Verdin and Hannah Wood.

I am enormously grateful to Mary, Annabel, Hugh, Peter and Circe for everything. To Georgiana, whose expected arrival provided joy in the midst of it all. Lastly, my heartfelt thanks go to my late grandparents, David and Una, who fostered my love for learning, inspired me to pursue doctoral research and always supported me. I dedicate this book in memory of their unending generosity.

NOTE ON TRANSLITERATION AND TRANSLATION

This book follows the Library of Congress system of transliteration from the Cyrillic to the Latin Alphabet. The titles of articles, books, films, plays and works of art and literature are given in English and Russian on first mention, and thereafter in English only. All translations from Russian to English are my own, unless otherwise specified.

INTRODUCTION

In 1927, the year in which he worked on the set designs for Lev Kuleshov's film *Your Acquaintance* (Vasha znakomaia), the prominent Russian Constructivist artist Aleksandr Rodchenko wrote an article entitled 'The Production Artist and the Material Environment in Fiction Film' (Khudozhnik i material´naia sreda v igrovoi fil´me), in which he attempted to define the role of the production artist in cinema.[1] In this article, Rodchenko declared that the production artist should not be reduced to a mere '*dekorator*' (decorator), a technical craftsman who assembles ornamental scenery following the orders of the director. Rather, he claimed, the production artist is responsible for devising the different material environments in which the characters of the film will 'live'; consequently, he must be involved in all aspects of film production, including composing actors, props and scenery, selecting camera angles and lighting and framing scenes. Rodchenko was not alone in his awareness of the production artist's importance. Throughout the 1910s and 1920s in Russia, a number of filmmakers, artists and critics addressed questions about the nature and the scope of the production artist's role. This debate was concerned not only with the division of professional responsibilities in film production and the recognition of authorship rights. It also related to differing conceptions of film's nature as a new art form, its relationship to other creative media and to broader questions about the role of artists within modern society.

This book takes Rodchenko's article as a starting point and sets out to explore the figure of the production artist in early-Russian and Soviet cinema, from the birth of the national fiction-film industry in 1907 to the end of the silent era at the beginning of the 1930s. From as early as 1908, the year in which Aleksandr Drankov produced what is conventionally considered the 'first' Russian fiction film, *Sten´ka Razin*, the term *khudozhnik* was used in Russian cinema as the title for the position referred to in English as the production designer, the set designer or the art director.[2] Directly translatable as 'artist', the term *khudozhnik* carries connotations of individual self-expression, creative

autonomy and artistic excellence. As Rodchenko suggests in his article, the use of the title as opposed to others used in the applied arts, such as *dekorator*, *oformitel'* (scenery dresser) and *remeslennik* (craftsman), is significant.³ The employment of individuals under the title reflected both their backgrounds as trained artists and the ambitions of filmmakers to establish cinema as a legitimate art form, independent of its origins as a technological novelty, a commercial enterprise and a subsidiary of the theatre. It also related to the fact that, as Rodchenko insists, the profession's influence was not confined solely to constructing artificial scenery but extended to a wide range of aesthetic decisions that formed part of the filmmaking process.

Despite the wide-ranging responsibilities accorded to the production artist and their artistic credentials, the contribution of this figure to Russian cinema is a relatively under-researched subject. Indeed, Emma Widdis in her monograph *Socialist Senses: Film, Feeling, and the Soviet Subject, 1917–1940* (2017) identifies the production artist as 'the forgotten figure in film scholarship', noting that 'early Soviet cinematic set design has received particularly scant attention'.⁴ This book sets out to address some of the gaps in our knowledge about the production artist in late-Imperial Russian and early-Soviet cinema. Specifically, it considers the following questions: in what ways did production artists contribute to the aesthetic and technical decisions involved in film production? How did developments in set design relate to filmmakers' evolving understandings of cinema's expressive potential? What role did set design play in establishing a distinctive national cinema, in both the late-Imperial and early-Soviet eras? And lastly, how did production artists harness cinema's ideological potential and exploit set design to promote certain ideas about the material environment?

To explore these questions, this book adopts an institutional approach and examines how the working practices of production artists evolved during the first decades of Russian fiction cinema against the context of the increasing professionalization of the film industry and its nationalization from a private to a state enterprise in 1919. This follows the approach of David Bordwell, Janet Staiger and Kristin Thompson in their seminal study of Hollywood cinema and, more recently, Maria Belodubrovskaya in her monograph on Stalinist cinema, which rejects film history as a narrative of individual auteurs and instead focuses on the organizational structures and institutional frameworks of film production to understand developments in film style.⁵ The book therefore does not intend to provide a comprehensive study of the work of particular individuals. Rather, it seeks to establish

a typology of production artists in order to show how as a professional group they influenced the aesthetic and technical decisions involved in filmmaking.

Nonetheless, I also bring to light information on individuals such as Vladimir Balliuzek and Sergei Kozlovskii, who have received little attention in scholarship on Russian cinema despite occupying leading positions at late-Imperial and early-Soviet studios, where they were revered by their contemporaries. Not only did the sets which they designed provide aesthetic precedents for many subsequent Russian films but also the production methods they introduced and their writings on design principles informed the development of wider cinema practice and theory in Russia. Additionally, I draw attention to the involvement of such well-known figures as Kuleshov and Rodchenko in the field of cinema design, which remains an under-researched aspect of their artistic oeuvre but was fundamental in shaping their perceptions of cinema's expressive and ideological potential. The decision to include in this book an appendix with translations of articles written by these individuals, among others, serves to demonstrate how their thinking on set design was closely tied to their evolving understanding of cinema's nature as an art form and its social function.

The emphasis on production artists in this book does not seek to undermine the significance of other filmmakers, most notably the director; indeed, Russian cinema in the 1910s and 1920s was based on a director-centred mode of production.[6] However, as Philip Cavendish's work on camera operators, Anna Kovalova's studies on late-Imperial screenwriters and Belodubrovskaya's research into early-Soviet screenwriters and film executives show, within the formal studio hierarchy film professionals other than the director did have a significant impact on shaping aesthetic decisions and production practices.[7] Aesthetic choices that studies on Russian cinema often attribute to an individual director were more frequently the result of a collaborative process involving a number of filmmakers, including the production artist. The intention of this book is therefore to locate the contribution of production artists within a matrix of influences on film production in order to understand the institutional framework within and collaborative process through which films were made.

In the context of Russian cinema, the idea of creative collaboration was initially important as a union among filmmakers around the shared goal of developing a new art form. After the 1917 Revolution, it also acquired ideological significance as a renunciation of the perceived bourgeois concept of individual authorship. The production artist, as

this book will demonstrate, served an important function in facilitating collaboration, through their requirement to work with the whole range of studio personnel, including lighting assistants, technicians and craftsmen. In their role as coordinators of the many studio workshops and members of the main filmmaking unit, which also included the camera operator, the director and the screenwriter, production artists mediated between the technical and creative sides of studio filmmaking, shaping how collaboration worked in practice, as well as how visual ideas were realized cinematically.

Within the Russian studio system, the production artist held an important technical function in organizing and innovating production practices and technology. In the early-Soviet period, a discourse developed around the production artist that emphasized their role as an 'architect' (*arkhitektor*) of production practices within the film studio – known in Russian as '*fabrika*', which translates as 'factory' – with a view to economizing and rationalizing filmmaking. This played into wider debates at the time about production art (*proizvodstvennoe iskusstvo*), which, as Maria Gough demonstrates, positioned artists as 'engineers' whose main goal was to work directly with industry to transform the systems and processes of production in order to expedite Soviet industrialization.[8] While few Soviet artists were able to achieve the goal of rationalizing industrial production, I argue that cinema production artists did, in fact, realize some of the ambitions of production art through their work in economizing set design methods and studio filmmaking.

New set technology and production practices also had a profound impact on cinema aesthetics. This book, therefore, also explores how available technology, the studio environment and professional partnerships, as much as the creative visions of individuals, shaped the evolution of film style. In so doing, it contributes to a growing body of scholarship on Russian cinema that examines the influence of technological innovations on film aesthetics. Scholars such as Cavendish, Lilya Kaganovsky and Masha Salazkina have shown how technological advances relating to lighting, colour film and sound also affected filmmakers' evolving understandings of cinema's artistic and ideological potential.[9]

In addition to bridging the technical and creative sides of film production, the production artist provides a link between the late-Imperial and early-Soviet eras of Russian cinema. While a new generation of directors and camera operators came to work in Soviet cinema after the nationalization of the film industry in 1919, many

of the production artists who had started their careers in the 1910s continued to work in cinema after that date: Balliuzek, Vladimir Egorov, Kozlovskii, Kuleshov and Vasilii Rakhal's, for example, all had successful careers that stretched over several decades. This generational continuity enables us to trace not only changes but also continuities that cut across common periodizations of late-Imperial Russian and early-Soviet cinemas. The 1917 Revolution and the subsequent reorganization of the film industry undoubtedly had profound ramifications for cinema. However, production artists working in the Soviet era continued to draw on expressive techniques and practices developed in late-Imperial cinema, often adapting them in line with shifting ideological parameters.

During this period, cinema emerged not only as a new national industry, however. It was also born as a new art form. Many filmmakers and critics debated the extent to which set design, as an expressive element of film that had its origins in the theatre and drew upon the methods of painting and architecture, could contribute to the development of a new cinematic, artistic language. Some considered film primarily a photographic phenomenon that should use the real world as its material and, accordingly, renounced artificial scenery as inauthentic. Instead, light, space, the *faktura* (texture) of objects and the composition of the frame were considered the most important aspects of the production artist's work. Others, however, recognized that constructed sets could significantly increase cinema's expressive potential, including through enhancing the impression of flatness and depth, intensifying the play of light and shadow and providing a range of camera angles and frame compositions. The use of sets was, therefore, closely tied to a series of complex questions about visual perception and audience engagement in cinema, including the nature of the film screen as a flat pictorial surface and the representation of three-dimensional space on screen. The complexity of the aesthetic ideas with which filmmakers grappled and the nuances in their varying views of the expressive potential of sets are reflected in the articles translated in this book. Additionally, the strong rhetoric used in many of the articles, some written in the style of manifesto statements, demonstrates how important filmmakers felt it was, at the time, to lay out their claims for a particular direction for cinema to develop along as an art form. This book therefore demonstrates how developments in the production artist's practice related to different understandings about the nature of cinema as an artistic medium and contributed to the evolution of silent cinema aesthetics in Russia. In so doing, it

charts the main developments in set-design aesthetics in late-Imperial Russian and early-Soviet film.

Cinema's development as an art form took place during a period of intense experimentation in the arts. During the first decades of the twentieth century in Russia, the rejection of art academies, the modernist thirst for experimentation and the emergence of new technologies encouraged artists to pursue alternative trends in interdisciplinary practice and to become involved with a range of creative media outside the fine arts, such as photography, illustration and poster, fashion, furniture and theatre design. This book situates the evolution of set design practice in the context of these broader artistic developments. It explores the close dialogue that developed between cinema and other artistic fields as production artists drew on both established traditions and modernist experiments in theatre, architecture and the graphic and pictorial arts.

In particular, the sphere of theatre design went through a notable period of experimentation. While up to the late nineteenth century, the theatre existed primarily to serve the playwright, as a living illustration of a text, from the 1890s it became a legitimate artistic realm.[10] Lighting, scenery and costumes were no longer considered ancillary, but were vital to a performance's meaning. Such eminent artists as Konstantin Korovin and Aleksandr Benua (Benois) collaborated with the theatre to produce designs and costumes that were widely perceived as valuable creative works in their own right. As cinema emerged as an art in the 1900s and 1910s, new ideas about the importance of theatre scenery inevitably came to influence approaches to film design, with many production artists, including Egorov and Simov, entering cinema from careers or apprenticeships in the theatre. These production artists brought with them an informed understanding of the various ways in which cinema differed from the theatre, including in terms of spatial representation and audience engagement. They sought to develop new approaches that were distinctive to cinema and that would heighten its unique expressive potential.

The involvement of artists in spheres outside of the fine arts was closely associated with shifting conceptions of their role within society. During the 1910s and 1920s, a number of artists' manifestos claimed that in the modern era the artist should no longer be a solitary creative figure confined to the studio, but must work to integrate art into life.[11] Following the Revolution, the idea of fusing art and life had potent appeal. Artists acquired a new social responsibility: through transforming the material environment and offering new models of

living that corresponded to socialist ideals, they were to be active agents in the building of a new Soviet state.

Recognizing artists' social responsibility, a number of critics writing in the contemporary cinema press in the mid- to late 1920s claimed that the production, artist had an obligation not only to represent the material environment but also to promote certain ideas about everyday life (*byt*) and thus show audiences new ways of living. The critic K. Gazdenko, for example, argued, 'The task of the production artist is to express his attitude to the environment, to inspire the viewer, to direct him along the path to a new life, and to make him reconsider the foundations of his own life from the viewpoint of its setting.'[12] Cinema set design reflected deep ideological concerns during this period about the material environment and the status of 'things', including as luxuries, commodities and modern technologies that informed certain ways of living, both real and imagined. This monograph examines how production artists exploited cinema's ideological potential and used set design in films to express contemporary debates about the material environment, from issues relating to consumerist desire and domesticity to questions about industrialization and machine technology. Thus, in contrast to studies on Russian cinema that privilege the role of montage and other cinematographic techniques in conveying ideological meaning, this book highlights how filmmakers also used the textures, forms and spaces of sets as vital means to explore the relationship between people and their object world.

Critical approaches to set design

Although there is a wealth of practical manuals on cinema sets, the academic literature on the subject is sparse.[13] There exist few detailed historical and critical studies of cinema design, and it is only since the mid-1990s that a range of methodological and theoretical approaches to the subject have developed. The first critical studies to address cinema design focused on the relationship of sets to the narrative of films. In their *Sets in Motion: Art Direction and Film Narration* (1995), Charles Affron and Mirella Jona Affron provide a taxonomy consisting of five categories – 'denotation', 'punctuation', 'embellishment', 'artifice' and 'narrative' – to analyse the extent to which a set serves, enhances or occasionally overwhelms a film's narrative.[14] The Affrons' narrative approach takes into account how meaning in films unfolds sequentially across a succession of frames, locales and events and raises questions

about the extent to which sets can function independently from a film's narrative. This is particularly pertinent in the case of Russian cinema in the 1900s and 1910s, when production artists at times designed sets with limited knowledge of a film's narrative and were, on occasion, also responsible for creating a film's scenario.

Writing in response to the Affrons, scholars such as Charles Tashiro and Sarah Street have argued that sets exert an impact beyond their narrative function, emphasizing that they carry pre-existing associations that provide additional meaning not contained within the film's scenario.[15] In contrast to the Affrons' model, which privileges the meaning pre-ascribed by filmmakers, the approaches of Tashiro and Street acknowledge that films are open to multiple, and fluctuating, historically specific readings. Both scholars adopt an expansive definition of set design to include, in Tashiro's words, 'all those elements which comprise the total cinematic image', such as lighting, camera work and the positioning of actors, recognizing that sets work in conjunction with other cinematic techniques.[16] Street, in particular, gives prominence to the relationship between actors and scenery, claiming that sets often function as 'performative arenas', in which the actor's body becomes an essential part of the mise-en-scène which draws the viewer's attention to particular elements, while also encouraging them to consider a space beyond the frame.[17]

While Street is concerned with how movement within sets encourages new readings of film frames, a number of scholars have analysed how such movement activates kinaesthetic and haptic models of spectatorship. In *Atlas of Emotions: Journeys in Art, Architecture and Film* (2002), Giuliana Bruno examines how architectural structures in cinema convey a sense of travelling, as both a spatial and an emotional experience.[18] Adopting a phenomenologically oriented approach, in *The Architecture of the Image* (2001) Juhani Pallasmaa explores how film architecture works to imply a kinaesthetic way of experiencing space that encourages viewers to 'construct spaces in the mind' and 'a sense of being in the world'.[19] Bruno and Pallasmaa do not ground their study in a particular context, instead using diverse examples from different historical and national cinemas. By contrast, Antonia Lant and Peter Wollen view spatial perception and spectatorial engagement as culturally specific and draw on the writings of early cinema theorists in Europe to examine how design and architecture in early cinema were associated with a particular cultural understanding of spatial representation that privileged haptic and kinaesthetic models of spectatorship.[20]

While the scholars mentioned above consider the relationship between cinema and architecture in terms of their similar modes in engaging viewers, other scholars have analysed how the two media are engaged in a close dialogue from a stylistic viewpoint. Donald Albrecht and Sabine Hake both recognize cinema as a platform to promote new architectural and design movements and as a training ground to shape public tastes and generate consumer demands.[21] Although Albrecht and Hake examine the cultural context of a film's production, these scholars do not, however, take into account how the commercial and production pressures of the cinema industry might inform the choice of design in films.

Another branch of scholarship analyses set design as a practice, taking into account industrial pressures and production contexts. Tim Bergfelder, Sue Harris and Sarah Street's 2007 monograph on British, French and German set design in the 1930s and Lucy Fischer's 2015 edited book on set design in American cinema focus on the working practices of set designers, acknowledging that institutional structures and technological developments have a considerable impact on the environments that filmmakers are able to represent.[22] These authors view cinema as an economic and cultural institution, taking into account not only films themselves but also media discourses, production documents and filmmakers' memoirs. They show that the evolution of set aesthetics is closely associated with commercial demands and socio-political imperatives, including ambitions to dominate domestic markets and strategies to promote national cinemas abroad. These studies act as a point of departure for this book's analysis of the working practices of production artists in early-Russian cinema. Like these authors, I examine historically and culturally specific production practices and contexts in order to understand how set design related to industrial developments and to shed light on the dynamics of filmmaking.

Although the focus of Bergfelder, Harris and Street is on British, French and German cinema, they recognize the significance of Russian émigré set designers, such as Lazare Meerson and Andrei Andreiev, in shaping a particular approach to scenery in European cinemas. Léon Barsacq's *Caligari's Cabinet and Other Grand Illusions: A History of Film Design* (1976), originally published in French as *Le Décor de film 1895–1969* (1970), is one of the few comparative studies on European set design to address Russian cinema specifically.[23] Barsacq's analysis of Russian set design covers Russian cinema from 1914, claiming that before this Russian films 'never rose above the level of honest

mediocrity; the revelation of Russian cinema did not occur until after the 1917 Revolution'.[24] This dismissal of late-Imperial cinema is based on the very limited sources and films from the era accessible to researchers until the late 1980s. Since then, however, a number of studies on Russian film have shown that Russian cinematic design, from both the late-Imperial and early-Soviet eras, is a productive field for further research.

Analysing set design in Russian and Soviet cinema

Although set design has been identified as a field of interest since the mid-1940s in English-language scholarship on Russian cinema, scholarship dedicated to it has been sporadic. In her 1947 article 'Scenic Design in the Soviet Cinema', Catherine de la Roche recognizes that in Soviet cinema, in comparison to other national cinemas, production artists collaborated particularly closely with other filmmakers and pioneered a new cinematic approach to design that expanded understandings of the expressive potential of light and space in cinema.[25] However, in the book she co-authored with Thorold Dickinson on Soviet cinema, published just one year later, the contribution of production artists to filmmaking remains unexplored.[26] This omission of production artists is consistent in historical surveys of Russian and Soviet cinema, which tend to focus on the socio-political context of the film industry or on institutional developments.[27]

During the mid-1960s to the late 1970s, a number of monographs were published in Russian that analysed the stylistic approaches of individual production artists, including Anatolii Arapov, Evgenii Enei, Vladimir Egorov and Iosif Shpinel'.[28] Richly illustrated with set design sketches and documented with archival sources and memoirs, these monographs indicate the wealth of primary sources – aesthetic and discursive – that exist on set design and provide valuable biographical information about the individuals concerned. However, these studies consider individuals within a hermetic framework of their own practice and, consequently, offer little analysis of the extent to which they contributed to the evolution of set design aesthetics and filmmaking in Russian cinema more broadly. Adopting a similarly close reading of archival documents and memoirs, Gennadii Miasnikov's multi-volume study of set design, published in the 1970s, provides the most comprehensive account of developments in set practices in late-Imperial

and early-Soviet cinema up to the end of the Second World War.[29] Miasnikov describes in detail technical and aesthetic developments in set design, the working practices of production artists and the expansion and growing technological sophistication of studios. He does not, however, support his study of set design with visual analysis of films themselves due, as he himself notes, to restrictions on accessing films at the time of writing.

After a hiatus of almost four decades, Emma Widdis was the next scholar to specifically address the role of set design in Russian cinema.[30] In her chapter 'Cinema and the Art of Being: Towards a History of Early Soviet Set Design' (2016), Widdis provides an overview of the major preoccupations that shaped set design practices, aesthetics and theory in early-Soviet cinema in the 1920s and 1930s.[31] As Widdis states, it is beyond the limits of her chapter to provide a comprehensive study of early-Soviet set design; rather, her aim is to draw attention to set design as an 'overlooked part of Soviet film history' and to encourage research in the field.[32]

Although very few studies address set design as their main focus, scenery is regularly commented on in scholarship on late-Imperial Russian and early-Soviet cinema. A number of scholars have considered set design in their analyses of how contemporary artistic movements influenced the aesthetics of certain films.[33] Such scholars as Neia Zorkaia, Iurii Tsiv′ian, Valentina Kuznetsova and Oksana Chefranova have also explored how filmmakers drew on certain representational strategies employed by artists and borrowed motifs from the visual arts, showing how this was connected with filmmakers' interest in the nature of cinematic representation and its relation to other art forms.[34] And Tsiv′ian, Rachel Morley, Mikhail Iampol′skii and Alyssa DeBlasio have all discussed how filmmakers working across the period under consideration used sets in relation to their experiments with the expressive potential of cinema, particularly cinematic space and audience engagement.[35] In her studies on early-Soviet cinema, Widdis draws on theories of haptic perception to argue that Soviet filmmakers' experiments with cinematic devices, including set design, formed part of a broad revolutionary project to remake the relationship of Soviet subjects to their surrounding material environment by offering a new sensory apprehension of the world.[36] Widdis's study thus provides a model for how set design can be studied in relation to broader theoretical questions about the material environment.

The production artist: Approach and scope

While Widdis focuses specifically on how Soviet filmmakers used sets as a means to heighten cinema's sensory impact and to convey materialist ideas, this book provides a broader account of set design practices, theory and aesthetics, highlighting the many and varied ways in which filmmakers employed cinema design and the diverse ideological meanings that sets held in both the late-Imperial and early-Soviet eras of cinema. Given the very limited historical analysis that exists on Russian cinema design from this period, my focus is to elaborate on the specific historical and intellectual contexts in which film sets were produced and received, rather than to apply more contemporary theoretical frameworks as a method of analysis or draw international comparisons with other national cinemas. In addition to close formal analyses of films and related visual material, including film stills and surviving set design sketches from this period of Russian cinema, I examine a number of primary sources relating to the material environment. These include articles in late-Imperial and early-Soviet newspapers, specialized journals and the popular press on issues such as domestic life and luxury, as well as the writings of Russian cultural theorists of the era, including Boris Arvatov, Viktor Shklovskii and Sergei Tret′iakov, on material agency and object desire. I also examine a range of primary and archival sources relating to the production process, including filmmakers' memoirs, set design manuals and the contemporary cinema press, as well as such documents as studio contracts, expense receipts and production stills held at the Russian State Archive of Literature and Arts (Rossiiskii gosudarstvennyi arkhiv literatury i iskusstva, RGALI) and the State Film Archive of the Russian Federation (Gosudarstvennyi fond kinofil′mov Rossiiskoi Federatsii, Gosfil′mofond). Many filmmakers' memoirs and articles in the contemporary cinema press were concerned more with advancing a particular perception about production artists and their role than with describing actual working practices. I therefore pay close attention to these texts in terms of their use of language, focusing on how shifts in terminology related to evolving perceptions about the production artist and the practice of set design.

This focus on the rhetorical effect of language and the development of a discourse around set design is reflected in my choice to translate the original Russian title for the profession – *khudozhnik* – as production artist. In the context of Russian cinema, the title *khudozhnik* poses a

particular challenge with regard to its translation. To translate the term directly as 'artist' would lead to confusion with other areas of artistic endeavour that are independent from cinema. Elsewhere in articles and book chapters I have retained the original Russian term *khudozhnik* in my discussion of the profession.[37] In this monograph, however, I choose to refer to individuals practising the profession by the term production artist in an attempt to make accessible and to clarify to non-Russian speakers and those unfamiliar with the Russian artistic context some of the connotations and the importance attached to the original Russian title.

'Production artist' is not a term conventionally used in the English language in relation to different cinema traditions, with the titles production designer, set designer or art director being more common. As Fischer notes in relation to the US film industry, these Anglophone titles have themselves been up for debate throughout cinema history: each title encompasses a different range of tasks associated with filmmaking and also reflects a particular conception of the profession as a trade, a craft or a creative art.[38] Among these existing titles, there is not a clear choice that is most appropriate in the context of Russian silent-era cinema. Scholars of Russian cinema have variously applied these titles when referring to the profession in the 1910s and 1920s: Tsiv´ian and Morley use the term 'set designer' in relation to late-Imperial cinema and Widdis applies both set designer and production designer in her work on early-Soviet cinema.[39] The term 'production designer' was coined in US cinema in the late 1930s to describe 'a supervisory figure overseeing a large workforce and exerting considerable influence over the production process' and became widely used from the 1940s.[40] By adding the prefix 'production' to the direct translation of *khudozhnik*, I seek to emphasize that the role in Russian cinema similarly had responsibility for a whole range of creative and technical spheres that formed part of the film production process. The use of the Anglophone term 'design' (*dizain*) is, however, problematic within a Russian artistic context. As several design historians have noted, design only became formulated and professionalized as a discipline in Soviet Russia from the 1960s;[41] even then, the term 'designer' (*dizainer*) was barely used in Russia before the 1980s on account of its perceived capitalist associations with developing new products in the context of a competitive market economy, with critics and creatives favouring the professional term *khudozhnik-konstruktor* (artist-engineer).[42] The title production artist has another distinct benefit in its similarity to the Soviet artistic discourse of production art, the goals of which I argue in

this book were realized by such individuals as Kozlovskii through his work in rationalizing studio filmmaking.

As I discuss in Chapter 1, Russian filmmakers and critics in their writings on cinema did, at times, apply various terms to the profession other than *khudozhnik*, including *arkhitketor* (architect), *dekorator* (decorator), *konstruktor* (engineer). These were used more for rhetorical effect in pieces of criticism to demonstrate a point about the profession's remit and its relationship to other creative and technical disciplines rather than ever being officially adopted by film studios as an official professional title. Where these other terms are used in the sources discussed in this book, I provide the original Russian in brackets.

The book spans the entirety of the silent era of Russian cinema, from the first attempt to create a native fiction film in 1907, with Aleksandr Drankov's adaptation of Aleksandr Pushkin's classic *Boris Godunov* (1831), up to the advent of sound technology at the beginning of the 1930s.[43] The transition to sound posed technical challenges and altered working practices for many filmmakers, including production artists, who faced pressures in constructing artificial scenery for the increasing number of films shot in studios adapted for sound technology.[44] The coming of sound also coincided with the cultural and political upheaval of the First Five-Year Plan (1928–32) and the accompanying Cultural Revolution, which led to a complete restructuring of the Soviet arts under the new ideological precepts of Socialist Realism and a widespread campaign to centralize the cinema industry. These changes radically altered both the way in which films were produced and the context in which they were received. The effects of the transition to sound, the industry's centralization and the rise of Socialist Realist ideology on Soviet cinema design warrant their own attention and lie beyond the parameters of this monograph.

The book comprises five chapters. Chapter 1 addresses the major preoccupations affecting the theory and practice of set design in late-Imperial and early-Soviet cinema. Drawing on archival and primary sources, I provide a typological account of production artists and how their working practices evolved across the silent era. I examine the professional backgrounds of production artists, highlighting the importance of their training in the fine arts and their links to artistic communities. I show that, in their endeavours to increase cinema's cultural standing, Russian filmmakers recruited individuals with artistic training to work as production artists and used publicity strategies to associate film design with the high arts, particularly painting. I explore the relationships that production artists formed with other filmmakers,

as well as the responsibilities that they held in filmmaking teams. I trace how, as studio resources developed in Russia, production artists became responsible for coordinating production workshops and innovating technical solutions to economize the design process. In considering how the production artist acted as a bridge between the technical and creative sides of studio film production, this chapter emphasizes the importance that filmmakers ascribed to the qualities of versatility, technical expertise and a collaborative work ethic, in addition to individual artistic vision.

The subsequent four chapters analyse the sets that production artists created for specific films. These chapters are thematic, with each examining the representation of a different material environment: the rural provinces, the domestic interior, the workplace and artistic or entertainment spaces associated with artistic production and performance. These environments were among the main settings that characterized Russian films in the silent era. Indeed, in 1919 the filmmaker Aleksandr Razumnyi included four of them – a room in workers' quarters, an office in a Soviet institution, the interior of a peasant *izba* and a domestic room in the city centre – in a proposed list of five standardized settings for films to be made by the newly nationalized and restructured Soviet cinema industry.[45] In these thematic chapters, I draw on select case studies of films, rather than attempting to give a comprehensive overview, as my intention is not to provide an exhaustive account of the various ways in which different material environments were represented in Russian cinema but to consider key characteristic features. The choice of case studies is intended to strike a balance between well-known films and less canonical works. In this way, I hope to provide an alternative perspective on films that have a large body of secondary literature dedicated to them but have been little analysed in terms of their set design, as well as to expand the canon of films typically considered in English-language studies on Russian cinema. These chapters all follow a loosely chronological order, stretching from the first decade of Russian fiction cinema to the end of the silent era in the early 1930s. In this way, I attempt to delineate how aesthetic and ideological concerns developed across the period as a whole and to consider issues of continuity and change between late-Imperial and early-Soviet cinema.

Due to limitations in studio space and lighting technology, many of the first Russian fiction films were shot on location in rural settings. Chapter 2 therefore explores the ways in which the rural provinces were represented in films. It examines how during the silent era the use

of rural settings was tied to debates about the merits and disadvantages of outdoor filming as opposed to using artificial studio sets, paying particular attention to the writings and designs of the production artist Dmitrii Kolupaev, a key interlocutor in these discussions. As Kolupaev's writings reveal, filmmakers chose to use rural settings not only for practical considerations, however. Their use also illustrated filmmakers' interests in cinema's capacity to convey ethnographic knowledge about traditional Russian life and customs. The chapter therefore also considers depictions of rural communities and landscapes in relation to theoretical debates about cinema's potential as an ethnographic tool to convey knowledge about traditional Russian life and customs.

In Chapter 3, my examination turns to the urban environment. From the early to mid-1910s, filmmakers increasingly used urban settings in their films. The chapter explores how production artists harnessed elements of interior design and architecture, including windows, doorways, curtains and patterned textiles, to enhance cinema's expressive potential. In particular, it highlights the work of Boris Mikhin, one of the first production artists to use interior elements for their formal expressivity. The chapter argues that production artists such as Mikhin also, however, used interior sets to convey meaning about inhabitants' experiences of domestic life and their attitudes to consumerist concerns about luxury and commodity pleasure. While these issues were pertinent in the late-Imperial era, they acquired particular significance following the 1917 Revolution and during the conflicted years of the New Economic Policy (NEP, 1921–7), when the Soviet government reintroduced limited market capitalism. Drawing on the writings of the cultural theorists Boris Arvatov and Sergei Tret′iakov, the chapter analyses how representations of domestic interiors in early-Soviet films related to wider social issues about material agency.

Chapter 4 explores the material environment of the workplace. While a number of studies have emphasized the importance of the factory work floor in late-Imperial and early-Soviet culture, this chapter focuses on the environment of the private office or study. It examines how filmmakers represented these spaces as realms associated with individual fantasy and personal desire. In so doing, the chapter explores the place of imagination and pleasure in late-Imperial and early-Soviet discourses about work. A key focus of this chapter is Evgenii Bauer, who used private studies in many of his films to comment on the fantasist nature of his male protagonists.

This chapter also discusses how filmmakers such as Lev Kuleshov and Vasilii Rakhal's – both of whom worked as production artists under Bauer at the Khanzonkov studio – subsequently used the private study in films made after the Revolution, namely *Engineer Prait's Project* (Proekt inzhenera Praita, 1918), *Strike* (Stachka, 1925) and *Your Acquaintance* (Vasha znakomaia, 1927), in relation to Marxist ideas about imagination and labour.

The final chapter considers the cinematic representation of a number of spaces associated with artistic creation and performance, in particular artists' ateliers, cinema auditoriums and studios and the circus arena. It examines the evolving ways in which production artists used creative settings to comment self-referentially on the nature of different artistic practices and on cinema's status as a new artistic medium. While in the early to mid-1910s filmmakers such as Mikhin, Egorov and Bauer used artists' studios and motifs in order to examine different artistic traditions, as the decade progressed production artists turned to representing filmmaking environments so as to explore questions about cinema's status as a cultural industry. The chapter argues that, by the end of the 1920s, filmmakers shifted their interests away from ontological concerns about art forms to focus instead on issues relating to creative independence and the social function of artists in revolutionary life, using the circus as a metaphor for artistic liberation and political activism.

Complementing these chapters is an appendix of eight primary source texts, relating to set design and the role of the production artist, translated from Russian into English. This includes unpublished texts from the archives of Andrei Burov and Egorov which are translated and made accessible here for the first time. They reveal important insights into how these individuals approached the task of working in cinema in contrast to their respective practices in architecture and theatre design. Additionally, the appendix includes articles written by such prominent creative figures as Iutkevich, Kuleshov, Pudovkin and Rodchenko and which were published in the contemporary cinema press, demonstrating the centrality of discussions about set design to wider debates about cinema during the period. While several of these texts, including those by Kuleshov and Rodchenko, have previously been translated into English, these new translations serve to clarify the use of certain terminology relating to set design that remain ambiguous in existing translations. All the texts included in the appendix not only provide crucial information on the practice of cinema design but also

offer insights into their authors' evolving perceptions about cinema's nature as an artistic medium and its relation to other art forms. It is therefore hoped that this monograph, with its accompanying appendix of translations, will serve as a resource for further exploration of artistic and ideological concerns in Russian silent-era cinema.

Chapter 1

EARLY RUSSIAN PRODUCTION ARTISTS: PROFESSIONAL PRACTICES AND CULTURAL CONTEXTS

> Above all else, we demand from production artists versatility. The production artist is an architect, a painter and an applied artist. He must know almost all crafts. He must know no worse than the camera operator lighting techniques, methods of camera operation (in particular optical properties). No worse than the director, he must know the styles of the historical eras which different films seek to portray.
>
> —Sergei Kozlovskii, 'Film studio technology' (Tekhnika kinoatel´e), 1925

In his 1925 article 'Film Studio Technology', the head of the art department at the Soviet Mezhrabpom-Rus´ studio Sergei Kozlovskii (1885–1962) attempted to define the role of the production artist in cinema. As the statement in the epigraph to this chapter demonstrates, Kozlovskii emphasized that the production artist must be skilled in all the arts and involved in all aspects of film production. That this same statement appeared in Kozlovskii's writings on cinema on three further occasions within five years indicates the importance that he ascribed to the quality of versatility among production artists.[1] While Kozlovskii's statement is partly geared towards self-aggrandizement, it is clear from a number of articles and memoirs written by other filmmakers that versatility did indeed characterize the work of the production artist in early-Russian and Soviet cinema. Demonstrating a willingness to take on various filmmaking responsibilities, the production artist was a key figure in the aesthetic and technical decisions that led to the creation of a film. However, the varied nature of their work means that analysing the specific contribution of production artists to film production is not always easy, and this has contributed to the fact that they have not always been fully recognized for their input, either by contemporaries or by scholars writing subsequently on the period.

This chapter examines how the roles and working practices of production artists evolved in Russian cinema in the silent era against the context of the increasing professionalization of the film industry and its nationalization from a private to a state enterprise in 1919. The period under consideration was one of immense artistic change, a time when traditional boundaries between artistic media were contested and cinema emerged as a new art form. It was also a period of great social and ideological change in Russian life, which in turn affected the structure of the film industry and of arts institutions. I will therefore analyse the evolving roles and working practices of production artists in relation to this cultural and social context. The chapter provides a typological account of production artists, assessing the conventions that were common among them rather than circumstances that were specific to individuals. First, it explores the professional backgrounds and prior artistic training of the figures who came to work as production artists and considers how this influenced their creative approach. It then examines the reasons why film producers sought to recruit individuals to work as production artists at a time when Russian cinema was still very much in its infancy. Last, it investigates the nature of the professional relationships that production artists formed with studios and production units, as well as the responsibilities that they acquired within filmmaking teams. In its focus on set design as a practice, this chapter demonstrates how available technology, the studio environment and professional partnerships, as much as the creative visions of individuals, shaped the evolution of early-Russian film aesthetics and influenced contemporary understandings of cinema's artistic and ideological potential.

Eclecticism and innovation: Professional backgrounds and training

In contrast to the first generation of directors and camera operators, who had backgrounds in the commercial and entertainment spheres of theatre, photography or actuality filmmaking, the first production artists to work in Russian cinema had all received formal training in the fine arts.[2] Many had studied at established arts institutes, such as the Academy of Arts in Saint Petersburg (from 1914 Petrograd and from 1924 Leningrad), the Kiev Art Institute and the Moscow College of Painting, Sculpture and Architecture (MUZhVZ). This differs from the initial education of set designers working in other European

cinemas of the period, who had generally trained at applied arts and technical colleges, where commercial imperatives took precedence over experimentation and individual artistic vision.[3]

The particular institutes where production artists initially studied naturally helped shape their creative outlook and approach. A number trained in the painting department at MUZhVZ under Konstantin Korovin, a member of the World of Art (*Mir iskusstva*) movement.[4] The activities of World of Art played an important role in the first decades of the twentieth century in elevating theatre design, which had previously been considered a minor art form, to the height of fine art.[5] Alongside his pedagogical work, from 1901 to 1918 Korovin designed scenery and costumes for the Imperial Theatres in Moscow and Saint Petersburg.[6] His earliest designs, such as those for Nikolai Rimskii-Korsakov's 1909 opera *The Golden Cockerel* (Zolotoi petushok), use intricate patterning and strong tonal juxtapositions to create a sense of vibrancy. In an unpublished article, preserved in his personal archive, Sergei Kozlovskii acknowledged the importance of World of Art to the sphere of set design.[7] Following the example of World of Art, many early-Russian production artists used patterned textiles and wallpaper to exploit the tonal variations and contrasts attainable with orthochromatic film.[8]

Several of the most prominent production artists in the late-Imperial era, including Evgenii Bauer (1865–1917), Vladimir Egorov (1878–1960), Mikhail Kozhin (1877–1966) and Aleksei Utkin (1891–1965), studied under the architect Fedor Shekhtel´ at the Stroganov Institute for Technical Drawing. Shekhtel´ was a leading figure in promoting a form of art nouveau in Russia, typically referred to as *russkii modern*.[9] Several scholars have noted the influence of *russkii modern* on Bauer's films and the earliest designs of Utkin and Egorov for cinema.[10] A striking example of this is the neogothic study of the wealthy industrialist, Zheleznov, in Bauer's *The Alarm* (Nabat, 1917); its pointed arches, stained-glass windows and deeply carved woodwork distinctly recall Shekhtel´'s designs for Zinaida Morozova's Moscow mansion.[11] As Neia Zorkaia argues, the influence of *russkii modern* on Russian cinema of the 1910s is evident not only in terms of the specific stylistic features of sets but also in the way in which filmmakers used exaggerated contrasts of light and shadow to heighten psychological tension.[12]

While these connections with the World of Art and *russkii modern* are undoubtedly important, production artists were also associated with a number of diverse artistic circles, including The Wanderers (*Peredvizhniki*) association of realist artists, the symbolist Blue Rose

(*Golubaia roza*) group and an impressionist style of landscape painting.[13] Likewise, production artists refer in their memoirs to eclectic aesthetic influences. Kozlovskii explains how Leonardo da Vinci's writings influenced his creative approach.[14] Following da Vinci's teaching that artists must train their observational skills on the natural world, as a young art student Kozlovskii compiled albums of sketches and photographs of Odessa's daily life and architecture, which he later referred to when developing set designs. He also assembled albums of paintings of the various Moscow suburbs depicted by The Wanderers artists Mikhail Nesterov, Vasilii Polenov and Isaak Levitan, which he consulted when working on films.[15] Sergei Iutkevich (1904–85), who began his career in cinema as a production artist before becoming one of the most prominent Soviet directors, recalls how, while studying painting under Aleksandra Ekster at the Kiev Art Institute, he developed an interest in cubo-futurist principles regarding movement, space and time.[16] For the Lenfil´m production artist Nikolai Suvorov (1889–1972), the work of German expressionists, such as Otto Nagel and Heinrich Zille, had a particular influence on his practice while a student at the Saratov Art School.[17]

Although influence can be discerned in general terms, it is impossible to identify a single dominant stylistic influence among early-Russian production artists. Importantly, in their memoirs many production artists identified with artistic traditions more as conceptual approaches to the problem of visual representation than as aesthetic styles to be directly translated to cinema.[18] As Kozlovskii wrote, 'the tradition of painting established its own laws, which were not entirely obligatory for every [production artist], but which did inform in one way or another his artistic worldview'.[19]

In addition to this eclectic mix of influences, production artists had experience working with diverse artistic media. A number of the production artists working in early-Russian cinema had trained in both architecture and painting, while most of them also had experience in the graphic arts, contributing illustrations to journals or designing posters.[20] Working with graphics provided production artists with an understanding of the expressive potential of a monochrome palette. In his memoirs, Iutkevich discusses how his background in the graphic arts led him to adopt an approach to cinema design that privileged the play of light and shadow.[21] Iutkevich's sketches for one of his first projects as a production artist, the Goskino studio's *The Traitor* (Predatel´, 1926), use stark tonal juxtapositions to model volume. An interest in graphics is also discernible in Egorov's set design sketches, which are characterized by their bold lines and strong tonal contrasts.

1. Early Russian Production Artists

The early-Russian filmmaker Vladimir Gardin even claimed that Egorov introduced a graphic approach to cinema, explaining that 'for the scenery specified by a scenario, Egorov always found a synthetic-semantic graphic expression. Details were eliminated, and the "essence" was conveyed so clearly that the viewer's eye did not need to search about, but just saw, as with a good poster.'[22]

Stylistic eclecticism was a common feature of artistic culture in the 1910s and 1920s in Russia, with interdisciplinary societies such as the Commission for Painting, Sculpture and Architecture (Zhivskul´ptarkh, 1919–20) promoting a synthesis among the visual arts. However, the diversity in the professional training of production artists is remarkable and supports Emma Widdis's argument that, for production artists, creative talent and broad artistic training were more significant than specialization in a particular style or medium.[23] A broader education in the arts continued to be important for aspiring production artists throughout the 1920s, even after the establishment of specialist film schools such as the State Institute of Cinematography (GTK, from 1925 GIK and from 1934 VGIK). During the late 1920s, art institutes became the home for a number of specialist courses for film design. In 1927, the State Institute for the History of Arts (GIII) in Leningrad established a cinema department and in 1929 the production artist Boris Dubrovskii-Eshke (1897–1963) founded a special department of film art direction at the Academy of Arts. Archival documents relating to the Academy of Arts indicate that Dubrovskii-Eshke placed particular emphasis on the development of painting and drawing skills, as well as the acquisition of a wide knowledge of artistic styles, in preparing future production artists.[24] This outlook persisted well into the 1930s, when an arts faculty was eventually opened at VGIK in 1938 and the easel painter Fedor Bogorodskii was appointed its director.[25]

Although opportunities for aspiring production artists to gain specialist instruction increased throughout the 1920s, there still remained considerable concern about the type of institute that should be responsible for delivering training.[26] In the first manual on set design, published in 1929, Kozlovskii and the critic Nikolai Kolin noted that it was still not clear whether a cinema institution such as GIK, an existing art school or an entirely new establishment should be responsible for educating production artists.[27] This lack of resolution over the nature of training suggests that cinema design continued throughout the silent era to be appreciated as an essentially hybrid practice, which drew on diverse disciplines, and that into the 1930s breadth of experience was still valued over specialization.

Set design experience: The Moscow Art Theatre

With limited options for Russian production artists to gain specialist instruction in film design, the career paths of most typically led from the art institute to the theatre. Here, they became accustomed to working on a large scale and as part of a collective; they also acquired experience in lighting technology, as well as an awareness of the need to consider the relationship between scenery and actors. During the first two decades of the twentieth century, there existed very few opportunities to undergo formal training in theatre design, and most production artists developed their skills working as assistants to experienced theatre designers.[28]

It is perhaps not surprising that the majority of production artists working in early-Russian cinema had previous experience as theatre designers. What is notable, however, is that so many of them gained this experience from the Moscow Art Theatre (Moskovskii khudozhestvennyi teatr, MKhT). The majority of the first production artists to work in Russian cinema – Anatolii Arapov (1876–1949), Vladimir Balliuzek (1881–1957), Egorov, Dmitrii Kolupaev (1883–1945), Boris Mikhin (1881–1963) and Czesław Sabiński (1885–1941) – had come directly from the MKhT.[29] During the years 1900 to 1919, the MKhT's approach to set design was intimately connected with Viktor Simov, who headed the design department from the theatre's inception in 1898 until 1912 and again from 1925 until his death in 1935.[30] Under Simov, the MKhT initially adopted a realist approach to set design.[31] In line with its repertoire, which was dominated by the dramas of Anton Chekhov, contemporary settings of everyday life replaced the Romantic-style landscapes that were typical of Imperial Theatre productions during this period. The MKhT departed from the common practice adopted at this time of reusing scenery; instead, a team of in-house designers created sets for individual productions from scratch. Wall-papered rooms with real wooden furniture and stucco architectural features replaced the painted canvas backcloths that were typical of theatre design up to this point (Figure 1.1). Simov also introduced more complex spatial compositions: niches, recesses and corners were used to create a series of interconnected spaces among which different elements of the drama were staged. Structures, such as balustrades and benches, were often placed in the foreground to emphasize the so-called fourth wall, the illusory barrier at the front of the proscenium stage that separates the audience from the production (Figure 1.2).[32]

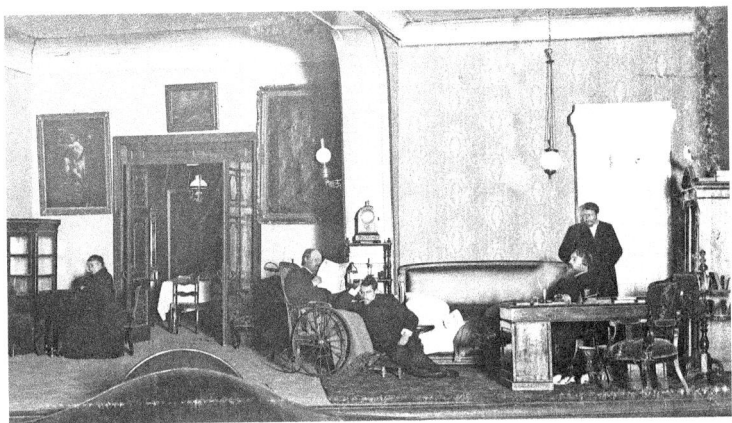

Figure 1.1 Viktor Simov's interior set for the 1898 Moscow Art Theatre (MKhT) production of Anton Chekov's *The Seagull* (Chaika).

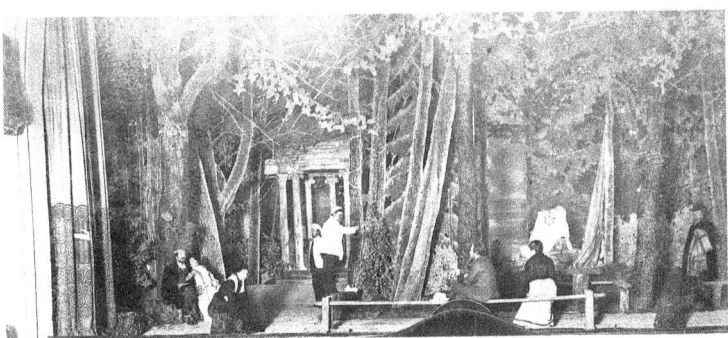

Figure 1.2 Simov's exterior set for the 1898 MKhT production of Chekov's *The Seagull* (Chaika).

From the early to mid-1910s, production artists employed similar techniques in cinema. For example, Mikhin's interiors for Vladimir Gardin's 1914 adaptation of Lev Tolstoi's *The Kreutzer Sonata* (Kreitserova sonata) for the Thiemann and Reinhardt studio consisted of a series of interconnected spaces of different depths and dimensions that were linked by a combination of doorways, arches and staircases. As will be discussed in Chapter 3, these spatial variations worked to convey shifts in dramatic tension and changes in atmosphere as the narrative developed. In one scene, Mikhin placed a balustrade in the extreme foreground, behind which the action takes place (Figure 3.2). As in Simov's designs, this technique serves to reveal the fourth wall,

while it also makes the viewers aware that, as in Tolstoi's original text, they are being presented with a rendition of events told from the protagonist's perspective. As Rachel Morley notes, in a number of his films Bauer also used sets as framing devices to reinforce the idea that the audience is viewing events from a particular character's viewpoint.[33] From 1909 on, Simov began to move away from the strict adherence to realism that had characterized earlier MKhT productions; instead, he adopted an approach to set design based on using neutral backdrops and incorporating a few objects, characteristic of the setting and the period of the production, as a means of heightening psychological tension.[34] From the early to mid-1910s production artists exploited a similar method in films, and in the early 1920s austere settings characterized Soviet cinema, as will be discussed in the following chapters in relation to both aesthetic and ideological concerns of the period.

In addition to Simov, Egorov also played a major role in the development of set design at the MKhT, where he worked as a designer from 1905 to 1920.[35] In contrast to Simov, Egorov advanced a design approach that drew upon symbolist tendencies, which placed greater emphasis on atmospheric effects as a way for the audience to identify with the psychology of characters. In particular, Egorov employed textiles to heighten the expressive impact of lighting. His use of gauzes and black velvets for a 1908 production of Maurice Maeterlinck's *Blue Bird* (Siniaia ptitsa) won critical acclaim for enhancing the interplay of shadow and light to create dramatic tension.[36] When *Blue Bird* was performed in Paris, the critic E. Beskin even referred to Egorov's designs as 'cinematographic' for the way in which they exploited light.[37] Egorov transferred this use of textiles as a means to exploit expressive light effects to his earliest work in cinema. Kuleshov recalls how Egorov in one of the first films he worked on – *For the Right of the First Night* (Za pravo pervoi nochi, 1916), also known as *At Sea* (V more, 1916), used a black velvet background to enhance the impression of glittering ripples of light on the water's surface.[38] From the mid-1910s, production artists similarly experimented with textiles to produce tonal variations. As several scholars have noted, Bauer in his sets for *Twilight of a Woman's Soul* (Sumerki zhenskoi dushi, 1913) used layers of fabrics of different opacities – from diaphanous tulle to heavy, black velvet – to create lighting effects that conveyed the psychological state of the film's protagonists.[39]

The influence of the MKhT on cinema design was manifest not only in specific stylistic tendencies, however. It was also evident in how the role of the production artist was conceptualized. Scholars

typically consider the MKhT under Stanislavskii's leadership in terms of its elevation of the director to an auteur position.⁴⁰ However, it also promoted a new conception of the designer's role in theatre: no longer was he simply a technical craftsman; rather, he played a decisive role in the overall development of a production. As head designer at the MKhT, Simov involved himself in all the developmental stages of a production: he attended castings and readings; brought set models to rehearsals, enabling actors to gain an appreciation of the production's setting; and worked together with Stanislavskii on preparing prompt books for actors.⁴¹ Reflecting on Simov's work, Stanislavskii later wrote that '[Simov] was the founder of a new era in the sphere of artistic scenery, the forefather of a new type of "*khudozhnik-rezhisser*" (artist-director)'.⁴²

Simov adopted this same approach to design when he came to work in cinema in the late 1910s. While working on the Rus´ studio film *The Virgin Hills* (Dev´i gory, 1919), Simov brought models of all the sets to the studio during filming. According to the proprietor of Rus´ Moisei Aleinikov, these models ensured a cohesion in style throughout the film and helped the actors stay in character during shooting breaks.⁴³ Aleinikov also notes that Simov's close collaboration with the director Aleksandr Sanin and the camera operator Iurii Zheliabuzhskii helped raise the standard of production practices at Rus´, setting a precedent for future works.⁴⁴ Thus, it becomes clear that while scholarship typically focuses on the MKhT's influence on acting techniques in early-Russian cinema, the theatre also had a significant influence on set design in film, from both a stylistic and conceptual viewpoint.⁴⁵

Enter cinema: Recruitment and accreditation

During the earliest years of the Russian fiction-film industry, filmmakers used set design as part of a strategy to increase the cultural standing of cinema by associating it with a fine arts tradition. They borrowed terms from the fine arts lexicon to describe film aesthetics, including *kartina* (picture) to refer to a film and *rembrandtizm* to describe a lighting approach based on strong contrasts of light and shadow. Most significant in this respect was the choice of the term *khudozhnik* (artist) as the professional title for cinema set designers, as opposed to other designations such as *dekorator* (decorator), *oformitel'* (scenery dresser) or *remeslennik* (craftsman). The term *khudozhnik* was used as early as 1908 to describe the work of V. Fester in creating the sets for some

of the Aleksandr Khanzhonkov studio's first fiction films, *Song about the Merchant Kalashnikov* (Pesn´ pro kuptsa Kalashnikova) and *A Sixteenth-Century Russian Wedding* (Russkaia svad´ba XVI stoletiia), both directed by Vasilii Goncharov.[46]

Producers also associated cinema with the fine arts through publicity materials advertising that the visual designs of films were based on the works of eminent Russian artists. For *Song about the Merchant Kalashnikov* and *A Sixteenth-Century Russian Wedding*, Fester's designs were credited as being created 'according to the drawings' (*po risunkam*) of the acclaimed painters Viktor Vasnetsov and Konstantin Makovskii.[47] Likewise, publicity material for the joint Khanzhonkov and Pathé studio's *The Year 1812* (1812 God), made in 1912 to mark the centenary of the Napoleonic Wars, noted that Fester and Czesław Sabiński, who worked together on the sets, had created their designs based on Vasilii Vereshchagin's celebrated painting cycle of the same subject.[48] At the same time as the film's release, the cycle was on display at the Imperial History Museum in Moscow as part of an exhibition to mark the war's centenary, prompting contemporary critics to note similarities between Vereshchagin's compositions and certain scenes in the film.[49] This promotional strategy continued to be used throughout the 1910s. Bauer's designs for Aleksandr Drankov and Aleksei Taldykin's *The Tercentenary of the Rule of the House of Romanov* (Trekhsotletie tsarstvovaniia doma Romanovykh, 1913) were similarly promoted as being based on works by Makovskii, Vasnetsov and Ivan Bilibin.[50] The fact that filmmakers chose to associate the visual designs of films with the works of Russian painters in particular reflects a desire to affiliate cinema with a national artistic tradition. This can be seen to relate to a larger ambition among Russian producers to rival the popularity of foreign produced and imported films through creating a distinctively national cinema, which employed native actors and creative personnel, depicted traditional Russian subjects and used settings that were recognizably Russian.[51]

The association of cinema design with painting was not merely a publicity strategy, however. It also revealed an understanding among filmmakers and critics that cinema shared certain aesthetic and ontological features with painting. These shared properties were remarked upon in the contemporary cinema press. In a 1915 article in the journal *Cinema Herald* (Vestnik kinematografii), the poet Sergei Gorodetskii even coined a new term for cinema: '*zhiznopis´*' – an amalgam of the Russian words for painting (*zhivopis´*) and for life (*zhizn´*) – to reflect the medium's similarity to painting, as well as its

ability to capture movement and its roots in reality.⁵² Critics also spoke of the work of certain filmmakers as similar to painting. In an article dedicated to Bauer, Valentin Turkin stated that: 'in film [Bauer] worked as an artist does, not as a decorator (*khudozhnik-dekorator*), but as a painter (*khudozhnik-zhivopisets*), creating film frames following the laws of the pictorial arts and observing trends in spatial composition and the rhythm of movement, lines, surfaces and masses [...]. This similarity of the screen to the painted canvas is crucial for Bauer's talent'.⁵³

Production artists themselves also perceived certain similarities between their work and painting. In an unpublished article, entitled 'The Artist of the Theatre Stage and the Artist of the Film Picture – Masters of Decorative Scenery', Egorov explained how his practice in cinema differed from his work in the theatre and related more closely to the pictorial arts.⁵⁴ Illustrating his article with examples of paintings juxtaposed with cinema set diagrams, he demonstrated how production artists perceived cinematic space in similar terms to pictorial space and borrowed certain compositions (Figure 1.3).⁵⁵ Egorov also compared these set diagrams with those showing how theatre designers had previously approached the mise-en-scène, so as to emphasize the differences between cinematic and theatrical models of space and framing. He detailed how for such films as *The Picture of Dorian Gray* (Portret Doriana Greia, 1915) he designed scenery that took into account the different positions of the camera and the various angles from which the set would be filmed.⁵⁶

The way in which production artists were credited and films were associated with the fine arts supports Denise J. Youngblood's argument that many film producers were motivated not only by the prospect of financial gain but also by a sincere desire to acquire artistic respectability for cinema.⁵⁷ To this end, they also promoted cinema as a community of cultured individuals and invited established creatives from other artistic spheres, including designers from the theatre. Although most of the first Russian production artists established successful careers in cinema that stretched over several decades, few seem to have had a genuine prior interest in film. Nor did they make the choice to work in the industry independently, but rather producers actively recruited them to join studios to heighten the artistic calibre of films. For high production-value films, such as the Thiemann and Reinhardt studio's *Russian Golden Series* (Russkaia zolotaia seriia), filmmakers sought individuals with artistic reputations. For the studio's highly publicized biographical film about the writer Lev Tolstoi, *The Departure of the Great Old Man*

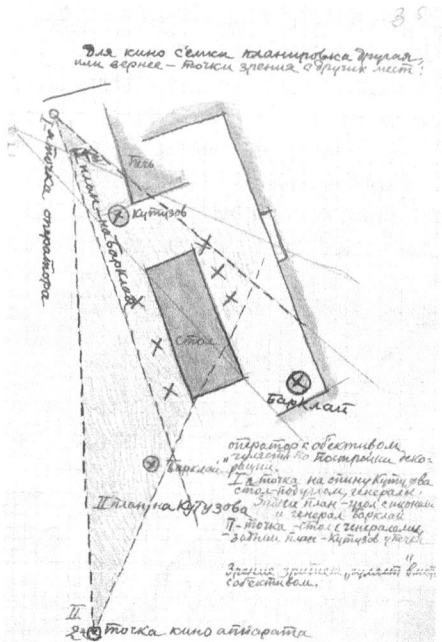

Figure 1.3 Vladimir Egorov, 'The Artist of Theatre Stage Scenery and the Artist of the Cinema Picture… What's the Difference?'. RGALI f. 2710, op. 1, ed. khr. 59, 5.

(Ukhod velikogo startsa, 1912), the director Iakov Protazanov recruited the artist Ivan Kavaleridze, who was working on a commission of a portrait bust of Tolstoi at the time.[58] Impressed by the MKhT's 1915 production of Aleksandr Pushkin's *Little Tragedies* (Malen´kie tragedii, 1830), Protazanov enlisted the production's set designer, Balliuzek, to work as the production artist on his 1916 adaptation of Pushkin's *The Queen of Spades* (Pikovaia dama).[59] In 1915, Thiemann and Reinhardt approached Egorov to work on a highly anticipated adaptation of Oscar Wilde's *The Picture of Dorian Gray* (1890), directed by the renowned theatre director Vsevolod Meierkhol´d. According to Gardin, Egorov's arrival at the studio was a significant step forward in elevating the artistic quality of cinema: 'The artist V. E. Egorov came to Thiemann. Everywhere people began talking about a new direction in the firm's productions, about the introduction of pictorial techniques and the construction of frames based on the beauty of the overall decorative scheme'.[60]

The mid-1910s saw a growing appreciation of set design as an independent artistic practice, with a shift away from associating it with painting to a greater appreciation of sets in and of themselves. From 1915,

promotional material in the cinema press began to use cinema design widely as a marketing tool: stills of richly decorated interiors occupied full- and half-page spreads; advertisements publicized a production's 'luxurious' sets and costumes;[61] and the names of production artists featured in an equally prominent position beside those of the director, well-known theatre actors and the author of a film's literary text. Indeed, the journal *Cine-Phono* (Sine-fono) advertised Egorov's involvement in *The Picture of Dorian Gray* with a full-page spread.[62] In other advertising material for the film, Egorov's name was featured in bold type next to that of the famous Meierkhol´d himself. The inclusion of the names of production artists during this period marks a significant step forward in the recognition of their contribution to cinema. Their position was further cemented at the end of this decade by the inclusion in *Cinema Newspaper* (Kino-gazeta) of a regular feature on individual production artists, with articles dedicated to Aleksei Utkin, Aleksandr Loshakov, Kuleshov and Egorov.[63]

Despite this increase in recognition, throughout the 1910s films continued, however, to be produced without formally accrediting production artists. We cannot be sure whether this meant that some films were produced without the involvement of a production artist or that their contribution was not deemed significant enough to warrant recognition. According to Miasnikov, only seven of the fifteen films released in 1919 credited the involvement of production artists.[64] Formal recognition of creative input continued to be a matter of concern among production artists during the 1920s. During this decade, a number of production artists wrote articles defending their distinctive contribution to filmmaking, and in 1928 the union of production artists published a resolution in which they demanded formal recognition for their work.[65]

Collaboration and stylistic reputations: Studios and filmmaking teams

During the 1910s, several studios came to establish stylistic reputations based, in part, on the set design used in their films. An interest in traditional Russian life and customs was a hallmark of Pathé, where Sabiński worked as the head production artist from 1910 to 1914. During his time at Pathé, Sabiński developed a particularly close working partnership with the director Vladimir Gardin, whom he followed to the newly founded Ermol´ev studio in 1914. The Khanzhonkov studio,

which initially from 1909 to 1913 employed Mikhin to oversee its art department and in 1914 enlisted Bauer as one of its lead filmmakers, became known for its grandiose interiors crowded with objects.[66] Indeed, the derogative term *khanzhonkovshchina* became a synonym for cinematic decadence in the 1920s.[67] Creating an estimated seventy films in the three years that he worked for Aleksandr Khanzhonkov until his death in 1917, Bauer's aestheticism no doubt helped to cement a certain reputation for Khanzhonkov films. However, as Alyssa DeBlasio argues, 'although [Bauer] was associated with the Khanzhonkov studio for the majority of his career, his design choices are distinctly his own'.[68] In his lifetime, he established a reputation for his distinctive approach to designing interior spaces, which Kuleshov termed 'the Bauer method'.[69] As Kuleshov explains, this involved using large architectural structures, with many planes and recesses to create expressive light effects and give the impression of deep illusionistic space on screen. Scholars such as Iurii Tsiv′ian and Rachel Morley have subsequently remarked on Bauer's unusually spacious interiors, innovative use of texture and distinctive method of employing architectural features, such as columns, furniture and staircases, to enhance the sense of illusionistic depth in films.[70]

In addition to these studio affiliations, the 1910s also witnessed the formation of several close creative partnerships between production artists and other filmmakers, many of which continued into the Soviet era. In 1917, Egorov began to work with Gardin while at Neptun, establishing a partnership which stretched until the end of the 1930s. In his memoirs, Gardin singles out Egorov as his 'favourite' (*liubimogo*) production artist, noting in particular the way in which Egorov would develop a range of different design options for the director to choose from.[71] Balliuzek formed a particularly close partnership with Protazanov while they were working together at the Ermol′ev studio from 1915, recalling in his memoirs:

> It was easy and interesting to work with Protazanov. As a director, he did not restrict the production artist's fantasy and encouraged the initiative of team members [...] Another valuable aspect was that Protazanov did not only want the production artist to produce effectively painted sets, but directed his attention toward revealing the characters' psychological essence by visual means.[72]

As noted in Balliuzek's memoirs, his shared interest with Protazanov in using design to create atmosphere and psychological tension helped to establish the Ermol′ev studio's reputation for producing psychological

dramas. Balliuzek and Protazanov's partnership was ruptured only after the nationalization of the film industry in 1919 when Protazanov left Russia with Ermol´ev to set up a new studio in Paris and Balliuzek remained to assist in establishing several new studios in various Soviet republics.

In addition to Egorov and Balliuzek, the majority of the production artists working in Russian cinema in the 1910s continued to work in the industry following its nationalization and came to occupy leading roles in newly established studios. Kozlovskii, who made his debut in 1915 with the late-Imperial studio Biofil´m, was later appointed to lead the design department of the Rus´ studio in 1917 and continued as head of the design department after the studio's nationalization in 1920 to form the Mezhrabpom-Rus´ studio (from 1928 Mezhrabpomfil´m), where he remained throughout the 1920s. The former Khanzhonkov production artist Vasilii Rakhal´s, who assisted Bauer on several of his films, was appointed in 1923 to take the reins of the design department at the newly founded Goskino studio (from 1924 Sovkino).

As well as employing a head production artist, early-Soviet studios would also engage individuals for particular commissions, resulting in a high level of mobility among production artists. Between 1923 and 1930, for example, Balliuzek worked on films for Mezhrabpom-Rus´, Sevzapkino and Sovkino, as well as the Belarusian Belgoskino and the Azerbaijan Photo-Cinema Administration (AFKU).[73] Egorov similarly worked for a number of studios during the 1920s, including Mezhrabpom-Rus´, Goskino, the All-Ukrainian Photo Cinema Administration (VUFKU) and Belgoskino. Such levels of mobility undoubtedly limited the development of distinct studio styles in set design. As Robert Bird argues, in the 1920s Sevzapkino and Mezhrabpom-Rus´ were the only two studios with distinct stylistic profiles.[74] It can be no coincidence that these studios were known for the prominent position they accorded to production artists. Indeed, Kozlovskii recalls that Mezhrabpom-Rus´ was remarkable for its attention to design techniques and engaged a prestigious roster of individuals, including Balliuzek, Egorov, Simov and Ivan Stepanov.[75] Mezhrabpom-Rus´ films exhibited what Bird describes as 'vernacular modernism' through their incorporation of avant-garde design elements. This is exemplified by the expressionist and constructivist-style sets created by Kozlovskii and Simov for *Aelita* (1924). The Leningrad studio Sevzapkino was characterized during the 1920s by the existence of close creative alliances within which the production artist had an unusual degree of importance. The most notable example of this is the Factory of the Eccentric Actor (Fabrika ekstsentricheskogo aktera,

FEKS) collective made up of the directors Grigorii Kozintsev and Leonid Trauberg, the camera operator Andrei Moskvin and the production artist Evgenii Enei.[76] According to Petr Bagrov, the prominence of the production artist within Leningrad filmmaking teams led to the establishment of a distinct style of cinema based around the tight framing of faces and objects.[77] Aside from these two studios, however, film production during the 1920s was characterized more by distinct schools of filmmakers rather than studio styles. As Philip Cavendish shows, this period saw the formation of a number of close creative alliances between filmmakers with similar artistic temperaments.[78]

The appointment of a production artist to a filmmaking unit was typically determined by studio administrators.[79] Production artists on permanent studio contracts were expected to work with a number of different directors and camera operators on a range of film genres and styles; they also often worked on more than one film at a time. Adaptability and flexibility, it would seem, were required from production artists more than an individual style. Besides practical demands, the cultivation of an individual style was also discouraged on ideological grounds. Critics vociferously rejected films with idiosyncratic or elaborate décor for demonstrating a form of individual hubris associated with a prerevolutionary, bourgeois tradition of cinema. One critic even declared that the best sets were those in which the production artist's involvement was imperceptible, citing as an example the scenary that Rakhal´s created for Sergei Eizenshtein's *Strike* (Stachka, 1925).[80] Production artists themselves also heavily criticized films with elaborate décor and argued that they must suppress their own creative preferences for the greater good of a production.[81] Indeed, Nikolai Suvorov claimed that 'the "inconspicuousness" of the production artist's work in a film is, for the most part, his greatest merit'.[82] Recalling his experience as a young production artist, Iutkevich chastised his ambition to create a distinctive style:

> When I started working in cinema, I was commissioned to design sets for the film 'The Traitor.' I threw myself into my work with great enthusiasm, and, since it was my 'debut', I decided to show off everything I could do, to make it, as they say 'my calling card.' We had to build a lot of pavilions – around thirty, and I began to build them in different ways [...]. I could try out different combinations that fascinated me, but in the most important aspect, I was mistaken.[83]

There exist a number of instances when an individual worked in a style that contrasted with the approach with which they were typically

associated. Kozlovskii, who described his own approach to set design as 'realistic' and concerned with 'verisimilitude', was responsible for creating not only the contemporary everyday life sets in *Aelita* (1924) but also the fantastical Mars scenery.[84] Likewise, Balliuzek, whom Miasnikov associates with the creation of sumptuous interiors for period dramas, worked on the minimalist sets of Mezhrabpom-Rus´'s *The Two Buldis* (2-Bul´di-2, 1929), directed by Kuleshov and Nina Agadzhanova-Shutko.[85]

Despite this requirement for flexibility, many production artists did, however, cultivate certain stylistic preferences, which informed their selection for special commissions and led them to establish partnerships with particular filmmaking teams. Protazanov carefully enlisted Kozlovskii when a film demanded precision in detail and Egorov when atmosphere was the primary concern.[86] Widdis identifies several cases when the collaboration of an individual production artist with filmmakers had a marked influence on stylistic approach, specifically noting the partnership of Rakhal´s with Sergei Eizenshtein and the camera operator Eduard Tisse.[87] Other such instances include Kozlovskii's collaboration with Pudovkin and the camera operator Anatolii Golovnia on no fewer than six films in the 1920s, including *Mother* (Mat´, 1926) and *The End of Saint Petersburg* (Konets Sankt-Peterburga, 1927).[88] As I will discuss in subsequent chapters, Kozlovskii's stark sets for such films contributed to the development of a style of cinematic representation based upon compositional restraint and precision. Kozlovskii recalls that his collaboration with Pudovkin and Golovnia was particularly productive and was ruptured only by Pudovkin's departure from Mezhrabpomfil´m to Mosfil´m in the 1930s.[89] Enei's collaboration with FEKs stretched to seventeen productions over four decades. The way Enei's sets exploited the interplay of light and shadow to create atmosphere contributed to the development of a particular filmmaking approach that was concerned with what Cavendish terms 'the poetic qualities of light'.[90]

The role of the production artist: Versatility, creativity and technological expertise

As filmmakers frequently note in their memoirs, in the first decades of fiction-film production in Russia the divisions of responsibilities among filmmakers were fluid and individuals often took on a variety of tasks as the immediate situation demanded.[91] The role of the production

artist was, however, particularly amorphous, encompassing many and varied responsibilities. This ranged from practical tasks associated with coordinating production workshops and developing design technology to aesthetic decisions relating to the overall artistic concept of a film. This reflects both how cinema set design was, from its inception in Russia, seen as much as a technical as an artistic practice, and that production artists were often caught in delicate negotiations between diverse cultural, economic and ideological pressures.

In their first, more technical role, production artists oversaw the construction of artificial scenery. The fact that late-Imperial studios employed few people meant that production artists usually had to participate in the physical construction of sets. Sabiński recalls that at Pathé in the early 1910s he worked without carpenters or painters in a small production team of ten to fifteen members.[92] Aleksandr Khanzhonkov's memoirs attest to the technical challenges that production artists were required to battle with in creating sets that were suited to the needs of filmmaking, rather than the theatrical stage.[93] For the painted backdrops that were initially used as cinema scenery, all the motifs required for the various scenes had to be painted onto a single canvas sheet. Recesses and projections had to be portrayed graphically, taking into account the positioning of the camera. When filming outdoors, this type of scenery was vulnerable to sudden gusts of wind, which would cause the canvas sheets to quiver and distort the carefully painted illusion of perspective.

A key requirement of production artists, therefore, was to strengthen the technical foundations of cinema through innovating design technology to support filmmaking practices. Mikhin recalls in his memoirs how he approached Khanzhonkov in 1909 with the offer to work as the studio production artist on the basis that he could innovate set technology that would allow filmmakers to move away from using the painted canvas backdrops reminiscent of the theatre.[94] Between 1910 and 1913, Mikhin and Sabiński, simultaneously yet independently from one another, developed a method of prefabricated sets made of standardized parts, known as the *fundus* system.[95] The *fundus* significantly reduced both the time and resources needed to assemble sets, as well as increasing the variety and complexity of architectural spaces which could be constructed in films, as will be discussed in further detail in subsequent chapters.[96] Sabiński is also credited with replacing theatre props with objects specially adapted for films and introducing patterned wallpaper and stucco architectural moulding to interior settings.[97] In particular, he was praised by contemporaries for

innovating the use of models, which permitted filmmakers to create certain special effects. Most notable in this respect are his models for *The Year 1812*, which allowed the filmmakers to depict a town up in flames. Balliuzek also established a reputation for the technical innovations he introduced to late-Imperial cinema. In his work on *The Queen of Spades*, Balliuzek recalls:

> I wanted to film the entire scene in which Liza writes a letter giving a detailed description of the layout of the countess's house differently from the way it is done in the theatre. I thought it would be more interesting from a cinematic viewpoint to show the hero passing through the endless enfilades of that musty mansion [...] I made a special device out of two bicycles. The camera followed closely behind German, revealing before the viewer a panorama of endless drawing rooms in the old mansion. The moving camera allowed the viewer to share German's feelings on surveying those unfamiliar surroundings for the first time.[98]

As Balliuzek explains, the innovation of devices to facilitate the moving camera, in addition to being able to convey the effect of the character's surroundings on his psychological state, also permitted new possibilities in portraying movement through space that fundamentally differed from the theatre and exploited the expressive potential of cinema as an artistic medium.

The technical innovations introduced by production artists, therefore, not only modified production practices but also had a profound influence on film aesthetics and were closely related to evolving understandings of cinema's expressive possibilities. They are thus associated with the production artist's role as a 'consultant' on visual aspects of filmmaking. Several production artists note that, because of their training in the arts, during the earliest years of cinema filmmakers relied upon them for their knowledge of pictorial conventions and aesthetic styles.[99] Studios produced films at a rapid pace and, with no time for in-depth research, so production artists were often expected to draw on their extensive artist knowledge and present design options to directors.[100] Kozlovskii and Razumnyi recall that they consulted specialist art publications together with directors to select appropriate visual motifs.[101] Kozlovskii's personal archive at the Russian State Archive of Literature and Arts (RGALI) contains hundreds of examples of paintings, costumes, decorative patterns and architectural motifs in various styles.[102]

In addition to selecting visual motifs, the production artist's influence as an artistic consultant often extended to a wide range of aesthetic decisions, crossing over into areas typically associated with the director, the scenarist and the camera operator. Production artists often complain of the shortage of sufficiently skilled filmmakers, which required them to step in to help direct and films scenes. Sabiński recalls how, while working at Pathé, he advised on coordinating actors and helped stage scenes of Russian folklife in the capacity of a director.[103] Kozlovskii's first role in cinema, working at Biofil'm in 1915, also included directing, as well as designing scenery.[104] Similarly, Razumnyi writes that his work at the Ermol´ev studio in the late 1910s quickly exceeded overseeing scenery to include making decisions about directing, camera operation and editing film.[105]

In the earliest years of Russian cinema, it was rare for studios to employ permanent scenarists and it was occasionally production artists who undertook the task: Sabiński started writing scenarios for Pathé in 1910 and continued to produce them throughout that decade,[106] in 1913 Mikhin also began to work as a scenarist alongside his role as a production artist,[107] and Kozlovskii recalls writing a number of scenarios for films from the mid-1910s.[108] The involvement of production artists in creating the scenario in addition to the settings for a film raises questions about the relationship between sets and a film's narrative, particularly in terms of the extent to which narratives were constructed around the opportunity to present certain settings.

A number of texts suggest that the production artist collaborated closely with the camera operator on lighting decisions.[109] During the earliest years of cinema, formal responsibility for lighting was not yet established, which at times led to disagreements between filmmakers. Meierkhol´d recalls how during work on *The Picture of Dorian Gray*, Egorov and the camera operator Aleksandr Levitskii argued over lighting responsibility.[110] As Meierkhol´d explains, 'in the theatre it is given to the set designer. But once the camera is in the hands of the camera operator, then naturally he must be responsible for lighting since he knows much better what to do in order to light the picture.'[111] However, Egorov's sketches for the film, with their concern for how different camera viewpoints would create striking compositions and light effects, demonstrate what Tim Bergfelder, Sue Harris and Sarah Street term 'camera consciousness' to describe the way in which cinema designers anticipated the placement of cameras and lighting equipment.[112] Several other sources indicate that production artists conceptualized cinema design in terms of how it would be processed by the camera. Kuleshov notes that when he worked as a production artist for the Khanzhonkov

studio he would construct sets while looking through the camera viewfinder.[113] According to Miasnikov, Kozlovskii would use spare film stock to record set fragments, which he then studied to develop new design techniques.[114]

Following the emigration of many directors and camera operators after the 1917 Revolution and the subsequent nationalization of the cinema industry in 1919, production artists were highly valued for their wide-ranging experience in the different aspects of filmmaking and played key roles in the establishment of new studios. In 1919, Neptun studio hired Kozlovskii to oversee a second proposed studio.[115] It was Kozlovskii's recommendation that Aleinikov sought when hiring a permanent camera operator for his new studio, Rus´, in 1919.[116] While working at Mezhrabpom-Rus´ in the 1920s, Kozlovskii also assisted the theatre director Leonid Baratov in directing his first productions.[117] Balliuzek supported the establishment of new studios in the Soviet Republic of Azerbaijan, where he assisted on directing films and writing scenarios alongside his work as a production artist. In 1922, Mikhin was appointed the head of the third production studio of Goskino, where he advised on appointing personnel to filmmaking units and monitored film production.[118]

The flexible nature of the production artist's role and his close involvement with the various aspects of cinema led to the acquisition of skills that could be directly transferred into the sphere of directing. It is therefore unsurprising that a large proportion of production artists of the 1910s and 1920s went on to work in an official capacity as directors during their careers. These figures include Balliuzek, Bauer, Iutkevich, Kavaleridze, Kuleshov, Mikhin, Razumnyi and Sabiński. As directors, many former production artists can be described as auteurs in the sense that they maintained a large degree of control over decisions extending to cinema design, scenario writing and camera operation as well as directing. Bauer is routinely considered to be the first auteur of Russian cinema.[119] Both Razumnyi and Sabiński even used the title *kino-master*, instead of the accepted term *rezhisser* (director), to reflect the multiple roles they embodied.[120]

Cinema 'decoration' and cinema 'constructivism':
Set design as an artistic practice

An awareness that the production artist's work in cinema was not only confined to creating artificial scenery but also encompassed a whole range of tasks associated with the visual aesthetics of a film is evident

in a number of articles on the role of the production artist which began to be published in the contemporary cinema press from the late 1910s. In 1917, Kuleshov was the first to explicitly address this idea in a two-part series of articles he wrote for the *Cinema Herald*.[121] For Kuleshov, cinema's nature as a primarily visual medium meant that the production artist's work must also extend to encompass tasks that were typically viewed as being the realm of the director or the actor, including overseeing costumes and makeup, arranging actors and objects within a frame, consulting on an actor's psychological expression and advising on the colouring and toning of film and the lighting of scenes. In order to heighten cinema's expressive potential, Kuleshov declared that production artists must renounce the approach of painters and theatre designers and instead 'paint with *objects*, surfaces (walls) and *light*'.[122] In working with these features, Kuleshov stressed that the production artist must have an understanding of cinema's distinctive properties as a visual art form so as to create new artistic effects that are not possible in painting, sculpture or architecture. Kuleshov identified two approaches to composing scenery: the first, employed by filmmakers such as Bauer, involved using large architectural structures, with many planes and recesses, to recreate a sense of deep illusionistic space on screen; the second, however, was based on simplifying sets through placing objects with strong symbolic associations in the foreground and darkening the background or replacing it with black velvet.[123] For Kuleshov, both approaches had their shortcomings: the 'Bauer method' required considerable time, space and money to realize, and was therefore at odds with cinema's nature as a practice rooted in expediency; simplified sets, however, could be shot from one viewpoint only.

In an article published the following year and entitled *The Art of Light Creation* (Iskusstvo svetotvorchestva, 1918), Kuleshov again proclaimed the need for production artists to understand cinema's unique properties as an artistic medium and, rather than borrowing methods from other realms, in particular the theatre, to develop techniques that are specific to cinema.[124] In a change of position, however, he explicitly rejected the 'Bauer method' of constructing sets to give the illusion of receding spatial depth on screen; instead, he promoted the use of methods that would enhance the non-stereoscopic quality of 'light-painted' images and exploit the expressive potential of the flatness of the film frame – a feature he saw as distinctive to cinema.

The interest in medium specificity was characteristic of artistic discourses more broadly during this period in Russia. Since the mid-1910s, formalist groups such as the Saint Petersburg Society for the

1. Early Russian Production Artists

Study of Poetic Language (Obshchestvo izucheniia poeticheskogo iazyka, OPOIaZ) and the Moscow Linguistic Circle (Moskovskii lingvisticheskii kruzhok, MLK) had demanded that creative practitioners working in all artistic fields should exploit the distinctive expressive features of art forms, including the sound of words and the painterliness (*zhivopisnost'*) of paint.[125] The concept of *faktura*, typically translated as 'texture', acquired particular significance in artistic discussions at the time as a means to describe the way in which materials had been worked to heighten the inherent expressive properties of particular artistic media.[126] The interest in ontological questions about the nature of different artistic media continued beyond the Revolution. In 1919, the Institute of Artistic Culture (Institut khudozhestvennoi kul'tury, INKhUK) was founded as a state-funded interdisciplinary group with the aim of conducting research into the specific properties of various art forms.[127] Constructivist practitioners and theorists dominated the early teachings of INKhUK and conducted numerous formal experiments to remove what were seen to be supplementary factors and instead to exploit art's essential materials: light, space, volume, surface and *faktura*.[128] As Maria Gough argues, the context of the early-Soviet years brought a new social significance to the concept of *faktura*.[129] In constructivist debates, *faktura* became closely connected with the problem of individual authorship and subjectivity: in allowing a medium's inherent properties to become the dominant expressive feature, the signature style of the individual artist, which the bourgeois tradition of art had long held to be a marker of value, could be minimized and even eradicated.

Although the study of cinema was not included in INKhUK's programme, a number of filmmakers working in the early 1920s did share the institute's interest in exploring questions about medium specificity in their writings and cinema experiments. Having recently entered cinema as a production artist from the theatre, the young Iutkevich advanced the need for production artists to develop a design method that was specific to cinema. In an article published in *Soviet Screen* (Sovetskii ekran) in 1925 and entitled 'We Decorate with Light', Iutkevich proposed that 'The work of the true production artist lies not in painting and installing sets in a naturalistic or purely expressionistic style but in the value of his trained eye, which coordinates the entire visual atmosphere and composition of a frame'.[130] Specifically, he advocated that production artists should follow the approach of constructivism in cinema, which he defined as working with cinema's genuine materials: light, space and the *faktura* of real objects. For

Iutkevich, the approach of constructivism in cinema contrasted with that of decoration, which he rejected as uncinematic, using it as a pejorative term to describe the styling of artificial sets according to fashionable aesthetic trends. In this respect, he denounced the 'cardboard expressionism' of Robert Wiene's German film *The Cabinet of Dr. Caligari* (Das Cabinet des Dr. Caligari, 1920) and the 'stylized tinsel kingdoms' of the Mezhrabpom-Rus´ studio's *Aelita* (1924). He lamented how critics had applied the label of constructivism to the sets in such films, reducing the term to a fashionable style to describe scenery with abstract, geometric forms; rather, he claimed, constructivism should be understood as a principle for working with light, space and *faktura* to create expressive visual effects that were distinctively cinematic.[131]

Iutkevich was not alone in focusing his attack on stylized sets on the films *Aelita* and *The Cabinet of Dr. Caligari*. In an article also published in 1925 in *Soviet Screen*, an anonymous critic denounced the sets in both films for their 'deceptive' quality.[132] The critic argued that the abundance of false effects in these films demonstrated artistic hubris on the part of the production artist. By contrast, the critic singled out *Strike*, made the same year as *Aelita* and released in 1925, for providing an exemplary model for Soviet production artists to follow, praising the 'decorative freshness' and 'truthfulness' of the stark scenery made by Vasilii Rakhal´s.[133] That same year, Pudovkin weighed in on the debate on the production artist's role in cinema, writing an article in which he also declared that in Soviet cinema the task of the 'true production artist' was to create austere décor based on the visual principle of maximum economy.[134] For Pudovkin, cinema's nature as an artistic medium meant that all superfluous detail must be eradicated in order to create frames that are visually expressive: '*Maximum economy leads only to maximum expressivity* (original italics).'[135] Pudovkin lamented the way in which production artists in other European and late-Imperial cinemas crowded their sets with a chaos of things, which overwhelmed viewers and distracted their attention.[136] For a number of critics and filmmakers, therefore, the principle of economy in set design was not only beneficial on artistic grounds as an approach most suited to the medium of cinema and its distinct expressive features; it was also ideologically appropriate to Soviet cinema in that it departed from the decadent scenery of films made under the influence of European and pre-revolutionary filmmaking, which was seen still to pervade some Soviet studios, most notably Mezhrabpom-Rus´, with its connection to the German film industry and cadre of filmmakers drawn from late-Imperial cinema.

Striving to put the principle of maximum economy into practice, Aleksandr Rodchenko describes in his 1927 article 'The Production Artist and the Material Environment in Fiction Film' how he adopted this approach while working alongside Kuleshov on the film *Your Acquaintance* (Vasha znakomaia, 1927).[137] He explained that by reducing cinema scenery to just those 'characteristic' objects, which exemplified either a quality of a particular character or a feature of a certain space, he sought to engage viewers' full attention, rather than leaving them to search unaided for meaning. According to Rodchenko, '*It is important that the production artist finds a characteristic object which has not been filmed before and shows this ordinary thing from a new point of view, as it has not been shown before*' (original italics).[138] This echoes Rodchenko's statements on his photographic practice, in which he consistently advanced that 'I prefer to see ordinary things in extraordinary ways'.[139] Like the majority of the photographs that he took from 1925 onwards, the photographs that Rodchenko used to illustrate the article demonstrate this argument through presenting the steel girders and glass walls of the Sovkino studio taken from unusual vantage points to create a dramatic sense of perspective and defamiliarize space.[140] For Rodchenko, the production artist's task related primarily to the question of visual perception and audience engagement. It was in this sense that the production artist's role departed from that of a *dekorator*, whose responsibility was limited to designing scenery in a range of aesthetic styles.

The kino-arkhitektor *and the rationalization of film production*

During the mid-1920s, Soviet critics and filmmakers began to stress the importance of economy not only as an aesthetic principle but also as a production method. From 1924, a number of articles were published in the cinema press which addressed the responsibilities of the production artist, focusing on practical concerns relating to their function in the production process rather than on questions about cinema aesthetics.[141] A key proponent in these discussions was Kozlovskii, who was then the head of the design department at Mezhrabpom-Rus´. In 1925, he wrote the first of a number of articles he would produce on the production artist's responsibilities, under the title 'Film Studio Technology'.[142] In this article, which is cited as the epigraph to this chapter, Kozlovskii emphasized the production artist's role as a versatile multi-tasker,

who possesses a range of artistic skills and technical knowledge about lighting techniques and camera optics, as well as set construction. The importance ascribed to the quality of versatility (*raznostoronnost'*) among production artists can be found throughout Kozlovskii's writings on cinema, as well as in many other articles about production artists published in the contemporary cinema press in the mid- to late 1920s.[143] In the earliest years of Russian cinema, shortages in personnel, scarce resources and the limited technical and artistic knowledge among some filmmakers meant that versatility was a practical requirement among production artists. In the early-Soviet era, however, the quality of versatility also held ideological value insofar as it was associated with the principles of resourcefulness, economy and collective creation that were prided within the new Soviet value system. The emphasis placed on versatility among production artists during the early to mid-1920s must also be seen in the context of the Soviet suspicion towards '*spetsy*' – old specialists who had been active under the Imperial regime and, through their adherence to traditional techniques, were seen to preserve pre-revolutionary values. With so many production artists having come from the ranks of late-Imperial cinema, the profession was exposed to this accusation. Emphasizing the versatile nature of the production artist's role therefore helped mitigate this risk and aligned the profession with the new Soviet values of resourcefulness and flexibility.

In addition to versatility, many articles addressing the production artist's responsibilities also stressed the importance of technical proficiency. Kozlovskii, for example, argued that the production artist must use his creative skills to innovate methods of rationalizing studio filmmaking in order to support the growth of Soviet film production. From the mid-1920s, a campaign to rationalize Soviet cinema gathered momentum in response to problems of poor productivity and attacks against the so-called 'artisanal' (*kustarnyi*) nature of the industry which the Soviets had inherited.[144] In addition to inadequate resources and technology, the cause of the issue was blamed on the mismanagement of production. In this context, production artists came under increasing pressure to innovate techniques that would expedite the production process. At Mezhrabpom-Rus´, Kozlovskii introduced a series of both technological and organizational solutions to increase productivity, including new mechanized equipment, standardized paints, improvements to the *fundus* system, including an inventory system of *fundus* parts, and a photographic archive of potential locations for outdoor filming.[145]

The Soviet press avidly reported on Kozlovskii's efforts in improving production methods. In a 1927 edition of *Soviet Cinema* (Sovetskoe kino), Rodchenko dedicated an article to Kozlovskii's achievements, titling it 'M-R. 80x100. S-Zh' in reference to the inventory code that Kozlovskii had developed for the *fundus* system.[146] Rodchenko denounced the way in which certain Soviet studios, in particular Sovkino, were organized into individual workshops without any coordination. He even compared Sovkino to a theatre in that it was characterized by 'narcissism' (*samovliublennost´*), false ideas of genius and outmoded forms of 'handcraftsmanship' (*kustarshchina*). By contrast, Rodchenko claimed, at the Mezhrabpom-Rus´ studio Kozlovskii had introduced organization and economy through innovations to the *fundus*. He argued that Kozlovskii's working practice differed from that of the typical 'free-willed' (*svobodnyi*) artist, describing him instead as 'a factory engineer, a true factory *konstruktor*', recalling the rhetoric used by constructivist theorists and practitioners to endorse collaboration between artists and industry. Similarly, in a diary entry of 25 November 1928 made after a discussion in the offices of *New Left* (Novyi LEF), the constructivist artist Varvara Stepanova praised Kozlovskii's work in developing set technology and contrasted his design approach with that of other production artists, in particular Egorov, whom she denounced as 'senseless' (*bessmyslennyi*) and concerned only with creating novel effects and stylized interiors.[147]

Other articles published in the mid- to late 1920s celebrated the *fundus* as a major advance in cinema technology.[148] Photographs of the system also occupied full- and half-page spreads in journals. Rather than representing the *fundus* in its constructed and decorated form ready to be filmed, these images emphasized its nature as a production system, showing it as a series of modular components made from bare plywood sheets. In such photographs as those used to illustrate the article 'The Cinema Production Artist: A Conversation with S. M. Kozlovskii, Inventor of the *Fundus* System' (1927), published in *Soviet Cinema*, the way in which the plywood sheets are arranged into various geometric configurations distinctly recalls the non-objective sculptures of constructivist artists, such as Rodchenko's *Spatial Construction* (1920), which was also made from plywood sheets that were assembled and dissembled into an ever-changing three-dimensional form.[149] Indeed, throughout the 1920s Rodchenko was fascinated with modular design and developed a number of furniture prototypes made from modular units that could be assembled to meet changing specifications.[150] Kristin Romberg refers to this process of design as 'the flexible universal' in

that, rather than as a system of standardization in which variation was removed, it allowed a near infinite number of formal variations to be created from a rationalized method.[151]

The interest in modular design systems, such as the *fundus*, and the emphasis on the need for production artists to rationalize the design process correlates with Soviet productivist discourses of the early to mid-1920s. In her study of Soviet constructivism, Gough identifies the existence of both an object-oriented and a process-oriented trajectory among constructivist artists and theorists.[152] Adherents of both trajectories increasingly rejected the self-reflexive theorizing and abstract experiments of INKhUK artists of the early 1920s, preferring to pursue 'real practical work in production'.[153] While the object-oriented faction called for artists to collaborate with industry to mass produce new everyday things that would encourage Soviet citizens to adopt a lifestyle based on socialist principles, the process-oriented faction of productivists, however, urged artists to direct their energies towards innovating production methods. In his 1923 tract *From the Easel to the Machine*, the productivist theorist Nikolai Tarabukin argued that artists must devote their time not to producing new objects, whether utilitarian or non-utilitarian; rather, they must improve production systems, declaring that 'the process of production itself [...] is the goal of activity'.[154] Moreover, Tarabukin rejected the idea that artists would operate remotely, using their specialist skills to improve production without becoming involved in factory life and without gaining a genuine understanding of how technology would serve the societal aims of the collective. Rather, he emphasized the need for artists to be embedded in the production process, so as to form genuine collaborative partnerships with industry and optimize the production networks between workers.[155]

The production artist's role as not only a technical innovator but also a coordinator of a number of production personnel and workshops became increasingly important during the late 1920s. As the material, technological and human resources of film studios developed during the 1920s, coordinating all the many production workshops was no small task. In 1929, an audit found that Mezhrabpomfil´m employed thirty-five lighting technicians and twenty-eight craftsmen for assembling prefabricated scenery.[156] By 1930, studios typically counted eight different technical workshops: production technicians, a wood workshop, a painting workshop, a scenery workshop, a prop workshop, a costume workshop, a makeup department and a lighting department.[157] Noting the requirement for the production artist to work with the full

range of production departments, many filmmakers' memoirs and cinema press articles emphasized the collaborative nature of their role.[158] Kozlovskii even argued that 'In the studio organism, the production artist is connected by a thousand threads with each individual worker, with each individual workshop. The work of the production artist is more collective than that of the director, camera operator or actor.'[159] As Kozlovskii claims, direct interaction with the studio workshops was seen to be distinctive to production artists. Moreover, as a member of the main filmmaking unit, which also included the director, the camera operator and the scenarist and which was responsible for the creative ideas behind a film, the production artist was seen to act as 'the essential link' between the creative and technical sides of filmmaking.[160] In bridging the technical and artistic sides of filmmaking, Kozlovskii claimed 'the cinema artist (*kino-khudozhnik*) is in essence more truly a cinema architect (*kino-arkhitektor*)'.[161] For Kozlovskii, cinema set design was similar to architecture in that it combined a wide range of artistic and technological expertise, as well as the ability to coordinate numerous personnel.

The conceptualization of set design as an architectural practice was reiterated throughout the late 1920s. In 1928, when the union of production artists issued their first resolution on working rights, they even chose *khudozhnik-arkhitektor* (artist-architect) as their professional title.[162] The union stressed the importance of the *khudozhnik-arkhitektor*'s role in overseeing film production and stated that their main responsibility was to innovate technology that would reduce the cost and production time involved in location and studio filmmaking. They emphasized, however, that the *khudozhnik-arkhitektor* was by no means a technical labourer; rather, he was a 'functional coordinator' who worked in close collaboration with the other members of the film collective. In 1930, Kozlovskii, together with the critic Nikolai Kolin, published the first professional manual on cinema set design similarly using the title *Khudozhnik-arkhitektor in Cinema*.[163] As the cover image depicting a working studio indicates, the manual directly located the work of the *khudozhnik-arkhitketor* in the production side of studio filming. Kozlovskii and Kolin defined architecture in cinema as the rational construction of sets with a concern for how they would produce expressive light effects, create a sense of perspective on screen and accommodate various camera angles.[164] For the authors, therefore, the aesthetic function of sets was still significant. Indeed, they stated that the decorative element of set design was important, but that it was now no longer the primary concern of the *khudozhnik-arkhitektor*, who

must devote his time to developing new methods in rationalizing film production.

For some critics writing in the late 1920s, the *khudozhnik-arkhitekor*'s influence extended beyond improving production methods within the film industry, however. Recognizing cinema's propaganda potential, they argued that production artists could introduce to the masses new production innovations that had an application to everyday life in supporting the rapid development of Soviet industry, as outlined under the First Five-Year Plan (1928–32). In an unpublished article written in 1929 and entitled 'Architecture and Cinema', the architect Andrei Burov described in these terms his decision to accept Sovkino studio's invitation to work with Vasilii Kovrigin and Rakhal´s on the sets for Grigorii Aleksandrov and Sergei Eizenshtein's *The Old and The New* (Staroe i novoe, 1929), originally titled *The General Line* (General´naia liniia).[165] Burov explicitly rejected the position previously promoted in the cinema press that the production artist's role was to heighten the expressive potential of cinema aesthetics, through modelling light and shadow and working with camera optics and the rhythm of the human body.[166] Indeed, he denounced the creation of aesthetic effects as a goal in itself as a form of 'decoration'. He argued that the *kino-arkhitektor* (cinema architect) should instead innovate new methods in rationalizing production that in the future could be applied to real life. To this end, for *The Old and The New* he developed mechanized methods for food production and rational solutions for storing grain and housing livestock. Burov envisaged his set functioning as a working dairy farm which would provide a model for the future industrialization of agriculture.

In two articles published in 1928 and 1929, both entitled 'Life as It Ought To Be', the architectural critic Nikolai Lukhmanov singled out *The Old and The New* among Soviet fiction films for providing practical solutions for improving present-day production.[167] Adopting the rhetoric of the First Five-Year Plan, which stressed the need to bring about the rapid industrialization of all spheres of Soviet industry, Lukhmanov argued that cinema was a powerful tool in supporting the social construction of the Soviet state through educating the masses in how to build a path to a new everyday life. In his more extensive 1929 article, Lukhmanov praised *The Old and The New* not only for demonstrating new industrial methods of agricultural production but also for providing a model for collaboration between the different spheres of art, industry and science. In his view, 'the formation in cinema of new collectives to serve the current tasks of industrial production

would inevitably lead both to the improvement of Soviet cinema and to a new cadre of *kino-proizvodstvenniki* (cinema-productivists)'.[168] For Lukhmanov, this cadre of *kino-proizvodstvenniki*, with their specialism in different fields, would work to find solutions to current problems in the realm of production. This emphasis on the need for specialist workers to apply their expertise to particular problems is reflective of a wider shift in the late 1920s away from early-Soviet suspicions towards *spetsy*. Specifically, for production artists, instead of their role as versatile multi-taskers who were prided for their wide-ranging artistic and technical skills, their value was seen to lie in applying architectural and design methods to rationalize everyday life. For Lukhmanov, the engagement of this new cadre of specialist *kino-proizvodstvenniki*, as demonstrated with *The Old and The New*, would lead to both the improvement of cinema production and the realization of the goals of the cultural revolution in using art as a key factor in the industrialization and social reconstruction of the Soviet state.

Chapter 2

THE RURAL ENVIRONMENT

Many of the earliest Russian fiction films used rural settings that combined outdoor filming with artificially constructed sets. Restrictions in studio space and limitations in lighting technology encouraged Russian film producers, such as Aleksandr Khanzhonkov, to establish filming bases on the outskirts of Moscow, which had served as the centre of Russian film production since the 1900s.[1] For Khanzhonkov, the existing natural features and architecture were important considerations in choosing filming sites, as he recalls: 'For the setting of pictures, I searched for a remote patch of land with a forest, a lake and, as far as possible, buildings in the Russian style. All these conditions were satisfactorily found at a country house plot in Sokol'niki, which I quickly rented for filming.'[2] In his memoirs, the production artist Boris Mikhin describes the Khanzhonkov studio's main outdoor filming base, established in 1908/9 at Krylatskoe lake in Moscow's Kuntsevo suburbs, as a small site with a single wooden stage erected next to a peasant *izba*, which was used primarily for preparing the actors' costumes and make-up but was also, on occasion, incorporated as a set in films.[3] Painted canvases were nailed to two bars on the stage. When the wind blew, the canvases would flap, destroying the illusion of painted scenery and halting filming.[4]

Despite the rudimentary nature of such film sites, even in the very earliest Russian fiction films the rural environment was much more than a picturesque backdrop; rather, filmmakers used the natural and the artificial features of rural settings as a means to structure composition, to heighten dramatic tension, to create mood and atmosphere and to convey narrative and symbolic meaning. The story of Aleksandr Drankov's endeavour in 1907 to produce the first Russian fiction film – an adaptation of Aleksandr Pushkin's *Boris Godunov* (1831) – reveals the importance that filmmakers attached to the rural environment as scenery. It also demonstrates the potential that rural scenery had to undermine a film's success, for Drankov would later deny *Boris Godunov* the title of the first Russian fiction film, conferring it instead on the later and apparently more accomplished *Sten'ka Razin* (1908). The

2. The Rural Environment

recollections of one of the film's actors, Nikolai Orlov, about working on *Boris Godunov* are so illuminating both about the difficulties which the natural and the artificial elements of scenery caused in the production process and about the conflict which they created between filmmakers and actors that they are worth quoting at length:

> [The actor G. F. Martini] went on strike when he realised that the scene by the fountain would be shot without the sets but next to a real fountain that was situated between the theatre and a café-chantant. However, it was not long before Marina Mniszech (played by K. Loranskaya) and Drankov were able to convince him that everything would turn out even better by the real fountain. So they decided to start with this scene by the fountain, and it was the view of both Martini and Loranskaya that the whole sense of the scene derived from precisely the point that Marina Mniszech suddenly appears from out of the bushes. After endless arguments Drankov decided to pay for some trees to be felled, brought along and re-erected as artificial shrubbery... Next day, early in the morning, a lot of tall felled trees were brought along and laboriously erected round the fountain. They produced quite a picturesque landscape, but it was spoiled by the fact that, through the trees, you could see quite clearly and distinctly various buildings that were remote in style from the sixteenth century ... Martini, seeing the whole set that had been prepared for shooting absolutely refused to start filming [...]. When at last everyone had stopped arguing and agreed to 'rush' the scenes in front of the camera, it turned out we had to move the trees. Since nine o'clock, when the trees had been erected round the fountain, the sun had moved and the shrubs were beginning to produce shadows that we didn't want. This meant that we had to change the whole mise-en-scène and that meant changing the set as well. Once again we began to argue: what should we change? The mise-en-scène or the set?[5]

Orlov's memoirs convey the steps that the filmmakers took to alter the natural environment so as to create a particular effect. They also demonstrate how the rural landscape's scenic elements – both those existing prior to the filmmakers' arrival and those that were the result of the filmmakers' interventions – interfered with filming, either because their aesthetic style was incompatible with the scenario or because they produced undesirable lighting conditions. Moreover, as the reaction of Martini suggests, for many actors, accustomed to performing on the

theatre stage with artificial sets, the use of elements of the real world as scenery breached accepted conventions.

As Orlov's memoirs demonstrate, some filmmakers did recognize that the natural elements and the material infrastructure of the rural environment could be more effective than artificial scenery, however. Debates about the merits and disadvantages of these approaches to scenery would continue throughout the 1910s and 1920s in Russia. For many filmmakers, the use of location filming over studio sets was associated with an interest in cinema's capacity, as a photographic medium, to convey ethnographic knowledge about traditional Russian life and customs.

Since the rise of Slavophile thought at the beginning of the nineteenth century, rural life had been identified as the locus of the national spirit and identity.[6] Uncorrupted by Western capitalist values, the rural peasantry was seen to perpetuate a simple and honest lifestyle that preserved native customs and traditions. This chapter will explore how the representation of the rural environment in fiction films was associated with articulations of national identity and filmmakers' attempts to create a native Russian cinema. It will also examine how, in the 1920s, filmmakers addressed the collision of rural traditions and customs with new Soviet ways of life, and the extent to which the provincial environment and lifestyles might be transformed through infrastructural and technological development.

Authenticity, the Russian landscape and the search for a native cinema

In 1908, the French production company Pathé Frères began work on a series of twenty-one documentary films about Russian life, collectively titled *Picturesque Russia* (Zhivnopisnaia Rossiia).[7] The series enjoyed limited success in Russia, however, as its ethnographic-style observations of everyday life were aimed primarily at a foreign audience interested in learning about Russian customs.[8] As Jay Leyda notes, by the end of 1907 the Russian press had began to publish demands for a 'native' cinema.[9] In response, a number of Russian filmmakers set out to create fiction films that drew on subjects rooted in national folklore and traditions, featured a cast of Russian actors and used distinctly Russian settings. The first of these 'natively produced' films, Aleksandr Drankov's *Sten′ka Razin*, which was released in 1908, the same year as Pathé's documentary films, was a huge success.[10] This experience encouraged Pathé, in the

2. The Rural Environment

summer of 1909, to establish its first production unit operating from Moscow, which employed native actors and filmmakers to create films on Russian historical and traditional folk subjects.[11]

The Dashing Merchant (Ukhar´-kupets, 1909) was the first of a series of fiction films on Russian life that Pathé produced. Based on Ivan Nikitin's popular folk song of the same title, *The Dashing Merchant* tells the story of a drunken peasant who, despite his wife's protests, sells his daughter Masha to a merchant at a village dance. In a review published in the journal *Cine-Phono* (Sine-fono), the critic Samuil Lur´e claimed that the film's portrayal of Russian folk life was especially convincing as a result of using Russian actors and personnel in the production process.[12] According to Lur´e, 'So much in Russian life is distinctive, and it can be conveyed only by a person who has experienced it from birth'.[13] Publicity material similarly emphasized that the film drew on Russian expertise and the Russian lived experience.[14] In particular, Pathé sought native talent for the film's sets and employed Mikhail Kozhin, an established stage designer who had created scenery for the Malyi theatre and the Bol´shoi opera since 1904, to work as the production artist alongside the French camera operators Georges Meier and Toppi.[15] At the same time as he designed the sets for *The Dashing Merchant*, Kozhin worked as the production artist on two other Pathé films based on historical Russian subjects, *Peter the Great* (Petr Velikii, 1910) and *An Episode from the Life of Dmitrii Donskoi* (Episod iz zhizni Dmitriia Donskogo, 1910).

For all three of these films, reviews in the contemporary cinema press commented on the authentic representation of Russian life, noting in particular the historical and ethnographic details of the set design. An anonymous reviewer writing in *Cine-Phono* praised *Peter the Great* for the filmmakers' high standard of historical research and the attention paid to the costumes, sets and props.[16] Another reviewer writing in *Cinema Journal* (Kine-zhurnal) noted that the director Vasilii Goncharov had based the film's scenario on historical research and that the filmmakers had drawn on the history paintings of the esteemed artist Nikolai Samokish for representing the battle scenes.[17] As discussed in Chapter 1, early-Russian filmmakers frequently associated films with the paintings of well-known artists in line with their endeavours to place cinema on a par with high culture. The fact that films were associated exclusively with the paintings of Russian artists also suggests that filmmakers were concerned to associate cinema with a national artistic tradition.

The same concern for historical and ethnographic authenticity is apparent in Kozhin's set designs for *The Dashing Merchant*. Indeed, in

his review of the film Lur´e claimed that 'all the decoration appears to be a fragment of reality'.[18] This ethnographic verisimilitude is achieved primarily through the intricacy of Kozhin's painted scenery. In the scenes that take place in the peasant *izba*, furniture is ornamented with patterning and the areas surrounding the doors and the window are embellished with elaborate motifs, drawn from traditional folk art (Figure 2.1). While a number of films made in the late 1900s and the early 1910s incorporated decorative patterning in their painted scenery of *izbas*, such as the Khanzhonkov studio's *Mazepa* (1909) and *The Boyar Orsha* (Boiarin Orsha, 1910), Kozhin's designs are remarkable in terms of their level of detail.[19]

Kozhin had initially trained at the Stroganov Institute for Technical Drawing under Fedor Shekhtel´, who played an important role in reviving interest in Russian folk art in the first decades of the twentieth century.[20] Subsequently, he worked as a theatre designer at Savva Mamontov's Private Opera alongside such artists as Konstantin Korovin, who was known for his elaborate theatre sets that drew inspiration from native folk legends. Mamontov's Private Opera was one of a number of Russian

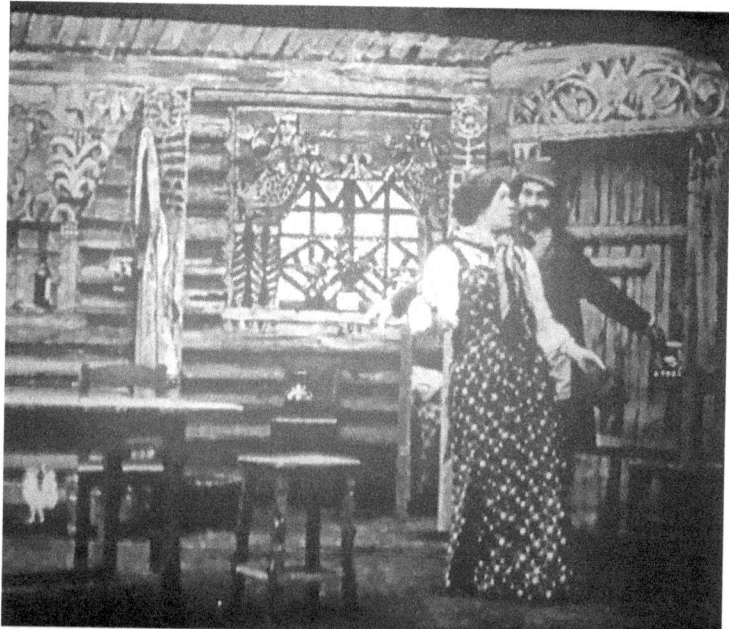

Figure 2.1 *Izba* interior. *The Dashing Merchant* (Ukhar´-kupets) directed by Vasilii Goncharov © Pathé 1909. All rights reserved.

theatres at the turn of the twentieth century that demonstrated a marked interest in the ethnographic and historical accuracy of sets, props and costumes. Designers often undertook intense preliminary research, which included studying historical sources, regional topography and ethnographic iconography.[21] Similarly, the Malyi theatre, where, as we recall, Kozhin worked on a number of productions, was known for the historicism of its sets, which designers often created in consultation with trained ethnographers and archaeologists.[22]

In addition to reflecting an interest in ethnographic and historical authenticity, the use of folk patterning in *The Dashing Merchant* creates a striking visual effect. The filmmakers' concern to make a film that was aesthetically pleasing, as well as ethnographically accurate, is also demonstrated through their experimentation with colour. *The Dashing Merchant* was the first hand-coloured Russian fiction film.[23] In the absence of original colour prints it is impossible to tell precisely what effect colour would have had. However, it is likely that its application would have accentuated the folk patterning. Moreover, decorative details serve to highlight particular characters. It is notable that, in contrast to other characters, it is the protagonists – the peasant father and his daughter Masha – who are most frequently framed against patterning. The arrangement of sets also works to privilege certain characters. In a number of scenes, the male patriarch is positioned in the centre of the composition, and tables and chairs are angled so as to direct the viewer's eye towards him. The patriarch is situated in front of an area of empty space, which functions as a stage for various characters to come and address him. As Iurii Tsiv´ian notes, the use of precision blocking, in particular the central positioning of protagonists, is a feature that is distinctive to early-Russian cinema and one way in which it departs from the tradition of the theatre, in which the range of vantage points in the auditorium means that the precise positioning of actors is less effective.[24]

In comparison to the fiction films on Russian life designed by Kozhin, the Pathé films made on traditional Russian subjects from 1910 onwards exploited the expressive potential of natural outdoor settings to convey a sense of atmosphere. That year, Pathé hired the Moscow Art Theatre (Moskovskii khudozhestvennyi teatr, MKhT) set designer Czesław Sabiński [Cheslav Sabinskii] to work as the production artist on several films on Russian life, including *Mara* (1910), *L'Khaim* (1910) and *The Tale of the Fisherman and the Little Fish* (Skazka o rybake i rybke, 1911). According to Sabiński's memoirs, his responsibilities stretched beyond designing scenery and included consulting on acting

techniques, placing actors within the frame and 'representing traditional Russian life'.[25] For *The Tale of the Fisherman and the Little Fish*, Sabiński even wrote the scenario, which was based on Aleksandr Pushkin's fairy-tale verse of the same title published in 1833. *The Tale of the Fisherman and the Little Fish* tells the story of a fisherman who catches a magical fish, which promises to grant his and his wife's wishes for increased wealth and social status in return for its freedom. While there is no information on what influenced Sabiński's choice of Pushkin's tale for the film scenario, presumably part of its attraction for the experienced theatre designer lay in the opportunity to experiment with a number of different types of sets to correspond with the various ranks of rural society, from the peasantry to the boyar class, as well as to use coastal and provincial landscapes.

As with Pathé's earliest films, Sabiński's set designs for *The Tale of the Fisherman and the Little Fish* demonstrate a concern with ethnographic accuracy. Rashit Iangirov characterizes Sabiński's style of sets as 'high quality reproductions of the ultra-realist school of the Moscow Art Theatre'.[26] As with the Malyi theatre, the MKhT's productions of the late 1890s and early 1900s were notable for the historical and ethnographic authenticity of their scenery. For many of these productions, such as *Tsar Fedor Ioannovich* (1890), the MKhT's principal director Konstantin Stanislavskii and head designer Viktor Simov undertook research trips to the Russian provinces to observe traditional rural life and to gather ethnographic material.[27] For *The Tale of the Fisherman and the Little Fish*, the filmmakers similarly conducted research trips, travelling to a coastal area that corresponded with Pushkin's description of the landscape.[28] A concern for ethnographic detail is also evident in the artificial scenery that Sabiński designed for the film. The exterior of the boyar's house is decorated with intricate patterning, while the palace interiors are ornamented with elaborate painted frescos. In addition to painted decoration, Sabiński strove to create a sense of authenticity through the rural environment's material artefacts and infrastructures. In the scenes that show the fisherman's peasant hut, pots and tools of different sizes and materials are strewn across the ground. Details such as the hut's lopsided wood panelling, its small sunken window and the ragged textiles that hang outside its entrance convey the poverty of peasant life and the fisherman's downtrodden existence.

These scenes of rural poverty contrast starkly with the picturesque quality of the landscape. In several of the coastal scenes, dazzling reflections of light gleam on the water's surface. Compositions are carefully constructed so that the sweeping curve of a bay is contrasted

with the vertical trunks of trees. As Paolo Cherchi Usai notes, several of the films on which Sabiński worked in the early 1910s are remarkable in terms of their picturesque landscapes.[29] He even refers to the woodland scenes in *L'Khaim* as 'Arcadian' in terms of how the female figures are arranged on a bank to resemble classical mythological compositions.[30] In *The Tale of the Fisherman and the Little Fish*, the ethereal quality of the landscape corresponds to the film's fairy-tale scenario. In his commentary on the film, Cherchi Usai argues that the natural beauty of the coastal scenes contrasts with the 'clumsiness' of the over-sized *papier-mâché* fish.[31] However, the fact that Sabiński held a reputation in early-Russian cinema for his proficiency as a prop and model maker and the level of verisimilitude achieved in the film's scenery for the palace and boyar's house suggest that the artificial appearance of the fish is deliberate, and is intended to heighten the fairy-tale quality of these episodes.[32] In the coastal scenes, the shiny surface of the fish's body echoes the glittering reflections of light on the sea, while its exaggerated size alludes to its magical properties as well as to the power it holds over the fisherman.[33]

Over the course of the film, subtle changes in the seascape work to convey a shift in the relationship between the fisherman and the natural world. Initially, the sea is calm and light gleams off its undisturbed surface. On the fisherman's first expedition, during which he catches the magical fish, he is pictured in control of the sea, with his boat positioned in the centre of the composition taking up the majority of the frame. As the film progresses, however, and the relationship between the fisherman and the fish is reversed, leaving the fisherman dependent on the fish's will, the sea fills a greater proportion of the frame while the fisherman is left marginalized, standing on a small rock in the corner of the composition. The sea becomes more turbulent and waves crash against the jagged rocks, conveying the limits of the fisherman's control over the natural world. Thus, Sabiński used the natural landscape not only for verisimilitude but also to convey the change in atmosphere in Pushkin's tale.

From 1911/12, there was a noticeable decline in films with rural settings that were based upon traditional Russian folktales or verses. Rather, filmmakers began to use the rural environment as a setting to explore contemporary everyday peasant life with an emphasis on its backwardness and deprivation. In 1912, the Khanzhonkov studio produced several films that focused on the hardships of rural life, including *The Brigand Brothers* (Brat´ia-razboiniki), *The Peasants' Lot* (Krest´ianskaia dolia) and *The Incestuous Father-in-Law* (Snokhach).

Although no production artist is credited with working on these films, the carefully composed landscapes and set design details are crucial to their representations of rural hardship. Indeed, Rachel Morley identifies *The Incestuous Father-in-Law* as remarkable among early-Russian films for the way in which the filmmakers exploited natural settings 'to establish mood and atmosphere, to mirror the protagonists' state of mind and to foreshadow their ultimate fates'.[34]

The Brigand Brothers is similarly notable for how the filmmakers exploited the rural environment to convey meaning and to enhance visual expressivity. Goncharov worked as the director and the scenarist on the film alongside the camera operator Louis Forestier. Another adaptation of a Pushkin work, this time his 1821 poem of the same title, the film focuses on the chief of a group of bandits, who recounts to his followers, as they sit gathered on the banks of the Volga river, how he and his brother eked out an existence as orphaned children in the countryside, first as beggars and then as highway robbers. The film's diversity of terrains, ranging from flat plains to steep valleys and dense woodlands, forms a key element of its visual impact. As Neia Zorkaia demonstrates in her discussion of Drankov's treatment of outdoor settings in *Sten´ka Razin*, since the earliest days of Russian cinema filmmakers used the elements and textures of the natural world to heighten cinema's expressive potential.[35] In *The Brigand Brothers*, the different terrains create variations in lighting effects: the flat and even light of the open plains contrasts with the intense shadows of the thicketed pathways and the dappled sunlight of the dense woodlands.

Natural settings are also one of the crucial means through which the filmmakers convey the brothers' misfortunes and pitiful existence. In an early sequence in which villagers haul the corpse of the brothers' drowned mother from a river, water takes up the majority of the frame and the characters are marginalized in a corner, alluding to the river's awesome power.[36] As the brothers proceed on their journey through the countryside, they are forced to ascend a steep and rocky path, jump across deep ditches filled with giant boulders and traverse fields of long grass. Details such as scraggy branches, overgrown vegetation and trees gnarled with age work to convey the hostility of the rural environment. These scenes are similar to the way in which, in *The Incestuous Father-in-Law*, the filmmakers used natural settings to portray the distressed emotional state and wretched situation of the young peasant girl Lusha, who is raped by her father-in-law in accordance with the traditional Russian custom of *snokhachestvo*.[37] In both films, the representation of the protagonists as oppressed by

their natural environment alludes to the fact that their misfortunes are not self-inflicted but result from circumstances of birth and from the society in which they find themselves.[38]

In addition to the natural features of the rural landscape, the filmmakers also exploited the infrastructure of rural settlements to convey the brothers' hardships. Throughout the film, the brothers are pictured at a distance from rural settlements and are framed next to fences, alluding to their social isolation and marginal existence. As a notable example, in one scene the brothers are shown walking next to a town wall, which fills the entire height of the frame and dwarfs them; behind them stretches a faintly trodden path that eventually leads to a settlement, just visible on the distant horizon. In another sequence, in which one of the brothers embraces the village girl with whom he falls in love, a broken fence dominates the foreground of the frame; its jagged stakes jut violently into the centre of the composition and create a sense of foreboding. This composition prefigures a sequence in the Libken studio's *Merchant Bashkirov's Daughter* (Doch´ kuptsa Bashkirova, 1913) in which, as the merchant's daughter and her lover embrace, they are framed by a broken gate in the foreground. Such bleak landscapes closely relate to The Wanderers' (*Peredvzhniki*) tradition of representing rural life, which emphasized its social backwardness. The landscape paintings of Vasilii Perov and Aleksei Savrasov, for example, rejected pastoral imagery to linger instead on empty scrublands, eroded pathways and battered fences, conveying the destitution of rural society.[39]

In the early 1910s, the contemporary cinema press focused its praise of films depicting rural life on their expressive landscapes and their detailed and truthful recreation of provincial everyday life.[40] As the decade progressed, however, very few films were produced which took as their subject the everyday life of rural inhabitants. Instead, filmmakers began to focus on representing urban life. Additionally, some critics began to denounce films that they saw to be overly concerned with precise ethnographic detail. In a 1916 article published in *Cinema Herald* (Vestnik kinematograf), an anonymous critic announced that in Russian cinema 'The time for depicting everyday life has passed'.[41] According to the critic, films of rural life should not be mired in ethnographic detail; instead, scenery should function 'only as the background for an interesting, lively drama'.[42] The critic praised the Khanzhonkov studio's *Who Ruined Her?* (Kto zagubil, 1916) as a new departure in this direction, arguing that 'All everyday-life dramas previously shown on the screen suffer from an abundance

of ethnographic details and are overloaded with everyday life to the detriment of dramatic content'.[43]

As with the Khanzhonkov studio's earlier rural dramas of 1912, no production artist is credited with designing the sets for *Who Ruined Her?* Nikandr Turkin worked as the director alongside the camera operator Mikhail Vladimirskii. The scenario, adapted by Zoia Barantsevich from her novella *The Forest Lodge* (Lesnaia storozhka, 1916), follows a love affair between a young peasant girl and the son of a wealthy businessman, who owns a country estate near the girl's village. According to the *Cinema Herald* critic, the film broke from the typical mould of rural everyday life dramas in that, rather than attempting to recreate settings in precise detail, the filmmakers portrayed only the 'typical'.[44] Indeed, *Who Ruined Her?* is notable for its pared-down interiors. Apart from a single icon on the wall and patterned curtains and a tablecloth, the young peasant girl's *izba* is devoid of decorative features (Figure 2.2). The scenes which take place in the *izba* are filmed at a medium distance, emphasizing the sparseness of the scenery. In *Who Ruined Her?*, the filmmakers' focus is on creating a sense of atmosphere and psychological tension. This is achieved primarily through the effects of light in the outdoor settings. In contrast to the spartan interior of the *izba*, the outdoor scenes display a richness of textural and tonal contrasts, created by different types of vegetation. Areas of dense woodlands are juxtaposed with open vistas, creating variations in lighting effects. Although, since the earliest days of Russian cinema,

Figure 2.2 Peasant interior. *Who Ruined Her?* (Kto zagubil?) directed by Nikandr Turkin © Aleksandr Khanzhonkov & Co 1916. All rights reserved.

filmmakers had considered the ways in which the rural landscape could heighten dramatic tension, in the mid- to late 1910s they began to devote more of their attention to developing specific methods towards achieving this goal.

Ethnographic and psychological realism

Throughout the 1910s and into the 1920s, critics continued to comment on the ethnographic authenticity of the settings of films that based their action in the rural provinces. In comparison to the reviewer writing in 1916 in *Cinema Herald*, however, many critics considered that ethnographic accuracy and a wealth of naturalistic detail could heighten a film's psychological intensity. This is evident in the reception of *Polikushka*, produced in 1919 by the late-Imperial studio Rus´ but released only in 1922 due to the hardships that the Russian film industry endured during the civil war period. Contemporary critics and film historians alike have remarked on how the film combines a concern for authenticity with an interest in psychological fantasy. In a review published in 1923, the German critic A. Kepp argued that in *Polikushka* the filmmakers 'convey *reality* with fantastic veracity and *fantasy* with the truth of reality'.[45] More recently, Denise J. Youngblood has described the film as 'a fascinating combination of dreary naturalism, extreme theatricality and even a little supernaturalism'.[46]

The film's scenario was adapted by Fedor Otsep and Nikolai Efros from Lev Tolstoi's 1863 story of the same title, which presents a brutal exposé of the poverty of Russian rural life in the nineteenth century. The eponymous peasant Polikushka lives a downtrodden existence, committing petty theft to support his drinking habit while his family goes hungry. When a wealthy female landowner entrusts him with delivering an envelope of money, he receives an opportunity to prove himself and rise above his disreputable lifestyle. During the journey, however, Polikushka loses the envelope; distressed at his sense of failure, he commits suicide. *Polikushka* was one of a series of films that Rus´ made in collaboration with the MKhT in 1918/19, with the studio's filmmakers working alongside a cast of actors and theatre professionals from the MKhT and the Malyi theatre.[47] For *Polikushka*, the production artist Sergei Kozlovskii and the camera operator Iurii Zheliabuzhskii collaborated with the theatre director Aleksandr Sanin. This continued the close and productive partnership that these three figures had established when, as we recall from Chapter 1, they worked together on

The Virgin Hills (Dev'i gory, 1919), the first joint production between Rus' and the MKhT.[48]

Contemporary reviews of *Polikushka* focused on the naturalistic detail of Kozlovskii's scenery. Writing in 1922 in the newspaper *Cinema* (Kino), the critic Veronin noted that Kozlovskii's sets were made in the ethnographic tradition of the Malyi theatre.[49] He even declared that the sets were too naturalistic and seemed as if they had been made to please a foreign audience who pined to see an 'exotic' Russia.[50] Kepp also compared the film in terms of its level of naturalistic detail to the paintings of the sixteenth-century Netherlandish artist Hans Memling, whose dense compositions of religious subjects set against rural landscapes were intended to prolong and to intensify spiritual contemplation.[51]

The level of detail in Kozlovskii's sets is indeed remarkable, especially considering the limited resources available to the filmmakers at the time.[52] In their wealth of detail, Kozlovskii's sets recall those that Simov created for the MKhT's 1902 production of Maksim Gor'kii's *The Lower Depths* (Na dne, 1901), which also represents the deprivation of Russian peasant life. As in *The Lower Depths*, and in *The Brigand Brothers*, set details serve primarily to emphasize the protagonists' impoverished existence. In the scenes set in Polikushka's hovel, the composition is densely packed with dirty pots and pans, ragged textiles and overgrown foliage. An enormous tree, with its rough bark clearly visible, cuts through the middle of the hut, and twigs and straw protrude from the ceiling, making the space appear more like an outdoor shelter than a domestic interior. The mass of vegetation that intrudes into the shack seems to restrain the movements of Polikushka and his family and conveys the constraints of their social situation, which they struggle to escape.

Since the MKhT's inception, Stanislavskii and Simov had used sets with an abundance of detail as a way to help actors identify with the inner emotional feelings of their characters. As we recall from Chapter 1, in contrast to other Russian theatres at the beginning of the twentieth century, where actors had very little interaction with sets and were usually only introduced to them immediately before a performance, at the MKhT Simov brought models of the sets to the rehearsals;[53] he even, on occasion, constructed full-scale sets behind the theatre back-curtain so that actors could get into character before appearing on stage.[54] In his memoirs, the Rus' studio proprietor Moisei Aleinikov notes that for *The Virgin Hills* Simov drew on his experience at the MKhT and used set models as a strategy to help actors prepare before filming began and to stay in character during shooting breaks.[55]

Similarly, the details of Kozlovskii's sets in *Polikushka* serve to convey the temperament and the psychological states of characters. Polikushka's uncouth nature is visually expressed in the grubby rags and rubble that fill his dirty shack of a home. The house's overgrown vegetation echoes Polikushka's bedraggled appearance, with his long strands of uncombed hair, and alludes to his uncultivated nature. In several scenes, Polikushka stands next to a horse, his straggly hair echoing the creature's matted mane and emphasizing his primitive nature. In addition to conveying his crude character, Polikushka's environment also evokes his frenzied state of mind. In one scene, he crouches against the crumbling brickwork of a building, which reflects not only his destitute state but also his distressed thoughts. The building's classical columns dwarf Polikushka, who huddles close to the ground, and convey his social insignificance. Moreover, in the sequence in which Polikushka discovers that he has lost the landowner's money, he is framed against a bleak landscape of barren trees, whose skeletal forms hint ominously at his fate. In the sequence in which he hangs himself, a mass of foliage obscures his face entirely, reducing his identity to an anonymous corpse.

The effectiveness of the film's set designs was acknowledged at the time of its release and beyond. In his text 'The Visible Man' (Der sichtbare Mensch, 1924), which was reviewed in the Soviet press from 1925, the Hungarian formalist critic Béla Balázs marked out *Polikushka* for its ability to convey human emotions and psychology through the landscape.[56] Balázs argued that in fiction films, such as *Polikushka*, landscape is not simply a background for action; instead, the physical features of the land reveal a person's character and psychology.[57] He describes landscape as a form of physiognomy, writing that topography acts as 'a face of a particular place with a very definite expression of feeling'.[58]

Despite the interest among contemporary film critics in the expressive potential of landscapes, very few Soviet fiction films of the early to mid-1920s exploited rural settings as a means to convey individual psychology. Instead, many films of the period set their action in urban environments and explored social and class issues. Lev Kuleshov's *By the Law* (Po zakonu, 1926) is a notable exception, however, in terms of how the filmmakers used the rural environment to convey the emotional states of characters. Indeed, the Association of Revolutionary Filmmakers (Assotsiatsiia revoliutionnykh kinematografistov, ARK) identified the film as the first psychological drama in Soviet cinema and noted that its scenery played an important role in conveying emotional tension.[59] More recently, Philip Cavendish has claimed that *By the Law* is 'one of the very first Soviet films to imbue the landscape, both interior

and exterior, with a powerfully dramaturgical dimension'.[60] According to Kuleshov, his main aim was to explore 'life by the law and life by the soul', or how individuals are psychologically affected by the struggle between their primal anxieties and emotions and their sense of duty to uphold established ethical codes in the name of the church and the state.[61] For Kuleshov, the focus on the psychological experiences of individuals was a marked departure from many early-Soviet films, which were preoccupied with crowd mentality and mass reaction.[62]

In addition to taking on the role of director, Kuleshov worked on the sets alongside the production artist Isaak Makhlis. He also co-authored the scenario with the formalist critic Viktor Shklovskii. The pair based *By the Law*'s scenario on Jack London's short story *The Unexpected* (1906), which follows a group of prospectors digging for gold in the Alaskan Yukon at the turn of the nineteenth century. The group's drudge, an Irishman named Michael Dennin, is forced to perform domestic chores instead of being allowed to participate in the search for gold. In an attempt to overturn the inequality between him and his comrades, Michael murders two of the group's members. The survivors, Hans and Edith Nelson, resist taking immediate bloodthirsty revenge on Michael and hold him captive as they seek to bring his crimes to trial. However, as winter sets in and they become trapped with Michael in the isolated cabin, Hans and Edith struggle with their feelings of compassion for their murdered comrades and their sense of ethical justice and civic duty to uphold the law.

As several scholars have argued, although *By the Law* is set in a time and place remote from contemporary Soviet life, Kuleshov and Shklovskii used the film as a metaphor for society caught on the brink of revolution.[63] Cavendish notes that the prospectors' cabin and its immediate surrounding environment represent two separate symbolic entities: the cabin, with its hierarchical pecking order and its ethical pretensions based on established codes, metaphorically represents bourgeois society; the surrounding wilderness, by contrast, stands for the primal human urges and emotions that threaten to undermine social order.[64]

The film's action takes place in the single environment of the cabin. The limited use of settings was partly a result of the filmmakers' desire to create a film economically.[65] Shklovskii later exalted the fact that, in comparison to the high production costs of many other 1920s Soviet films – such as the historical drama *The Decembrists* (Dekabristy, 1927), which cost over 300,000 rubles – *By the Law* was made at a total expense of 18,000 rubles.[66] During the mid-1920s, filmmakers and critics became concerned with ways to economize the production process, particularly

in terms of set design.[67] In a special feature dedicated to the tasks of the production artist published in a 1925 edition of *Cinema-Journal ARK* (Kino-zhurnal ARK), both Kozlovskii and Makhlis contributed articles in which they called for maximum economy of materials and simplicity of expression in set design.[68]

In *By the Law*, the filmmakers' concern for economy in set design was not, however, at the expense of visual authenticity and expressivity. For the exterior settings, they undertook various research expeditions to Moscow's suburbs in search of a site that corresponded with their knowledge of the Yukon gained from American films, before they eventually settled on a location near Tsaritsynskoe lake.[69] Initially, the cabin was built on a spit that jutted into the Moscow river. When in the spring the ice melted, causing the water level to rise and the cabin to flood, the filmmakers transferred filming to an artificial cabin constructed in the Goskino studio.[70] Kuleshov notes how they took great care in constructing the artificial cabin so that the switch would not be apparent to viewers.[71]

The filmmakers decided to use a single environment not only for economic reasons, however. In his memoirs, Kuleshov claimed that the choice of a one-room cabin in the isolated countryside was essential to their aim of revealing the psychology of individuals.[72] He stated that it is only within confined and private settings, away from social codes and expectations, that individuals expose their true emotions and anxieties.[73] This concern can already be seen in the pre-revolutionary films that Kuleshov worked on as a production artist alongside Evgenii Bauer. For *In Pursuit of Happiness* (Za schast´em, 1917), for example, the female protagonist Li abandons herself to her romantic feelings for her mother's lover, the lawyer Dmitrii Gzhatskii, as she reclines on a secluded beach in a sheltered spot, surrounded by rocks.[74]

In *By the Law*, the cabin's social isolation is made immediately apparent in the opening scenes. A series of establishing shots show the great expanse of the Yukon river and the cabin on an uninhabited bank, silhouetted against a desolate landscape. Horizontal forms dominate the frame and are ruptured only by the skeletal body of a tree, which hints ominously towards its later function as a means for Hans and Edith's attempted execution of Michael. Rosemari Baker notes how the filmmakers' emphasis on the cabin's isolation in the opening sequences departs from London's original narrative, which shows Edith performing domestic chores inside the cabin.[75] Similarly, Evgenii Gromov argues that, while London's text is relatively vague about the cabin's setting, in *By the Law* the filmmakers devote considerable attention to establishing

a sense of isolation.[76] Indeed, in his memoirs Kuleshov notes that the filmmakers carefully constructed compositions so as to exclude from the frame any existing infrastructure at the filming location.[77]

As the film progresses, the landscape becomes increasingly hostile, conveying how, in their prolonged separation from civilized society, Hans and Edith's primal emotions gradually erode their ethical pretensions. Initially, the land refuses to give itself up as a resource to the prospectors while they search for gold. As Edith pans for gold, the water reflects only her own face. Later in the film, the natural environment takes on a more active agency as it begins to resist acts of human intervention. Rain and snow submerge pathways and a gale overturns the prospectors' sledge. In the sequence in which Hans attempts to dig a grave for his murdered comrades, the wind and rain lash him, frustrating his efforts, and the icy terrain refuses to yield to his pick-axe. As winter sets in and the cabin becomes increasingly cut off from its surrounding environment, tensions mount between the characters. Shots of the snow-covered cabin are intercut with close-ups of the faces of Hans and Edith contorted into anxious grimaces. In the spring that follows, the melting ice leaves the cabin clinging to a slither of land amid a flooded plain. In several of the springtime sequences, the cabin is positioned off-centre of the composition or in a marginalized corner, emphasizing its inhabitants' existence on the fringes of civilized society.

As in *Polikushka*, the cabin's primitive appearance also serves to demonstrate the inhabitants' separation from civilized society. Its walls are made from logs of rough wood with the bark clearly visible; a tree trunk cuts through the centre of the interior; furs are draped over the walls and furniture; sawn tree trunks function as stools; and a fire pit built from rocks occupies the corner of the interior that in a peasant's house is usually reserved for the stove. For Gromov, the cabin's primitive appearance alludes to the brutish nature of human emotions.[78] However, the prospectors attempt to impose established social codes and practices on their environment. This is demonstrated through their interventions in the cabin's primitive interior. The centre of the cabin is dominated by a large, sturdy table around which the inhabitants enact their daily routines. The table's smooth surface contrasts starkly with the cabin's rough walls. When Hans and Edith bring Michael to trial, they use the table to construct a mock court, covering it with a white cloth and placing on top of it a copy of the bible. Hanging above the table is a portrait of Queen Victoria in her regal attire. As Gromov notes, Makhlis and Kuleshov's inclusion of a portrait departed from London's text.[79] In his memoirs, Kuleshov stated that the portrait was intended as a symbol

that encapsulated the law-abiding pretensions and hierarchical order of bourgeois society.[80]

Despite the prospectors' endeavours to impose control on their environment, their efforts are futile. The gradual intrusion of the natural world into the cabin alludes to the way in which primal human emotions and anxieties gradually undermine established codes. As Cavendish notes, the natural elements intrude into the cabin at crucial moments in the narrative and influence the relationships between characters.[81] During spring, the ice melts and water floods into the cabin, coinciding with a warming in relations between Hans and Michael. In a gesture of compassion, Hans gives a blanket to Michael, who shivers in his drenched clothes. Moreover, as winter thaws and spring emerges, signalled by shots of a singing bird and branches with fresh buds, the group gathers around a cake to celebrate Edith's birthday and Michael gives his watch as a present to his comrade.

In his memoirs, Kuleshov notes that the filmmakers used artificial methods to create natural effects that would heighten the sense of atmosphere: a fire hose created the impression of pouring rain and an aeroplane propeller gave the effect of wind.[82] The actress Aleksandra Khokhlova, who played Edith, stated that these effects helped her 'to live through' (*perezhivat'*) her character. As Gromov notes, Khokhlova's use of the verb '*perezhivat*'' is interesting insofar as the term is connected with Stanislavskii's acting method.[83] Indeed, Aleinikov used the term to describe the form of acting that was used in *The Virgin Hills* and *Polikushka*.[84] The psychological and emotional intensity expressed in *By the Law* was not, however, well received by all contemporary critics. In a review in *Cinema*, Mikhail Levidov attacked the film for its 'instances of pathology and hysteria', which he criticized as 'a sick phenomenon' that harms Soviet cinema.[85] Similarly, writing in *Cinema-Front* (Kino-front), the critic A. Arsen denounced several scenes, such as those of Edith's birthday, for expressing bourgeois rituals and mysticism.[86] Youngblood notes that the criticism of *By the Law* was even more harsh among ARK, which condemned the film primarily on account of its 'mysticism'.[87]

Transforming the rural environment: The enchantment of infrastructure and technology in early-Soviet fiction films

While many Russian fiction films of the 1910s had celebrated the mystical practices and beliefs of rural peasant life as an essential part of Russian national identity, in Soviet cinema of the 1920s this mysticism

came to signify rural society's backwardness, and was represented as an obstacle to social and technological transformation. A number of 1920s Soviet films pictured the rural environment as caught amid a struggle to replace religious mysticism with a new belief system rooted in technology's promise to overcome hierarchical class divisions and to ensure social and economic progress. Through the technological and infrastructural transformation of the countryside, rural society would become a vital contributor to the state's industrial development. Moreover, in contrast to *By the Law*, which represents the natural world as untameable, many late 1920s Soviet films showed rural inhabitants as able to assert control over the forces of nature and their surrounding material environment through the use of technology.

The issue of how the infrastructural transformation of the rural environment would contribute to social progress and industrial prosperity is directly addressed in *The Old and The New* (Staroe i novoe, 1929). Initially titled *The General Line* (General´naia liniia), the film originated as a social commission between the Party Central Committee and the Sovkino studio to demonstrate the urgency to modernize and to collectivize the Soviet countryside.[88] Sovkino assigned Sergei Eizenshtein and Grigorii Aleksandrov to work as the film's scenarists and directors alongside the camera operator Eduard Tisse and the production artists Vasilii Kovrigin and Vasilii Rakhal´s. Production began in 1926 and by 1927 the filmmakers had finished shooting a significant proportion of the film.[89] However, Eizenshtein, Tisse and Kovrigin's involvement in 1927 on *October* (Oktiabr´), to mark the tenth anniversary of the 1917 Revolution, interrupted production work.[90] By the time the filmmakers resumed work in June 1928, the party line on agriculture had shifted and a different ideological emphasis was required, as reflected in the film's change of title to *The Old and The New*. While in the period between 1925 and 1927 agricultural policy had concentrated on increasing production through mechanized labour, the 15th Party Conference in December 1927 called for a focus on new ways of organizing production and of socializing rural communities, identifying collectivization as the main strategy for realizing these goals.[91]

Despite this shift in policy, in the final version of the film forms of mechanized agricultural production, such as the tractor and the cream separator, continue to occupy a central role. As Eizenshtein would later recall, rather than providing a social analysis of the transition to collective farming methods, the filmmakers focused on 'the pathos of the machine', a term he used to describe the villagers'

affective response to forms of mechanization.⁹² In this way, *The Old and The New* demonstrates a similar concern for the agency of objects as Eizenshtein and Rakhal´s' previous collaboration, *Battleship Potemkin* (Bronenosets Potemkin, 1925). In contemporary reviews of *Battleship Potemkin*, several critics remarked on how objects and infrastructure, such as battleship machinery, jetties and bridges, incited desires for social and revolutionary change.⁹³ Writing in 1926 in *Life of Art* (Zhizn´ iskusstva), the critic Aleksei Gvozdev even claimed that in the film it is the objects, rather than the actors, that act and become the heroes.⁹⁴ Likewise, several critics remarked on the role that objects played in *The Old and The New*, in particular focusing on agricultural infrastructure and machinery, such as fences, the collective dairy farm and tractors.⁹⁵

As had been the case with many Russian fiction films of the 1910s that were set in the rural provinces, Eizenshtein, Kovrigin and Rakhal´s based the scenery for *The Old and The New* on intense ethnographic research, which included consulting newspaper reports on the condition of the countryside, conducting interviews at research institutes that specialized in agricultural matters and undertaking reconnaissance trips to villages and cooperatives outside Moscow.⁹⁶ For the rural settings, the filmmakers sought out a range of filming locations both in Moscow's suburbs and in various Soviet republics. In a promotional article for the film in *Cinema-Front*, Eizenshtein noted that filming took place in the Mugan Steppe (a region south of Baku), at large-scale collective farms outside Moscow, at the Bronnitsa Meadows, situated by the Moscow River on the road to Riazan´, at the village of Mnevniki and at the Konstantinovo State Breeding Farm in Riazan´ province.⁹⁷

In the mid- to late 1920s, diverse and often far-flung rural settings were used in a number of films such as *Jews on the Land* (Evrei na zemle, 1927), which incorporated footage shot in Crimea, and *The Parisian Cobbler* (Parizhskii sapozhnik, 1928), for which the filmmakers travelled to Pskov.⁹⁸ The cinema press avidly reported on these filming expeditions, with many articles extolling the merits of outdoor filming over studio work, which was criticized as extravagant despite the fact that it was usually more economical.⁹⁹ A number of critics, among them Viktor Shklovskii, complained that the sets of rural provinces made in the studio were monotonous and 'boring' (*skuchnye*), and insisted that filmmakers must make films of village life that depicted the local character of provinces.¹⁰⁰ Indeed, Shklovskii denounced *The Old and The New* for the way in which the filmmakers combined material from a number of different rural provinces and created a picture of rural life that was too generic.¹⁰¹ Other critics encouraged filmmakers to pursue

location filming in order to capture an authentic representation of the natural world. In a 1925 article titled 'Towards Location Filming!' (Na naturu!), published in *Soviet Screen* (Sovetskii ekran), an anonymous critic argued that filmmakers should undertake expeditions to capture not only genuine rural experience but also the beauty of natural light.[102] While ceding that not all films could be shot on location, the critic declared that the industry should strive for 70 per cent of its productions to be filmed outdoors.[103] The attention given to filming expeditions correlates with a general interest in ethnographic research during the mid-1920s. According to Widdis, between 1925 and 1926, 633 scientific expeditions were organized with the aim of gathering historical and ethnographic material.[104]

In addition to participating in filming expeditions for *The Old and The New*, Eizenshtein, Kovrigin and Rakhal´s undertook research on agricultural technology and infrastructure. Anne Nesbet notes that the filmmakers collected specialist articles on agricultural machinery, including milk coolers and cream separators.[105] In particular, O. Davydov's text *People of Maklochko* (Maklochane, 1926), which traces the growth of Soviet collective farms, became a vital source of information on how technology could improve farming methods.[106] Davydov's study paid particular attention to the cream separator as a device for transforming the countryside.[107] Besides analytical charts that demonstrated the separator's role in increasing economic productivity, Davydov included anecdotes and interviews with peasants that revealed their psychological investment in the object as an agent of social change.

In *The Old and The New*, Kovrigin and Rakhal´s used agricultural technology and infrastructure in the sets to indicate the level of industrial development and social integration of rural society. Initially, before the peasant Marfa Lapkina embarks upon the task of transforming her rural community through introducing new farming methods, fences proliferate and serve as an impediment to agricultural productivity. In the sequence in which the viewer is introduced to Marfa, she sits on barren ground with her back to a fence, which separates her from an expanse of uncultivated land. In several scenes, fences carve up the land into a patchwork of individual plots, too meagre for significant agricultural cultivation. One sequence shows how these fences result from the division of an estate between two brothers, who split their house in half and use its frame to create fences. The willowy and fractured wood used for the fences alludes to the land's barrenness. These brittle branches are also used by the villagers to make ploughs, which struggle to carve furrows in the rocky soil. The narrow furrows

visually echo the rib cage of an emaciated cow and contrast starkly with the bulging folds of fat in the wealthy kulak's face.

While in *The Brigand Brothers* fences serve to indicate social exclusion and isolation, in *The Old and The New* they primarily convey social division and tension among a single, rural community. In a number of Soviet films made in the mid- to late 1920s that take place in the rural provinces, fences similarly appear as an impediment to social cohesion and economic prosperity. In Kozlovskii's scenery for *The Captive Earth* (Zemlia v plenu, 1927), the landscape is repeatedly shot through metal grillwork, which conveys the landed gentry's control over the countryside and the prohibition of the serfs to farm the land they are entitled to, while in *Don Diego and Pelageia* (Don Diego i Pelageia, 1928), for which Kozlovskii also designed the sets, fences act as a social barrier, which rural bureaucrats impose on the peasant pedlars to prevent them from trading with the prosperous middle-class clientèle who pass through the local station.

In *The Old and The New*, while fences cause division within the rural community, machinery such as the cream separator and the tractor serves as a means for social cohesion around the shared goal of industrial development. The cracked, lacklustre wood of the fences visually contrasts with the smooth and shiny funnel of the cream separator. In his reading of the film, Noël Carroll argues that machinery is associated with the concept of exponential growth.[108] As Marfa sleeps in the presence of the separator, she dreams of overflowing streams of milk, vast production lines of milk bottles and rows of cattle harnessed to electrical milking units. Similarly, the tractor pulls a long line of carts through the rural settlement. Stretching from one edge of the frame to the other, the line of carts seems never to end. And, at the end of the film, scenes that show a group of tractors ploughing the earth in an enlarging circle are followed by those that display an abundance of grain sacks.

In its ability to induce exponential growth, machinery appears almost magical. This idea is conveyed through the filmmakers' use of religious imagery to represent technological devices. In the sequence in which the separator is introduced to the villagers, it is hidden under a veil in a corner of the room, such as that usually reserved for icons. As it is unveiled, the machine is shown out of focus, and its shimmering metallic body entrances the villagers. The reflective surface of the cream separator has a visual parallel in the gold- and silver-plated icon art that features in the preceding sequence, which shows a religious procession. Moreover, the milk that drips from the separator's funnel visually

echoes the drops of wax that fall from the candles during the religious procession. In his later analysis of the film, Eizenshtein drew on religious imagery to describe these scenes, writing that the separator appeared to be lit by an inner light as if it were an image of the Holy Grail.[109] Similarly, he compared the fountains of milk that shoot from the separator to the rivers of water that Moses brings forth from the mountains in the Bible.[110] Distortions in scale also work to accentuate the separator's mystical quality. In the scenes set in the peasant hut, the separator and milk canisters take on gigantic proportions against the low-ceilinged interior with its minuscule windows. According to Eizenshtein, the perspectival distortions in the film were intended to convey how technological objects could defy the laws of nature, and 'extend beyond' themselves and 'beyond their natural bounds'.[111]

The filmmakers also drew on religious imagery and the idea of magical transformation to represent the cooperative dairy farm. Eizenshtein invited the architect Andrei Burov, a member of the Constructivist Union of Contemporary Architects (Ob′′edinenie sovremennykh arkhitektorov, OSA), to construct a full-scale prototype of a collective dairy farm for the film.[112] Burov created the dairy farm in an architectural style that closely resembles the buildings of the modernist architect Charles-Édouard Jeanneret, known as Le Corbusier, with whom he was closely acquainted (Figure 2.3).[113] The pristine white walls of the dairy farm and the brilliant light that floods into the interior through elongated windows give the structure an ethereal quality.[114] With its abundance of light and space, the cooperative dairy farm contrasts starkly with the peasants' cramped and darkened huts, which provide the only other interiors in the film. Although, as we recall from Chapter 1, Burov claimed that he approached the task of creating the dairy farm not as a 'decorator' (*dekorator*) but as an architect involved in constructing a real building that would continue to be used after filming had finished, the cooperative dairy farm appears as if a utopian vision.[115] Occupying a remote space cut off by trees and a river from contiguous habitation, the dairy farm corresponds to descriptions of utopian space, such as that of Francis Bacon's *New Atlantis* (1627), which, as Katerina Clark demonstrates, became popular in Soviet Russia during the Cultural Revolution, from the late 1920s to the early 1930s.[116] Moreover, in several scenes the dairy farm appears to lack any distinct meeting point with the land, but instead seems to hover weightlessly above the ground. Like Bacon's utopia, the dairy farm is a space where technological marvel and high culture triumph over nature: baby chicks are hatched on experiment trays under artificial conditions; and images

Figure 2.3 'Architectural frames from the film *The General Line* (General´naia liniia). A Sovkino Production by S. M. Eizenshtein. Architecture by A. K. Burov', *Sovremennaia arkhitektura* 5–6 (1926): 136–7.

of slaughtered pigs, which hang heavily with their heads to the ground, are juxtaposed with those of porcelain pig figurines, which twirl around triumphantly with their snouts raised high in the air.

Burov's architectural work in the 1920s was limited to utopian designs for civic spaces, such as workers' clubs, which never developed beyond paper.[117] Indeed, the majority of architectural projects designed in Soviet Russia at this time were prospective visions that were utopian in their proposed scale and far beyond the state's engineering capacities in terms of available resources. The utopian nature of the cooperative dairy farm is further indicated by the fact that stills and photographs of the building were included in the Soviet architectural journal *Contemporary Architecture* (Sovremennaia arkhitektura) alongside blueprints of utopian projects for workers' clubs (Figure 2.3).[118] Moreover, in two articles published in 1928 and 1929, both titled 'Life as It Ought To Be' (Zhizn´ kak ona dolzhna byt´), the architectural critic Nikolai Lukhmanov used photographs of the dairy farm as illustrations.[119] In his more extensive 1929 article, Lukhmanov identified *The Old and The New* as one of the very few Soviet films that, rather than showing the underside of contemporary Soviet reality, presented an ideal vision of Soviet society that viewers could strive towards.

For Marfa and the rural community, the promise of social cohesion and economic prosperity offered by the cooperative dairy farm and the cream separator provides the foundations for an alternative belief system to religion. As such, *The Old and The New* corresponds to what Anthony Vanchu identifies as the presence of esoteric impulses in Soviet literary works of the mid-1920s that feature the representation of technology and infrastructure.[120] Vanchu demonstrates how in works such as Andrei Platonov's *The Homeland of Electricity* (Rodina elektrichestva, 1926) 'the aura of mystery' and 'the potential for magical transformation' associated with the occult were shifted onto science and technology.[121] As Vanchu argues, belief systems provide a means through which people can relate to their surrounding material environment.[122] In *The Old and The New*, the new Soviet belief system of technology privileges people's ability to shape their material environment and to overcome the blind forces of nature through individual initiative and inventiveness.

In his article 'The Border Line' (Pogranichnaia liniia), published in 1927 in the newspaper *Cinema* (Kino), the formalist critic Viktor Shklovskii marked out *The Old and The New* as exemplary for conveying Soviet cinema's transition to a 'second phase', in which articulating a person's relationship to their material environment became paramount.[123] Shklovskii argued that while working on a production filmmakers will no longer be concerned with using objects only for their symbolic associations; rather, 'cinema will become a factory of our relationship with things'.[124] Several scholars have noted the ecstatic, and even erotic, encounters that Marfa and the villagers have with technology.[125] In her reading of the film, Widdis claims that this relationship is articulated in terms of a harmonious interaction between human bodies and machines.[126] She argues that in the sequence in which the tractor breaks down, Marfa experiences a 'joyous' and 'embodied' encounter with the tractor as she offers part of her underskirt to a local farmworker who is attempting to fix its engine.[127]

This sequence can also be read in relation to what the anthropologists Penny Harvey and Hannah Knox describe as 'the enchantments of infrastructure'.[128] In their analysis of road construction in Peru, Harvey and Knox consider the affective responses of the people who live alongside roads or who are involved in their construction, and how these responses reveal an enchantment in infrastructure's promise of social transformation and economic prosperity.[129] They argue that it is precisely at moments when infrastructure seems to threaten to collapse or to fail that enchantment is generated and reinvigorated.[130]

Their analysis resonates with Bill Brown's position in his seminal article 'Thing Theory' (2001) that people become aware of objects as independent entities only when they stop working or fail to perform in intended ways.[131] In *The Old and The New*, in the sequence in which the tractor is demonstrated to the villagers, it initially falters; as the engine is ignited, sparks fly and smoke bellows; the tractor tentatively crawls over a mound of earth, as horses with carts gallop past; close-ups focus in on the tractor's tar-stained body and on its wheels trapped in heavy mounds of earth. The tractor's marginalized position in a corner of the frame, with its engine angled downwards, emphasizes its vulnerability. Following Harvey and Knox, the deferral of the tractor's promise of transformation and progress seems, however, to reinvigorate Marfa and the driver's enchantment in the machine. Light glistens on the tractor's body and reflects in their faces as they work to fix it. Once the engine begins to run, the tractor effortlessly pulls a line of carts across ditches and over hills. The posts of the carts stick up triumphantly, punctuating the skyline, and echo the celebratory banners erected for the tractor's inauguration. The technological development of the countryside thus appears as a tale of achievement against the odds. As in *By the Law*, the rural environment is far from a passive force that offers itself up for transformation; rather, inhabitants are forced to do battle with the land.

Instances when technology stalls or malfunctions are evident in a number of Soviet films in the late 1920s and early 1930s that represent the rural environment's infrastructural transformation. In *Earth* (Zemlia, 1930), for example, when the tractor runs out of water, the farm workers urinate into its tank in order to restart it. Here the successful working of technology is dependent on human intervention. Similarly, the front cover of a 1929 edition of *Soviet Screen* featured a still from the kul´turfil´m *The Colossal State Farm* (Sovkhoz gigant, 1929) that shows peasants repairing a tractor.[132] In the image, the wheel of the tractor dominates the composition, dwarfing the peasants who are pushed to the margins of the frame. As in *The Old and The New*, this emphasizes human determination in the face of technological failure.

While in the films mentioned above the introduction of new technology to the countryside leads to social cohesion and economic prosperity, in the Soiuzkino studio's *A Major Nuisance* (Krupnaia nepriatnost´, 1930) the arrival of mechanized transport in a provincial village becomes the cause of confusion and tension among rural inhabitants. In the film, a new bus route is established in a village, symbolically named Otshib (the fringes), that connects it to a train station, which in turn links it to the city. The villagers' reactions to the

arrival of new technology are complex. The rural inhabitants are split into two opposing ideological camps, one that embraces the new Soviet way of life and another that remains attached to their belief in traditional religious practice.[133] Both camps take advantage of the new bus route: the Soviet pioneers welcome a cultural worker to lecture at the local club, while the religious congregation invite a preacher to give a church sermon. *A Major Nuisance* thus explores the various ways in which a community might respond to technology, as a means to advance a new Soviet lifestyle or as a device that facilitates the entrenchment of ways of life that are directly opposed to Soviet goals.

During the 1920s and 1930s, the state undertook major development of the Soviet transport network in an attempt to overcome what was seen as the isolation of rural communities by integrating various provincial localities into a single, inter-connected Soviet space.[134] In its representation of automobile transport, *A Major Nuisance* departs from the majority of Soviet films of the 1920s, which pictured connections between the rural provinces and the city in terms of train travel.[135] Interest in automobile travel grew during the early 1930s, prompted by the Soviet government's approval in 1928 of the construction of a new Moscow automobile factory capable of producing thousands of vehicles a year.[136] In 1930, the journal *Automobilization of the USSR* (Avtomobilizatsiia SSSR) was launched, and the automobile society Avtodor's membership peaked at around 40,000.[137]

The scenario for *A Major Nuisance* was written by Aleksei Popov, who also worked as the director alongside M. Karostin and the camera operator Vladimir Solodovnikov. *A Major Nuisance* was the second film that Popov worked on after *Two Friends, a Model and a Girlfriend* (Dva druga, model' i podruga, 1927), which was similarly set in the rural provinces and depicted its young inhabitants as eager to engage with technological developments. Like Kuleshov before him, Popov was closely involved in the preparation of the scenery for *A Major Nuisance*. Before coming to cinema, Popov had worked as a theatre set designer, first at the MKhT and subsequently at various Moscow theatres.[138] In this role, he created scenery for a number of plays that were set in the rural provinces, such as the MKhT production in the late 1910s of Nikolai Gogol''s *Vii* (1835).[139] Surviving set design sketches show Popov's interest in how village infrastructure, including fences and roads, could create visual impact.[140] Similarly, in *A Major Nuisance* the village's material environment became a main source of the film's visual power. In the opening scene, the windows and wood fretwork of the various house fronts form a patchwork of contrasting geometric forms.

In several scenes, layers of fences of different sizes and configurations fill the frame and create striking patterns of intersecting and diverging lines. In the images of the village fire station, hoses snake across the wood banisters to create an intricate criss-crossing design. And in scenes of the local church, the metal grillwork of the windows casts dramatic geometric shadows against the interior's whitewashed walls.

Working alongside Popov on the scenery was the production artist Dmitrii Kolupaev, who designed the sets for several films set in the rural provinces in the 1920s.[141] Initially, Kolupaev worked as a landscape painter and was closely associated with The Wanderer artists.[142] From the mid-1920s, he became a major advocate of filming expeditions and ethnographic research, which he promoted in several articles. In his 1925 article 'On Set Design' (O dekoratsiiakh), Kolupaev denounced those 'village-life' (*derevenskie*) films which were made in studios for their monotonous depiction of *izbas*, barns and village details. He argued that filmmakers could achieve a more authentic representation of the provinces by engaging artistic and photographic commissions and undertaking filming expeditions.[143] Following this example, for *Peasant Women of Riazan´* (Baby riazanskie, 1927) Kolupaev created scenery in consultation with the anthropologist Ol´ga Vishnevskaia, who advised on ethnographic matters relating to the Riazan´ community.[144] In comparison to *Peasant Women of Riazan´*, however, which examines a specific provincial locale, *A Major Nuisance* presents an archetype of rural life. This corresponds with what Widdis identifies as a broader shift in focus in the early 1930s away from concerns about local identity to an interest in the typical.[145] Material for the fictional village Otshib was shot at a number of locations, including Kaluga province, the historic town of Uglich and south of Novocherkassk in Rostov province.[146] As Widdis notes, the film incorporates a number of typical motifs of provincial life: women wash clothes in a river, onion-domed church spires punctuate the horizon and houses are decorated with intricate wooden fretwork (Figure 2.4).[147] Moreover, while *Peasant Women of Riazan´* follows the tradition of The Wanderers and of early-Russian and Soviet films in revealing the social backwardness of rural society, *A Major Nuisance* represents the provinces in terms that are not entirely negative. In one sequence, the female protagonist Marusia and the bus driver embrace in a rowing boat against a backdrop of shimmering water. In another, as Marusia looks up from washing her clothes in the river as the bus hurtles into the village, light sparkles on the water behind her. These scenes mark a return to the myth of the provincial idyll that became increasingly apparent in Soviet fiction cinema of the 1930s and reached its height in such films such *Tractor Drivers* (Traktoristy, 1939).

Figure 2.4 The bus and village architecture. *A Major Nuisance* (Krupnaia nepriatnost'). 1930. All rights reserved.

The opening scenes of *A Major Nuisance* are marked by the inauguration of the new bus route. As in *The Old and The New*, the villagers are not simply passive assimilators of new machinery; rather than displacing traditional culture with new technology, they integrate it into established practices and traditions. A group of villagers celebrate the new bus route in a ceremony that incorporates religious pomp. Initially, the bus is raised on a podium high above the villagers, who stare up, transfixed, at its veiled body. Church bells ring out as they remove the veil. The group then drives the bus around the village in a procession that takes it through a decorated arch and past the onion-domed spires of the local church, drawing more villagers along the way, before they park it outside the local club. The building's elaborate fretwork contrasts starkly with the bus's sleek body and provides an ornate frame for the community's newest asset (Figure 2.4).

This process of mystification is followed by one of demystification. In one sequence, the bus driver removes the exterior body of the bus in order to explain to Marusia how the engine works. As she studies the engine, diesel stains her face. The demonstration of the bus engine serves to emphasize technology's status as a rational phenomenon that can be rendered comprehensible to the population. On two occasions, the bus breaks down and the villagers come to the rescue. After one of its tyres becomes trapped in a rift in the bridge, the villagers work together to free it. A series of close-up shots focus in on the wheel caught among splintered wood, showing it from dramatic diagonal angles. In a later

sequence, the villagers unite together to push the broken-down bus up a steep hill and back to the village. According to Widdis, such scenes convey the bus as a shared project around which a number of villagers can collectively unite.¹⁴⁸

However, the bus's potential to bring about social cohesion and collective unification remains limited. Several of the villagers embrace the arrival of the new bus route, but continue to live according to existing practices. In one sequence, a group of villagers, mainly of the old generation, bypass the traditional horse and carts and file into the bus, which brings them from the train station to their Sunday church service. The same social group subsequently takes advantage of the village's new transport connection to invite a religious preacher to the local church. Although throughout the film religion is subjected to ridicule, it continues to possess agency. This is demonstrated in the sequence in which a group of Komsomol members participates in whitewashing the church interior. As one member poses the question of who is against new technology, the camera focuses in on the painted murals of God and the disciples, who are depicted with their hands raised. As the Komsomol member turns to look outside, he is again confronted with a religious sculpture with its arm raised. Despite the introduction of new infrastructure and technology, old practices continue to survive and to have a voice among the rural community.

As Widdis argues, *A Major Nuisance* presents 'a subtly different type of provincial space' from that depicted in many Soviet films of the 1920s and early 1930s insofar as the provinces are inhabited by different generations with diverging values and lifestyles.¹⁴⁹ That said, the way in which the filmmakers represented the rural environment as deeply connected with mystic beliefs and feelings of enchantment has roots in early-Russian fiction films such as *The Tale of the Fisherman and the Little Fish*. While many late-Imperial films celebrated mysticism as an essential part of national identity and provincial life, in early-Soviet films such as *The Old and The New* religious spirituality was negatively coded, functioning as an obstacle to national transformation and prosperity. The emphasis in *The Old and The New* and in *A Major Nuisance* on the pressure to modernize and to transform old ways of everyday life was played out in many other early-Russian fiction films, notably in those that were set in domestic interiors. The next chapter will explore the various ways in which representations of the domestic interior in late-Imperial Russian and early-Soviet fiction films manifest collisions between old and new ways of life.

Chapter 3

THE DOMESTIC INTERIOR

While in the first years of Russian fiction cinema the majority of films were shot outdoors in rural locations, from around 1913 domestic interiors became increasingly popular as settings. Indeed, Richard Stites observes that from 1913 the domestic, bourgeois melodrama became the dominant genre in Russian cinema, accounting for almost half of the total films made in the pre-revolutionary era.[1] Despite a brief lull during the period of the industry's nationalization and reconstruction from 1919 to 1923, when very few fiction films were produced at all and those that were tended to be on historical revolutionary subjects, the popularity of films set in the domestic interior continued throughout the 1920s and into the 1930s.[2]

The interest in representing interior space was in part due to the prominent position that domestic life and housing conditions occupied in social discourses in late-Imperial and early-Soviet Russia. During this period, the domestic sphere became the focal point for exploring a range of pressing social issues, including women's role in society, the ethics of servant labour and Russia's rapid urbanization. This chapter will focus on how filmmakers used representations of domestic space to explore contemporary attitudes towards marital and sexual relations and old and new ways of life, as well as changing attitudes to luxury and comfort.

The use of interiors in films also, however, corresponded to the growing sophistication of Russian studios and innovations in set technology, as well as to filmmakers' evolving understanding of cinema as a medium. From the mid-1910s, interior settings became the focus of a number of debates within the filmmaking community about the merits and the inadequacies of artificial studio sets, as opposed to real, outdoor locations, and the role of interior architecture, ornament and textile in structuring cinematic space. This chapter therefore also considers how filmmakers harnessed elements of interior design to exploit cinema's expressive potential.

The house as entrapment: The domestic interiors of Boris Mikhin and Evgenii Bauer

In the first decades of the twentieth century, Russia was a strict patriarchal society constructed around rigid social hierarchies and conventions.[3] These codes governed the domestic sphere as much as public life. As Louise McReynolds writes, the domestic environment 're-created a microcosm of the patriarchal status quo'.[4] Correspondingly, many late-Imperial and early-Soviet films set in the domestic environment represent the house as a space of entrapment which oppresses its inhabitants. In late-Imperial cinema, this idea is notably expressed in the interiors created by Boris Mikhin and Evgenii Bauer, both of whom worked extensively on films set in the domestic household. In their set designs, the interior's boundaries and thresholds come to hold particular significance, and they exploited them in order to explore notions of confinement, control and transgression from social and gender perspectives.

Mikhin used sets to explore these ideas in one of the first films that he worked on as a production artist: the Khanzhonkov studio's *The Little House in Kolomna* (Domik v Kolomne), which was directed by Petr Chardynin and photographed by Władysław Starewicz.[5] Released on 19 October 1913, the film is among the earliest Russian fiction films set predominantly in a domestic interior. *The Little House in Kolomna* is an adaptation of Aleksandr Pushkin's narrative poem of the same title, which was published in 1833. Pushkin's text was notable in its time for eschewing representations of aristocratic society to show instead the ordinary life of urban dwellers.[6] Contemporary cinema critics praised the film's faithfulness to Pushkin's original text, noting that there were very few anachronisms in its set design.[7] More recently, however, Denise Youngblood has judged its aesthetics as 'humdrum'.[8] Although the film's lighting and cinematography are relatively unremarkable, Mikhin's mise-en-scène is, however, sophisticated in terms of the way in which it is used to convey meaning about social hierarchies and conventions. Mikhin's careful attention to the spatial arrangement of objects and actors betrays his previous experience working as a set designer and sculptor at the Moscow Art Theatre (Moskovskii khudozhestvennyi teatr, MKhT), which was known for the way in which its designers used sets to heighten dramatic tension.[9] Mikhin's sets for *The Little House in Kolomna* exemplify the move towards more complex staging, which

appears in Russian fiction films from 1913 onwards.[10] According to Philip Cavendish, such complex compositions demonstrate a growing awareness among filmmakers of 'the symbolic and metaphorical dynamic of film space'.[11]

The Little House in Kolomna is set in the household of a widow and her daughter, Parasha, in the petit-bourgeois Kolomna district of Saint Petersburg in the nineteenth century. Parasha is an adept housekeeper, but also secretly indulges in flirting with the officers who pass by her window. One day, the widow sends her daughter to find a new, and cheap, domestic servant. Capitalizing on the opportunity, Parasha persuades an officer, of whom she is particularly fond, to pose as the housemaid Mavrusha so that they can pursue their romance. The issue of domestic servants was pertinent at the time. In 1912/13, *Housewives' Magazine* (Zhurnal' dlia khoziaek) included a number of articles that directly addressed the problem.[12] Many of these texts focused on the tensions between housewives and domestic servants, which resulted from the poor working conditions and limited rights experienced by servants. As Barbara Engel and Rebecca Spagnolo note, domestic service was one of the most common occupations for women in urban centres in early-twentieth-century Russia.[13] It was also among the most degrading: domestic servants endured long hours, limited freedom, demeaning treatment from employers and, frequently, sexual harassment.[14] *The Little House in Kolomna*'s portrayal of a male character in such a demeaning role would therefore have been particularly ironic for contemporary audiences. The issue of servants' rights was addressed in many other films of the 1910s that were set mainly in domestic interiors, including *The Peasants' Lot* (Krest'ianskaia dolia, 1912), *Silent Witnesses* (Nemye svideteli, 1914) and *The Maidservant Jenny* (Gornichnaia Dzhenni, 1918), as well as in films of the 1920s such as *The Prostitute* (Prostitutka, 1926) and *The House on Trubnaia* (Dom na Trubnoi, 1928).

The main action of the film takes place in four interior settings: the living room, the bedroom and the kitchen of the widow's house, and the officers' quarters. Decorated with pot plants, an ornamental birdcage, floral-patterned wallpaper, a lace tablecloth and curtains and dark wood furniture in the empire style, the design of the living room – in which the film's opening scenes are set – clearly establishes the social class of the widow and her daughter as petit-bourgeois (Figure 3.1). As Catriona Kelly observes, pot plants, patterned wallpaper and birds in cages were among the components that domestic advice literature of the late-Imperial era outlined as requirements of the well-regulated

3. *The Domestic Interior* 83

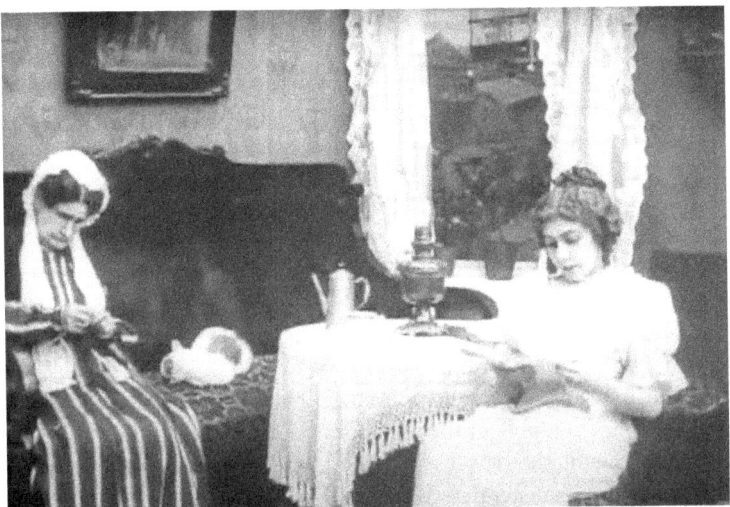

Figure 3.1 The widow's living room. *The Little House in Kolomna* (Domik v Kolomne), directed by Piotr Chardynin © Akcionernoe Obscestvo A.H.i.K./Khanzhonkov 1913. All rights reserved.

household.[15] Production artists would continue to use such furnishings as common signifiers of the petit-bourgeois lifestyle and its values up to the end of the 1920s.[16] In *The Little House in Kolomna*, the living room's furnishings also serve to convey a sense of claustrophobia and to emphasize Parasha's confinement within the domestic sphere. There is very little empty space in the frame; rather, it is filled with different surfaces and patterning. A high-backed sofa dominates the frame and distances the widow and Parasha, who sit in the foreground, from the room's single window, positioned in the background. The sturdy form of the sofa, on which the widow sits firmly ensconced, visually represents the immutability of petit-bourgeois values and conventions. Parasha is placed opposite the widow, shown sitting across the table and underneath a birdcage, which alludes to her confined status within the domestic environment.

Architectural features also repeatedly work to emphasize ideas of confinement and control. Doorways, for example, are strategically placed at the frame's boundaries throughout the film.[17] As Iurii Tsiv′ian notes, in early-Russian cinema filmmakers widely used the tactic of positioning doorways at the edge of the frame in order to provide a sense of narrative continuity between scenes.[18] In *The Little House in Kolomna*, however, the positioning also emphasizes the doorway's

function as a threshold to the house, and the ways in which different characters seek to obstruct or to transgress it. A striking example of this comes in the film's opening sequence. Initially, the living room is shown without a doorway, casting it as a closed, hermetic space. Instead, the widow's upright back is aligned with the edge of the frame, indicating her control over the household. In order to leave the room when the widow has dozed off, Parasha is forced to traverse the entire width of the frame. As she does so, a horizontal pan allows the camera to follow her while bringing a doorway into view. The doorway's positioning at the very edge of the frame, directly behind the back of the widow, serves to emphasize the widow's status as a gatekeeper to the domestic environment, and Parasha's entrapment within her household.[19] As Cavendish writes, horizontal panning shots were often used in early-Russian films to highlight the boundaries of the frame and its tensions, through drawing the viewer's attention to the space that lies beyond the frame.[20] In the sequence described above, the doorway's position and the slow pan work together to emphasize the living room's enclosed status through hinting at a room that lies beyond, but that is concealed from the viewer. Only darkened space is visible behind the doorway, giving the appearance that the room is disconnected from the wider world.

While the widow is aligned with the architectural feature of the doorway, Parasha is associated with the open window. After she leaves the living room, Parasha is shown in the bedroom sitting alone, sewing, next to an open window, out of which she glances intermittently in the hope of catching sight of a passing officer. As Julia Bekman Chadaga observes, in traditional Russian culture, the window in particular was perceived as the border with the hostile, external world.[21] Julian Graffy also notes that in nineteenth-century Russian literature the aspirant Romantic heroine is typically portrayed gazing out of the window, examples being Lizaveta in Pushkin's 'The Queen of Spades' (Pikovaia dama, 1834) and Tat´iana in his *Eugene Onegin* (Evgenii Onegin, 1833), who spends entire days in this pose.[22] This trope was common in films made in 1913 and 1914, such as Bauer's *Twilight of a Woman's Soul* (Sumerki zhenskoi dushi, 1913), in which the viewer sees Vera glimpsing at the outer world from her bedroom window, and his *Child of the Big City* (Ditia bol´shogo goroda, 1914), in which Mania observes the Moscow streets from the window of her sewing workshop and contemplates a better life.[23] It also continued to be used in the 1920s, most notably in *Bed and Sofa* (Tret´ia Meshchansksaia, 1927), in which Liuda repeatedly gazes out of the window from the confinement of her single-room semi-basement apartment.[24]

3. The Domestic Interior

In *The Little House in Kolomna*, the sequences of Parasha looking out of the window are shot in medium close-up, with the window filling the majority of the frame. After soliciting the attention of an officer, Parasha hauls herself up onto the ledge and leans out of the window, transgressing the boundary between the domestic household and the exterior world.[25] It is notable that in the scenes shot in the bedroom, the spatial relations of the widow and the daughter are reversed from those in the living room. While in the living room the widow sits next to the interior's threshold and Parasha is situated on the opposite side of the frame, in the bedroom it is Parasha who is seated next to the threshold of the window and the widow who is positioned on the opposite side of the frame, with her back to the window.

In addition to their positioning, the way in which characters move through space and within the set is revealing. For example, when the widow and Parasha go to Mass and leave Mavrusha alone in the house, his deportment and the way in which he inhabits space alters dramatically: he lifts his skirt to perform exercises, stretching his body across the entire frame; he is shown to be at ease and in full possession of the space, prefiguring the way in which in many 1920s films, such as *Bed and Sofa* and *The Girl with a Hatbox* (Devushka s korobkoi, 1927), male protagonists demonstrate their dominance over domestic living space through vigorous exercise. Mavrusha's energetic manner of inhabiting space contrasts starkly with that of Parasha. Throughout the film, Parasha is shown mainly standing stationary or sitting down engaged in reading or sewing. As Rachel Morley notes, sewing was a pervasive trope in nineteenth-century Russian literature and culture and was frequently used to express the moral and spiritual redemption of 'the fallen woman'; when, in early-Russian cinema, a female protagonist is shown to cast aside her sewing, it is, therefore, revealing.[26] Thus Parasha is quick to put aside her sewing in order to catch the attention of a passing officer. As she flirts with Mavrusha in her bedroom, a piece of cloth covers her sewing frame and clothes are strewn carelessly over a chair and across the dressing table. The cultural historian Rozsika Parker identifies that, historically, sewing signifies women's self-containment and submission and engenders in the viewer 'an awareness of the extraordinary constraints of femininity, providing at times a means of negotiating them, and at other times provoking the desire to escape constraints'.[27] In addition to interpreting Parasha's disinterest in sewing as a marker of her unchaste nature, we can also read it as a sign of her desire to escape the constraints of domestic life, and the conventions this imposed on women during the period.

Mikhin continued to exploit in his set designs the boundaries and thresholds created by interior architectural features in order to convey ideas about confinement and control, most notably in *The Kreutzer Sonata* (Kreitserova sonata, 1914). Although produced just one year later than *The Little House in Kolomna*, the film is markedly more experimental in its set design and more complex in its spatial arrangements. Mikhin worked on the film alongside the director Vladimir Gardin and the camera operator Aleksandr Levitskii. It was made as part of the Thiemann and Reinhardt studio's *Russian Golden Series* (Russkaia zolotaia seriia), which aimed to increase the cultural status of cinema through adapting classic Russian literary works for the screen. The elaborate set designs that characterize many of the series' productions undoubtedly also contributed to this goal. The film was based on Lev Tolstoi's 1889 novella of the same title, which explores the gradual disintegration of marital and amorous relations between a wife and husband and was intended as a denunciation of the institution of marriage and an argument for the ideal of sexual abstinence. As Susan K. Morrissey and Barbara Engel have both observed, narratives of marital dispute were a recurring trope in social discourse in late-Imperial Russia, reflecting the increasingly widespread calls to reform marriage laws to recognize the complex needs of individuals.[28]

The disintegration of love and the protagonists' growing sense of entrapment in married life are represented spatially in Mikhin's sets through a shift from more open, exterior settings to enclosed, claustrophobic interiors. The initial scenes, in which the couple meet and fall in love, are set outdoors on a veranda and in parklands. The veranda's white walls, open glass doors, urns of flowers and water fountains evoke a sense of fecundity and lightness. A darkened interior, visible through the open doorway further emphasizes the luminosity of the veranda and also foreshadows the film's exploration of the constraining nature of married life. Once the lovers are married, scenes take place predominately in enclosed, domestic interiors. As the husband and wife become more oppressed by married life, the interiors appear increasingly darkened, confined and cut off from the exterior world. The first interior in which we encounter the couple after they have married is brightly illuminated and decorated with lustrous silks. Shot looking in through an outside window, the room maintains a close connection with the exterior world. In subsequent interiors, however, dark wood furniture dominates the space, heavy velvet drapery lines the walls, compartmentalizing the room, and closed doorways restrict the viewer's gaze.

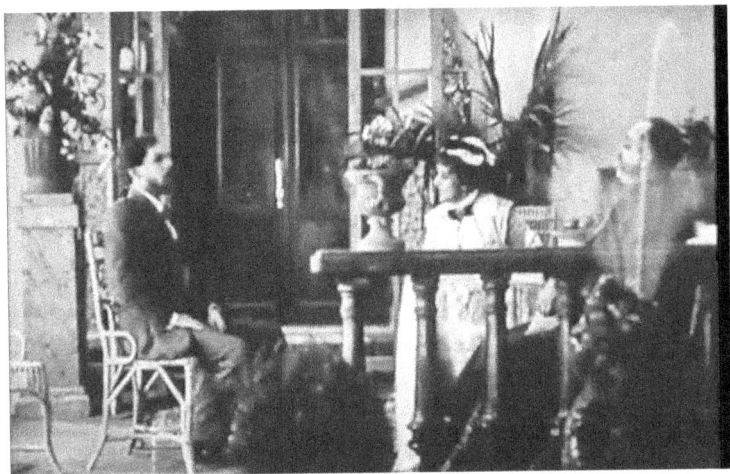

Figure 3.2 Veranda. *The Kreutzer Sonata* (Kreitserova sonata), directed by Vladimir Gardin © Thiemann & Reinhardt 1914. All rights reserved.

As in *The Little House in Kolomna*, Mikhin strategically positions doorways and other thresholds, such as partition walls and drapery, for formal and thematic effect. In comparison to in this film, however, in *The Kreutzer Sonata* he uses these elements extensively to create complex spatial compositions consisting of a series of interconnecting rooms. As we recall from Chapter 1, the MKhT, where Mikhin had worked as a set designer between 1910 and 1912, had pioneered the construction of interior sets with multiple interconnecting rooms in its productions of Anton Chekhov's plays, such as *The Cherry Orchard* (Vishnevyi sad, 1903).[29] The introduction of this technique to cinema was facilitated by the innovation of the *fundus* system, which Mikhin claims he used successfully for the first time in *The Kreutzer Sonata*.[30] In several of the interior scenes, Mikhin employs doorways, drapery and partition walls to divide the frame into multiple vertical and horizontal planes, which enhance the impression of deep illusionistic space. Such complex spatial compositions also encourage a variety of movements from actors across the frame's width and through spatial depth. As Tsiv´ian notes, this compositional tactic was used in many early-Russian films.[31] In his memoirs, Lev Kuleshov recalls how, when he first came to work as a production artist at the Khanzhonkov studio, he was instructed to create sets with a combination of landings, passages and stairwells in order to diversify actors' movements and to increase the visual dynamic of the frame.[32]

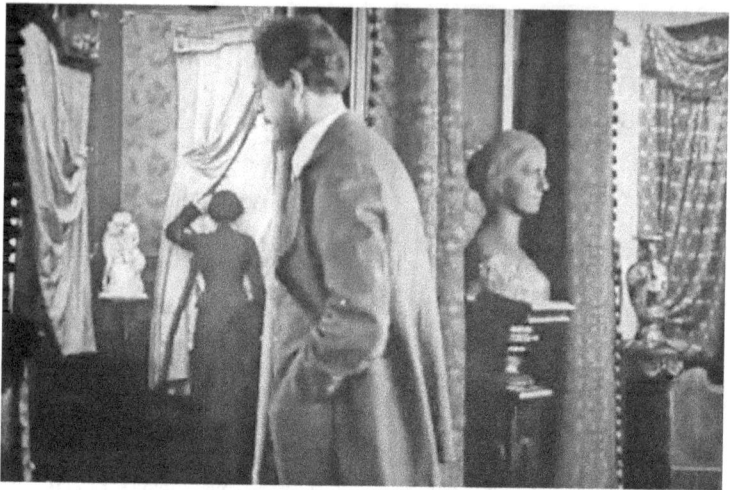

Figure 3.3 Interior, *The Kreutzer Sonata*.

On a thematic level, the compartmentalization of the frame heightens the sense of claustrophobia and conveys the couple's increasing separation from one another. An example of this is evident in the first sequence in which the couple are shown arguing (Figure 3.3). A doorway and drapery divide the frame vertically into two adjoining rooms. First, the husband goes in search of his wife in the room on the right of the frame, only to find it empty. He then finds her in the adjacent room, in which she is isolated in the background gazing out of a window with her back to the viewer. He stands on the room's threshold, unwilling to enter. As the couple begin to quarrel, the wife advances to the front of the frame and then pauses at the threshold. A curtain separates the wife from her husband, acting as a barrier, as they continue their argument. The wife then passes into the room on the right and closes the door behind her, creating a physical barrier between them.

Moreover, Mikhin uses elements of interior architecture and design as self-reflexive framing devices that draw the viewer's attention to their position as a spectator and to the artificial nature of cinematic representation. As Rachel Morley observes, Bauer had already begun to employ this tactic at the end of 1913 in *Twilight of a Woman's Soul*.[33] Morley argues that in a number of his films Bauer uses elements of set design, such as curtains and the trope of the stage, to reveal the constructed nature both of the shot and of the female protagonist and to emphasize that such scenes are structured through the gaze of the male

protagonist.³⁴ This strategy is also evident in Mikhin's set designs for *The Kreutzer Sonata*. Significantly, Tolstoi's original text uses the literary technique of a frame narrative in which the husband Pozdnyshev recounts his story to another narrator. In the filmic adaptation, many elements of Mikhin's set work to convey the notion that the viewer is being presented with Pozdnyshev's perspective of events. As described above, one sequence is shot looking into an interior through a window. The frame of the window repeats that of the film screen, while the curtains recall the stage curtains of the theatre. The use of lighting is also reminiscent of the theatre, in which the stage performers are illuminated by footlights while the audience remains in darkness. As another example, in the sequences set on the veranda in which Pozdnyshev courts his future wife, Mikhin places a balustrade in the extreme foreground of the frame (Figure 3.2). As discussed in Chapter 1, the tactic of placing architectural features or objects at the foot of the proscenium stage to rupture the illusion of the imaginary 'fourth wall' was introduced and widely used in productions at the MKhT. It is also notable that in these sequences the veranda is raised slightly, as if a stage. In Tolstoi's text, Pozdnyshev attacks courtship and marriage as a mere social performance. Thus, Mikhin's use of self-reflexive compositional devices both highlights the viewer's position as an audience member watching events from Pozdnyshev's viewpoint and conveys Pozdnyshev's opinion that marriage is an artificial, social convention.

Mikhin's extensive use of mirrors also serves to comment on the artificial nature of marriage. In one scene, the wife is shown contemplating her appearance in a mirror, alluding to the argument in Tolstoi's text that in nineteenth-century Russian society women endeavour to present themselves as objects of desire for men.³⁵ Mirrors also have formal significance. Tsiv´ian notes that production artists began to incorporate mirrors into cinema set design around 1911, reflecting a growing recognition of the specificities of cinematic space in comparison to that of the theatre.³⁶ According to Tsiv´ian, mirrors were initially employed to activate the backspace and to reveal new information to the viewer, thus aiding narrative economy by eliminating the need for additional scenes.³⁷ Mikhin was already using mirrors for this purpose in 1913 in his earliest surviving film, *The Sorrows of Sarra*. Tsiv´ian argues that from 1912/1913, however, filmmakers began to use mirrors as a way to increase the symbolic resonance of particular objects.³⁸ This shift is evident in *The Kreutzer Sonata*. As one notable example, in the sequence in which the wife stands before a mirror contemplating her image, a white statuette of a couple embracing

passionately is visible behind the wife's reflection in the mirror. On one level, the statuette is used for ironic effect to provide a contrast between the ideal of love and the oppressive reality of the married life which the couple experience.

The iconography of this statuette also has particular diegetic significance, however. Sculptural figures began to be used in cinema set design around 1912 and are most commonly associated with the sets of Bauer. Mikhin's training as a student of sculpture at the Saint Petersburg Academy of Art, where he gained a scholarship to study Auguste Rodin's works in Paris, and his experience working as a sculptor at the MKhT meant that he would undoubtedly have been aware of the significance of particular sculptural compositions.[39] It can be no coincidence that the aforementioned statuette of a couple embracing closely resembles Rodin's *The Kiss* (Le Baiser, 1888–98). Rodin's sculptural composition was inspired by an episode in Dante Alighieri's *The Divine Comedy* (Divina Commedia, 1308–20) in which Paolo and Francesca embrace in a moment of reckless passion before Francesca's husband kills them. Thus, the iconography of the statuette acts as a prelude for subsequent events in *The Kreutzer Sonata*. The statuette is positioned close to the wife in several scenes in the film, acting as a constant reminder of her fate. Its earliest appearance is in the scene of the couple's first argument, when it stands near the window out of which the wife gazes. Later, in the scene in which the violinist, who has an affair with Pozdnyshev's wife, first comes to the house, the statuette appears behind the wife.

Mikhin repeats this strategic placement of statuettes and sculptural busts to comment on characters and their relationship with one another throughout the film. For example, a classical female portrait bust is positioned by the doorway to Pozdnyshev's study. The idealized form of the bust alludes both to Pozdnyshev's tendency to objectify women and to his fantasies of the perfect wife as passive and pure. This recalls Morley's observation about the way that in Bauer's *Child of the Big City* the classical statuettes in Viktor's study reveal his attitude towards women.[40] In several scenes, the bust is placed in direct opposition to Pozdnyshev's real wife on the other side of a curtain. As in *Child of the Big City* the comparison alludes to Pozdnyshev's wife's inability to live up to her husband's naïve expectations. In the sequence in which the couple argue in the husband's study, Pozdnyshev stands framed between two classical busts of an erudite nobleman, which allude to both his social status and his image of himself as a rational man until he enters into wedlock. In a fit of rage, Pozdnyshev hurls one of the

statuettes at his wife and the classical female portrait bust next to which she stands. This action conveys the corrupting effect that Pozdnyshev perceives marriage to have both on himself as a person and on society in general.

As will be clear from the discussion so far, the use of the domestic interior as a setting to explore ideas about marital and sexual relations is closely associated with the films of Evgenii Bauer, on which he acted as both the production artist and the director.[41] In a number of Bauer's melodramas, beginning with *Twilight of a Woman's Soul* and continuing in *Child of the Big City, Silent Witnesses, Daydreams* (Grezy, 1915), *A Life for a Life* (Zhizn´ za zhizn´, 1916) and *Nelli Raintseva* (1916), the domestic interior appears as a space in which female protagonists are entrapped and oppressed either by social conventions or by male predators. This reflects the increased opposition in early-twentieth-century Russia to the absolute authority that the male patriarch wielded over the household and the growing recognition of women as autonomous individuals with independent lives that extended beyond the domestic sphere.[42] Indeed, in her essay 'The New Woman' (Novaia zhenshchina, 1913), the female activist Aleksandra Kollontai identified the transformation of woman from a submissive housewife into an independent person who strives for her own career, lifestyle and interests, and emphasized the importance of cultural tropes in reflecting the social change in women's roles.[43] Following Kollontai's writings, from 1913 *Housewives' Magazine* incorporated a regular feature on 'Women's Life' (Zhenskaia zhizn´) that addressed concerns about female independence. Several critics who contributed articles to the feature questioned whether these 'new women' were indulging in their independence at the expense of their domestic and maternal duties.[44]

Correspondingly, in Bauer's *Children of the Age* (Deti veka, 1915) the idea of the house as a space of entrapment is addressed, and problematized, in both the film's narrative and its aesthetics. *Children of the Age* tells the story of how the prospect of wealth and increased social status gradually lures Mariia Nikolaevna away from her life as a mother and a housewife, married to a modest bank clerk. While out shopping in Moscow's arcades, Mariia encounters an old friend, Lidiia Verkhovskaia, who indulges in a glamorous lifestyle and moves in fashionable high society. Lidiia introduces Mariia into her social circle, and at several of her gatherings the rich businessman Lebedev pursues Mariia. Although at first Mariia resists, after Lebedev rapes her twice and engineers her husband's firing, she eventually leaves her husband, taking their child and beginning a new life as Lebedev's mistress.

Bauer had already worked on a number of films as the director and the production artist and had established himself as one of the leading filmmakers of the era when he made *Children of the Age* for the Khanzhonkov studio. He initially began his career in cinema in 1912 working as a production artist on Aleksandr Drankov and A. G. Taldykin's commemorative historical film, *The Tercentenary of the Rule of the House of Romanov, 1613–1913* (Trekhsotletie tsarstvovaniia doma Romanovykh, 1613–1913). Prior to entering the world of cinema, Bauer worked as an actor, a caricaturist, a satirical journalist, a portrait photographer and a theatre set designer.[45] As Morley notes, Bauer was known in the theatre for his innovative and elaborate sets, and he quickly developed a distinctive approach to set design and the treatment of the mise-en-scène in his films.[46] Indeed, both Alyssa DeBlasio and Emma Widdis claim that Bauer's innovative sets distinguish his work from that of other filmmakers of the late-Imperial era.[47]

As Morley argues, in addition to their remarkable aesthetics, Bauer's films are also characterized by their refusal to moralize in simple positive and negative terms.[48] Bauer's rejection of straightforward binaries is evident in *Children of the Age* in the way that the domestic environment is represented in relation to other spheres of social life. Mariia and her husband's house is modest, especially when compared to the film's other interiors or to the domestic interiors in many of Bauer's other films, such as Mary's room in *Child of the Big City* with its abundance of 'things'. Mariia's living room is sparsely decorated with only necessary furniture and a few ornaments to give a sense of comfort. The simple lines and unadorned forms of the modern-style furniture and ceiling lamp allude to the honest values of traditional family life upheld by petit-bourgeois society. In the majority of the scenes shot in the living room Mariia is positioned at the centre of the composition and is shown in control of the space. An adept housewife, she busily engages in domestic chores and is quick to attend to her crying child. That said, it is notable that her worktable is marginalized, with only a small corner of it visible in the lower-left edge of the frame. In contrast, a closed door is shown in full view in a central position directly behind Mariia. Unlike in *The Little House in Kolomna*, however, Mariia's access to the doorway remains unobstructed, and she freely comes and goes, despite her husband's growing objections to her outings. These details reveal Mariia's ambiguous relationship to her domestic life and suggest that although she has little interest in her role as a housewife and finds it confining, the domestic sphere by no means entraps her. This corresponds with what McReynolds describes as the ambivalent

attitude towards changes in women's roles in society during the period, in which women felt trapped by customs but also insecure about their liberation from them.[49]

In comparison to the living space of Mariia and her husband, the interiors of Lebedev's house (which are the only other internal domestic spaces in the film) are characterized by luxury and excess. Lebedev's study, for example, is filled with an abundance of furniture and objects, and its walls are decorated with ostentatious wallpaper. Likewise, Lebedev's drawing room is crowded with people and things. In contrast to her authoritative position in her own home, Mariia sits at the corner of the table, marginalized from the rest of the party. As Morley argues, Mariia's positioning alludes to her uneasiness about the decision to leave her family and her discomfort within the new society in which she now finds herself.[50] The comparison between Mariia's position in her own living room and that in Lebedev's drawing room is encouraged by the fact that the same tablecloth is used in both spaces.

Moreover, the idea that the domestic environment is a sphere that oppresses and entraps Mariia is problematized when it is compared to the exterior settings in the film. It is notable that Lebedev's amorous advances and his eventual rape of Mariia take place mainly outdoors. Each of Lebedev's increasingly forceful attempts to seduce Mariia occurs in an evermore open and exposed exterior. The first time that Lebedev displays an interest in Mariia is when the couple are seated in a glass conservatory, after they are introduced by Lidiia at one of her glamorous parties. Although technically an interior space, the conservatory appears distinctly open with its expansive glass walls that fill nearly two-thirds of the frame and through which a background of dense foliage is visible. The next advance happens when Mariia and Lebedev are strolling in an urban park; the first time Lebedev rapes Mariia occurs during an afternoon gathering in woodlands; and the subsequent rape takes place while the couple are driving in the city streets.[51] As such, it is the wider, exterior world that appears as a space in which women face sexual oppression and moral corruption. It is notable that, following Lebedev's harassments, Mariia on two occasions flees directly to the sanctity of her home. Although the domestic environment may confine women, it also functions as a safe haven from the corrupting influence of modern, urban life. Thus, as Youngblood notes is the case in many of Bauer's films, the home is cast as an ambiguous space where both negative and positive possibilities exist.[52]

The idea that places can have both positive and negative associations is also evident in the way in which Bauer represents the shopping arcade

in *Children of the Age*. The rise of the shopping arcade in the late-Imperial era as a new public sphere for women was seen as both a liberation and a liability: while it gave women new responsibility as consumers for the household, it also exposed them to the corrupting influence of materialism, dragging them away from their domestic chores.[53] Both possibilities are presented in *Children of the Age*. Mariia is shown to be a conscious consumer, carefully inspecting items before selecting a doll as a gift for her child. On returning home, Mariia places her purchases next to the sewing machine, associating her act of consumption with her responsibilities as a housewife. By comparison, Lidiia is enticed by a shop-window display of elegant furniture and silverware, recalling the scene in Bauer's *Child of the Big City* in which Mania gazes longingly at a jewellery shop's window display. On meeting Mariia, Lidiia readily bestows on her reacquainted friend one of her recent purchases, with little consideration for what the gift is.

Bauer reveals the moral qualities of Mariia and Lidiia not only through their relationship to commodities and the pursuit of consumption but also through their relationship to the traditional female sphere of textiles and the activity of sewing. As Morley observes, in *Children of the Age* a sewing machine acts as a *dikovinka* for Mariia.[54] Translated as 'a wonder' or 'a marvel', *dikovinka* was the term that Lev Kuleshov used to describe the object that Bauer chose to characterize the set of a particular scene.[55] As Morley writes, in Bauer's films 'the *dikovinka* assumes symbolic significance, highlighting aspects of character or theme'.[56] Observing that, in *Children of the Age*, Mariia gradually loses interest in sewing as she is co-opted into Lidiia's social circle, Morley provides a close reading of the symbolic treatment of the sewing machine *dikovinka* as a marker of Mariia's gradual corruption by Lidiia and Lebedev.[57] It is not only the sewing machine that signifies Mariia's descent into infidelity, however. Bauer's treatment of fabric is also significant in this respect. The luminous whiteness of the cloth that Mariia's husband sorrowfully contemplates alludes to his yearning for Mariia to remain a pure and perfect housewife. Similarly, it is no accident that, as the maid packs Mariia's belongings for her move to live with Lebedev, she folds Mariia's white shawl but does not place it in her case.

Indeed, fabric plays an important role in the film in other ways. It is striking that both Lidiia and Lebedev occupy spaces that are enveloped in textiles. A close-up shot of Lidiia while she is hatching a scheme to procure Mariia as Lebedev's mistress shows her within a cocoon of fabric. Lebedev's bedroom is draped in layers of silks, satins and diaphanous tulles. The frills and soft folds of the drapery emphasize the

sensual nature of the space. And, in the final scene of the film, a close-up shot reveals the dead body of Mariia's husband lying across a bed with lace coverings. Within the established genre of deathbed painting, figures are typically depicted lying surrounded by plain white cloth to emphasize their purity and ethereality. The intricacy of the lacework in *Children of the Age*, however, is striking and serves to emphasize the female characters' connection with Mariia's husband's suicide. Bauer thus presents a contrast between the productive act of sewing and its positive associations with the maintenance of the domestic household and the decorative and sensual qualities of fabric, which evoke ideas of lust, indulgence and deceit. This contrast corresponds to what Widdis describes in relation to 1920s Soviet films as the distinction between the resourceful homemaker, who participates in acts of handcraft (*rukodelie*) such as sewing, and 'the indolent consumer of bourgeois luxury'.[58]

Although contemporary critics generally praised the film, noting in particular the striking performance of Vera Kholodnaia as Mariia, an anonymous reviewer in *Theatre Newspaper* (Teatral´naia gazeta) criticized the opulent sets in some of the scenes, especially those of the boating party.[59] From the mid-1910s, criticism of Bauer's tendency towards highly ornamental sets was common in the contemporary cinema press. Indeed, in a 1914 review of *Child of the Big City*, an anonymous critic wrote that 'one very much feels that a director-decorator and not a director-actor put together the picture'.[60] The typical attack against Bauer's elaborate sets was that they overwhelmed the actors and thus the film's psychological intensity, which was seen to be distinctive to Russian cinema. For example, in a review of *A Life for A Life*, a film which was known for its particularly lavish interiors, an anonymous critic wrote that 'in the picture, the desire to achieve greater technical sophistication and exterior beauty [...] weakens those elements typical for Russian cinema: inner beauty, the beauty of psychological truth and spiritual experience'.[61]

The house as ornament: Excess and visual expressivity

Produced by the Khanzhonkov studio just a few months after *Children of the Age* at the end of 1915 and released in 1916, Bauer's *Iurii Nagornyi* in many ways exemplifies the ornate scenery for which contemporary critics denounced his films. Like *Children of the Age*, the film depicts in Morley's words a new woman with 'a career, a mind and a life of her

own'.⁶² The scenario, written by Andrei Gromov, who also acted in the film, tells the story of a dancer (played by Bauer's wife, Emma Bauer), whom the eponymous protagonist Iurii Nagornyi attempts to seduce, despite the fact that she is already married.⁶³ Initially, the dancer seems to encourage Iurii's advances. As the film progresses, however, it is revealed to the viewer that this is part of a plan to take revenge on Iurii, who had previously seduced and then abandoned the dancer's younger sister, leading her to commit suicide. After inebriating Iurii, the dancer sets fire to his apartment. Iurii survives, but is left with severe facial scars.

A significant proportion of the film's action takes place in the sumptuous households belonging to the dancer and to Iurii. Decorated with a wealth of art nouveau and rococo furnishings and ornaments, these domestic interiors convey both the characters' social position as part of an elite class and their fashionable lifestyles. As Lucy Fischer notes, in North American and European cinema of the 1910s and 1920s, the discourse of abundance and prosperity is specifically coded through art nouveau aesthetics.⁶⁴

Besides its associations with grandeur and debauchery, the décor of the protagonists' interiors also has formal significance. In his discussion of the film, Cavendish argues that the film is primarily a technical experiment, in which Bauer explores the 'significance for the diegesis of background detail and interior landscape'.⁶⁵ Cavendish notes the radical way in which Bauer uses lighting techniques in conjunction with scenery to create formal effects, in particular staging in depth.⁶⁶ In the scenes in the dancer's bedroom, for example, an illuminated doorway at the background of the frameworks to create an impression of deep perspectival depth. Directed lighting also highlights the stucco relief ornament on the doors and the rococo arabesques of the table lamp, creating pronounced shadows which endow these features with a sculptural quality. In the scenes in Iurii's bedroom, the layers of fabrics of different opacities, from diaphanous tulles to heavy velvets, create a sense of receding space. This impression of perspectival depth is emphasized in one notable sequence, in which the dancer follows a drunken Iurii into his bedroom before setting the room alight: initially, the dancer stands against the opaque panels of a closed door, positioned in the extreme foreground of the frame; she then opens the door partially to reveal a view of the bedroom. The opaque panels of the closed door render part of the frame a flattened tableau, while emphasizing, through contrast, the recession of space visible beyond the open doorway. The technique of placing doorways in the extreme foreground to create

perspectival depth has been popular in pictorial representations of interiors since the renaissance.[67] As Oksana Chefranova observes, it continued to be used by early-twentieth-century Russian painters, such as Konstantin Somov in his interior painting *Winter* (Zima, 1904).[68] Bauer employed doorways as formal framing devices in a number of his films. In several scenes in *Child of the Big City*, for example, the characters' arrival at a nightclub is framed through a backlit glass door. As Chefranova argues, in scenes such as these the doorway seems to have little narrative significance, but is used primarily for visual impact.[69] Thus, in contrast to Mikhin's sets for *The Little House in Kolomna* and *The Kreutzer Sonata*, Bauer uses doorways primarily as formal devices for the creation of spatial depth and evocative visual effects, rather than to convey narrative or symbolic meaning.

The placement and movement of the actors within the frame also serve primarily to draw the viewers' attention to the scenery rather than to convey narrative meaning. As Cavendish observes, in the sequence in which the dancer enters her room from the door in the background and moves to sit at her desk in the foreground, she switches on a lamp as she progresses towards the viewer, gradually revealing the spatial layout of the room, with its careful distribution of vertical lines, as well as its rich decoration.[70] Throughout the film, the slow movements of the actors encourage the eye to roam and consider the various ornaments that decorate the interior. In a sequence in which the dancer visits her husband in his study, she weaves slowly through a complex composition of furniture, inclined at diagonal angles. As she moves into full view, the chequered detail on her dress is revealed to be the same as that on the arms of the chairs and the fretwork of the bookcase. Bauer's interiors thus become what Sarah Street describes in relation to Lazare Meerson's sets of the 1930s as 'performative arenas'.[71] For Street, sets function as 'performative arenas' in sequences in which the body of actors become an essential feature of the mise-en-scène, creating 'the illusion of expanded space' and 'drawing attention to the significance of particular elements of décor, architecture and furniture'.[72] She argues that in such sequences it is 'as if the entire construction of a sequence has been designed to display the set' in a way that 'exceeds the immediate demands of the narrative'.[73]

While many of the interiors in *Iurii Nagornyi*, such as the bedrooms of Iurii and the dancer, are decorated with elaborate ornaments, others display a stark reduction in decoration. In the dancer's dining room, for example, only a couple of glass bottles stand on the table, which is framed against a completely dark background. This contrasts notably

with the scene that immediately follows, which depicts Iurii's dining room, with its abundance of crystal glassware. On other occasions, the stark reduction of objects works to draw the viewer's attention to the *faktura* of different materials and surfaces. In a number of scenes, Bauer juxtaposes objects of various *faktura*, including crystal glassware, glazed china and polished wood, so as to heighten the frame's expressivity. As Cavendish observes, beyond their associations with wealth, Bauer's motivation for the inclusion of certain ornaments is, however, often unclear or appears tangential to the narrative of the film.[74] Rather, it seems that Bauer approached the décor in *Iurii Nagornyi* as a technical exercise in how various sets could be used to structure cinematic space and to heighten the visual expressivity of a frame.

The attack on elaborate sets was directed not only at Bauer's films. From the mid-1910s in the contemporary cinema press, critics waged a campaign against ostentatious interiors with an excess of ornaments, in a similar way that, as we recall from Chapter 2, critics denounced films of the rural provinces that had an abundance of ethnographic details. In an article published in 1918 in *Cinema Newspaper* (*Kinogazeta*), the critic A. Ostroumov argued that many contemporary films were cluttered with 'cheap splendour' (*deshevym velikolepiem*) that 'screams' (*krichit*), overwhelming the narrative and distracting the viewer's attention from the actors.[75] In contrast to such films, Ostroumov praised *The Maidservant Jenny* for the way in which the filmmakers rejected elaborate sets in order to focus instead on creating 'a reflection of life as it is, without ugly fabrications'.[76] Ostroumov's review is puzzling, however, considering the highly elaborate sets that Vladimir Balliuzek designed for *The Maidservant Jenny* that drew on and developed many of Bauer's techniques.

The Maidservant Jenny was produced by the Ermol´ev studio, which was known for the artistic and technical quality of its films. Indeed, in the 1920s it became one of the principal targets among late-Imperial studios that critics denounced for their concern with aestheticism.[77] Balliuzek worked alongside the director Iakov Protazanov and the camera operator Fedor Burgasov on the film. It was the fourth occasion that Protazanov and Balliuzek had collaborated on a fiction film. In the years before the nationalization of the Russian film industry in 1919, Balliuzek formed a close partnership with Protazanov. *The Maidservant Jenny*'s ostentatious scenery, whose formal significance often exceeds its narrative function, in many ways, exemplifies what, as we recall from Chapter 1, Balliuzek describes in his memoirs the unrestricted creative freedom that Protazanov allowed production artists.

3. The Domestic Interior

The film is set within aristocratic society in an unspecified European country. After Count Chamberaud (Shambero) dies, his wife and his daughter, the eponymous Jenny, are left with scant financial means. Despite this, the Countess objects to her daughter entering employment. Jenny therefore secretly moves to the city to search for work. Without any previous experience or recommendation, she at first struggles, but eventually secures a job as a governess in the household of Baroness Angers (Anzher). The Baroness's son returns from service, and he and Jenny fall in love. Eventually, Jenny's ancestry is revealed, the couple marry and Jenny and her mother regain their privileged lifestyle.

On one level, Balliuzek's elaborate sets represent the affluent lifestyle of aristocratic society. Opulent details, such as intricate carvings on doors and mantlepieces, combinations of fabrics of different patterns and textures and large-scale hereditary crests, serve as indicators of privilege and class.[78] As in *Iurii Nagornyi*, the interiors in *The Maidservant Jenny* are decorated in a style that mixes rococo ornament with elements of art nouveau, including geometric patterning, black and white floor tiles and strong tonal contrasts. In *The Maidservant Jenny*, however, ornament acts chiefly as an indicator of social status rather than of material wealth. Despite being forced to downgrade their elite lifestyle, the Countess and Jenny continue to live among exquisitely designed furniture: the *armoire* in their new lodgings has elaborately carved feet, and the screen that they use to separate the room into different areas for eating and sleeping bears the same striking art deco oval pattern as a window in their former mansion. Similarly, the room in the boarding house that Jenny moves into while attempting to find work is furnished with chairs with ornate wood frames. Light is directed to highlight the chairs' intricate carvings, which have a visual echo in the tight curls of Jenny's hair. Rather than a reduction in ornament, then, it is a reduction in scale that indicates the Countess and Jenny's impoverished position.

In addition to rococo and art deco, Balliuzek's décor reveals a number of diverse artistic influences. The linear forms and the monochrome contrasts of art deco elements betray Balliuzek's interest in illustration, which he continued to practise throughout the 1910s alongside designing sets for the theatre and cinema.[79] In several scenes, areas that display a stark art deco aesthetic are juxtaposed with those of dense patterning. The contrasting patterns of fabric and wallpaper work to create a range of tones in the orthochromatic scale. This strategy was widely employed across Russian and European cinema in the 1910s and 1920s. As Emma Widdis notes, the French filmmaker Louis Delluc in his influential book *Photogénie* (1920), which was

published in Russian in 1924, included patterned textiles with a dark background in a list of objects that he deemed innately photogenic.[80] The use of pattern to create a lively visual dynamic was a technique also employed in the set designs of the *Ballets Russes* (1909–28). Balliuzek had studied art in Paris and designed sets for several Parisian theatres in the late 1900s at a time when the *Ballets Russes* were at the height of their popularity.[81] Moreover, Widdis argues that the use of excessive foreground patterning in cinema set design is 'painterly in feel', insofar as it renders the screen 'a flat, pictorial surface'.[82] This corresponds to Balliuzek's conception of set design as a pictorial process that drew on conventions from the tradition of painting, an idea that he promoted in his 1948 manual on set design, significantly titled *Painterly Work in Film Production: A Manual for Workers of the Veneer Workshop of a Film Studio* (Zhivopisno-maliarnye raboty na kinoproizvodstve: Posobie dlia rabochikh otdelochnogo tsekha kinostudii).[83] Balliuzek's use of various aesthetic styles can therefore be interpreted as a formal experiment in the potential of set aesthetics.

Like Bauer before him, Balliuzek also experimented with the cinematic potential of different materials and how their various opacities create contrasts in lighting effects. In several scenes, heavy velvets that absorb light are placed alongside diaphanous tulles that are illuminated by backlighting. Deeply carved woodwork, fluted columns and stucco relief decoration create pronounced contrasts between light and dark. Moreover, several scenes incorporate opaque doorways and windows that serve as screens against which figures appear silhouetted by a strong backlight.[84] On the one hand, these create different layers of action within the frame; on the other, they function as a self-reflexive device that draws the viewer's attention to the act of looking at the surface of a screen, rather than back into illusionistic space.

Balliuzek also plays with different types of cinematic space through the use of patterned textiles. In several scenes, doorways and partition walls split the frame in two; while one side of the frame is filled with patterning, the other opens onto an interior that recedes into illusionistic space. As Widdis argues in relation to production artists working in the 1920s, the incorporation in sets of foregrounded patterns appears 'to flatten the screen, drawing attention to its surface'.[85] Following Antonia Lant's reading of Alois Riegel's notion of different modes of perception, Widdis argues that the play with flattened space and depth of field creates variations in haptic and optical models of perception.[86] Thus, the way in which Balliuzek uses set design in *The Maidservant Jenny* not only to convey thematic and symbolic meanings but also to exploit

the expressive potential of cinematic space, prefigures early-Soviet filmmakers' experimentation with scenery, such as Sergei Iutkevich's work on *The Traitor* (Predatel´, 1926).[87]

In Iutkevich's scenery for *The Traitor*, what Widdis describes as the self-conscious play between two-dimensional and three-dimensional space that creates variations in haptic and optical forms of perception is undoubtedly more pronounced than in the sets of Bauer or Balliuzek in the 1910s.[88] Similarly, he incorporates a more diverse range of textures and shows a greater interest in how these can be intensified through lighting than either Bauer or Balliuzek do in their approach to scenery. Indeed, in publicity material for *The Traitor* Iutkevich referred to the film as an experiment in using 'the volumes and textures of surfaces rough, shiny and lacquered'.[89] However, I argue, many of Iutkevich's set techniques – such as the use of pattern textiles for tonal variation, screens to segregate the frame and to create variation in depth of field and fabrics with different opacities to construct multiple layers of action – draw on those that were developed by Bauer and later Balliuzek in their representations of interior space. Moreover, the film is littered with references to set elements frequently found in Bauer's films: the *russkii modern* entrance gates reference those used in films such as *Child of the Big City*, *Children of the Age* and *Iurii Nagornyi*; the diaphanous tulle curtains of Madame Giuio's brothel recall those in both Lebedev's and Iurii's bedrooms; and the bear rug also resembles that found in *Child of the Big City*, as well as in *A Life for A Life* and in several of the interiors in *Iurii Nagornyi*. Considering the fact that Iutkevich was assisted with the set design by Vasilii Rakhal´s, who had previously worked alongside Bauer at the Khanzhonkov studio, these references can be no coincidence.

Like Bauer's films, *The Traitor* received largely negative criticism for its extravagant aesthetics: 'Under the guise of this way of life, the film shows frivolous picnics, chic and spacious apartments, refined knick-knacks, elegant ladies' pyjamas and elegiac fountains', wrote an anonymous reviewer in 1926 in *Soviet Cinema*.[90] The critic's use of the adjective 'neplotnennye' (spacious) is significant in that it referred to surplus living space, which was defined as that with a greater number of rooms than its inhabitants. In Russia during the first decades of the twentieth century, the question of sufficient living space was of particular importance. As Graffy notes, in 1917 just weeks after the Revolution, Lenin outlined a project for requisitioning 'flats of the rich to relieve the needs of the poor'.[91] This issue was the subject of one of the first Soviet films to be made, Aleksandr Panteleev's *The Consolidation of*

Living Space (Uplotnenie), which was released on the anniversary of the Revolution on 7 November 1918.[92]

In addition to attacking Iutkevich's sets on ideological grounds, critics also denounced them for their cinematic shortcomings. Like the critics of elaborate sets in late-Imperial cinema, several reviewers argued that Iutkevich's scenery overwhelmed the narrative and the actors. Indeed, a reviewer writing in 1926 in *Evening Moscow* (Vecherniaia Moskva) claimed that the sets had even become 'a participant in the action'.[93] There was, however, a notable and revealing shift in the focus of criticism away from set design's effect on the psychological intensity of the film, which had been a main concern of critics writing in the 1910s. Rather, reviewers attacked Iutkevich's absurdist décor for its economic wastefulness. In a 1926 article entitled 'An Economy of Means, but Not an Economy of Imagination' (Ekonomiia sredstv, no ne ekonomiia vydumki), the critic I. Urazov lamented that Soviet cinema was awash with films that required dozens of sets, resulting in a shameful waste of resources.[94] Although the critic did not name any films in particular as examples of such wastefulness, the article was illustrated with stills from *The Traitor*.[95] Such attacks continued throughout the mid-1920s, with a number of critics denouncing ornate décor as remnants of the wasteful, pre-revolutionary approach to filmmaking promoted by the Khanzonkov and the Ermol´ev studios in particular.

The house as shelter: Representations of material and psychological comfort in 1920s Soviet cinema

In their search for a more economical model of filmmaking, during the 1920s a number of critics and filmmakers denounced artificial studio sets and instead promoted location filming. As Widdis notes, while this posed a particular problem for production artists in terms of how they might represent the domestic interior, even the most vociferous opponents of studio scenery recognized that interior settings in films could not be discarded entirely.[96] Indeed, Leo Mur, a major advocate of outdoor filming, wrote in the article 'Filming Outdoors and in the Studio' (S´´emki na nature i v atel´e):

> *Kinoki* have their own raison d'être for grunting with contempt at 'canary cinema studios', but life is not confined only to the streets. A great part of a person's life takes place not under the sky, but under a ceiling. And thus the film-camera had to acquire its own 'home' –

the studio, where, free from patches and protuberances, the electric sun's volt arcs shine brightly and where the film-camera can shoot at 'point-blank' range two-walled rooms, revealing all the secrets of the hearth.[97]

As the criticism of the interior scenery in *The Traitor* demonstrates, the question of how to represent interior space posed a challenge to production artists on not only aesthetic but also ideological grounds. During the 1920s, the domestic sphere became the focus of the battle against the entrenchment of bourgeois values and pre-revolutionary ways of life. This battle was seen to be both a physical one against the material comforts of the bourgeois household and a psychological one against the emotional attachment to bourgeois dwelling habits. For many critics, the entrenchment of bourgeois values was exacerbated by the state's adoption of the New Economic Policy (NEP, 1921-7), which permitted limited market capitalism. The NEP era also witnessed an exacerbation of the problem of sufficient housing, brought about by mass urban migration and the devastation of the Civil War years.[98] A lack of available living space meant that many city dwellers were forced to live in cramped, overcrowded conditions alongside strangers.

The Girl with a Hatbox (Devushka s korobkoi, 1927) was one of a number of films made between 1926 and 1928 that explicitly addressed the Soviet housing problem.[99] According to production records, the film was made under the remit of engaging with the issues 'of living space in Moscow, the relationship between the new bourgeoisie and their subordinates, the relationship between different genders and questions about everyday life'.[100] In the film, Natasha works as a milliner for Madame Irène's Moscow boutique. Although Natasha lives with her grandfather in a cottage outside Moscow, Madame Irène keeps a room in her apartment in Natasha's name, which allows her and her husband, Trager, to hold onto extra living space. The issue of lodging rights was acute at the time. In the same year that the film was produced the state introduced the non-voluntary policy of 'self-compression' (*samouplotnenie*), which required surplus living space be offered to lodgers.[101] One day, while travelling to Moscow by train, Natasha meets the student Il´ia. Eventually taking pity on Il´ia's homeless condition, she proposes that they marry so that he has the right to live in 'her' room at Madame Irène's. In the original screenplay, Il´ia initially seeks a room in student dormitories, but the conditions there are so bad that he chooses instead to wander homeless among Moscow's streets.[102] At the end of the film, Natasha gives her state lottery winnings to improve

the student dormitories. This sub-plot about the student dormitories was axed from the final version of the film, presumably for portraying a form of communal housing in a negative light.[103]

The Girl with a Hatbox was the first of a number of films, including *The House on Trubnaia* and *Outskirts* (Okraina, 1933), on which the production artist Sergei Kozlovskii collaborated with the director Boris Barnet. Widdis identifies the films of Barnet and Kozlovskii as notable examples of the '"everyday" style in Soviet set design'.[104] Indeed, as we recall from Chapter 1, Kozlovskii was a major proponent of an economical approach to set design, in terms of both aesthetics and the production process. *The Girl with a Hatbox* is notable for its spartan interiors. In several scenes, Natasha's room in Madame Irène's apartment appears bare except for a light switch and a crystal chandelier.

In the manual he co-authored on set design, Kozlovskii argued that production artists could convey a character's identity or the atmosphere of a place to the viewer more expediently and forcefully with a few carefully selected objects, than with an accumulation of detail.[105] In other words, according to Kozlovskii, sparse sets heighten the rhetorical power of individual objects. In *The Girl with a Hatbox*, objects carry particular symbolic significance. The characters are introduced to the viewer through specific objects that act as markers of their identity: Il´ia is shown with his stack of books and patched-up *valenki*, alluding to his status as a student and a native of the provinces; Natasha is never without her hatbox; and a shot of Trager with a silver tea service indicates his adherence to bourgeois customs.

The rejection of excess to focus on individual details was an aesthetic approach that gained widespread appeal in a number of artistic circles from the mid-1920s. Notably among the Soviet avant-garde, Osip Brik in his 1927 manifesto of factography, 'The Fixation of the Fact' (Fiksatsiia fakta), campaigned for an approach to film and literature based on individual details.[106] In his article 'The Production Artist and the Material Environment in Fiction Film' (Khudozhnik i material´naia sreda v igrovoi fil´me), also published in 1927, Aleksandr Rodchenko declared:

> *In cinema it is important to know how to get rid of things that do not work.* Cinema cannot stand realism 'as it is in life'. In life, so many things are thrown together that if you film it like that, then you would spend two days trying to work out what is in the frame. Cinema cannot stand it when on the screen there are eleven bottles and the characters only drink from two; the viewer will not see the others anyway.[107]

Likewise, as Alina Payne argues, the individual element became a focus of much modernist artistic discourse.[108] In his article 'Actualités' (1928), the French avant-garde artist and filmmaker Fernand Léger declared that fragments when isolated take on a life of their own;[109] and in his treatise *The Decorative Art of Today* (L'Art decoratif d'aujord'hui, 1925), Le Corbusier argued that in bare interiors objects become more visible and exert a great rhetorical force.[110] These artistic discourses mirrored contemporary social debates: a campaign against cluttered interiors dominated the discussion of living standards in the 1920s. As Victor Buchli observes, many Soviet domestic guidebooks advised against unnecessary ornament as it reduced light and space, harboured dust that was detrimental to the health and increased housework, which left women with less time to pursue social work outside the home.[111]

However, despite the widespread support across the 1920s for the cleansing of superfluous ornament from domestic space, vacant interiors also held negative connotations. Buchli notes how one of the first Soviet domestic guidebooks *Advice for the Proletarian Housewife* (Sovety proletarskoi khoziaike, 1924) emphasized that 'decorative elements should not be displayed with museum- or monastery-like austerity but gaily, vivaciously, dynamically and with variety'.[112] Walter Benjamin in his writings on the interior, which were closely informed by his experience of living in Moscow in the winter of 1926–7, saw the removal of superfluous ornament as emancipatory, but also argued that empty interiors impeded the formation of habits, which were essential to a dweller's sense of belonging.[113] Thus, as Widdis argues, many could not reject decoration wholesale.[114]

The ambiguous attitude towards the decorative is evident in Kozlovskii's sets for *The Girl with a Hatbox*. As Widdis observes, Kozlovskii creates several different interiors: Natasha and her grandfather's provincial home; the petit-bourgeois room of the station clerk Fogelev; Madame Irène's and Trager's Moscow apartment; and Natasha's room in which Il´ia eventually lives.[115] Alongside the stark interiors of Madame Irène's apartment and Natasha's room, Kozlovskii also created heavily ornamented interiors. Fogelev's room is decorated with floral-patterned wallpaper and an array of knick-knacks adorns the shelves. Similarly, Natasha and her grandfather's home displays many of the trappings of the comfortable bourgeois interior: a patterned wool rug lines the walls and heavy wood furniture and a plump armchair dominate the room (Figure 3.4). The scenes set here are mainly framed in medium close-up, which highlights the soft texture of the wool rug

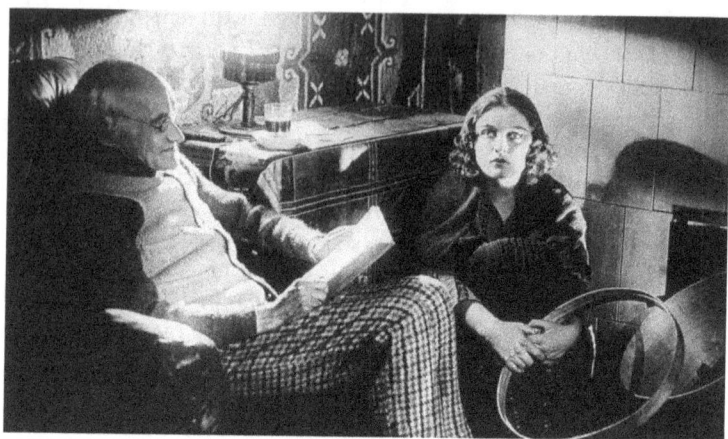

Figure 3.4 Natasha's father's dacha. *The Girl with a Hatbox* (Devushka s korobkoi), directed by Boris Barnet © Mezhrabpom-Rus´ 1927. All rights reserved.

and the snug folds of the armchair. Moreover, Widdis demonstrates how the complex attitude towards decoration is reflected in the film's production process: archival records state that Il´ia's room cannot be entirely vacant, but must be furnished with a table and chairs, a cupboard, a commode and a bed.[116] The film thus refuses to make a clear ideological distinction between different lifestyles based on design aesthetics alone. Cluttered interiors and sparsely furnished interiors can be both positively and negatively coded. How then is the film's social message about living space to be understood?

According to Buchli, during the late 1920s, as the NEP era drew to a close and the state initiated the Cultural Revolution (1928–32), there was a growing resistance to denotive understandings of material culture and to the idea that objects and aesthetic styles represented unambiguously a particular set of values.[117] Buchli argues that this was replaced by a contextual understanding, in which it was a person's relationship to their surrounding material environment that mattered. A growing interest in material relations is also evident among contemporary filmmakers. In a 1926 statement outlining his intentions for *Bed and Sofa*, the director Abram Room argued that in cinema close attention must be paid to things, which 'live, breathe, interfere in people's lives and keep them in close captivity'.[118] And, as we recall from Chapter 2, in his article 'The Border Line' (Pogranichnaia liniia), published the same year that *The Girl with a Hatbox* was released, Viktor Shklovskii wrote that cinema

was entering a second phase in which it would become a factory of the relationship with things.[119]

Correspondingly, I argue that in *The Girl with a Hatbox* it is a protagonist's relationship with their surrounding material environment that serves as an indicator of their social and moral qualities. In the way that they use their possessions for multiple functions, Natasha and Il´ia are shown to be resourceful. While homeless in Moscow's icy streets, Il´ia uses his books as a stool to perch on and as a screen to block a draught coming through some railings. Similarly, when he moves into Natasha's unfurnished room, he constructs a makeshift bed from his books and *valenki* felt boots. Likewise, when, after missing her train, Natasha is forced to stay the night in her Moscow room together with Il´ia, she uses Il´ia's books and her hatbox as a screen to partition a sleeping space for herself separate from where Il´ia rests. Natasha and Il´ia's intelligent use of objects contrasts with Trager and Fogelev's clumsiness. In one sequence Natasha successfully stays on her feet as a rug is pulled out from underneath her, while Trager is tripped up and breaks one of Madame Irène's figurines.[120] In another, Natasha confidently crosses the narrow bridge that connects her house to the train station, but Fogelev slips on its icy planks.

The idea of material intelligence was popular among Soviet cultural theorists of the 1920s. In his influential text 'Everyday Life and the Culture of the Thing' (Byt i kul´tura veshchi, 1925), Boris Arvatov envisions that an active and creative relationship with things will separate the new Soviet collective from bourgeois society.[121] According to Arvatov, the bourgeoisie apprehends things only in terms of material display.[122] By contrast, in the future Soviet collective the thing will become 'connected like a co-worker with human practice'.[123] For Arvatov, the distinction between bourgeois society and the new Soviet collective's relationship with things is evident in living practices. While the bourgeois individual does not go beyond rearranging things, changing only their distribution in space and not their form, the new Soviet person engages directly in the act of making, transforming the thing into a working instrument. Likewise, the cultural theorist Sergei Tret´iakov differentiates between the bourgeois and the new Soviet person's relationship to things in terms of 'acquirers' (*priobretateli*) and 'inventors' (*izobretateli*).[124]

A similar distinction in living practices, I argue, is evident in *The Girl with a Hatbox*. In contrast to Il´ia and Natasha's acts of homemaking, in which they transform their things and give them various new purposes, Trager and Madame Irène use their possessions

merely as decorative furnishings; accordingly, they are shown to simply redistribute them between spaces, as described by Arvatov.[125] When Trager and Madame Irène are forced to vacate Natasha's room midway through a dinner party, they move all their furniture with them. In a subsequent sequence, in which Trager seeks to reassert his claim over Natasha's room, he moves his wardrobe back in. Moreover, Madame Irène's boutique is shown exclusively as a place of material display. The boutique is bare except for its large glass shop windows and a cashier desk display. Against a background of opaque rectangular frames, the hats appear abstracted, with their form rather than their function emphasized. By contrast, it is Natasha's home that functions as a space of creation. The original screenplay states that in the first act of the film Natasha and her grandfather make hats together at the kitchen table.[126] The screenplay details how Natasha assists her grandfather with sewing, passing him material which he feeds through the machine. Although these scenes do not feature in the final version of the film, the home that Natasha shares with her grandfather remains associated with making: the kitchen table serves as a workspace for assembling hats and a sewing machine with a ribbon draped across it rests by the window. In the original screenplay, Natasha is again shown as a maker at the end of the film, when she uses her state lottery winnings to refurbish the student dormitories.[127]

For Arvatov, the new Soviet collective would become motivated through their creative engagement with things, while the bourgeoisie's passive relationship with their possessions hindered activity, constrained the body and led to social apathy.[128] Similarly, in *The Girl with a Hatbox* things interfere with the lives of Trager and Madame Irène, whereas they mobilize Il'ia. While in one sequence Madame Irène is shown entangled in laundry, in another Il'ia adeptly weaves his way through a maze of clothing lines to find a sink for washing. Moreover, Il'ia is shown vigorously exercising in Natasha's room. Using his stack of books as weights, he extends his whole body across the entire width of the frame. Trager watches Il'ia through a keyhole and mimics his movements; however, the cramped bedroom means that he hits Madame Irène in the stomach. He thus appears as a character who is only capable of imitating others, and ineffectively. The activities that he does engage in are typically asocial, solitary and inactive. He slumps in a leather sofa, detached from the real world, absorbed in listening to his personal radio through headphones. This recalls the sequence in *Bed and Sofa* in which Volodia listens to his personal radio in an attempt to shut out his surrounding environment. Thus, while domestic

3. The Domestic Interior

spaces impel Il´ia to action, for Trager they insulate him from Soviet everyday life.

The extent to which living space could empower individuals or reinforce old habits of everyday life is directly addressed in *Fragment of an Empire* (Oblomok imperii, 1929). The film tells the story of the non-commissioned officer Ivan Filimonov, who suffers amnesia as a result of an injury sustained while fighting during the First World War. He regains his memory to find himself in 1928 in post-revolutionary Soviet Russia. Determined to track down his wife, Filimonov travels to Leningrad, formerly Saint Petersburg, where he had previously lived, only to discover that the city has changed dramatically. His former employer, a factory manager, has been replaced by a committee and his wife is now remarried to a cultural worker. Initially Filimonov is disorientated and alienated in revolutionary Leningrad, but gradually he learns to appreciate the new way of life. He eventually locates his wife, who lives with her oppressive husband according to pre-revolutionary conventions. Filimonov offers his wife a means to escape her retrograde lifestyle, but she chooses instead the material comfort of her familiar life.

Fragment of an Empire was the third film that the production artist Evgenii Enei and the director Fridrikh Ermler collaborated on after *Katka's Reinette Apples* and *The House in the Snowdrifts* (Dom v sugrobakh, 1928). These films also addressed the theme of social alienation in revolutionary society. During the 1920s, Enei typically worked with the Factory of the Eccentric Actor (Fabrika Ekstsentricheskogo Aktera, FEKS) directors Grigorii Kozintsev and Leonid Trauberg, and he developed a distinct approach to set design that exploited the play of light and shadow for atmospheric and psychological effect. In *Fragment of an Empire*, this approach became key in revealing the psychological states of characters and expressing the conflict between retrograde and revolutionary lifestyles and their respective associations with ignorance and oppression and enlightenment and empowerment.

The domestic interiors that Enei created for *Fragment of an Empire* are dark and confined spaces, cut off from the outside world. Pierced by only a narrow ray of sunlight from its sole window, Filimonov's room in the provincial railway station, where at the beginning of the film he works as a stationmaster, is shrouded in darkness. Objects appear as indistinct, shadowy masses, reflecting Filimonov's confused mind. The rough texture of the walls and the wood floorboards, which are highlighted by the use of directed lighting, make the space seem cave-like and recall the war shelter in which Filimonov is introduced to the viewer. Additionally, in the domestic interior of Filimonov's previous

employer, the forms of dark wood furniture seem to coalesce amid the shadows. As in other films of the 1920s such as *Bed and Sofa*, the feeling of enclosed interior space is heightened through its contrast with expansive exteriors.[129] In the Leningrad scenes, the plain, white facades of the Constructivist-style offices and housing units gleam in brilliant sunlight. The office block is shot at a diagonal angle from a low viewpoint to emphasize the structure's soaring height and angular form. Likewise, the communal dining room and the recreational spaces of the workers' club, with their large glass windows and doors, lack of ornament and simple furniture, are bright and spacious.

Enei's darkened domestic interiors function as enclaves in which their inhabitants harbour pre-revolutionary ways of life. In the interiors of both Filimonov's wife and his former employer, space is divided according to bourgeois conventions of room usage. In many of the sequences shot in these interiors, the kitchen table dominates the frame visually, suggesting that the household continues to revolve around traditional domestic practices. Indeed, Filimonov's wife is largely confined to her role as a housewife. The one time in the film when the viewer sees her outside the domestic sphere she is crouching in the corner of a train wagon; her husband's coat separates her from the window, acting as a buffer to the exterior world. Similarly, the former factory owner's wife barricades herself in a corner of the living room behind a screen. Refusing to apprehend the world around her directly, she views her surroundings exclusively through a mirror and buries her face deep into the bedcovers as her husband informs Filimonov about current circumstances. Likewise, the former factory owner, dressed in pyjamas and clutching a German newspaper, appears detached from present-day Soviet life. In contrast to these characters' rootedness in the domestic sphere and their concomitant social isolation, Filimonov is able to transcend the home, and in so doing he becomes empowered.

In the domestic interior of Filimonov's wife and the cultural worker, material traces of their adherence to pre-revolutionary conventions are placed alongside objects with revolutionary connotations. While a collection of Lenin's works lines the living-room bookshelf, knick-knacks and religious ornaments clutter the top of the bedroom dressing table. On the coat-stand hang both a trilby hat and a workers' cap. Although the cultural worker addresses workers in a communal dining room, he eats alone with his wife at home. The wife makes simple cabbage soup (*shchi*) in a utilitarian tin pot, but serves it in traditional chinaware. And on the kitchen table a booklet on revolutionary culture rests among crystal glassware.[130] In an article entitled 'The

Thing in Cinema' (Veshch´ v kino), published in 1929 in *Cinema and Culture* (Kino i kul´tura), the critic V. Kolomarov argued that the unexpected juxtapositions of objects in *Fragment of an Empire* work to disrupt conventional modes of perception and force the viewer to see the material environment in a new, unfamiliar light.[131] According to Kolomarov, this induces greater aesthetic appreciation and increased social awareness among viewers.[132] In his writings of the 1920s, Sergei Tret´iakov argued that the battle against bourgeois comfort and taste was psychological.[133] He claimed that the bourgeoisie transfer fetishisms and memories onto their surrounding material environment; this emotional attachment leads to the entrenchment of habits to the extent that they become automatic. For Tret´iakov, familiar habits could be broken down through the process of 'defamiliarization' (*ostranenie*).[134]

In *Fragment of an Empire*, the technique of defamiliarization is used not only to heighten the viewer's awareness but also to aid the reconstitution of Filimonov's memory.[135] In one sequence before Filimonov regains his memory, he stumbles upon a paper boat. Unable to comprehend what the object is, Filimonov presses his head down next to the floorboards to peer at it from a different vantage point. While the paper boat yields no further meaning, a cigarette packet thrown from a train window serves as a memory trigger for Filimonov. As he touches the object, his mind begins to form connections based on perceived formal and aural associations. This initiates a process in which Filimonov's handling of various objects in his room causes memories of his former life to resurface. Turning the wheel of the sewing machine sets in motion the movement of the needle against the metal plate, which, for Filimonov, recalls the clanking machinery at the factory where he worked formerly. Similarly, the spool of the sewing machine running across the floorboards triggers a flashback consisting of various images relating to Saint Petersburg and his wife in her wedding dress.[136] It is notable that the process through which Filimonov's memory is reconstituted is triggered by objects associated with sewing. On one level, sewing is associated with the joining of fragments into a seamless whole. In the context of the Soviet 1920s, however, Widdis argues that sewing and other forms of handcraft had ideological significance and expressed 'the validation of labour' that was central to Soviet ideology.[137] Like Natasha and Il´ia in *The Girl with a Hatbox*, Filimonov – through his identification with making – is shown as a productive member of Soviet society.

In his later reflections on filmmaking, Ermler referred to *Fragment of an Empire* as a 'problem film' that posed questions rather than provided

answers.[138] Although Kolomarov praised the film's depiction of the communal dining room and the hostel as examples of a new Soviet approach to living, in general the film does not offer solutions about how to restructure life according to a Soviet model.[139] Indeed, very few films in the 1920s did show new socialist interiors or offer positive guidelines about inhabiting domestic space.[140] This continues the tradition observed in late-Imperial fiction films of representing the domestic interior in a negative light, using motifs of entrapment to convey ideas about the repressive patriarchal structure of early-twentieth-century Russia. In the 1929 version of his article 'Life as It Ought To Be' (Zhizn´ kak ona dolzhna byt´), Nikolai Lukhmanov lamented the fact that up to that point Soviet cinema had only presented a social critique of contemporary life and had failed to offer models for its improvement.[141] The only film that Lukhmanov praised in terms of its positive depiction of Soviet domestic space was *How You Live* (Kak ty zhivesh´, 1927), a *kul´turfil´m* created primarily for educational purposes and directed by G. Shirokov and with sets created by the architect Gleb Glushchenko. The film has not survived, but the stills that illustrate the article show an open-plan apartment with high ceilings, large windows, plain walls and simple geometric-frame furniture. Widdis argues that while interiors in Soviet fiction films continued to reflect models of bourgeois domesticity, it was the factory floor and the collective farm that offered a more positive model of socialist life.[142] Accordingly, the next chapter addresses how representations of the workplace in late-Imperial and early-Soviet fiction cinema engaged with questions about the material environment.

Chapter 4

THE WORKPLACE

In Russia, the late nineteenth and early twentieth centuries were a time of intense industrialization and commercial expansion. Against this climate, ideas about the restructuring of the workplace, labour conditions and professional relations naturally came to occupy a prominent position in social discourses. Equally, working life became a popular subject for artistic and literary representation. Existing scholarship on artistic responses to working life typically focuses on the spaces of industrial and proto-industrial production, and their representation as emblems of rationality and efficiency.[1] This chapter, however, considers how early-Russian and Soviet filmmakers represented the private study or office – a space associated with intellectual labour rather than with practical work, imaginative speculation and not manual production and individual desires rather than collective responsibilities. As such, the chapter seeks to explore the place of imagination and pleasure in discourses about work. Specifically, it focuses on how filmmakers used elements of set design to foreground imagination and pleasure within the workplace. For, as Mark Steinberg argues in his study of proletarian imagination in late-Imperial and early-Soviet Russia, imagination was seen to be constitutive of the individual no less than practical work, and workers' fantasies expressed many of the dominant anxieties of the time, most notably relating to class mobility, the efficacy of labour rights reform and the subordination of the individual to the state.[2]

Individual desires and power relations:
Private studies in Evgenii Bauer's films

Although since the late nineteenth century Russia had experienced the large-scale industrialization and the rapid expansion of the commercial sector, very few late-Imperial fiction films depicted spaces associated with industry and corporate enterprise.[3] Portrayals of working life were mainly restricted to domestic service, as discussed in Chapter 3, or to

agricultural activity in rural communities such as in the Khanzhonkov studio's *The Peasants' Lot* (Krest′ianskaia dolia, 1912).

Despite the lack of interest in working life, many of the films of Evgenii Bauer incorporate private studies. As Victoria Rosner argues in relation to American and Western European modernist culture, the secluded nature of the study – a room removed from the domestic and the entertaining spaces of a household and the social customs demanded of housewives – meant that it was an exclusively masculine realm.[4] Moreover, as a single-occupant room, the study was frequently associated with clandestine activity and the harbouring of secret desires.[5] Correspondingly, in Bauer's films the study is predominantly a space belonging to male protagonists.[6] Often reclusive romantics and fantasists, Bauer's male protagonists use their studies not for conducting business affairs or for intellectual study but rather to excuse themselves from social formalities and to indulge in personal fantasies. These fantasies often relate to the idealization and objectification of women; consequently, Bauer uses the study as a key space to explore gender concerns.[7] This differentiates the function of the study in Bauer's films from that in other late-Imperial films, such as the Khanzhonkov studio's *The Sorrows of Sarra* (Gore Sarry, 1913) and *Uncle's Apartment* (Diadiushkina kvartira, 1913), in which it is primarily associated with business transactions.

One of the earliest examples of Bauer's use of the private study to explore gender and class relations comes in the Khanzhonkov studio's *Silent Witnesses* (Nemye svideteli, 1914), which he worked on as both director and production artist.[8] In the film, Nastia, the granddaughter of the porter to an upper-class family, takes the place of the housemaid Variusha, who wishes to visit her children in the countryside. Nastia soon attracts the attentions of the son of the household, Pavel Kostyritsyn, who seduces her. However, when Pavel's marriage proposal to the socialite Ellen is accepted, he loses interest in Nastia and treats her only as a maid. As a critic writing in 1914 in *Cinema Herald* (Vestnik kinematograf) identified, the film's main theme is 'That border which sharply separates social ranks and places strong barriers between people of the higher and the lower class'.[9] According to Rachel Morley *Silent Witnesses* is remarkable among Bauer's extant films for consistently foregrounding class concerns over issues of gender and for dividing the protagonists into 'good' and 'bad' based on their class associations.[10]

Bauer conveys the protagonists' class status primarily through the spatial layout of the Kostyritsyn household, which is organized according to the conventional downstairs/upstairs social hierarchy.[11]

4. The Workplace

The importance of spatial hierarchies is made apparent in the film's opening scene, set in the vestibule of the Kostyritsyn house, in which an ornate staircase leading up to Pavel's room dominates the space, taking up over half of the frame. While Pavel's room is located upstairs, the kitchen in which the servants socialize is situated downstairs, at the bottom of another staircase. The simple wooden banister of the downstairs staircase contrasts starkly with the marble pilasters and the intricate rococo ironwork of the staircase leading to Pavel's room. Indeed, Bauer incorporates staircases into his set designs to indicate a change in a character's social ranking in a number of his films. As Morley notes, in *Child of the Big City* (Ditia bol'shogo goroda, 1914) as Mary accompanies the aristocrat Viktor to a fashionable nightclub, a low-angle shot shows her ascending a huge art nouveau staircase, suggesting her rising social status.[12] Similarly, in *Children of the Age* (Deti veka, 1915), when Mariia moves into the house of the wealthy Lebedev, she immediately climbs a staircase to his room. The same tactic is repeated in *Daydreams* (Grezy), which was released only one week after *Children of the Age*, on 10 October 1915: the ballerina Tina is shown ascending the stairs to visit the reclusive aristocrat Sergei Nedelin in his study. In *Silent Witnesses*, while Nastia is depicted in Pavel's room, we do not at first see her ascending the staircase to reach it. It is only in a sequence at the end of the film, once Pavel and Ellen are engaged, that Nastia is shown crying against the staircase's marble pilasters. Wearing her work uniform, she climbs the stairs alone, suggesting her inability to improve her social position and to be perceived by Pavel as anything other than a maid.

On several occasions in the film, Pavel retreats to the comfort of his study, where he pines for Ellen. As Alyssa DeBlasio notes, Bauer conveys the study's seclusion by combining a wide-angle shot and a tracking shot, which follows Pavel from a distance as he wanders alone through the large, uninhabited expanse of the room.[13] The framing and the mobile camerawork enable Bauer to make a connection between the secluded nature of the study and Pavel's psychological state, deep in thought about the object of his desire. As the camera weaves through the multiple layers of furniture and decorative objects, it also draws the viewer's attention to the study's set design, which further conveys Pavel's self-absorbed nature and his amorous yearnings.

The room's elaborate art nouveau décor gives the impression of a space of pleasure and entertainment. Indeed, in the scenes in which the viewer is introduced to the study, when Nastia helps put a lovesick Pavel to rest, the foreground of the frame is dominated by a divan,

which alludes to Pavel's later seduction of Nastia. By contrast, the writing desk is placed in a marginalized position in the room, with only a small corner of it visible at the edge of the frame. While throughout the film Pavel rarely uses his desk, he repeatedly reaches over to a side table covered with bottles of alcohol and pours himself another drink. In the sequences set in Ellen's room, her desk is also marginalized, placed in an alcove at the very back of the frame, while the foreground is dominated by large armchairs and a full-length mirror, in front of which she spends her time adjusting her appearance, recalling the way in which in *The Kreutzer Sonata* (Kreitserova sonata) the wife contemplates herself in a mirror. Similarly, in a number of his studies in other films, Bauer positions writing desks in a marginalized position. In *After Death* (Posle smerti, 1915), for example, Andrei sits with his back turned to the desk, which is only just visible in the corner of the frame, and instead interests himself in the artefacts relating to his dead mother that rest on the mantlepiece. The marginalization of desks in Bauer's films thus conveys the fantasist nature of characters, who are preoccupied with their individual desires at the expense of their wider social responsibilities.

In the very few sequences in *Silent Witnesses* in which characters are shown at their writing desks, they busy themselves not with work but with arranging romantic affairs. Baron von Rehren composes a letter to Ellen's father breaking off his engagement to his daughter at a desk under the light of a lamp decorated with cupid figurines. In another sequence, a split screen shows Ellen and Pavel sitting at their respective desks while on the telephone to one another, arranging a rendezvous. In a number of Bauer's films, characters pursue romantic affairs from their writing desks. In *Child of the Big City*, Viktor sits at his desk leafing through a photograph album of potential female partners. Love affairs and marriage proposals are thus conducted as if business transactions.

As with many of the desks in Bauer's films, Viktor's desk is decorated with a combination of work appliances, including a telephone, writing equipment and weighty books, and personal artefacts, such as classical statuettes of female nudes. As in Pozdnyshev's study in *The Kreutzer Sonata*, discussed in Chapter 3, the statuettes convey Viktor's idealization and objectification of women. The combination of the statuettes and professional equipment also conveys what Louise McReynolds identifies as a tension between social demands and sexual desire that exists in many of Bauer's film in which romantic liaisons take place.[14] She argues that Bauer shows that men, just as much as women, were oppressed by late-Imperial Russia's patriarchal order, which

required them to establish a position of authority in their professional and social life.

Bauer continued to associate marriage proposals with business affairs in one of the last films that he worked on as a director before his death, *The Alarm* (Nabat, 1917). Adapted by Bauer from Elisabeth Werner's German novel *On the Open Road* (Russian title Vol´noi dorogoi, date unknown) to contemporary Russia, the film follows the entanglement of the upper class in romantic intrigues, despite the growing workers' unrest in Saint Petersburg at the beginning of 1917. A significant proportion of the film's action takes place in the private studies of the various aristocratic characters. The studies were designed by the young Lev Kuleshov and are the earliest surviving examples of his work as a production artist. In comparison to the 'severe realism' (surovyi realism) of the set design in *Silent Witnesses*, the sets in *The Alarm* are constructed around highly stylized architectural forms.[15] Contemporary critics remarked on the film's aesthetics, with V. Akhramovich writing in *Theatre Newspaper* (Teatral´naia gazeta) that Bauer had mobilized 'his artistic and material strength to create a monumental picture'.[16] The filmmaker Ivan Perestiani noted that Bauer endeavoured to create the entire film using only studio sets.[17] More recently, David Bordwell has argued that Bauer, Kuleshov and the camera operator Boris Zavelev introduced a number of design innovations, including using black backgrounds and reverse camera shots to highlight the décor.[18]

The various studies featured in *The Alarm* are constructed according to distinct decorative styles, which reflect their occupants' temperaments and attitudes towards romance. As in Pavel's room in *Silent Witnesses*, in the study of the lazy romantic Viktor, the desk is barely visible, marginalized in a corner, while a divan occupies the central foreground. In several scenes, Viktor slumps over the side of his desk as he flirts with Zheleznov's daughter, Zoia. Similarly, in the room of Magda Orlovskaia, who spends her time planning her engagement to the wealthy Zheleznov, clothes are strewn across the writing desk, which is pushed to a corner at the back of the room. Above the desk hangs a rococo-style painting of a girl on a swing, which closely resembles the pictures of the eighteenth-century painters Jean-Antoine Watteau and Jean-Honoré Fragonard, who frequently employed the motif in their works to convey ideas about lust and unchaste desires.[19] In comparison to the silk and velvet drapes, the gilded furnishings and the rococo arabesques in Magda's room, Zheleznov's office is decorated in a stark gothic style, with dark turreted forms (Figure 4.1). The room is almost bare except for a couple of high-

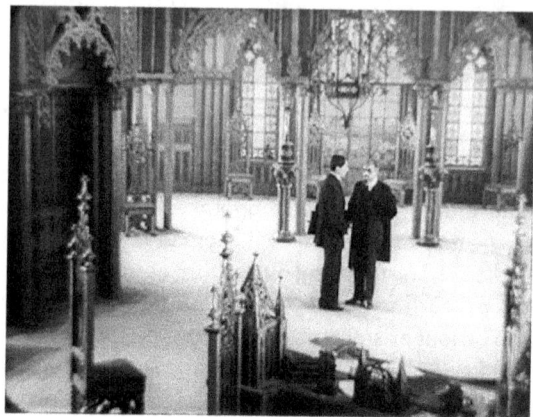

Figure 4.1 Zheleznov's office. *The Alarm* (Nabat), directed by Evgenii Bauer © Aleksandr Khanzhonkov & Co 1917. All rights reserved.

backed chairs and a large desk, which dominates the foreground. Going against the convention in Bauer's films, Zheleznov does use his office for work, conducting business meetings about his factory's fate as the workers' movement grows in strength.

The Alarm is one of the first Russian fiction films to include images of industry and workers' unrest, which became a frequent feature of fiction films made from the mid-1920s and into the 1930s.[20] In the scenes set in the factory, Bauer again uses spatial hierarchies to demonstrate class, positioning the work floor at the bottom of a series of staircases. The factory scenes are also notable for the use of dramatic contrasts of light and shadow to create a sense of tension, which is heightened by billowing clouds of smoke. Factory machinery is barely noticeable amid the shadows and the smoke, contrasting with 1920s Soviet films set on the factory work floor in which machines feature prominently, such as in *Strike* (Stachka, 1925), *Lace* (Kruzheva, 1928) and *Fragment of an Empire* (Oblomok imperii, 1929). In *The Alarm*, the focus is on conveying an atmosphere of instability and unrest. It is notable that in comparison to the scenes exposing upper-class romantic intrigue which take place around interiors, the majority of the scenes showing workers plotting against industrialists are set outdoors against bleak landscapes. In one scene, workers conspire in secret amid a secluded quarry; its jagged rocks create a feeling of discord and tension. In another, they rally on a barren, snow-covered plain. The film thus presents an opposition between individual aspirations and social responsibility in terms of interior and exterior settings.[21]

Contemporary reviews of *The Alarm* mainly focused on its social theme, with one critic even referring to it as a 'socialist drama'.[22] Several reviews criticized the fact that the theme of the workers' movement was not developed further and that it seemed incompatible with a plot about romantic intrigues.[23] Indeed, Bauer's combination of aristocratic romances and a workers' uprising in a single scenario does initially seem disjointed. His representation of the Russian aristocracy as absorbed in their own love affairs while social unrest brews can, however, be read as a condemnation of the heedlessness of the upper-class to wider social issues. Images of the workers' unrest also serve to reflect the unstable nature of romantic affairs that are negotiated according to social rank and wealth. It is significant that in the film the one romance which does end in a happy marriage is that between Zheleznov's daughter and Viktor, which is founded on true affection. Thus, in *The Alarm* Bauer provides a critique not only of the aristocracy's negligence of workers' reforms but also of the social conventions which position marriage as a commercial transaction.

Fantasy and the everyday reality of labour:
Aelita *(1924) and* The Overcoat *(1926)*

The private study continued to be associated with the personal desires and fantasies of male protagonists in Soviet fictions films of the 1920s, most notably in *Aelita* (1924) and *The Overcoat* (Shinel´, 1926). In contrast to Bauer's films, however, in *Aelita* and *The Overcoat* the male protagonists are not wealthy aristocrats absorbed in romantic musings; rather, they are defined by their professions – in *Aelita* Los´ is an engineer and in *The Overcoat* Akakii is a copyist. They are shown to delight in personal fantasies so as to transcend the mundane nature of their everyday working lives. In both films, the production artists exploited fantastical elements in their set designs to create imaginary realms that contrasted sharply with everyday reality.

The Mezhrabpom-Rus´ studio's *Aelita* was one of the first Soviet films to draw on the science-fiction genre, which became popular in the 1920s for capturing the scientific and technological utopianism of the era and providing a form of escapist entertainment that allowed audiences to distract themselves from the hardships of everyday life.[24] The film was based on Aleksei Tolstoi's 1923 novel of the same title about a Soviet engineer, who travels to Mars and incites revolution against the planet's ruling despots. The scenarists Fedor Otsep and Aleksei

Faiko retained little of Tolstoi's original text, however, except for the title and the protagonists.[25] The film follows the engineer Los´, whose fascination with space travel encourages him to daydream about life on Mars. For Los´, the boundary between his fantasy world and reality becomes increasingly blurred, with his imagination convincing him that his wife Natasha is pursuing an affair with the speculator Viktor Erlikh, who lodges in the same apartment.

The futuristic Mars sequences offered the filmmakers the opportunity to use exuberant sets and to create a film that in terms of its striking aesthetics could rival those on the international market such as the German *The Cabinet of Dr. Caligari* (Das Cabinet des Dr. Caligari, 1920). During the early to mid-1920s, Mezhrabpom-Rus´ was concerned with making films of 'an international quality' that would generate a profit and increase the reputation of Soviet films abroad.[26] In addition to hiring leading actors from the theatre, including Iuliia Solntseva, Nikolai Batalov and Vera Orlova, the film's director Iakov Protazanov sought out high-calibre artists and theatre designers to work on the film's costumes, props and sets. The cubo-futurist artist Aleksandra Ekster, who had experience designing scenery for Aleksandr Tairov's Chamber Theatre (Kamernyi teatr), was commissioned to design the Mars people's futuristic costumes, which were then manufactured by Nadezhda Lamanova's eminent costume studio.[27] Sergei Kozlovskii, who was working as the head production artist at Mezhrabpom-Rus´ at the time, recalls in his memoirs how Protazanov invited various artists to submit proposals for the Mars sets.[28] Initially, the grandiose models of Mars produced by the theatre designer Isaak Rabinovich impressed Protazanov and he selected them for inclusion in the film.[29] The German branch of Mezhrabpom-Rus´, Prometheus Film, offered to provide resources and studio space in Berlin to facilitate the construction of Rabinovich's ambitious sets in return for exclusive rights to the film's international distribution.[30] Mezhrabpom-Rus´ declined, however, preferring instead to retain independent control over exports.[31] As a result, Rabinovich's involvement on the film was limited to the creation of abstract sculptures in the Mars sequence. The task of creating the Mars sets fell instead to Kozlovskii and Viktor Simov, who were already working on the scenery for the Soviet everyday life sequences.[32] Once again, Kozlovskii and Simov worked alongside the camera operator Iurii Zheliabuzhskii, with whom, as we recall from Chapters 1 and 2, they had formed a productive working partnership in 1919 when making the Rus´ studio's *The Virgin Hills* (Dev´i gory) and *Polikushka*.[33]

Although Kozlovksii and Simov scaled back Rabinovich's original design for Mars considerably, critics nevertheless commented on the film's grandiose and elaborate scenery.³⁴ An article published in 1924 in *Cinema Weekly* (Kino-nedelia) was even dedicated to the workforce required to make the sets, noting that the Mezhrabpom-Rus´ studio had enlisted fifty veteran craftsmen, who had worked in cinema during the pre-revolutionary years for the Pathé and Ermol´ev studios.³⁵ The majority of critics were disparaging about the film's extravagant scenery.³⁶ An anonymous reviewer writing in *Pravda* even compared it to '*Aida* at the Bol´shoi theatre' in terms of its opulence.³⁷ However, rather than rejecting the film's stylized aesthetics outright, several critics argued that the fantastical design of the Mars sets was meant to convey the fact that it represented a figment of Los´'s imagination. Writing in 1924 in *New Spectator* (Novyi zritel´), an anonymous reviewer claimed that the filmmakers had depicted the whole trip to Mars as part of Los´'s imagination in order to correct the weak ideological content of the scenario.³⁸ The British film historian Paul Rotha later observed that the set was designed in a fantastic style in order to express an imaginary idea of the planet Mars and not, as in *The Cabinet of Dr. Caligari*, to emphasize the characters' distorted minds.³⁹ More recently, Ian Christie has drawn on Mikhail Bakhtin's writings on Menippean satire to argue that the abstract Mars scenes are an example of an extraordinary situation, which a person's imagination dreams up to allow the mind to play out internally motivated desires.⁴⁰

Indeed, Kozlovskii and Simov employ a number of strategies in their futuristic Mars sets which indicate that the scenes which take place here depict not only a parallel extraterrestrial world, but also a fantastical realm that exists in Los´'s imagination. The Mars scenes are constructed around an entirely different spatial paradigm from those that represent contemporary life. The sets are comprised of an assortment of abstract geometric and architectural forms, which have little correlation to any built landmarks found in the real world (Figure 4.2). Intertwining passages, stairways and landings seem to lead nowhere, but double back on themselves, producing an irrational spatial logic. Framed against a dark background, these structures appear to exist in an abstract, artificial space. Unnaturally stark contrasts between dark and light serve to heighten the artificial nature of the space. Modern industrial materials, such as aluminium, Perspex and glass, abound. Mars thus appears as a technologically advanced society that corresponds to Los´'s utopian engineering ambitions.

Los´'s fantasies of a technologically advanced Mars are juxtaposed with real feats of human engineering in the scenes of everyday urban life,

Figure 4.2 *Aelita*, directed by Iakov Protazanov © Mezhrabpom-Rus´ 1924. All rights reserved. Photo courtesy of Photo 12/Alamy Stock Photo.

many of which used documentary footage shot in the early to mid-1920s in New York and Moscow.⁴¹ It is notable that many of the contemporary life scenes depict modern constructions, including electric billboards, tramways, cast-iron bridges and the machinery of battleships. In one striking scene, Los´ jots down his engineering fantasies in a notebook as he sits framed against a background of a large-scale construction site. Mechanical cranes excavate large mounds of earth and rubble, and workers carrying building materials scurry along a vast network of scaffolding. The extreme physical labour evident in the construction site contrasts starkly with Los´'s pursuit of engineering as a conceptual practice.

The predominantly conceptual nature of Los´'s engineering work is also conveyed through the sets of his study, the space in which he most often indulges in his interplanetary fantasies. Secluded from the rest of the apartment behind a door and up a narrow staircase, his study is a distinctly private realm. Its secluded nature is also conveyed through the low ceilings, dim lighting and single, sunken window, on which Los´ draws or out of which he gazes. The shadows created by the window's frame recall the abstract geometric configurations of Aelita's court. Similarly, the contrasting linear and geometric forms of Los´'s chemistry set and model rocket resemble in miniature scale the Mars sets.

4. The Workplace

The presence of a number of models in the study is revealing about Los´'s attitude towards his practice. As Robert Bird argues, models and model-making had deep roots in Marxist thought and held particular significance in early-Soviet culture.[42] In *Capital* (Das Kapital, 1867), Karl Marx argued that modelling, insofar as it is associated with imagination, is a distinctive feature of human labour that separates humankind from other species.[43] A number of early-Soviet theorists also viewed modelling as characteristic of human, materialist societies. In a 1923 issue of the journal *Left Front of Arts* (Levyi front iskusstv, LEF), the theorist Nikolai Chuzak argued that model-making was an essential aspect of materialist societies that demonstrated their strivings to achieve scientific and technological progress.[44] In addition to their ideological appeal, the interest in models reflected the limited resources available in the 1920s. The founding curriculum of the Higher Artistic and Technical Studios (Vysshie khudozhestvenno-tekhnicheskie masterskie, VKhUTEMAS) developed in the early 1920s emphasized the importance of modelling, with several courses encouraging students to make three-dimensional models of abstract concepts, including space, time and motion.[45] During the early 1920s, models became a prominent feature of exhibitions and were incorporated in revolutionary festivals. Famously in 1921, Vladimir Tatlin's *Monument to the Third International* (Pamiatnik III Kommunisticheskogo Internatsionala) was paraded through the streets of Petrograd as a utopian symbol of the hope of leaping into a future, more advanced socialist society. By the mid-1920s, however, a number of critics and theorists had begun to criticize the prominence of models in contemporary culture, claiming that they reflected artists' preoccupation with conceptual and formal issues at the expense of engaging in real, practical work in tackling the problems of Soviet everyday life.[46]

Made in 1924, but set in 1921–3, *Aelita* also used models to comment on the utopian fantasizing that some critics felt dominated the early-Soviet years at the expense of real, practical work. In one scene, Los´ and his colleague Spiridonov carefully appraise a schematic blueprint, which is surrounded by a number of mechanical tools that remain unused. Throughout the film, Los´ rarely engages in physical labour. By contrast, Natasha is involved in a number of manual tasks. In one scene, she is depicted, with her sleeves rolled up, performing various household chores, while in others she is involved in the practical organization of social work, giving out food to the homeless, caring for children at an orphanage and registering peasants at the Evacuation Centre. The gendered division of work is notable throughout the film.

In a scene which shows Gusev and his fiancée Masha in their apartment in a requisitioned former private mansion, Gusev slouches in a chair with his feet up, while Masha is pictured at her sewing machine.[47] Furnished with high-backed gothic chairs and a classical white marble statuette, the interior closely resembles the studies in Bauer's films. The same statuette also appears in Los''s apartment, where it is placed surreptitiously on top of a dresser that is pushed to the back of the bedroom. On one level, the inclusion of the statuette in such a marginalized position represents the replacement of a traditional form of modelling with a new Soviet one. On another level, however, the statuette's presence serves to comment on the nature of Los', who, much like Bauer's male protagonists, is absorbed in his personal fantasies. The triumph of a new society founded on practical work rather than on the old order based around intellectual speculation is depicted in one of the final sequences in which a bare-chested worker hammers miniature models of classical architecture into a sickle. Moreover, at the end of the film, Los' abandons his extraterrestrial fantasies, removing his plans to build a rocket from their hiding place in the living room's mantlepiece and throwing them onto the fire, before announcing to Natasha 'Enough dreaming! Different work – real work – awaits us all!'.

The conflict between a person's everyday working life and their fantasy dreamworld is also a key theme of the Leningradkino studio's 1926 adaptation of Nikolai Gogol''s short story *The Overcoat* (Shinel', 1842), which was made by members of the Factory of the Eccentric Actor collective (Fabrika Ekstsentricheskogo Aktera, FEKS), including the directors Grigorii Kozintsev and Leonid Trauberg, the camera operators Evgenii Mikhailov and Andrei Moskvin, and the production artist Evgenii Enei. Gogol''s story tells the tale of Akakii Akakievich Bashmachkin, who lives a demeaning existence as a copyist until he allows himself to dream of acquiring a new overcoat. As a number of scholars have noted, Iurii Tynianov's film scenario deviated significantly from the original narrative and incorporated episodes from a number of Gogol''s texts, as reflected in the film's full title *The Overcoat, a Film-Play in the Manner of Gogol'* (Shinel', kino-p'esa v manere Gogolia).[48] Tynianov's creative reworking of Gogol''s writings recalls the way in which, as Rachel Morley notes, Bauer drew on and adapted nineteenth-century Russian literary sources in his films.[49] Most notably, Tynianov made use of Gogol''s short story *Nevskii Prospect* (Nevskii prospekt, 1831–4), which tells of a romantic young artist who becomes obsessed with a woman whom he once glimpsed on Saint Petersburg's streets. Indeed, the film's opening scenes are directly based on an episode in

Nevskii Prospect in which the artist pursues the woman of his dreams, only to discover that she is a prostitute. Thus, from the outset, the film foregrounds both the theme of fantasy and Akakii's nature as a dreamer and not his profession as a copyist. The filmmakers employed a number of innovative techniques to represent the phantasmagorical nature of Akakii's visions. In particular, Enei's surreal sets of Saint Petersburg, with their distortions of scale and stylized forms, play a crucial role in establishing a dream-like atmosphere and in conveying Akakii's anxieties and desires.[50]

The conflict between Akakii's wretched existence as a copyist and his fantastic desires is played out through the different sets of the two spaces directly associated with his working life: the bureaucrats' office and his private room. The office scenes emphasize the inconsequence of both Akakii himself and his bureaucratic work. Establishing shots of the office show rats gnawing neglected paperwork and a nondescript room with employees, heads bent and faces hidden, arranged around identical rows of desks. Seated behind a desk that is separated from his colleagues and marginalized to one side of the room, Akakii is hardly visible, his face obscured by a high stack of papers. As he leaves the office at the end of the day, he appears as a minuscule silhouette, barely identifiable, standing at the end of a vast corridor. Throughout the film, Enei exploits exaggerations in scale in his sets to emphasize Akakii's impotence and insignificance. In the sequences set in the Saint Petersburg streets, for example, Akakii is dwarfed by towering fences, buildings and statues.

In contrast to the banality and anonymity of his office existence, Akakii's personality as an individual is expressed in the décor of his private room. It is here that his emotional and psychological states are also revealed to the viewer. The focus is on the pleasure he gains from both his work and his fantasies. Recalling Los′'s study in *Aelita*, Akakii's room, with its single, sunken window and claustrophobic dimensions, which are emphasized by the use of medium and close-up shots, is a private, intimate realm. Despite its small dimensions, the room is not, however, a space of discomfort. A curtain and a small vase of flowers adorn the window and a high stack of pillows rests on the bed, conveying, as Emma Widdis notes, Akakii's pleasure in simple comforts.[51] In contrast to the bureaucrats' office, in Akakii's room his desk assumes a prominent position in the centre of the composition, reflecting Akakii's perception of the importance of his work and its centrality to his life. In one sequence, he sits at his desk copying a document and strokes his face sensually with a quill. Directly behind

his head, a surreal teapot of exaggerated proportions appears to hover in mid-air, resembling an apparition more than a tangible object. Dense clouds of steam emanate from its spout and engulf the room, signalling the transference into Akakii's dream world.

A significant part of Akakii's dream takes place in the bureaucrats' office. In Akakii's fantasy, the rows of desks have been replaced with an absurd combination of people and objects, including circus performers, water fountains and a harp player. These serve to communicate not only the fantastic nature of the sequence but also the artifice of the bureaucratic system. Soft-focus cinematography and various lens effects, achieved through methods such as applying lubricant to the edges of the lens, are used to blur objects and to heighten their surreal quality.[52] Akakii's dream world also has erotic overtones. At the centre of the room, lying on an enormous mattress is the woman who has occupied Akakii's imagination from the opening scenes of the film. Although the office has become emphatically a place of pleasure, Akakii's desk now occupies a prominent position in the foreground of the frame. This detail serves to remind the viewer of the pleasure that Akakii takes in his work, which acts as a stimulus to his dream. As the dream develops, it takes on a sinister dimension, however. The work instruments, which Akakii had previously fetishized in the comfort of his study, are turned against him. Akakii's colleagues throw sword-like quills at his body, which becomes trapped under their sheer mass, vividly symbolizing the central theme of Gogol''s story: the crushing of the 'little man' at the hands of bureaucracy.

A number of films of the mid- to late 1920s attacked the ludicrous pretensions and overbearing weight of Soviet bureaucracy through using hyperbole and exaggeration in their set design. In *The Old and The New* (Staroe i novoe, 1929), for example, in the scenes that take place in the agricultural ministry, objects are shot at extreme close-up and take on gigantic proportions: the giant spool of a typewriter appears to jut violently towards the viewer and a hefty book of legislation dominates the frame. Similarly, in *Don Diego and Pelageia* (Don Diego i Pelageia, 1928), work desks and regulation books acquire enormous dimensions. It is notable that in both films the bureaucrats' office is decorated with statue busts, figurines and paintings of individuals in positions of power. Just as Bauer used statuettes to convey the extravagant lifestyles of his male protagonists, the inclusion of highbrow artworks alludes to the decadence and artifice of the bureaucratic system.

Statues are also a recurring feature of Enei's sets for *The Overcoat*. As Akakii wanders the streets of Saint Petersburg, he encounters a number

of statues.⁵³ Shot in close-up and from a low-angle, they tower over Akakii, conveying his impotence in the face of power structures. As Valentina Kuznetsova notes, the scene in which the Bronze Horseman statue of Saint Petersburg looms over Akakii has distinct visual parallels to Aleksandr Benua's [Benois] 1905 illustrations of Aleksandr Pushkin's *poema The Bronze Horseman* (Mednyi vsadnik, 1837), which depict the horseman, silhouetted by the night, rearing over an individual, doubtless the poor Evgenii, another example of the 'little man' trope in nineteenth-century Russian literature.⁵⁴ In addition to the Bronze Horseman, Enei portrays statues from a range of historical and cultural traditions, including an Egyptian sphinx and a classical emperor, in a generic pose of power. Thus, the statues serve to critique not only Imperial Russia, but also overarching power systems in general. In contrast to the model in *Aelita*, which symbolizes the agency of individuals in creating a future new society, the statues in *The Overcoat* reveal their impotence against existing power structures.

Industrial settings and cinematic expressivity:
Engineer Prait's Project *(1918) and* Strike *(1925)*

The clash between ordinary working-class citizens and authoritarian systems of control was a consistent theme in Soviet films of the mid- to late 1920s that were set around the industrial workplace and portrayed workers' life (*rabochii byt*). One of the ways in which filmmakers effectively conveyed these social tensions was by juxtaposing the space of the factory work floor with that of the industrialists' private office. In contrast to the studies analysed earlier in this chapter, the offices of factory managers were designed principally to convey notions of authoritarian control. The private office also continued to be associated with individual desires. Pleasure was not solely identified with the private office, however. Many films set against industrial backdrops portrayed pleasure as an essential aspect of workers' experience.

One of the first Russian fiction films to make use of industrial settings was the Khanzhonkov studio's *Engineer Prait's Project* (Proekt inzhenera Praita, 1918), on which Lev Kuleshov worked as director and production artist, alongside the camera operator Mark Naletnyi. Kuleshov also co-wrote the film's scenario with his brother Boris Kuleshov, who drew directly on his experience as an electrical engineer.⁵⁵ The film tells the story of the American engineer Mark Prait, who develops a plan to turn peat into a cheap and readily available energy source to

fuel a Soviet power plant. As Robert Bird notes, the theme of peat production as a means for advancing the electrical capacity of Russia featured in a number of artistic and literary works of the early-Soviet period.[56] According to Bird, many of them glamorized peat production, representing 'peat and its associated lifestyle as objects of social and individual desire'.[57] Similarly, the scenario of *Engineer Prait's Project* dramatized peat production, turning it into a romantic thriller, which, as Kuleshov recalls in his memoirs, combined car chases, accidents, intrigue and 'a simple love story with a happy ending'.[58] The film's visual aesthetics and set design equally served to glamorize peat production through focusing on the opulent lifestyle that industrialization enabled.

Engineer Prait's Project was Kuleshov's directorial debut, which he seized on as an opportunity to experiment with various cinematographic and editing techniques.[59] As Cavendish has noted, the film showcased several innovations, including rapid editing and the dynamic use of an iris.[60] Additionally, Kuleshov experimented with the mise-en-scène and set design. His use of location filming at industrial sites and the attention he gave to factory machinery and technology were also novel.[61] By combining different locations with particular infrastructure and people, he created what he described as a 'new cinematic terrain'.[62]

Despite these innovations, however, Kuleshov's approach to set design, for the most part, continues to follow the distinct method that Bauer had developed and that he had trained in. His use of architectural forms to create a sense of deep perspectival space, for example, is closely derived from Bauer's set design approach. In the scenes that take place on the platform of a railway station, a series of steel pillars recede far into the background to create a sense of never-ending space, recalling how Bauer used classical columns in films, including, most notably, *A Life for a Life*. Kuleshov also continues to use *dikovinki* for their narrative and symbolic significance. In the interiors of the oil magnate's home, a statuette of a female nude, elevated on a pedestal, dominates the foreground of the frame, conveying the decadence and the dissolute values of aristocrat industrialists. In addition to this typical Bauer object, Kuleshov also uses mechanical devices as *dikovinki*. In one scene which takes place in Prait's office, the keys to the peat processing plant act as *dikovinki*, serving to emphasize Prait's technical expertise. As Bauer had previously used floral and decorative textiles, now Kuleshov exploits industrial material, such as the overlapping grid-work of electricity cables, to create visual patterning. Close-up shots and the use of an iris serve to highlight industrial objects and to emphasize their cinematic potential. Thus, Kuleshov draws on many of the same techniques that

Bauer had developed in his films, but adapts them to the new context of industry.

Engineer Prait's Project in many ways provided a prototype for early-Soviet dramas set in the industrial workplace. Kuleshov's exploitation of industrial material as an expressive cinematic element would be adapted and developed by a number of production artists working in the 1920s, including most notably Vasilii Rakahl´s in his sets for the Goskino studio's *Strike* (Stachka, 1925). As the first feature film that Sergei Eizenshtein directed, *Strike* is typically analysed as an example of his early montage theory.[63] As Cavendish argues, however, it is also remarkable from an aesthetic viewpoint in terms of the cinematography and the mise-en-scène.[64] The film also displays a number of innovations in its set design and use of industrial settings. Indeed, contemporary critics and filmmakers celebrated *Strike* as an example of a new Soviet approach to set design that was untainted by foreign and pre-revolutionary influences. For the filmmaker Sergei Iutkevich, the sets Rakhal´s created inaugurated a new form of 'cinema-constructivism' (*kino-konstruktivizm*) to replace the 'stylized tinsel' of *Aelita* and the 'cardboard expressionism' of the Weimar film *The Cabinet of Dr. Caligari*.[65] In his 1925 article 'The Role of the Production Artist in Filmmaking', an anonymous critic similarly praised Rakahl´s' use of real objects and structures for providing a new design approach that contrasted with the 'absurdity of the artistic-decorative aspect' of *The Cabinet of Dr. Caligari* and the 'aesthetic Constructivism' of *Aelita*.[66] He also argued that Rakhal´s' stark sets departed from the decadent use of objects that characterized the pre-revolutionary films of the Ermol´ev and the Khanzhonkov studios.

Although critics praised *Strike* for providing a new, and specifically Soviet, approach to design, I argue that a blend of pre-revolutionary and early-Soviet influences deriving from various artistic fields informs its set aesthetics. As we recall from Chapter 3, Rakhal´s had begun his career as a production artist in 1915 working for the Khanzhonkov studio under Bauer and alongside Kuleshov. This early cinema experience is discernible in his treatment of cinematic space. Drawing on the lessons he learnt from Bauer, Rakhal´s employs architectural structures such as glass-panelled doorways, columns and monumental staircases to frame the action. In several scenes, backlighting renders these structures as silhouettes and creates the impression of a frame within a frame, which serves as a self-referential device that draws the viewer's attention to the act of looking at a constructed image. In one notable scene, workers' bodies and mechanical apparatus appear silhouetted against

the factory's glass wall, which fills the entire frame, recalling Vladimir Balliuzek's use of glass windows in *The Maidservant Jenny* (Gornichnaia Dzhennii, 1918), as discussed in Chapter 3. In comparison to the scene in *The Maidservant Jenny*, the glass wall in *Strike* has a stark grid structure and human activity is compartmentalized into discreet zones, alluding to the regulation of working life under the oppressive bourgeois industrialists (Figure 4.3).

Rakhal´s also drew on Bauer's approach of employing architectural features and multiple planes of action to create an impression of deep perspectival space on screen. In a number of scenes, diminishing arcades, city walls or metal railings lead the eye towards the back of the frame. In contrast to Bauer, however, Rakhal´s also employs strategies that confuse the sense of deep perspectival space. In one scene in the factory corridor, for example, a series of open doors disrupts the impression of receding depth provided by a long shot of a corridor. Later in the film, paper is strewn across the corridor floor, functioning in a similar way to the doors by attracting the viewer's attention and distorting the sense of perspective (Figure 4.4). Widdis observes that in the 1920s a number of Soviet filmmakers played with models of spatial

Figure 4.3 *Strike* (Stachka), directed by Sergei M. Eizenshtein © Proletkult – Groskino 1925. All rights reserved. Photo courtesy of TCD/Prod.DB/Alamy Stock Photo.

4. *The Workplace* 131

Figure 4.4 Factory corridor. *Strike* (Stachka), directed by Sergei M. Eizenshtein © Proletkul´t – Groskino 1925. All rights reserved.

depth, resonating with a widespread artistic interest of the 1910s and 1920s in investigating space as a pictorial construct.[67] For example, from 1919, El´ Lisitskii began to create axonometric compositions of two- and three-dimensional architectonic forms, which he referred to as *Prouns*, an acronym for *Project of the Affirmation of the New* (Proekt utverzhdeniia novogo).[68] As in *Strike*, the ambiguous sense of perspective in Lisitskii's *Prouns* works to disorientate the viewer and to defamiliarize conventional ways of looking.

A number of set techniques in *Strike* also have notable visual parallels to those found in Soviet performance design. The incorporation of industrial scaffolding distinctly recalls Liubov´ Popova's open-lathe constructions for Vsevolod Meierkhol´d's 1922 production of *The Magnanimous Cuckold* (Velikodushnyi rogonosets).[69] Popova developed these structures in order to facilitate more diverse movements from actors.[70] In *Strike*, industrial scaffolding similarly works to fragment human bodies and objects and to enhance movement across the frame. In a number of scenes, workers are shown descending from industrial structures, their bodies intertwining with the metal framework. As in Bauer's films, spatial hierarchies convey differences in social class. Here, however, it is the workers who are repeatedly portrayed occupying high points, while spaces belonging to the wealthy industrialists are

positioned at the bottom of staircases, suggesting a reversal of power relations.

While Rakhal´s' sets draw on a number of pre-revolutionary and theatrical techniques, they are novel, I argue, in terms of the ways in which industrial settings are used to show workers' life as photogenic and to convey a socialist ideological message about labour. Building on Kuleshov's work in *Engineer Prait's Project*, Rakhal´s exploited industrial infrastructure to create striking visual patterns. Perforated steel grilles and the metal struts of electricity pylons dissect the frame into geometric configurations. In one scene, a curtain of thick ropes fills the frame, transforming it into an abstract linear canvas. In another, a mound of enormous steel wheels creates an abstract circular composition. Indeed, Kuleshov remarked on the striking pictorial compositions of *Strike*'s frames, and referred to Eizenshtein as a director of the individual frame.[71] Throughout the film, geometric patterns are repeated across frames in varying scales and configurations to provide a sense of visual cohesion. The circular form of a mechanical wheel, for example, reappears in the image of a dynamo, a clock-face, wooden barrels and an arched trapeze. It is notable that circular forms recur in those scenes associated with the striking factory workers, serving to convey ideas of motion and change. By contrast, strict linear formations, such as grids and vertical bars, dominate the scenes depicting the industrialists, expressing their authoritarian control and restriction of workers' rights. In the industrialists' offices and meeting rooms, for example, vertical lines appear in the form of fluted columns and the stacks of books. Similarly, a grid pattern is repeated in the parquet floor, the fabric of the chairs, the embossed surface of glassware, the banisters of a staircase and a map.

Rakhal´s' approach to set design in *Strike* is also novel in terms of the ways in which he uses intangible elements such as movement and light reflections to create visual impact and to convey an atmosphere of workers' unrest.[72] In several scenes, industrial infrastructure, such as cooling towers and electricity pylons, is captured as reflections in glass or on the surface of water, acting as a visual manifestation of the phrase 'All that is solid melts into air' in *The Communist Manifesto* (1848) by Karl Marx and Friedrich Engels. The way in which these reflections subtly distort industrial structures creates an impression of instability and imminent change. Doorways, staircases and landings facilitate the flow of movement, giving rise to a sense of volatility. Whirling machinery and jets of water fragment bodies and objects into an array of splintered forms. As several scholars have noted, this approach recalls Natal´ia

Goncharova and Mikhail Larionov's Rayonist paintings of the 1910s, in which bodies and objects are rendered as dynamic, intersecting rays of vivid colour.[73] In these works, Goncharova and Larionov attempted to capture the energy that emanates from living organisms.[74] Similarly, in Strike the emphasis on the power of machinery and of workers conveys the force of labour. Throughout the film, there is a distinct focus on labour as a collective force, rather than a form of industrial production for creating a specific output. This perhaps reflects a response to the challenge that the filmmakers faced in representing the pre-revolutionary factory from a post-revolutionary perspective. As Anne Nesbet notes, the filmmakers could not depict labour conditions or industrial production in negative terms, as these had changed little since the 1917 Revolution.[75] Through highlighting the force of labour, however, the filmmakers could emphasize the power of workers to incite change without displaying the demeaning conditions of factory life. Eizenshtein and Rakhal´s' focus on the photogenic quality of the industrial workplace served a similar goal of presenting labour conditions in a desirable light.

Objects of desire and the workplace: Your Acquaintance *(1927) and* Golden Mountains *(1931)*

Rakhal´s' designs for the Sovkino studio's *Your Acquaintance* (Vasha znakomaia, 1927), originally titled *The Woman Journalist* (Zhurnalistka), employed many of the techniques that he had previously used in *Strike* and demonstrated a similar interest in the cinematic potential of the material environment of the workplace. Rakhal´s worked alongside Kuleshov as the director, the camera operator Konstantin Kuznetsov and the constructivist artist Aleksandr Rodchenko, who assisted with designing the sets and the costumes and framing the scenes.[76] As with *Strike*, the sets designed for *Your Acquaintance* generated considerable interest in the contemporary cinema press. Kuleshov and Rodchenko's writings also attest to the importance that the filmmakers themselves attached to the film as a formal experiment.[77] In his treatise *The Art of Cinema* (Iskusstvo kino, 1929), Kuleshov later claimed that *Your Acquaintance* served primarily as 'an experiment in creating a film based on contemporary, everyday life material'.[78] He even described it as an 'anti-film', which rejected the conventional narrative format of fiction cinema: 'In essence, it's as if nothing happens in the film. The actors (principally Khokhlova) just live, and the camera carefully follows what

happens with meticulous attention to detail'.[79] According to Kuleshov, the film provided an opportunity to continue to explore many of the techniques that he had developed in *By the Law* (Po zakonu, 1926), including using a Spartan approach to set design, based on maximum economy of objects and simplicity of expression.[80]

Surviving production records demonstrate the filmmakers' concern to create an economical film, detailing that they spent just 3,763 rubles on props and studio sets.[81] They also illustrate the attention that the filmmakers paid to set details. As Widdis notes, the wealth of information documenting the sets is far greater than that which survives for other fiction films of the era.[82] Lengthy expense receipts itemize the amount spent on each of the various props, while shooting plans reveal that the filmmakers devoted considerable time to preparing and shooting certain sets, such as the newspaper editor's study and the reporters' office, which required nineteen and twenty days of work, respectively.[83]

Although the film does not survive in its entirety, extant footage demonstrates the filmmakers' interest in experimenting with the formal properties of sets and their cinematic expressivity. This is evident in what Widdis describes as the film's 'play with the specificity of cinematic space' (Figure 4.5).[84] In her reading of the film, Widdis details the various strategies which the filmmakers used in order to create both scenes that enhance the sense of spatial depth and those that draw the viewer's attention to the surface of the screen.[85] Many of these techniques have

Figure 4.5 The journalists' office. *Your Acquaintance* (Vasha znakomaia), directed by Lev Kuleshov © Sovkino 1927. All rights reserved.

4. The Workplace

a clear precedent in the approach to set design that Rakhal´s adopted in *Strike*, and highlight the importance of his involvement on *Your Acquaintance*. As a striking example, in the scenes that take place in the journalists' office, paper strewn across the floor shines brilliantly in the light, attracting the viewer's attention and disrupting the impression of receding spatial depth, distinctly recalling the way in which Rakhal´s used sheets of white paper in the corridor scenes in *Strike*. For Widdis, such scenes create 'a different kind of sensory spectatorial engagement' by drawing the viewers' eye to the *faktura* of the material environment on screen.[86]

It is precisely in this close attention to the material properties of objects and structures that *Your Acquaintance* departs from Rakhal´s' work on *Strike*. As Widdis argues, 'the *faktura* of sets, props and costume remains a consistent preoccupation' in the film.[87] Kuleshov himself admits that when he again came to concentrate on set décor in the late 1920s, following his earlier experiments with montage, his former concern with creating perspective was superseded by one with enhancing the material quality of objects and surfaces.[88] In his writings on set design, Kuleshov argued that 'the better the surface finish of the set, the better and more genuine the effect'.[89] He explained how in *Your Acquaintance* the filmmakers experimented with a number of techniques to make the properties of various materials appear more pronounced: different waxes, paints and varnishes were applied to objects and structures to accentuate their textures and create a variety of smooth, regular and coarse surfaces. Several sequences in the film seem to have little, if no, narrative importance, but rather are designed to exploit the cinematic potential of various materials. Widdis describes one notable sequence in which, after Khokhlova has been fired, she takes a final tour of the newspaper reporters' office, touching its different surfaces and objects – some metal scissors, a glass decanter, a crumpled paper note and discarded cigarette butts.[90] Here, the set becomes what Sarah Street terms a 'performative arena', as discussed in Chapter 3 in relation to Bauer's interiors in *Iurii Nagornyi* (1916);[91] Khokhlova's body is an essential feature of the mise-en-scène, drawing the viewer's attention to particular elements of the décor in a way that exceeds the immediate demands of the narrative.

During the mid- to late 1920s, a number of artists and critics professed an interest in the photographic potential of the material environment. In 1928, Rodchenko began taking a series of experimental photographs that focused on the play of light on glass surfaces.[92] In the same year, in an article entitled 'The Thing on the Screen' (Veshch´ na ekrane),

the critic N. Kaufman marked out *Your Acquaintance* for its attention to the material objects of everyday life.⁹³ Drawing on the writings of the French Impressionist filmmaker Louis Delluc, Kaufman argued that the filmmaker's task was to reveal aspects of the material world which normally go unnoticed by the human eye. Kaufman's pronouncement echoes Viktor Shklovskii's calls for filmmakers to show workers' life as photogenic. In a 1927 article titled 'Wool, Glass and Lace' (Sherst´, steklo i kruzheva), Shklovskii praised films of contemporary workers' life in which material was clearly expressed and 'real life displayed real photogenicity'.⁹⁴ The interest in the photogenic quality of workers' life was associated with a belief, widely held among Soviet artists, that altering a person's perception of the material world would lead to a new appreciation of and heightened engagement with their surrounding environment. Rodchenko explicitly addressed this idea in his article 'The Production Artist and the Material Environment in Fiction Cinema' (Khudozhnik i material´naia sreda v igrovoi fil´me), which he wrote in the same year as he worked on *Your Acquaintance*, declaring that the production artist's task is to find '*a characteristic object which has not been filmed before and shows this ordinary thing from a new point of view, as it has not been shown before*' (emphasis in original).⁹⁵ The photographs that he used to illustrate the article act as visual manifestos of this idea, portraying the glass walls and steel girders of the Sovkino studio from unusual vantage points.⁹⁶ Thus, in *Your Acquaintance* the formal strategies of set design were linked to an ideological agenda to produce a new relationship between Soviet subjects and their surrounding material environment.

Your Acquaintance was remarkable not only because of the formal properties of its sets, however. In a report written in 1927, Shklovskii praised the filmmakers for depicting a sphere of work – journalism and the press industry – that was rarely portrayed in Soviet fiction films.⁹⁷ Moreover, as Nikolai Lukhmanov later noted, in the 1929 version of his article 'Life as It Ought To Be' (Zhizn´ kak ona dolzhna byt´), *Your Acquaintance* was one of the few fiction films which provided a model of the Soviet workplace that was informed by principles of rationalization.⁹⁸ Lukhmanov's article even juxtaposed a still of the newspaper reporters' office with a photograph of a typists' office at the Chief Economic Administration (Glavnoe ekonomicheskoe upravlenie, GEU VSNKh) to illustrate how the contemporary workplace could be rationalized further.⁹⁹ Critics also praised Rodchenko's designs for the journalist's private study, which, according to Aleksandr Lavrent´ev, included a bed that folded up into a cupboard, a work desk with a built-in radio, a

photo-card index and a light table for viewing slides and negatives.[100] As the head of the metal and the woodwork departments at VKhUTEMAS, Rodchenko promoted the creation of multi-functional furniture. Indeed, foldable beds and tables were among the most popular objects designed by his students.[101] In the workers' club interior that he constructed for the Soviet display at *The International Exhibition of Modern Decorative and Industrial Arts* (L'Exposition internationale des arts décoratifs et industriels modernes), held in Paris in 1925, Rodchenko incorporated a number of multi-functional objects and open-lath structures, including folding screens for projecting films and for displaying agitational material.[102]

Rodchenko's interest in ideas about rationalizing the workplace extended beyond furniture designs, however. During the mid- to late 1920s, he also worked to popularize the principles of the scientific organization of labour by collaborating with a number of publications: he designed the cover for the 1925 Russian edition of Frederick W. Taylor's *The Principles of Scientific Management* (1911); he co-edited the journal *Time* (Vremia) of the Scientific Organisation of Labour (Nauchnaia organizatsiia truda, NOT); and he contributed articles and designed covers for the journal *Let's Produce!* (Daesh'!, 1929). In many of his designs, Rodchenko used grid-like structures, similar to the open-lath partitions in *Your Acquaintance*, that, with their regular and geometric form, symbolized the rationalization of working life promoted by NOT. The open grid also appears in the partition he created for the bathing room in *A Doll with Millions* (Kukla s millionami, 1928), in which it served a utilitarian purpose to organize everyday routines.

In the light of Rodchenko's commitment to the goal of rationalizing everyday life, Lavrent´ev has argued that the sets for *Your Acquaintance* present 'Rodchenko's dream of a high-tech living space'.[103] Widdis also interprets them as 'a celebration of the revolutionary ideas of Soviet modernism, providing prototypical models of the "exemplary" (obraztsovyi) life that had not yet taken real form in Soviet Russia'.[104] However, a close examination of the film's design, I argue, suggests that its message about Soviet everyday life is more ambiguous than these scholars propose. The surviving scenes of the newspaper reporters' office depict it empty of workers. Disused worksheets and cigarette papers are strewn across the floor, while small bundles of refuse paper nestle in corners and around the base of tables and chairs. Production records reveal that the filmmakers spent a considerable amount of money on the waste paper, suggesting that they deemed its inclusion significant.[105] As the critic V. Kolomarov noted, the office mess stood

in stark contrast to Rodchenko's modern, streamlined furniture.¹⁰⁶ He argued that the filmmakers continued to present everyday working life in all its typical chaos and disorder. More recently, Oksana Bulgakova has argued that Khokhlova's movements in this space are awkward, chaotic and clumsy: 'The heroine does not know how to move in this organized, Constructivist space, and the film is built on her unskilful handling of things [...]. Her mobility is impaired, her everyday life is chaotic and she infects others with this chaos'.¹⁰⁷ It is also significant that in Khokhlova's room, the multi-functional furniture is juxtaposed with bourgeois knick-knacks, in particular a glass statuette of an elephant. Rodchenko noted the emphasis that the filmmakers placed on finding such a 'characteristic thing' (kharakternuiu veshch´), which would signify instantly to the viewer the 'frivolous' (legkomyslennyi) attitude of the heroine.¹⁰⁸ While the scenes that feature this prop have not survived, a glass elephant statuette was similarly chosen to adorn the dressing table of Liuda, who indulges in superficial desires, in *Bed and Sofa*, on which in 1927 Rakhal´s also worked as the production artist alongside Sergei Iutkevich.

Other objects in *Your Acquaintance* acquire special symbolic significance, most notably the striped scarf belonging to Khokhlova. In a production document, the *LEF* cinema critic Viktor Pertsov writes that the scarf held particular importance as an agent in the development of the relationship between Khokhlova and the editor, Petrovskii: the editor first recognises Khokhlova by her scarf, associating her with a new type of modern, Soviet woman; he purchases the scarf as a present for his wife in an attempt to revolutionize her in Khokhlova's image; later, Khokhlova forgets her scarf in the office of the editor, who uses its return as a pretext to visit her.¹⁰⁹ Pertsov even proposed that the film should be titled *The Striped Scarf* (Polosatyi sharf). In extant footage and film stills, the stripes of the scarf function as a recurring visual motif, appearing in the linear light patterns in the journalists' office and, as a frame still published in *Soviet Screen* demonstrates, the carpet in the hallway to Khokhlova's flat.¹¹⁰ However, as with Rodchenko's streamlined multi-functional furniture, the filmmakers use the scarf to make an ambiguous statement about Soviet everyday life. While the modern aesthetic of its monochrome stripes evokes ideas of the new Soviet woman and a rationalized lifestyle, its role in the film's narrative is connected with Khokhlova's negligence of her work and Petrovskii's betrayal of his wife.¹¹¹ In one scene, the scarf is also shown as an alluring consumer object, framed in the window display of a Moscow boutique next to other fashionable clothes. It is

significant that the reflections of light on the glass window disrupt its strict monochrome stripes.

With its combination of rationalized furniture, office mess and consumer items, how, then, are we to interpret the film's message about Soviet everyday existence? Kuleshov notes that during the production process Sovkino made the filmmakers revise the scenario several times, resulting in a number of compromises.[112] Additionally, Rodchenko bemoaned the inadequate resources available at Sovkino.[113] Kuleshov's statements about the film suggest, however, that its incongruous meanings were intentional. In promotional material, Kuleshov claimed that '*Your Acquaintance* will not be a perfect example of everyday settings'.[114] Rather, it would present 'a satire on *meshchanstvo*'.[115] In this respect, Kuleshov's statement that in *Your Acquaintance* he continued to explore many of the same concerns that he had while making *By the Law* is also significant. As in *By the Law*, the film examines the conflict within individuals between their inner desires and social codes and responsibilities. I argue that the multiple and contradictory meanings present in the objects and the sets in *Your Acquaintance* convey the struggle that individuals face as Soviet citizens living in a new Soviet reality, but continuing to experience distinctly un-Soviet amorous desires, idleness and a weakness for the pleasures of consumerism.

The importance of certain objects as symbols of desire is also explored in the Leningrad Soiuzkino studio's *Golden Mountains* (Zlatye gory, 1931), which was directed by Sergei Iutkevich, with sets designed by the production artist Nikolai Suvorov. The film's scenario, written by Andrei Mikhailovskii and Vladimir Nedobrovo, follows the oppressive treatment of factory workers at a metallurgical plant in Saint Petersburg in 1914. In an attempt to gain the loyalty of one worker, Petr, the factory manager presents him with the gift of a pocket watch. Captivated by the pocket watch and its lure of increased social status and responsibility, Petr remains ignorant of the factory management's abuses. After witnessing the unjust arrest of a colleague, however, he is converted to the revolutionary cause. Thus the film's narrative focuses on the conflict that individuals experience between their personal aspirations and their social duty to support working class interests. This conflict is played out primarily through Petr's relationship to the pocket watch, which acts as both a symbol of his individual desires and an index of his psychological evolution, just as the striped scarf does in *Your Acquaintance*. In its concern to encourage the apolitical individual to develop an understanding of and sympathy for the socialist cause, *Golden Mountains* presents a prototype of the Socialist

Realist narrative in fiction cinema.[116] It is striking that, as in *Your Acquaintance*, the workplace is figured not as a space of physical labour and production, but instead as a site in which individuals are forced to negotiate the struggle between their desires and social responsibility. The film thus corresponds with what Widdis describes as the growing calls in the late 1920s and early 1930s for 'a cinema of "*socialist feelings* (*sotsialisticheskikh chuvstv*)"' (emphasis in original), resulting in a shift in focus onto human psychology and emotions.[117]

Golden Mountains enacted a shift on a formal level, also. The filmmakers drew on set traditions of the 1910s and 1920s, but adapted them to forge a new aesthetic style that corresponded with the Socialist Realist concern for individual psychology. This is evident if we compare *Golden Mountains* with Iutkevich's previous film about an industrial workplace, *Lace* (*Kruzheva*, 1928), on which he worked as both production artist and director. As Widdis observes, in *Lace* production sequences of mechanical lace manufacture form a significant part of the film's visual impact.[118] By contrast, in *Golden Mountains* machinery barely features; instead, much as in Bauer's *The Alarm*, the focus is on creating a sense of atmosphere that would enhance dramaturgical tension and convey the psychological states of the workers. *Golden Mountains* was made in the midst of the First Five-Year Plan (1928–32). As in *Strike*, the filmmakers faced the problem of how to represent pre-revolutionary industrial conditions, which were still to be modernized. By focusing on individual psychology, the filmmakers could suggest that the problem of revolutionizing Russia's industrial production lay not in inadequate resources or infrastructures, but in the mentality of its workers.

The film's focus on human psychology is also partly a result of Suvorov's artistic background and training. Reflecting on his practice, Suvorov recalls how as a young artist at the Saratov School of Fine Art he was impressed by the works of the German Expressionist artists Käthe Kollwitz, George Grosz and Heinrich Zille.[119] In *Golden Mountains*, Suvorov drew on the approach of such artists, focusing on how representational techniques, such as contrasts in light and distortions in scale, could convey characters' psychological conditions. Hyperbolic structures dwarf workers, conveying their feelings of impotence. In one scene, Petr is forced to climb an elongated step ladder to reach the workers' strike meeting. After his attempt to disperse the gathering fails, he is framed standing alone at the bottom of the ladder, which towers above him, conveying his isolation from his comrades. Similarly, in the scenes set outside the factory premises in the Saint Petersburg

streets, the factory's walls loom over Petr and cast dramatic shadows, which obscure forms and plunge parts of the frame into darkness. As a result, any sense of conventional perspective is destroyed, producing a feeling of spatial disorientation that corresponds with Petr's confused mind. This sense of dislocation and confusion is heightened through atmospheric effects. The incorporation of smoke combined with the use of soft-focus cinematography further works to obfuscate forms and to distort distances. Suvorov's techniques recall Enei's approach to set design in *The Overcoat*, reflecting the close professional relationship of these two production artists, who worked alongside each another at Leningrad film studios in the late 1920s and 1930s.[120] However, while in *The Overcoat* Enei includes a number of set details in order to convey Akakii's psychological state, Suvorov's sets are remarkably stark. Several scenes incorporate only a single object, often framed in close-up against a dark background.

This approach is most striking in the sequence in which the factory manager presents Petr with the pocket watch. Here, the focus is specifically on the watch's allure as an object and how its presentation as a gift alters the relationship between the factory manager and Petr. Close-up shots show the manager slowly revealing the watch from a dark case; its lustrous silver body and chain glimmer, visually echoing the metallic buttons of the manager's waistcoat and the metal filling in Petr's teeth, and thus link the three. The shimmering metal of the characters' garments stands in for the factory machinery, which is conspicuously absent throughout the film. On receiving the watch, Petr is also presented with a waistcoat, which he puts on, covering his worker's shirt. The watch is therefore directly associated with class status and Petr's social aspirations.

To emphasize the watch's function as an alluring bourgeois status symbol, the filmmakers exploited not only its material, but also its aural properties. Made at a time of innovation in sound technology, *Golden Mountains* explores the relationship between sound and image.[121] When opened, the watch plays a recurring waltz. As Joan Titus notes, the film's composer, Dmitrii Shostakovich, had previously used the waltz as a background score in *New Babylon* (*Novyi Vavilon*, 1929) to convey the bourgeoisie's decadence.[122] In *Golden Mountains* the noise that objects make also serves to represent the psychological states of characters. The waltz's whimsical melody conveys Petr's entrancement, while its repetitive tune expresses the factory manager's attempt to regulate Petr's actions. Watches and clocks appear in a number of films of the 1920s that addressed contemporary working life. In both *Engineer Prait's*

Project and *Aelita*, for example, recurring images of clocks emphasize the contemporary timeframe of particular scenes and convey the dynamic pace of modern life. In films of the 1930s, however, clocks and watches began to be used to symbolize ideas about regulation. As Lilya Kaganovsky demonstrates, in Enei's sets for Grigorii Kozintsev and Leonid Trauberg's *Alone* (Odna, 1931) the alarm clock suggests the state's control over its subjects.[123] In contrast to *Alone*'s alarm clock, which calls the female protagonist to her social duties in the film's opening sequence, the pocket watch enchants Petr with the promise of increased social status.

As well as the clock, Suvorov reused a number of avant-garde symbols of the 1920s in his set designs and reworked them to convey ideas about control. Notably, the horizontal light patterns, which in *Your Acquaintance* functioned as a form of defamiliarization, were used in *Golden Mountains* for symbolic meaning to express the workers' oppression. In the scenes that take place in the office of the Baku factory manager, intense sunlight streams through the blinds, casting horizontal light patterns across the workers' bodies. In their resemblance to prison bars, the light patterns convey the workers' subjugated condition. Similar horizontal configurations of light recur throughout the film to emphasize the theme of control. In the scene in which Petr stands next to the ladder leading to the workers' meeting, the ladder's rungs cast horizontal bars of shadow behind him. Similarly, grid configurations, which filmmakers had used in *Strike* and in *Your Acquaintance* as symbols for a rationalized approach to work, are used on a number of occasions in *Golden Mountains*. In the scenes set in the factory manager's residence, the grid appears in the form of the music rack of a grand piano, implying the bourgeoisie's oppressive nature.

During the 1930s, theatre set designers also reworked avant-garde visual tropes of the 1920s. Drawing on the aesthetic vocabulary of set designers of the 1920s, Vadim Ryndin in his scenery for the Chamber Theatre's 1933 production of Sophie Treadwell's *Machinal* (1928) used a series of grids to create a cage structure, which represented the restriction of individual rights that was a main theme of the play.[124] Rather than positioning them at various angles to one another, he placed each grid upright and stacked in ordered layers, creating a severe impression. As Margarita Tupitsyn argues, Ryndin's sets, in alluding to the similarity between the grid's geometric structure and a prison cage, endow the grid, as an 'abstract emblem of modernity', with an ideological meaning relevant to the increasingly hazardous political climate.[125] She further argues that this marked a shift away from the use in the 1910s and 1920s

of certain motifs as devices to explore self-reflexive questions about form and space to a greater interest in the late 1920s and early 1930s in their symbolic associations and their ability to convey a sense of mood and atmosphere. Correspondingly, while in *Golden Mountains* Suvorov drew on aesthetic approaches to set design developed during the 1920s, he adapted them to a new agenda of filmmaking that prioritized the psychological states of individuals.

Chapter 5

ARTISTIC ARENAS

From the earliest days of Russian fiction cinema, filmmakers used settings associated with artistic creation and performance, such as theatre halls, cabaret clubs, circus arenas, artists' studios and exhibition halls. On one level, the interest in representing artistic spaces was a response to the popular taste among cinema audiences for films that showed the glamorous and dynamic aspects of modern, urban life.[1] However, as Susan Felleman writes in her study of the ways in which post-war American and European films incorporate artworks, 'when a film undertakes the representation of "art" as a theme or engages an artwork as a motif, it is [...] entering into a contemplation of its own nature and at some level positing its own unwritten theory of cinema as art'.[2] On another level, therefore, filmmakers also used artistic settings in order to comment self-referentially on the nature of different artistic media and on cinema's status as an art. Ontological questions about the nature of different art forms were of great importance in the first decades of the twentieth century in Russia. As a number of historians of Russian art have noted, the period was one of intense artistic theorization.[3] These debates about art developed amid cinema's emergence as a new creative practice, which further intensified the climate of self-reflection, raising questions about different forms of visual perception, the creative potential of new technology and, particularly in the wake of the Revolution, art's social function and the artist's relationship to the state.

This chapter explores how Russian filmmakers represented a number of environments associated with the pictorial and performative arts as a means to engage with these contemporary debates. Specifically, it considers the settings of the artist's atelier, such filmmaking environments as the cinema studio and auditorium and the circus arena, which appeared in films on a number of occasions over the course of the 1910s and 1920s. A wide range of production artists – Vladimir Balliuzek, Evgenii Bauer, Vladimir Egorov, Dmitrii Kolupaev, Sergei Kozlovskii, Lev Kuleshov and Aleksei Utkin – engaged in representing such artistic spaces at certain points in their practice during this period, demonstrating a shared interest in using set design to articulate concerns

about artistic creation. Despite this common concern, however, they used artistic spaces in very different ways to voice a range of different preoccupations. Through examining filmmakers' changing engagement with artistic spaces, the chapter traces evolving perceptions of cinema's status as both an art form and an industry, as well as wider shifts in cultural preoccupations about artistic independence and the social function of art

The artist's studio

While the theme of artists in their studios had been popular since the Renaissance in European painting, in Russian art the genre was much less common.[4] As Rosalind Blakesley notes, depictions of artists' studios first appeared in the paintings of Ivan Firsov and Aleksei Tyranov in the late eighteenth century.[5] According to Blakesley, both Firsov and Tyranov used the theme to convey the status of artists as members of a cultural elite, employing compositions that challenged the social divide between the artists and the upper-class clients whose portraits they were engaged to paint.[6] In one of the first representations of an artist's studio in a Russian fiction film – the Khanzhonkov studio's *Behind the Drawing-Room Doors* (Za dveriami gostinoi, 1913) – the production artist Boris Mikhin adopted a similar strategy in his set design. The scenario, written by the film's directors, Ivan Lazarev and Petr Chardynin, follows a love intrigue between the artist Akhtyrin, his working-class model Nina and Elena, the daughter of the wealthy landowner Volotskii, who commissions Akhtyrin to paint her.[7] Jealous of Akhtyrin's romance with Elena, Nina attempts to destroy her portrait.[8] In telling this story, the narrative foregrounds concerns about the cultural status of artists, resonating with filmmakers' own desires during the 1910s to fashion themselves as members of a cultural intelligentsia.

While this film has received little critical analysis, several historians and critics have remarked on the formal innovations of Mikhin's sets, noting in particular the production artist's use of the *fundus* system and the way in which he incorporated paintings.[9] Made in 1913, *Behind the Drawing-Room Doors* was one of the first films in which the *fundus* was employed. In several sequences set in the artist's studio, Mikhin uses layers of curtains and wall partitions to create a sense of receding spatial depth, anticipating the way in which he would later use domestic furnishings to structure space in *The Kreutzer Sonata* (Kreitserova sonata, 1914), as discussed in Chapter 3. Additionally, Mikhin employs

canvas paintings as screens to create multiple layers of space and to increase the impression of height in the frame by drawing the eye to the space above the actors' heads.[10]

Mikhin used paintings not only as formal elements of the set, however; he also exploited their symbolic value in order to comment on Akhtyrin's position as a member of a cultural elite. It is notable that Akhtyrin maintains two studios, one in which the working-class model Nina poses for him and another in which he receives his aristocratic clients, such as Volotskii. In the first studio, paintings are left in disarray across the studio floor, with their backs turned to the viewer so as to hide the subject matter and to display instead the bare canvas and its wood support. Propped on the artist's easel is an unframed painting of humble peasant life, while a chalk portrait scrawled on the wall behind the canvas depicts the artist wearing a worker's flat-cap. These set details betray Akhtyrin's modest existence and working-class background. By contrast, his second studio contains paintings encased in heavy gilt frames that depict subjects from the academic tradition of art. It is also filled with props relating to high culture, including a suit of armour, a naval history painting, a classical bust, an anatomical model and a tapestry. Embroidered with the mythological figure of Hera and her peacock, the tapestry's subject alludes to the feeling of jealousy that Nina experiences when she discovers Akhtyrin's affair with Elena.[11] Decorated with rich velvets, an oriental rug and exotic palms, the interior more closely resembles a fashionable upper-class salon than an artist's studio. Similarly, the exhibition hall where Akhtyrin displays his works is decorated with classical marble columns and velvet drapery. The contrasts between the design of the two studios evoke the tension between Akhtyrin's working-class status and his ambitions to fashion himself as a cultured individual.

Mikhin's inclusion of specific paintings can be interpreted as a comment not only on the artist's cultural standing but also on the film viewer's cultural awareness. As Sergei Kozlovskii and Nikolai Kolin note in their manual on set design, early-Russian production artists had to rework paintings in black and white before including them in their sets, so that the camera could register the tones of the image accurately.[12] This suggests that production artists made a conscious decision about the specific artworks they included in films. It is notable that several of the paintings in the studio in which Akhtyrin receives his clients resemble works from the canon of Russian and European art history. The naval history painting is similar to those by the Russian Romantic artist Ivan Aivazovskii (1817–1900), who was renowned for

his seascapes.[13] Additionally, the female portrait, executed with loose brushstrokes and displaying a concern for the effects of light, closely resembles the paintings of the French Impressionist Pierre-Auguste Renoir (1841–1919).[14] With its walls lined with artworks that recall those by eminent artists, the studio set resembles the *kunstkammer* paintings that initially developed as a genre in early-Netherlandish art. As the art historian Victor I. Stoichita observes, *kunstkammer* paintings became popular in seventeenth-century European culture as a visual game of connoisseurship that would test the viewer's art historical eye and their cultural capital.[15] As with *kunstkammer* paintings, Mikhin's inclusion of well-known artworks in Akhtyrin's studio assumes a level of prior art-historical knowledge on the part of the film viewer and thus works to reaffirm their status as a cultured individual. This method of addressing the viewer as a cultured individual parallels, as we recall from Chapter 1, the way in which film advertisements of the early 1910s often referenced set design as being based on the paintings and drawings of eminent artists.

In *Behind the Drawing-Room Doors*, a number of the film's scenes also bear close compositional similarities to famous art works. In one sequence, Akhtyrin, Elena and a group of companions dressed in fashionable clothing picnic outside under the dappled light created by a tree in the extreme foreground, recalling Claude Monet's *Lunch on the Grass* (Le Déjeuner sur l' herbe, 1865–66).[16] Similarly, the sequence in which Akhtyrin and Elena boat on a lily-covered lake bears similarities with Impressionist paintings, such as Renoir's *Boating at Argenteuil* (La Seine à Argenteuil, 1873) and *The Skiff* (La Yole, 1875). As we recall from Chapter 3, Mikhin had studied in Paris in the 1890s, and he would have been familiar with the works of Impressionist painters from his time spent there, as well as from visiting Russian collections such as those of Ivan Morozov and Sergei Shchukin.[17] Reworking well-known compositions in paintings was a tactic that European artists had long used to affiliate themselves with a larger artistic tradition.[18] In his set designs, Mikhin appears to appropriate this strategy, similarly incorporating painted artworks and compositional techniques derived from the canon of art history to associate his practice as a production artist with the fine arts.

In the artists' studios that Vladimir Egorov designed for *The Picture of Dorian Gray* (Portret Doriana Greia, 1915) and *His Eyes* (Ego glaza, 1916), he similarly draws on strategies derived from painting in order to associate cinema with a fine art tradition. He also, however, adds another dimension to their significance, using them to explore ideas

about the nature of different forms of visual representation and cinema's specific expressive features as a medium. For his 1915 film adaptation of Oscar Wilde's 1891 novel *The Picture of Dorian Gray*, the director Vsevolod Meierkhol´d invited Egorov to work as the production artist, having previously collaborated with him at the Moscow Art Theatre (Moskovskii khudozhestvennyi teatr, MKhT). Although the film has not survived, production stills, contemporary reviews and filmmakers' memoirs demonstrate the attention that the filmmakers paid to the set design as a means to heighten the film's formal expressivity.[19] As several scholars have noted, *The Picture of Dorian Gray* self-consciously explores cinema's expressive potential and its artistic heritage in painting and the theatre: Philip Cavendish describes the film as 'a sustained enquiry into cinematic self-definition at the point where the theatrical and the visual intersect';[20] Anna Kovalova argues that it represents 'the first attempt to make a film with the emphasis on the poetics of the image, presupposing a genuine non-mechanical adaptation of the methods of theatre and painting to cinema'.[21] In the light of the filmmakers' self-reflexive interests, the ways in which they use specific motifs associated with visual representation – such as portraits and mirrors – and devise compositional strategies to depict the artistic realms of the painter's studio and the theatre auditorium have particular significance.

In her reading of the film, Kovalova argues that in Meierkhol´d's scenario the artist Basil Hallward is accorded a more significant role than in both Wilde's original novel and other adaptations of it.[22] Moreover, contemporary reviews and production stills suggest that Egorov's sets for Hallward's studio were styled in a highly unusual manner, which made the space stand out from the film's other settings. The art theorist Iakov Tugendkhol´d remarked on Egorov's use of black-and-white gamut screens to produce silhouettes and to enhance the play of shadow and light.[23] A still published in *Cine-Phono* (Sine-fono) illustrates how Dorian's portrait takes up the majority of the background, disrupting the impression of perspectival depth (Figure 5.1).[24] It is also notable that elements of the studio are repeated in the portrait, with the table in the room's foreground mirroring the painted piano in the picture, while the contours of the studio's walls are marked out in paint in the same sketchy manner as the portrait's brushwork. Such similarities create a sense of continuation between the pictorial space of the painting and the real space of the studio. According to Kovalova, Meierkhol´d specified that the studio sequences should be tinted in a sepia tone.[25] Together, these formal strategies would have undermined the impression of

5. Artistic Arenas

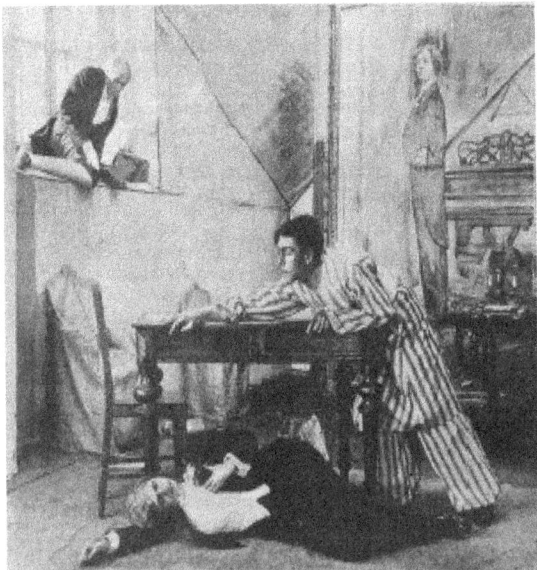

Figure 5.1 Basil Hallward's studio, *The Picture of Dorian Gray* (Portret Doriana Greia), published in *Cine-Phono* 21-22 (1915): 42.

photographic verisimilitude and drawn attention to the constructed nature of the scenes taking place in the studio, while emphasizing the space's function as an artistic realm.

Egorov's styling of the artist's studio corresponds to Meierkhol´d's denunciation of cinema as a photographic medium, which produced mimetic representations of the real world. Writing in 1912, the director argued that contemporary filmmakers, in their struggle against cinema's origins, borrowed methods from theatre and painting to associate film with established art forms:

> Cinema has undoubted significance for science, but when it is put to the service of art it feels its own impotence and in vain tries to justify the name 'art'. It therefore attempts to detach itself from the principle of photography; it recognises the need to justify the first half of its double denomination – 'theatre-cinema'. But theatre is an art, while photography is not. And cinema hastens to join in somehow with elements that are completely alien to it, to its mechanism, and so it tries to introduce colours, music, speech and song into its services.[26]

Meierkhol´d remained hesitant, however, about the tactic of drawing on existing artistic methods to overcome cinema's photographic and mimetic tendencies. In an article published in 1915, just a week before filming on *The Picture of Dorian Gray* began, he again expressed doubts about cinema's artistic potential and stated that in his work he intended to innovate cinematic techniques: 'My attitude towards the existing cinema is extremely negative. My immediate task is to investigate the methods of cinema that have not been used but undoubtedly lie concealed within it [...]. It is still too early to say whether cinema will be an independent art or subsidiary to theatre.'[27]

This desire to innovate is apparent in the sets that Egorov designed for the theatre auditorium in the film. Both contemporary critics and cinema historians have remarked on the formal inventiveness of the theatre auditorium sequence.[28] Sergei Iutkevich even wrote that the sequence 'revealed possibilities of cinema that were completely novel for the time'.[29] A production still printed in *Cine-Phono* in 1915 shows that, in the sequence in which Dorian, Lord Henry and Basil watch a performance of Shakespeare's *Romeo and Juliet* from their theatre box, the filmmakers positioned a mirror behind the protagonists' heads so as to reflect the performance while allowing the viewer to see the characters' expressions.[30] In a similar manner to the screens and canvases in the artist's studio, the mirror disrupts the impression of deep perspectival space; by reflecting the stage performance, it instead highlights the existence of space in front of the frame, an effect further emphasized through the programme that protrudes over the box edge. As Iurii Tsiv´ian notes, Russian filmmakers in the early to mid-1910s initially derived their use of mirrors from the precedent of painting, in which artists included them to inscribe the viewer into the pictorial space.[31] He argues that this was not a question of imitating painting, however, but an innovative tactic that demonstrated filmmakers' growing understandings of the specific features of cinematic space and how it differed from a theatrical model. Indeed, Egorov's set-design sketches for the film, which he later included in the unpublished text 'The Artist of Theatre Stage Scenery and the Artist of the Film Picture – Master of Decorative Staging' (Khudozhnik stseny teatra i khudozhnik kadra kino – mastera dekorativnogo oformleniia), reveal his concern for modelling cinema space in a way that departed from that used in the theatre (Figure 5.2).[32] His sketches for *The Picture of Dorian Gray* illustrate how he took into account the various angles at which the camera could be positioned when shooting certain scenes.[33] The mirror's significance is not only formal, however. As Tsiv´ian observes,

5. Artistic Arenas

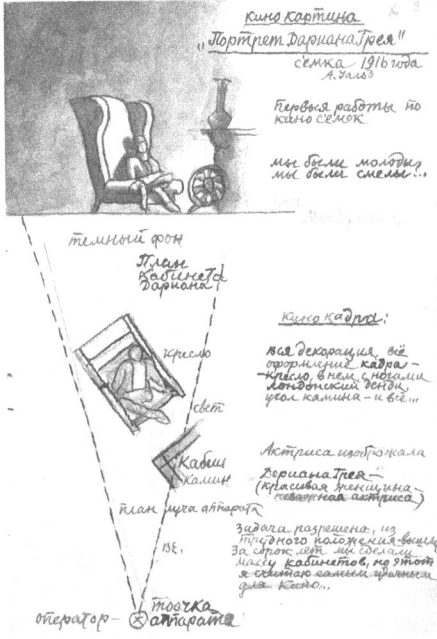

Figure 5.2 Vladimir Egorov, 'The Artist of Theatre Stage Scenery and the Artist of the Film Frame… What's the Difference?'. RGALI f. 2710, op. 1, ed. khr. 59, 8.

from around 1913 filmmakers also began to use mirrors in sets for their symbolic associations.[34] The image in the mirror shows Juliet on her balcony, repeating the architecture of the theatre box and thus functioning as a form of *mise en abyme*. This visual repetition in the form of a reflection evokes ideas about representational doubling and artistic mediation that are central themes in Wilde's text.[35]

In *His Eyes*, Egorov again paid close attention to how sets could be used to address ideas about the limits of visual representation in art. As in *Behind the Drawing-Room Doors*, the film's scenario follows a love intrigue between an artist and his model. Based on Aleksei Fedorov's novella of the same title, *His Eyes* tells the story of the artist Strel′nikov, who is blinded by his wife with acid after she discovers that he has fallen in love with his model. The film was part of the producers' *Russian Golden Series* (Russkaia zolotaia seriia), and they again capitalized on Egorov's expertise in set design to promote a more 'cultured' cinema. This is evident in the film's unusual opening, which, in the place of standard credits, shows the frontispiece to a copy of Fedorov's text with Egorov's name printed in bold next to those of the directors Viacheslav Viskovskii and Aleksandr Volkov.

Writing in *Theatre Newspaper* (Teatral′naia gazeta) in 1916, an anonymous critic noted that Egorov's sets for the artist's studio in *His Eyes* were particularly successful.[36] As in *The Picture of Dorian Gray*, Egorov uses screens and paintings to create an unusual play with perspectival space. In several scenes, an open doorway gives onto a view of the artist's studio, which is filled with paintings with their backs turned to the viewer so that only the wood supports of the canvases are visible. The stark contrast between the white canvases and the dark wood support recalls the black-and-white gamut screens that Egorov employed in *The Picture of Dorian Gray*. The turned backs of the canvases frustrate the process of looking, alluding to the film's subject of the loss of vision. This idea is also evoked through the half-finished drawings of a female nude pinned to the studio's walls, in which the soft pencil contours and light patches of shading render the female form barely perceptible. Egorov had previously used strategies to dematerialize and to obscure human forms in his theatre designs, notably for the MKhT's productions of Leonid Andreev's *The Life of Man* (Zhizn′ cheloveka, 1907) and Maurice Maeterlinck's *The Blue Bird* (Siniaia ptitsa, 1908).[37] In these performances, Egorov's layering of gauzes and screens made the human body appear as only a vague outline.[38] This technique was intended to evoke an atmosphere of loss, corresponding to the theme of death, which was central to both plays.[39] Egorov's design tactics also correlate with wider Symbolist thought on the disparity between sight and perception and its challenge to the primacy of visual expression. As noted in Chapter 1, contemporary critics even remarked on the 'cinematographic' nature of Egorov's designs in terms of the way they enhanced the interplay between shadow and light.[40] Egorov's continued interest in obscuring visual forms in *His Eyes* thus betrays his preoccupation with questions about visual perception and representation.

In a number of films that he designed as well as directed, Evgenii Bauer also explored questions about different forms of visual representation through depicting spaces such as painters' studios, photography darkrooms and theatre stages. Bauer's interest in painting's capacity to evoke aspects of the human condition, such as death, is evident in his earliest works in cinema. In 1913, he co-directed with Vitalii Brianskii and designed the sets for the film *Bloody Glory* (Krovavaia slava, non-extant), in which after a model commits suicide an artist attempts to paint her portrait. Bauer again explored the theme of painting's ability to represent death in *The Dying Swan* (Umiraiushchii lebed′, 1917). The film's scenario, written by Zoia Barantsevich, tells the story of Gizella, who is mute and who devotes

her life to ballet after the man she loves betrays her with another woman. Gizella quickly wins acclaim as a dancer for her interpretation of Mikhail Fokin's solo piece *The Dying Swan*, more commonly known by the French title *La Mort du cygne*.[41] On seeing Gizella's performance, the artist Count Valerii Glinskii, who is fixated on the idea of creating a painting on the theme of death, invites her to sit for him in her stage persona. In both its scenario and its visual aesthetics, the film demonstrates Bauer's close engagement with contemporary artistic discourses about methods of figurative and performative representation.

The film's scenario reflects the interest in the intersection between representation, death and eroticism in late-Imperial Russia among decadent writers, such as Andreev, and artists associated with Symbolist groups, such as the Blue Rose (*Golubaia roza*).[42] As Morley argues, Bauer parodies and ridicules this interest in death visually in the set he creates for Glinskii's studio: canvases depicting skeletons fill the room and an artificial life-size skeleton, positioned in the foreground in most of the scenes, acts as the *dikovinka*.[43] Decorated with flowers and urns, the studio is pervaded with a funeral atmosphere. In the corner of one canvas is a portrait of a grieving woman painted with sinuous lines. The subject and style of the portrait recall the works of the Norwegian artist Edvard Munch, whose macabre paintings that used female figures in mourning to express psychological pain influenced a number of Russian avant-garde artists such as Mikhail Vrubel´ and Elena Guro.[44] As Tsiv´ian argues, Munch's influence is also apparent in the insert shot in the sequence of Gizella's nightmare, which bears close iconographic similarities to the lithograph *Lust* (1895).[45]

The morbid feel of Glinskii's studio evokes ideas about the commemorative function of painting. Since the Renaissance, artists and theorists had commented on painting's role in preserving the memory of the deceased. In his treatise *On Painting* (De Pictura, 1435), the humanist theorist Leon Battista Alberti argued that 'painting has a direct power being not only able to make the absent seem present but even to make the dead seem almost alive after many centuries'.[46] In a number of his films, Bauer explores the capacity of visual representations to evoke the presence of the dead. In *Daydreams* (Grezy, 1915) Sergei Nedelin fills his study with paintings and photographs of his dead wife, while in *After Death* (Posle smerti, 1915) Andrei pines over a huge portrait of his deceased mother and a photograph of the dead actress Zoia Kadmina.[47] In her reading of *After Death*, Morley argues that while Andrei's photograph of Zoia 'remains an inert image', Bauer's cinematic

representation reanimates and revitalizes her, suggesting cinema's superiority to other art forms in bringing things to life.[48]

In *The Dying Swan*, I argue, Bauer similarly juxtaposes pictorial and cinematic representations in terms of their potential to convey a particular state of being. Like Andrei, who struggles in vain to evoke the living presence of Zoia in his photographs, Glinskii has limited success in capturing the true essence of death in pictorial form; rather than using the skeleton as a source of inspiration, he copies its figurative form in a crudely mimetic manner. As already noted, Bauer intends the viewer to recognize that his skeleton paintings are absurd. There can be no doubt that the naïve quality of the paintings expresses Glinskii's inability to distinguish between the real world and the realm of imagination and creativity. However, the simplified forms, bold contours and flattened space in Glinskii's paintings also recall the way in which during the 1900s and 1910s Russian avant-garde artists, such as those associated with the Union of Youth (Soiuz molodezhi, 1909–17), rejected formal precision and laws of perspective and reduced their imagery to a stock of basic symbols in their desire to express essential human feelings.[49] In their works, the Union of Youth artists questioned the merits of figurative painting in the service of mimetic representation and suggested an alternative artistic approach that exploited the expressive quality of colour, line and shape. Against this context, Glinskii's paintings can thus be read as a comment on the limits of figurative representation, and its capacity to express states of being and abstract sensations.

By contrast, Bauer emphasizes the expressive potential of performative and cinematic forms of representation in capturing feeling and emotion. Restricted by her inability to communicate verbally, Gizella uses dance as a medium to convey her sorrow at being betrayed.[50] In the sequence in which Gizella dances Fokin's *The Dying Swan*, she performs on a stage devoid of props and against a plain black background. Here, the focus is exclusively on the precise and fluid movements of Gizella's body, emphasizing its expressive capacity unaided by external accoutrements. The elegance of Gizella's body in motion contrasts starkly with the crude, static forms of Glinskii's paintings. In the 1900s and 1910s in Russia, Symbolist artists and writers placed great emphasis on the quality of movement in art: Pavel Kuznetsov referred to his paintings as visual symphonies;[51] and Viktor Borisov-Musatov argued that the more an artwork displayed 'musical qualities', the closer it was to the absolute.[52] Andrei Belyi even claimed that performance and music were more intuitive than the visual arts,

and could therefore express a person's spiritual and emotional reality more fully. In his 1910 Symbolist treatise, he declared:

> Movement is the basic function of reality. It rules over images. It creates these images. They are conditioned by movement... Beginning with the lowest forms of art and ending with music, we witness a slow but sure weakening of the images of reality. In architecture, sculpture and painting these images play an important part. In music they are absent. In approaching music, a work of art becomes deeper and broader.[53]

Bauer's framing of Gizella's dance sequence is also significant with respect to ideas about the expressive potential of performative and pictorial representations of the body. As Morley notes, while Bauer includes stage performances in a number of his films, the way in which he frames Gizella in *The Dying Swan* is unusual.[54] Unlike in his *Child of the Big City* (Ditia bol´shogo goroda, 1914) and in *Daydreams*, in which he films the stage from behind the heads of the audience, in *The Dying Swan* Bauer chooses to exclude the orchestra and the viewers from the frame.[55] Morley argues that Bauer's choice to shun verisimilitude creates the impression that Gizella's performance stands outside the film's narrative.[56] The dance sequence's extra-diegetic nature is further suggested through Bauer's choice of colouring. As Morley notes, according to Tsiv´ian, contemporary reviewers documented that in some of the prints of the film the sequence was tinted in various and constantly changing colours.[57] Bauer's approach to colouring recalls the American dancer Loie Fuller's *Serpentine Dance* (1892), in which her body was illuminated by multicoloured lights emitted from lanterns as she performed against a black background without scenery.[58] By accentuating the visual impact of colour and the body in movement, Bauer questions the primacy of mimetic representation and of cinema's function as a photographic representation of reality, demonstrating instead the medium's potential to produce an immersive visual experience.

In contrast to the way in which Bauer represents Gizella's performance, the sets and framing of Glinskii's studio work to emphasize the contrived nature of Glinskii's approach to representation. Gizella is made to pose next to an enormous bouquet of flowers on a podium, the edge of which is clearly visible, with the curtain behind left slightly open. These details serve to highlight the artificial nature of Glinskii's set-up. Contorted into an awkward pose, even Gizella's body appears

unnatural and artificial, emphasizing the fact that Glinskii is interested in representing not Gizella herself but her stage persona of the Dying Swan. It is Glinskii's inability to distinguish between Gizella as a real person and her stage persona that results in the film's tragic ending, in which Glinskii strangles Gizella when she no longer conforms to his ideal of a model.[59] After killing Gizella, Glinskii returns to his painting, and thus Bauer ridicules again the artist's reliance on figurative representation as a means to capture particular states of being.

Film studios and cinema theatres

After 1917 and, indeed, throughout the 1920s, artists' studios were very rarely depicted in fiction films.[60] The decline in interest in this previously popular artistic arena reflected a broader contemporary shift in Russian culture, in which many avant-garde creatives and theorists denounced the idea of the artist as a solitary individual, who created paintings for aesthetic pleasure from the confines of a studio.[61] In his polemical tract 'From the Picture to the Calico Print' (Ot kartiny k sittsu, 1924), Osip Brik, a prominent cultural theorist and leading member of the Left Front of the Arts (*LEF*), argued that painting was inextricably bound to capitalist ideology and no longer had relevance as an art form in Soviet society.[62] Similarly, in his 1926 text *Art and Production* (Iskusstvo i proizvodstvo), the Productivist theorist Boris Arvatov attacked easel art as a bourgeois tradition, defined by individualism and competition, and claimed that artists must abandon painting to work with technology and production.[63] A number of avant-garde critics and artists promoted experimenting with technologically advanced media, such as photography and film, in the place of painting. Lev Kuleshov argued in a 1922 article that, while painting led to a cul-de-sac, cinema was the art form most suited to modern life;[64] Brik similarly urged artists to study new developments in photography and film, arguing that they were the art forms most suitable for a modern socialist society.[65]

Against this climate of increasing opposition to painting and support for photographic media, filmmakers began to represent environments associated with film production and spectatorship in order to explore questions about cinema's nature as an art. One of the earliest fiction films to use the setting of a film studio to address explicitly the subject of filmmaking is the Ermol´ev studio's *Behind the Screen* (Kulisy ekrana, 1917).[66] The film survives only in part and information concerning its production and reception is scant.[67] The roles of scenarist and director

have been attributed variously to Aleksandr Volkov and Georgii Azagarov. Although it is not known who worked as the production artist, the set design is remarkable for the way in which the material environment of the film studio is used to comment on cinema's nature as both an artistic practice and a cultural industry associated with stardom.[68] In *Behind the Screen,* the well-known actor Ivan Mozzhukhin plays himself. The fictional scenario tells how Mozzhukhin loses his arm while attempting a stunt during filming, and is replaced as the studio's lead actor by a younger star.[69] Mozzhukhin is in despair, until the studio invites him to return to work as a director. In the extant scenes, Mozzhukhin and his wife, the actress Natal´ia Lysenko, who also plays herself, return to the film studio where they had previously worked and experience feelings of nostalgia for their former lives as film stars.

The sets created for the sequences that take place in the fictional film studio associate the world of cinema with a sense of modern glamour, while also serving to comment on film's nature as a form of visual representation. An enormous baroque mirror fills the main filmmaking arena, reflecting the studio's steel girders and high glass ceilings, as well as the hustle and bustle of the filmmakers working there. In comparison to the theatre auditorium mirror in *The Picture of Dorian Gray,* here the mirror dominates the frame, creating the impression of an all-reflecting background.[70] The mirror and its reflected image thus evoke the quality of a projection screen, which serves to make the viewer aware of different paradigms of looking and methods of mediating images. As the fictional filmmakers anticipate the arrival of Mozzhukhin and Lysenko, they peer through the glass walls of the studio, not only emphasizing the cult surrounding star actors but also specifically evoking the camera's mechanism as a glass-lens optical device through which filmmakers perceive the external world.

In addition to including self-referential optical devices such as glass and mirrors, the filmmakers incorporate different forms of artistic representation into the film-studio sets. A tapestry of ornately framed paintings decorates the studio's hallway from floor to ceiling. Representing a range of genres and executed in various styles, the collection of paintings recalls Mikhin's method of representing the artist's studio in *Behind the Drawing-Room Doors* and similarly works to associate cinema with the tradition of art history. Cinema's relationship to existing artistic traditions is also emphasized in the scene in which Lysenko prepares to leave her home to visit the film studio. Positioned between a self-portrait bust and a framed picture of herself with Mozzhukhin, Lysenko looks up at each of the works in turn, inviting

the viewer to draw a comparison between different representations of herself and how she appears before the camera. The filmmakers employ a similar strategy in the scene in which Mozzhukhin returns to his former dressing room. A torn publicity still of Mozzhukhin is pinned to the wall and others are stacked untidily on the table. The publicity stills portray Mozzhukhin in some of his most acclaimed roles in late-Imperial cinema, including as Germann in *The Queen of Spades* (Pikovaia dama 1916) and also as Prince Stepan Kasatskii in *Father Sergius* (Otets Sergii, 1918).[71] As Mozzhukhin leafs through the stills, his facial expression is reflected to the viewer in a mirror on the table. According to Aleksandr Deriabin, the shadow of Mozzhukhin's profile cast on the wall recalls the distinctive final sequence in *The Queen of Spades*.[72] The presence of shadows, reflections and torn publicity stills in the dressing-room sequence evokes ideas about the ephemeral nature of film stardom. Such images also contrast with the framed picture and classical bust in the actors' home which allude to Mozzhukhin and Lysenko's desire to preserve the memory of their former glory days. As in the sequence with Lysenko, the juxtaposition of numerous mediated images of the actor – Mozzhukhin himself, the publicity stills, the actor's image reflected in the mirror, the silhouette of his profile – again makes the viewer aware of different forms of representation and registers of looking. In a similar manner to Steven Jacobs' reading of close-ups of publicity stills in films, the prolonged shots of Lysenko and Mozzhukhin contemplating images of themselves disrupt the narrative flow of the film and create a moment of stillness that forces the viewer to focus on the character being presented to them and the actor's status as a star.[73]

The glamour myth associated with cinema is also addressed in the Mezhrabpom-Rus´ studio's *The Cigarette Girl from Mossel´prom* (Papirosnitsa ot Mossel´proma, 1924). On this film, the director and camera operator Iurii Zheliabuzhskii collaborated with the production artist Sergei Kozlovskii, continuing the partnership that they had formed in the late 1910s at the Rus´ studio. Vladimir Balliuzek assisted Kozlovskii with the set design. Immediately prior to working on *The Cigarette Girl from Mossel´prom*, Zheliabuzhskii and Kozlovskii had worked on *Aelita* (1924) with the writers Fedor Otsep and Aleksei Faiko, who also wrote the scenario for *The Cigarette Girl from Mossel´prom*.[74] As in *Aelita*, the film takes place in contemporary Soviet Moscow but conflates the boundaries between the fictive and the real. The scenario follows a fictional film crew as they attempt to produce a film on Soviet everyday life. While out shooting in Moscow's streets, the filmmakers

enlist the cigarette seller Zina as an extra in their production and the camera operator Latugin falls in love with her. Latugin secures a professional acting job for Zina and, before long, she becomes the star of her own film.

As a number of scholars have noted, *The Cigarette Girl from Mossel'prom* presents a critical take on Soviet filmmaking in the mid-1920s.[75] In particular, it satirizes the interest in films of Soviet everyday life.[76] Throughout the film, Zheliabuzhskii, Kozlovskii and Balliuzek use sets and compositional strategies to question the premise of creating a fiction film that represents everyday life authentically by repeatedly highlighting the constructed nature of the sequences presented to the viewer. For example, the opening scene – a panorama of Moscow shot from an aeroplane – emphasizes the film's use of contemporary urban life as a cinematic setting. In the lower-left corner of the frame, part of the aeroplane's body is visible, suggesting that the image presented is not objective reality but a view of Moscow mediated from a particular vantage point. In another scene, the director and Latugin use a large storefront display as a background in their film. The advertising images visible on the glass surface recall the *dorisovki* (painted glass backdrops) used in studio filmmaking to give the impression of background landscapes. As in the artist's studios in *Behind the Drawing-Room Doors* and *The Dying Swan*, empty space is left in the foreground of the frame, creating the appearance of a stage. In a later sequence, the filmmakers use a dummy to stage a scene of Zina jumping from a bridge; the metal railings of the bridge run parallel to the edge of the frame, reinforcing the presence of the frame's border. When Latugin loses his job as a camera operator, he is forced to work as a street photographer and resorts to using artificial sets, photographing a couple posed against a painted backcloth of mountain scenery as they sit in a Moscow park. The rugged nature of the painted landscape contrasts with the ornamental fountain and paved terraces of the city park, creating a play between appearances of the artificial and the real.

While, for the most part, the fictional crew refrain from using artificially constructed sets in their film of everyday life, the film studio is depicted in several sequences. An establishing shot of the studio shows it filled with a selection of props typically found in films produced before the nationalization of Russian cinema, including art nouveau furniture, patterned textiles and figurines.[77] Studio filmmaking is thus associated with the pre-revolutionary tradition of ornate interiors in contrast to a Soviet approach based on outdoor filming. In another sequence, the fictional crew attempt to shoot a scene using an interior

set decorated in a style reminiscent of Bauer's films. An enormous china vase, placed on a chest of drawers, towers over Zina, possibly satirizing Bauer's approach of using *dikovinki* – symbolically characteristic objects placed in the foreground of frames – by reducing their function to mere eye-catchers. Moreover, as in Bauer's films, Kozlovskii and Balliuzek use decadent interiors for their associations with commercialism. The film producer's office, with its richly patterned fabrics and gothic-style furniture, recalls the office of the wealthy industrialist Pavel Zheleznov in *The Alarm* (Nabat, 1917), as discussed in Chapter 4. Such styling indicates the producer's nature as a devious businessman, negligent of workers' rights and concerned primarily with financial gain. In one scene set in his office, an open doorway in the background leads onto a view of the studio backlot, which is filled with undecorated *fundus* parts. The juxtaposition of the producer's ornate interior and the bare plywood boards sets up a contrast between the studio management's commercial imperatives and the filmmakers' pursuit of economy and rational production.

It is notable that Kozlovskii and Balliuzek repeatedly use the undecorated *fundus* as a background. In one scene, Latugin and Zina flirt with one another as they sit amid a stack of plywood panels (Figure 5.3). With their flat geometric forms arranged into abstract patterns, the combination of *fundus* parts resembles the non-objective compositions that were produced by members of the constructivist group, such as Liubov' Popova's series *Painterly Architectonics* (Zhivopisnaia arkhitektonika, 1916–18).[78] Kozlovskii and Balliuzek's valorization of the *fundus* as an expressive element reflects the commitment to rationalizing production techniques evidenced by many production artists in the mid-1920s. As we recall from Chapter 1, Kozlovskii was a key interlocutor in debates about economizing production methods and innovating set technology, and he illustrated many of his articles on the subject with studio photographs of plywood panels assembled into various configurations.[79] In addition to the *fundus*, the filmmakers also romanticize Latugin's Pathé camera. In the sequences set in the studio, it is positioned on a raised dais in the centre of the frame, its simple but elegant geometric form contrasting with the jumble of ornamental props in the background. In several scenes depicting Latugin filming on location, the camera is framed against picturesque backgrounds of Moscow's parks and historic monuments such as Saint Basil's Cathedral. As he flirts with Zina, Latugin leaves the camera to film everyday life unaided, thus endowing it with a certain agency. The camera's anthropomorphic form, with its central body and

5. *Artistic Arenas* 161

Figure 5.3 The film studio. *The Cigarette Girl from Mossel´prom* (Papirosnitsa ot Mossel´proma), directed by Iurii Zheliabuzhskii © Mezhrabpom-Rus´ 1924. All rights reserved.

outstretched legs, further emphasizes its status as an active participant in representing everyday life over a mere technical device.[80]

Throughout *The Cigarette Girl from Mossel´prom*, there is also a distinct focus on cinema as a production process. We see technicians editing films and processing negatives. Close-up shots and directed lighting highlight the metallic body of the drying rack for film negatives, recalling the way in which industrial machinery is represented in the production sequences of films set in factories, as discussed in Chapter 4. Moreover, Kozlovskii and Balliuzek use the form of the film negative as a recurring visual motif, repeating its vertical pattern in the protagonists' striped costumes, in the wallpaper that decorates certain interiors and in the fences of Moscow's streets. The romanticization of film production and filmmaking equipment serves to emphasize cinema's creative possibilities as a new technology, contrasting with the way in which filmmakers and theorists of the 1910s strove to distance cinema from its mechanical nature by associating it with a fine arts tradition.

In comparison to the focus on the filmmaking process in *The Cigarette Girl from Mossel´prom*, in *The Kiss of Mary Pickford* (Potselui Meri Pikford, 1927) the main theme is the celebrity culture that cinema generates. The scenario, co-written by Vadim Shershenevich and the

film's director Sergei Komarov, tells of Goga Palkin's rise from cinema ticket-checker to local celebrity after he is accidentally included in a love scene with the Hollywood star Mary Pickford and receives a kiss from her. Palkin's new celebrity status enables him to pursue a romance with Dusia, who was previously interested only in star actors such as Douglas Fairbanks. The film satirizes the mania among Soviet audiences for Hollywood stars such as Fairbanks and Pickford, whose visit to the Soviet Union in July 1926 was a media sensation.[81] The filmmakers even used documentary footage of the couple's visit in the film.

The Kiss of Mary Pickford was another Mezhrabpom-Rus´ production for which Sergei Kozlovskii designed the sets, this time collaborating with the production artist Dmitrii Kolupaev. As discussed in Chapter 2, during the mid- to late 1920s Kolupaev was interested in ethnographic research and promoted the merits of location filming over studio filming. His involvement in this film, which was largely shot in the studio and used artificial sets, is therefore surprising; it highlights the fact that during this period film studios typically employed production artists on contracts that required them to work on a variety of film genres regardless of their own creative preferences.

In *The Kiss of Mary Pickford*, Kozlovskii and Kolupaev's interiors convey the decadence and glamour of cinema culture. As in *The Cigarette Girl from Mossel´prom*, the studio administrator's office is decorated with ornate art nouveau furniture and statuettes, while the cinema foyer has an elegant art deco staircase and flooring and is filled with exotic palms. As Tsiv´ian and Lucy Fischer both demonstrate, the art deco style was closely associated with cinema culture, with both sharing roots in industrialization and modernity and invoking a sense of dynamic mobility.[82] From the mid-1920s, Hollywood and European cinemas became major showcases for popularizing the style.[83] Kozlovskii and Kolupaev's use of art deco for the cinema therefore works to convey Soviet cinema's emulation of and fascination with Western cinema trends. Moreover, the foyer's walls are covered with publicity posters and celebrity headshots of American actors such as Douglas Fairbanks, highlighting Soviet cinema culture's fascination with Hollywood celebrities.[84]

The hold that celebrities exert over the public's imagination and fantasies is emphasized through Palkin and Dusia's interaction with publicity images. Palkin decorates his home with advertising posters of Fairbanks playing Zorro in the 1920 Hollywood production *The Mark of Zorro*. Emulating Fairbanks, Palkin wears a similar mask while he attempts to perform stunts. When Palkin falls, the camera cuts in

to focus on the image of Zorro, whose smiling face appears to taunt Palkin. This recalls an earlier sequence in the cinema theatre in which, after Dusia rejects Palkin, the same poster of Zorro appears to mock him, leading him to tear it from the wall. Throughout the film, portrait photographs also play a key role in forming characters' desires and negotiating their relationships with one another. Dusia and Palkin's romance is largely played out through photographs. As Dusia voices her lack of interest in Palkin, she defaces a photograph of him, drawing a moustache on his face. This gesture of ridicule also makes Palkin resemble Fairbanks in the headshot that Dusia later steals from the auditorium wall to keep as a love memento. Palkin keeps in his jacket pocket a photograph of Dusia, which he periodically looks at, and he is distraught when it is ruined during a cryogenic experiment. Publicity posters and portrait photographs therefore allude to Dusia and Palkin's fantasist nature and their habit of forming desires based on constructed representations rather than on reality.[85]

Ideas relating to visual trickery are conveyed through a number of Kozlovskii and Kolupaev's sets. In one sequence, a silhouette of two figures seen through the glass door of the cryogenic lab deceives Palkin, who is convinced that a doctor is strangling a patient. As Palkin receives cryogenic treatment, the large turning wheel spins him so fast that he is flung into a corner of the room, leading the scientists to believe that he has vanished. The spinning wheel distinctively recalls a fairground attraction, such as that depicted in *The Devil's Wheel* (Chertovo koleso, 1926). A number of the film's sets function as apparatuses for performing stunts. In one scene, Palkin is hoisted on a concrete slab high above the film studio; when he falls, the filmmakers think he has performed a disappearing act. In another, Palkin performs a bicycle trick on a tightrope.

Kozlovskii and Kolupaev also incorporated trick objects in their sets. Telephones and office equipment are revealed to be hidden cameras, which secretly film Palkin. The use of sets as a form of visual gag or as apparatuses for stunt performances was a typical feature of American film comedy, and thus again served to satirize American cinema culture.[86] It was also a hallmark of circus forms such as the *balagan*. As Douglas Clayton observes, during the 1920s a number of filmmakers perceived certain similarities between cinema and the circus *balagan*.[87] In their 1922 theatre adaptation of Nikolai Gogol''s *The Marriage* (Zhenit´ba, 1842), the Factory of the Eccentric Actor (Fabrika ekstsentricheskogo aktera, FEKS) directors Grigorii Kozintsev and Leonid Trauberg combined elements of the circus, such as genuine acrobats and clowns,

with the screening of visual material from a Charlie Chaplin film.[88] Sergei Eizenshtein similarly created the film sequence *Glumov's Diary* (*Dnevnik Glumova*, 1923) to be projected against the background of his circus-inspired sets for Sergei Tret´iakov's 1922 adaptation of Aleksandr Ostrovskii's *Enough Stupidity in Every Wise Man* (Na vsiakogo mudretsa dovol´no prostoty, 1868).[89] By incorporating techniques from the circus into their practice, avant-garde creatives could highlight cinema's appeal as a form of mass entertainment appropriate to modern society, departing from the way in which filmmakers in the 1910s employed set techniques derived from the fine arts to elevate cinema's status as an artistic medium.

The circus

During the late 1910s, there were several films set around the circus, including Petr Chardynin's *Forget about the Fireplace, the Flames Have Gone Out...* (*Pozabud´ pro kamin, v nem pogasli ogni...*, 1917) and his 1918 two-part drama *Still, Sadness... Still...* (Molchi, grust´... molchi...) and *A Tale of Precious Love* (Skazka liubvi dorogoi), on which Aleksei Utkin worked as the production artist. However, it was during the Soviet 1920s that filmmakers engaged with the circus as an environment in and of itself. In particular, they were drawn to the circus as a setting for its associations with artistic freedom and liberation. In FEKS's *The Devil's Wheel*, the high art establishments of the House of Culture (*Dom kul´tury*) and the Institute of Pictorial Arts (*Institut plasticheskogo iskusstva*) are taken over by circus acrobats and magicians, whose performances are frequented by city lowlifes and criminals who use the space as an illicit drinking den. In addition to its potential for dramatizing ideas about rejecting established codes, filmmakers were also interested in the agitational potential of the circus. Since the mid- to late 1910s, Russian critics had associated the circus with overcoming physical obstacles and disrupting social boundaries.[90] In his text 'The Art of Circus' (1923), for example, the *LEF* writer Viktor Shklovskii argued that the principle of 'difficulty' defined the circus as an art.[91] Similarly, Kuleshov viewed circus tricks as more than mere stunts; rather, they demonstrated the accomplishment of challenging tasks, comparing them to a form of work.[92] A number of avant-garde creatives also sought to harness circus buffoonery for political ends. In his scenario for *Enough Stupidity in Every Wise Man*, Tret´iakov used the circus arena as an agitational space, with clowns and

acrobats playing roles that parodied contemporary political figures.[93] Eizenshtein's set for the adaptation was modelled on a circus arena and was equipped with various acrobatic apparatuses, including trapeze wires, planks, tightropes and a trampoline.[94] This fascination with the agitational potential of the circus continued throughout the 1920s. As several critics writing in the contemporary cinema press observed, a number of films of the late 1920s and early 1930s – including *The Two Buldis* (2-Bul'di-2, 1929), *The Last Act* (Poslednii attraktsion, 1929), *The Benefit of Clown George* (Benefis klouna Zhorzha, 1930, non-extant) and *Deadly Humour* (Smertnyi iumor, 1930, non-extant) – set their action against the backdrop of the Revolution and the Civil War and used circus tricks and acrobatics to address issues of social struggle.[95] In the two surviving films, *The Two Buldis* and *The Last Act*, the filmmakers exploit and problematize the circus as a vehicle for political agitation.

When approaching the task of representing the circus in the Mezhrabpom-fil'm *The Two Buldis*, Kuleshov collaborated with the production artist Kozlovskii, who was again assisted by Balliuzek.[96] The scenario, by the LEF theorist Osip Brik, tells the story of a father-and-son clown duo, who work for a provincial circus in a Russian town initially under Bolshevik control during the Civil War.[97] As the White Army approaches, the son, Little Bul'di, mobilizes the circus in an attempt to resist. Nevertheless, the town falls and the circus becomes subject to the terrors of pro-tsarist rule, with Big Bul'di forced to perform degrading comic acts, such as setting himself on fire. Believing that his son has been shot by counter-revolutionary forces, Big Bul'di initially submits to the Imperial regime before experiencing a political awakening when he discovers that his son is alive.

While *The Two Buldis* is set during the Civil War years, the theme of the subjugation of artists to political regimes held particular significance in the late 1920s when the film was produced. Work on the film began in 1928, but criticism of both its lack of appropriate political content and its perceived formal inadequacies meant that it underwent a number of script re-writes.[98] It was also partially re-filmed with the assistance of the director Nina Agadzhanova, before being granted limited release in August 1929.[99] The film's production therefore coincided with a period of increased centralization in Soviet cinema, which was outlined at the first All-Union Party Cinema Conference in March 1928.[100] During this period, the circus was also subjected to greater state control, as set out in a series of decrees passed from 1928 by the Central Administration of State Circuses (Tsentral'noe upravlenie gosudarstvennykh tsirkov, TsUGTs,).[101]

In *The Two Buldis*, the close relationship between art and politics is made clear through the setting of the opening sequences, which depict soldiers at the Front. A group of them gather in a circle, anticipating the form of the circus ring that is the film's principal setting. In the background of the frame, the ropes of the army tents evoke the trapeze wires of the circus, while the tracks of military artillery in the barren landscape have a visual parallel in the chariot wheel tracks that appear in the circus arena in later sequences. The connection between the circus and militant activity is also emphasized in the introductory shots of the circus ring, which cast it as a political arena. From its centre, Little Bul´di makes an agitational speech, encouraging the audience to support the Bolshevik cause. Later in the film, the audience is filled with Red Army soldiers, their upright rifles framing the arena. Kozlovskii and Balliuzek's austere sets for the arena, devoid of the pageantry and glamour typically associated with the circus, are also significant in this respect.

The circus's ideological potential was well recognized throughout the 1920s and into the 1930s. Following the 1917 Revolution, the Bolsheviks requisitioned the circus for political ends, developing a range of didactic and agitational spectacles that promoted revolutionary themes and messages.[102] During the Civil War era, the Red Army staged a number of circus performances to disseminate their account of events at the Front to the masses.[103] In a 1925 article 'Five Years of State Circuses' (Piat´ let gosudarstvennykh tsirkov), the People's Commissar for Education and Enlightenment Anatolii Lunarcharskii emphasized the circus's potential, as a revolutionary art form, for being close to the masses and argued that it could be used to enlighten and to instruct the Soviet proletariat.[104] However, despite official recognition of the circus's propaganda potential, throughout the 1920s critics complained of the Soviet circus's conservatism.[105] Writing in 1929 in the journal *The Circus and The Stage* (Tsirk i estrada), the critic Sergei Sokolov noted that circus performances continued to be based on bourgeois, pre-revolutionary traditions and were devoid of agitational content.[106]

The disparity between the circus's bourgeois heritage and its revolutionary potential is played out in the film through the juxtaposition of different costumes and acts. Dressed in a ridiculous outfit of oversized clothes and with garish make-up, the buffoon-like clown Big Bul´di contrasts with Little Bul´di and his agile physique, sumptuous costume and subtle make-up. On one level, the pairing of the two Bul´dis references the traditional circus partnership of the eccentric red-headed clown (*ryzhii*), who wreaks havoc, and the elegant

white-faced clown (*belyi*), who maintains order.¹⁰⁷ On another, however, the two Bul′dis represent the clash between the old tradition of the circus and its revolutionary potential. As Donald McManus notes, in early-twentieth-century theatres this opposition frequently functioned as a political metaphor for tensions between existing, authoritarian social orders and revolutionary class struggle.¹⁰⁸ Big Bul′di performs simple comic tricks, which emphasize his ridiculous nature and are often based on body humour: he trips and tumbles as he chases a ball around the ring, the audience laughing at his clumsy and uncontrolled movements; he sets himself on fire, then bumps his head, causing an enormous swelling to appear, before spurting jets of tears.

By contrast, Little Bul′di performs acrobatics that demand physical strength and poise. As pro-tsarist forces storm the city, Little Bul′di somersaults to avoid their gunfire. Similarly, at the end of the film, he trapezes his way across the circus arena to freedom. Little Bul′di's acrobatics recall the 1918 performance of the eminent Russian acrobat Vitalii Lazarenko, which became known as the 'Revolutionary Leap' for the way he vaulted across a series of obstacles.¹⁰⁹ Moreover, in a 1928 decree, TsUGTs singled out acrobatics for their potential to enlighten the masses insofar as they demonstrated the qualities of determination and rigour.¹¹⁰ Little Bul′di is further portrayed as a new, revolutionary type of circus artist through his activities as an agitator and a social activist. The reconceptualization of the artist as activist gained currency in the late 1920s. In 1928 – the same year in which Kuleshov began work on *The Two Buldis* – Tret′iakov published in the journal *New LEF* (Novyi LEF) a number of polemical tracts in which he called for artists to take up agitational roles to mobilize the proletariat to carry out tasks that would advance the socialist cause.¹¹¹ Since the 1910s, a number of creatives had marked out the circus as a space for individual empowerment and political activism.¹¹² In the 1919 article 'The Happy Sanatorium' (Veselyi sanatorii), the artist and theatre designer Iurii Annenkov identified the circus as a special place in which anyone might become a hero.¹¹³

Placed in contrast to the heroic, revolutionary activist Little Bul′di is the horse-tamer, who demonstrates pro-tsarist sympathies. Dressed in a white shirt with leather gloves and seated on a horse ostentatiously decorated with tassels and animal furs, the horse-tamer represents the equestrian showmanship favoured in late-Imperial circuses.¹¹⁴ Whipping the horses to gallop in particular formations, the tamer uses force to subordinate others to his will. His victory lap round the ring is later repeated by the White Army Cossacks when they seize the circus.

The horse-tamer therefore represents how art can be appropriated as a method of guidance and control, in contrast to the positive image of art in the service of social activism embodied in the figure of Little Bul´di.

The idea that art should serve an agitational function was not uncontested, however. In his 1923 text *Knight's Move* (Khod konia), Shklovskii lamented that 'the greatest misfortune of our time is that the government is regulating art without knowing what it is [...]. The greatest misfortune of Russian art is that it is not allowed to move organically, as the heart moves in a man's chest: it is being regulated like the movement of trains'.[115] Released in September 1929, the Sovkino studio's *The Last Act* (Poslednii attraktsion) criticizes the state's requisitioning of the circus to propagate ideological messages to the masses. Ol´ga Preobrazhenskaia and Ivan Pravov directed the film and Aleksei Utkin designed the sets. Shklovskii's scenario for the film tells the story of a travelling circus troupe from the Caucasus which is requisitioned during the Civil War when an agitator joins the troupe and forces them to adapt their acts into highly propagandistic and theatricalized performances that will edify the rural masses.

Following the Sovkino studio's preference in the mid- to late 1920s for location over studio filmmaking, most of the film is shot outdoors.[116] In his sets, Utkin exploited the natural features of the rural landscape to convey the unrefined character and carefree lifestyle of the circus performers. Introductory shots of the troupe show them half-dressed and framed against rugged rock faces, wild vegetation and countryside untouched by human intervention. Such scenes emphasize the troupe's existence on the margins of civilized society, as well as the performers' uncouth nature. The rickety carriage which carries them across the countryside and the make-shift stage on which they perform reflect the improvised quality of the performers' acts and convey the circus's status as a low art form. Moreover, the troupe's costumes are stylized and their bodies grotesque: like that of Big Bul´di, the clown's make-up is garish and his costume is exaggerated; the weightlifter's grubby belly protrudes from his tight leotard; and the dancer's tutu is revealing, permitting extended views of her cleavage and buttocks.

The grotesque bodies and unrefined nature of the circus troupe contrast starkly with the pretensions of the Bolshevik agitator. In the scene in which the agitator is introduced to the viewer, he wears a plain worker's overall and contemplates a bust of Socrates as he searches for propaganda inspiration. Despite the agitator's aspirations, the propaganda performances that he orchestrates for the circus troupe are contrived and derivative. In one scene, in order to impress a group of

villagers, the agitator dresses as a fake weightlifter, stuffing his jumper to create the blatantly artificial impression of muscles. In another, he repaints the circus caravan with an image of menacing Imperial soldiers carrying a banner with the agitational slogan 'The enemy brings slavery, hunger and death', but using the same stylized forms as the caravan's previous circus advertisement. In a later sequence, the agitational spectacle which he creates for the troupe to perform in front of villagers is highly theatricalized and draws on well-known stereotypes. The production tells of the ills of capitalism and the triumph of labour, recalling in theme one of the first Bolshevik agitational performances about the struggle between labour and capital, Ivan Rukavishnikov's 1919 *Political Carousel* (Politicheskaia karusel').[117] Cast in the role of the greedy American capitalist, the clown wears a costume of a bulging money sack and stands framed against an enormous spider's web, closely resembling the fat capitalists in Viktor Deni's agitational posters, such as *Capital* (Kapital, 1919) and *League of Nations: Capitalists of the World, Unite!* (*Liga natsii: kapitalisty vsekh stran soediniaites'!*, 1920).[118] The money sack's opening, however, recalls the traditional ruff of a clown costume, emphasizing the comic nature of the capitalist's caricatured appearance. In similarly exaggerated costumes, the young female acrobat carries an artificial oversized sickle and bundle of corn, while the male acrobat is dressed as a worker with an enormous hammer.

The rehashing of Soviet propaganda stereotypes serves to critique the agitator's perception of culture as a vessel for propagating ideological messages. This idea is clearly portrayed in a sequence which depicts the agitator sitting in front of a blank propaganda placard (Figure 5.4). As he stares at it, trying to think up an agitational slogan, a projection of a Bolshevik agitator appears across its surface. Devoid of a background setting and any artistic intervention or stylization, the image appears exclusively as a form of agitation to disseminate a political message. In this way, it recalls Shklovskii's criticism in *Knight's Move* that following the Revolution artists' skills were being reduced to designing propaganda posters that lacked artistic merit.[119] The way in which the placard is propped on a stand resembles a canvas on an easel. Moreover, the varnish on the wooden planks recalls the texture of a painted canvas, while the projected quality of the image evokes the cinema. These details suggest that the filmmakers were expressing a broad criticism of the state's requisitioning of not only the circus but also art forms in general to serve a purely political function. Such a message would have held particular urgency in the late 1920s and early 1930s, when the state was increasing its control over artistic production in a

Figure 5.4 Theatre performance. *The Last Act* (Poslednii attraktsion) © Sovkino 1929. All rights reserved.

process which would lead to the inauguration of Socialist Realism as the official method for all cultural forms under the 1932 decree 'On the Reconstruction of Literary and Artistic Organisations' (O perestroike literaturno-khudozhestvennykh organizatsii).[120]

In the 1930 Souizkino production *Cities and Years* (Goroda i gody), directed by Evgenii Cherviakov and with sets designed by Semen Meinkin, part of the film's action takes place in the Munich studio of the fictional Russian émigré artist Andrei Startsev. While in the 1910s filmmakers had included artists' studios in a number of films, by the 1930s it was a highly unusual choice of setting. As in *Behind the Drawing-Room Doors*, the artist Startsev is initially concerned with increasing his cultural status, using his studio to secure patronage from members of the upper class, in particular a high-ranking German officer. Meinkin's set represents the studio as situated in an attic overlooking Munich's rooftops and isolated from social life. Sitting with his back to the window, Startsev's sole interest is his painting, which, placed in the centre of the studio, dominates the room. Throughout the film, painting is derided as a superficial and outmoded art form: gilt-framed paintings in avant-garde styles are exhibited at salons frequented by shallow members of the bourgeoisie, who senselessly follow the latest fashions; in a later sequence, a painted portrait of the Tsar is paraded through the Saint Petersburg streets by supporters of the Monarchy. As the Revolution breaks out in Russia, however, and the country is

plunged into civil war, Startsev experiences a political awakening – as with Big Bul´di in *The Two Buldis*. He begins to paint morbid canvases condemning 'human massacres' (*chelovekoubiistvo*). Subsequently, he returns to Russia to join the Red Army and becomes involved in 'social work', reconstructing the city's infrastructure.

In contrast to filmmakers of the 1910s, Cherviakov and Meinkin thus use the figure of the artist and his working environment not only to pose self-reflexive questions about the cultural status of artists but also to explore the social responsibility of creatives in revolutionary society, corresponding with the way in which filmmakers in the late 1920s used the circus arena. *Cities and Years* therefore exemplifies the shift in filmmakers' preoccupations in representing artistic environments that this chapter has traced, from exploring ontological questions about the nature of artistic media and cinema's status as an art to addressing social issues about creative independence and the artist's role in revolutionary society. This shift corresponds with what the art historian Benjamin Buchloh identifies as a change in agenda among Russian artists working across the 1910s and 1920s, from a concern with self-reflexive issues of artistic representation to a focus on questions about their role as social and political activists.[121] The chapter thus highlights how filmmakers also engaged with contemporary artistic debates, using cinema to explore questions about the ontological nature of different artistic media and the social responsibilities of artists.

CONCLUSION

As Soviet filmmakers embarked on a new era of sound cinema in the 1930s, the production artist's role remained a subject of debate. Throughout the decade, production artists continued to lament that they were still not fully recognized for their distinct contribution to cinema.[1] In an article titled 'The Production Artist in Cinema', published in the journal *The Art of Cinema* (Iskusstvo kino) in 1936, Vladimir Kaplunovskii noted that cinema audiences and even filmmakers continued to ask the questions: 'who is the production artist (*kino-khudozhnik*), what are his responsibilities, and what is his place in cinema?'.[2] He claimed that the various titles used for the profession – *khudozhnik-arkhitketor* (artist-architect), *khudozhnik-oformitel'* (artist-scenery dresser) and *khudozhnik-dekorator* (artist-decorator) – had only added to the confusion. As Kaplunovskii explained, these various titles reflected the wide-ranging artistic knowledge that continued to be demanded of production artists. Echoing by previous statements made by production artists in the 1920s, such as Sergei Kozlovskii, about the importance of artistic versatility for the role, Kaplunovskii declared:

> The production artist must unite in his role all the diverse artistic professions. In particular, he must be a master of: the architect's practice, for decoration in film is the combination of architectural forms and textures in space; the theatre designer's practice, for illusion and decoration play a part in the creation of sets; the decorator's practice, which combines paint, furniture, props and light with architectural forms; and lastly the draftsman's practice, which reproduces in sketches the costumes and sets of a film.[3]

For Kaplunovksii, the wide-ranging artistic knowledge of production artists meant that their influence extended beyond constructing sets to ensure that there was an overall aesthetic cohesion across the different frames and scenes of a film. This understanding of the importance of production artists in helping to determine the overall aesthetic concept of a film recalls the first articles written on the role of the production

artist in 1917 by Lev Kuleshov, in which he declared that, insofar as film was primarily a visual art form, the production artist played a crucial role in determining film aesthetics.[4]

However, during the 1930s cinema's status as a primarily visual medium was challenged by the arrival of sound film. An anxiety about what an increased interest in sound, as opposed to visual, elements of film would mean for the role of production artists is evident in the cinema press of the period. Kaplunovskii's article, for example, appeared alongside others dedicated to the increased importance of the composer and the scenarist in Soviet cinema, suggesting a concern about what new responsibilities for other filmmakers would mean for the production artist's role. Other filmmakers also began to demonstrate a new interest in the acoustic potential of sets. In his study of Soviet set design from 1931 to 1945, Gennadii Miasnikov writes how production artists in that period began to choose certain settings and objects that would allow filmmakers to incorporate expressive sound effects.[5] Lilya Kaganovsky has highlighted the prevalence of certain objects, including loudspeakers, radios and gramophones, which filmmakers used in the late 1920s and early 1930s to convey a certain type of spoken address.[6] With the advent of synchronous sound filming, production artists were also required to consider the acoustic properties of their sets: spaces had to be configured so as to prevent echoes and special materials were used to muffle extraneous noise or to make the desired sound effect.[7] Initially, early sound technology required many films to be shot in studios in order to accommodate the use of sound equipment. This in turn placed greater demands on the construction of artificial studio scenery, with production artists required to develop inventive techniques for conveying a range of settings where location filming was no longer a viable option. Sound filmmaking therefore both placed significant pressures on and opened up new opportunities for production artists.

As well as advances in sound technology, the 1930s also witnessed several other technological innovations which provided a whole new range of challenges and possibilities for production artists. The development of the composite shot and rear projection had particular significance for set design, with production artists often required to develop intricate models of settings. The opportunities that new technological innovations brought for production artists in the 1930s have led those writing about set design in other European cinemas to label this period a 'golden age' in set design.[8] More research is needed to test the extent to which this claim holds true for Soviet set design.

The advent of new cinema technology, including sound, also coincided with significant shifts in cultural and artistic attitudes in Soviet Russia. The First Congress of Soviet Writers, held in Moscow in 1934, established Socialist Realism as the official method for all Soviet arts.[9] Under the remit of Socialist Realism, artistic works were required to display 'The truthful, historically concrete representation of reality in its revolutionary development'.[10] In terms of cinema, filmmakers were required to work within these new ideological parameters and also follow directives outlined by Boris Shumiatskii, the appointed leader of the Soviet cinema industry from 1930, to produce films that were commercially successful and popular among the masses. These new ideological and commercial requirements prompted a reconfiguration of genres: historical revolutionary and musical comedy films gained prominence, both genres of which required a more obtrusive type of set design.

The new challenges and opportunities for set design that resulted from aesthetic and ideological shifts in filmmaking during the 1930s lie beyond the parameters of this monograph and warrant their own attention to do justice to what remains a little researched field in scholarship on Soviet cinema. From a look at the cinema press in the 1930s, these shifts in filmmaking did little, however, to clarify understandings about the production artist's role. Writing in 1938 in an article also titled 'The Production Artist in Cinema', Nikolai Suvorov stated that 'Questions about the artistic culture of cinema are still far from resolved. It is even not clear what position the production artist (*khudozhnik*) plays in film production. But we hope that art historians will pay attention to this "unknown", but very important participant in the filmmaking process.'[11]

This book has responded to Suvorov's appeal in tracing the various roles that production artists held in silent filmmaking and how their responsibilities evolved across the era. What, then, can we conclude about the production artist's distinct contribution to late-Imperial and early-Soviet cinema?

The production artist: Versatile multi-tasker, technical expert and willing collaborator

Evolving perceptions of the production artist's role in the silent era were closely aligned with broader shifts in understandings about what it meant to be a creative practitioner working in a collaborative

context. The idea promoted at the Moscow Art Theatre (Moskovskii khudozhestvennyi teatr, MKhT) that the set designer was not just a technical craftsman but a creative individual who was involved in the entire artistic development of a production provided a model for the first production artists working in the late 1900s and early 1910s. Indeed, a significant number of production artists – Boris Mikhin, Czesław Sabiński, Vladimir Balliuzek, Vladimir Egorov and Viktor Simov – came to cinema directly from the MKhT. With the rise of production art as a dominant artistic discourse in the 1920s, critics and filmmakers increasingly emphasized that the production artist's significance did not lie solely in their creative vision. They were also valued for their technical expertise, which enabled them to innovate rational solutions, such as the *fundus* system, which economized and improved the design process by reducing the production time and the materials wasted. The increased importance ascribed to technical expertise was reflected in debates about the production artist's title: from the early 1920s the term *kino-dekorator* (cinema-decorator) was used in a derogatory manner to refer to a creative concerned only with aesthetic effects, while the titles *kino-arkhitektor* (cinema-architect) and *kino-konstruktor* (cinema-engineer) were used to evoke the qualities of technical competency, versatility and a collaborative work ethic. While such qualities carried particular weight in early-Soviet ideology, they were also necessary in the context of studio filmmaking in the 1910s and 1920s in Russia, when resources were often scare, personnel limited, technology underdeveloped and studios placed pressure on filmmakers to produce films quickly. With their breadth of technical skills and artistic knowledge gained from prior experience in a range of creative spheres – painting, graphic illustration, architecture and theatre design – production artists were particularly suited to this type of work environment. Several individuals, among them Sabiński and Sergei Kozlovskii, established indispensable roles for themselves as versatile 'multi-taskers', who advised on a number of aspects of filmmaking, including lighting and framing scenes, directing actors and writing scenarios.

Also valued in the context of studio filmmaking was a production artist's flexibility: the effective production artist had to be able to work with a number of different filmmakers, each of whom had their own artistic style, and on films of varying genres, each of which demanded a specific aesthetic approach. This resulted in some surprising instances of collaboration. Two cases in point are Kozlovskii and Simov's fantastic sets for *Aelita* (1924) and Dmitrii Kolupaev and Kozlovskii's art deco

scenery for *A Kiss from Mary Pickford* (Potselui Meri Pikford, 1927), both of which contrast with the stark approach to set design that these individuals typically favoured. This flexibility undoubtedly contributed to the perception among certain filmmakers that production artists must suppress their own artistic preferences in order to create sets that corresponded to a studio brief. Nikolai Suvorov even argued that the ability to adapt to different styles was the key attribute of a successful production artist.[12] The importance attached to versatility and flexibility raises questions about how we value creative input in collaborative projects such as cinema. It highlights that, besides an individual creative vision, filmmakers appreciated a range of professional qualities which related to the more technical side of film production. It also draws our attention to the significance of studio dynamics and collaborative partnerships in filmmaking.

The question of creative alliances is, however, complex and difficult to establish in relation to production artists. While Philip Cavendish has shown that a number of directors and camera operators formed close working partnerships in the 1910s and especially the 1920s,[13] surviving sources suggest that production artists were more mobile in terms of their professional collaborations. There are some instances of enduring creative alliances based on shared conceptual and aesthetic principles, such as Evgenii Enei's partnership with the Factory of the Eccentric Actor (Fabrika Ekstsentricheskogo Aktera, FEKS).[14] For the most part, however, studio contracts required production artists to work with a number of different filmmaking units. The question of a production artist's studio allegiance is similarly complex and unevidenced. Apart from Kozlovskii and Vasilii Rakhal´s, who in the 1920s headed the design departments at Mezhrabpom-Rus´ (from 1928 Mezhrabpom-fil´m) and Goskino (from 1924 Sovkino) respectively, production artists in both the late-Imperial and the early-Soviet eras moved relatively freely between commissions at various studios. The working dynamics of late-Imperial and early-Soviet studios are an under-researched subject in Russian film studies. A greater understanding of how studios functioned would help to expand the picture of the professional relationship between studios and individual filmmakers, including production artists.

Although this monograph has focused on providing a typology of production artists and their working practices, it has also revealed how the backgrounds, prior artistic training and creative dispositions of a number of individuals shaped their creative approach and influenced the sets they designed for films: Vladimir Balliuzek's association with

the World of Art (*Mir iskusstva*) informed his use of patterning in the interiors for *The Maidservant Jenny* (Gornichnaia Dzhenni, 1918); and Kolupaev's background as a landscape painter and his affiliation with The Itinerants (*Peredvizhnik*) meant that he was inclined to design sets that used rural scenery to comment on social issues relating to provincial life.

Additionally, this book has highlighted the role of individuals as early theorists of set design, whose writings shaped how the discourse around the practice developed across the 1910s and 1920s. Kolupaev, for example, was a key interlocutor in the debates about the merits of location filming over using studio sets in the mid- to late 1920s. In his extensive writings produced between 1924 and 1930, Kozlovskii encouraged economy as both an aesthetic principle and a design method. The issues of studio filming and economy had resonance beyond set design, however, and fed into much larger debates about early-Soviet filmmaking, such as rationalizing film production and cinema's nature as a photographic medium and its ability to represent the real world accurately. The writings of production artists thus highlight how the profession was actively engaged with and helped to shape cinema discourses in the silent era.

Late Imperial and early Soviet set design: Medium specificity and national cinemas

Tracing the role of production artists has also enabled this book to examine the ways in which set design aesthetics developed across the period. Changes in set aesthetics were closely associated with filmmakers' evolving understandings of cinema's expressive potential, its nature and status as an art form and its relation to other artistic media. Initially in the late 1900s and early 1910s, filmmakers approached set design as a strategy to elevate cinema's cultural standing through associating it with a fine arts tradition. Publicity materials in the contemporary cinema press compared the visual design of films with the works of eminent Russian painters. Filmmakers also borrowed a number of terms from the fine art lexicon to describe film aesthetics, including *kartina* (picture) to refer to a film, *rembrandtizm* to describe a type of lighting effect and, most notably, the title *khudozhnik* (artist). The association of film design with the fine arts was not merely a publicity strategy, however; it also revealed filmmakers' understanding that the film frame shared certain aesthetic properties with pictorial representations.

This is also expressed in the set design sketches and writings of many production artists. For example, Egorov's illustrated article 'The Artist of the Theatre Stage and the Artist of the Film Picture – Masters of Decorative Scenery?' demonstrates his appreciation of the fact that cinematic space differed considerably from theatrical models and was much more similar to pictorial space.[15]

These understandings about cinema's expressive potential and its relation to other art forms are also evident in the sets that production artists designed for films. Egorov often borrowed both compositional methods and motifs, such as mirrors, from pictorial traditions in order to heighten a frame's expressivity; Balliuzek, among others, included textiles and wallpaper with different patterns and objects with various types of *faktura* (texture) to provide textural and tonal contrasts. Moreover, the way in which Bauer used the techniques of blocking and framing, which are less effective in the theatre due to the reduced range of vantage points possible in a theatre auditorium, reflects his growing understanding of cinema's specific expressive features. Together, these approaches to set design demonstrate the highly creative ways in which production artists responded to the challenges of designing an image that would be captured on orthochromatic film stock and projected onto a flat screen.

Changes in set aesthetics did not only reveal filmmakers' evolving understandings of cinema's expressive features, however. They also reflected different perceptions of what a distinctively Russian and, from the 1920s, a distinctively Soviet form of cinema should look like. In the late-Imperial era, the choice of associating a film's visual design with the works of Russian artists served to align cinema with a national artistic tradition. During the 1920s, many filmmakers and critics denounced the approach popular in late-Imperial cinema of designing sets with an excess of objects and different patterned textiles. According to Iutkevich, for example, the elaborate scenery of films produced by the Khanzhonkov and the Ermol´ev studios exemplified the decadence of the pre-revolutionary era. Moreover, he condemned the stylized forms of German Expressionist films as symbolic of the depraved values of Western, capitalist societies. In contrast to these set approaches, Soviet filmmakers promoted stark sets with only a very few objects, exemplifying visually the principle of economy that was a cornerstone of early-Soviet ideology.

This book has, however, questioned the idea that Russian cinema of the silent era was marked only by rupture and not by continuity. Although some new talent entered the ranks of production artists

during the 1930s, most notably Kaplunovskii and Boris Dubrovskii-Eshke, many production artists who had begun their cinema careers in the 1910s, including Balliuzek, Egorov, Kuleshov, Rakhal's and Aleksei Utkin, continued to work in the industry during the Soviet era. In several of the sets they created in the 1920s, these individuals drew upon design approaches that had been developed in the late 1900s and the 1910s. For example, the gradual move towards using sparse sets for both ideological and aesthetic reasons is already evident in the mid-1910s in films such as *The Little House in Kolomna* (Domik v Kolomne, 1913), designed by Boris Mikhin, and *Children of the Age* (Deti veka, 1915), with scenery by Evgenii Bauer, under whom Kuleshov and Rakhal's worked as production artists. Additionally, although the Revolution wrought massive changes across all aspects of Russian life, filmmakers in the late-Imperial and early-Soviet eras continued to address many of the same social issues relating to the material environment, including questions about domesticity, commodification and technological advancement. In representing the rural provinces, for example, ethnographic research remained important throughout the 1910s and the 1920s. Such continuities in the sphere of set design invite a re-appraisal of how we consider the relationship between late Imperial and early Soviet cinemas more generally.

The material environment: Authenticity, psychological intensity, object relations and social practices

As we recall from Rodchenko's 1927 article, 'The Production Artist and the Material Environment in Fiction Film' (Khudozhnik i material'naia sreda v igrovoi fil'me), which was cited in the Introduction, the production artist was responsible not only for innovating new approaches to set aesthetics but also for creating the entire 'material environment' (*material'naia sreda*), in which the characters of the film will 'live' (*zhit'*).[16] Many production artists used the material environment in films to convey an authentic representation of Russian life. In some of the earliest Russian fiction films, Mikhail Kozhin carefully sourced props and designed artificial scenery in order to create an authentic depiction of traditional Russian customs, corresponding with filmmakers' desires to establish a native cinema that looked distinctively Russian. Similarly, for Sabiński, 'The main thing in a film is that everything is genuine, that there is no deviation from nature nor any deception'.[17] This concern for authenticity was important not only for the first Russian production

artists, however. During the 1920s, Kolupaev undertook reconnaissance expeditions to rural communities, while in *The Old and The New* (Staroe i novoe, 1929) Rakhal´s and Eizenshtein drew on specialist agricultural research to source props. For many Soviet filmmakers, the concern for authenticity related to their interest in cinema as a photographic phenomenon and its ability to capture and to reveal aspects of the real world that normally go unnoticed to the human eye.

Many production artists were concerned not merely with creating an authentic representation, however. They also used set details in films to create atmosphere and to convey characters' psychology. In *The Brigand Brothers* (Brat´ia-razboiniki, 1912), for example, the barren landscape worked to express the orphaned brothers' pitiful existence. Moreover, in *By the Law* (Po zakonu, 1926), Kuleshov and Isaak Makhlis carefully selected and framed landscapes in order to heighten the film's emotional intensity and to make visible to viewers the characters' inner emotions. In addition to the natural features of the landscape, production artists employed interior architecture and ornaments to articulate characters' emotions. In a number of the interiors he designed, Mikhin used windows and doorways to evoke the feeling of entrapment experienced by the films' female protagonists.

The representation of the material environment was also an effective way for filmmakers to express social relations and tensions between characters. Bauer frequently employed in his interiors the motif of a staircase in order to articulate social hierarchies. Filmmakers were not only concerned with expressing the relationship their protagonists had with one another, however. They were also interested in exploring characters' relationship to material things. For the filmmaker Abram Room, the material world exerted a powerful influence on subjects. Writing about the apartment's furnishings and objects in *Bed and Sofa* (Tret´ia Meshchanskaia, 1927), Room declared that 'Each of them has a fate, a past, a present and a future. They all live, breathe and interfere in people's life and hold them in close captivity.'[18] Drawing on such statements made by Soviet filmmakers and critics about the object world, Widdis has demonstrated how in the 1920s and 1930s set design was part of a wider endeavour to remake Soviet subjects' relationship to their surrounding material environment.[19] This book, however, illustrates how filmmakers explored a number of different types of relationships that characters had with their object world. In *The Old and The New* and *A Major Nuisance* (Krupnaia nepriatnost´, 1930), for example, the villagers related to new technology in a way that was similar to religious belief.

In their representations of the material environment, filmmakers were also able to explore certain types of activities and social practices. The study and the private office were realms through which they could consider ideas about personal fantasy and the hold it has over protagonists, leading them to blur the distinction between imagination and reality. And in many films of the late 1920s, the circus arena was used to address concerns about artistic independence and the social responsibility of creatives. Thus, it is clear that cinema sets were an important means through which filmmakers could encourage viewers to reflect on the different spheres of their everyday lives. As a critic writing in 1928 in *Soviet Screen* (Sovetskii ekran) acknowledged, 'Film makes us sense everyday life first and foremost through the representation of surroundings and settings'.[20] For this, it is the production artist whom we should thank.

APPENDIX

Lev Kuleshov, 'Concerning the Tasks of the Production Artist in Cinema' [1917][1]

The art of light-creation (*svetotvorchestvo*), as a medium perceived by the eye alone and producing impressions that are purely visual, should undoubtedly have given the production artist (*khudozhniku*) a greater role than that which he currently holds in filmmaking. The perception of visual impulses means that his role is closest of all to the creator of external appearances, the creator of visual guises and not to the conjuror of psychology or thought and not to the artist of the word. It is true there are many reasons why production artists have persistently been ostracized from the realm of cinema, and these same masters of the brush must themselves share the blame for this, but at the same time we must recognize the working conditions that confronted production artists when they came to work as a new force in the restrictive atmosphere of the film studio. The idea that production artists are irrelevant to cinema lies mainly in their stubbornness, their inflexibility and their reluctance to renounce the rules and practices of easel painting and painted theatrical scenery which had been worked out once and for all. Perhaps this is explained by the fact that artists did not come to work in this new but great field of art with enough sincerity and faith (if cinema is an art, then it is undoubtedly a great art, as there is no such thing as a minor art). The essence of cinematic art lies in the creative work of the director and the production artist, everything is rooted in composition. In order to create a picture, the director must combine scenes that have been photographed separately, that have no order to them and have not been connected into a single whole; he must juxtapose individual moments into a favourable, more coherent and more rhythmical sequence, just as a child constructs a word or a phrase from single blocks of scattered letters. This is a basic idea about the composition or *montage* of a film picture, and a detailed analysis of this directorial process is absolutely not the aim of this article. The work of the production artist, as mentioned above, is similarly completely governed by the law of composition and juxtaposition, but in two distinct directions:

1. It is essential for the production artist to consider the sequential order of the appearance of the filmed action in the setting which he has created, for it is very important what he reveals first: something black or white, something rich or poor; should he first amaze with an enormous room followed by a tiny corner or should he show several spacious settings at once? For the effect to work, the production artist must collaborate closely with the director and understand clearly the rules of *montage*.

2. When making studio sets, the production artist must forget and renounce once and for all painting images with oils or drawing them with pencil or charcoal.

The production artist (*khudozhnik kino*) paints with *objects*, surfaces (walls) and *light*, collaborating with the camera operator. His canvas is the thirty-five-degree angle of vision of the film camera, like a triangle on a plane. On the screen, it is almost not important what appears in a frame; what is essential, however, is how the objects are positioned, how they are composed in the frame. This is the principal task, which is very difficult to take in for artists who have come from the theatre or from the painter's studio.

There is a big difference between the way that the theatre viewer and the film camera perceive a scene. The theatre viewer can see a scene from many different positions in the auditorium, while the film camera has only one viewpoint. The film camera fixes space at a 35-degree angle only (sometimes a little more), while the theatre spectator can view a much wider expanse of the stage. It is thus impossible because of technical conditions to apply theatrical methods of constructing sets to cinema. One of the shortcomings of the moving image (*zhivaia fotografiia*) is its non-stereoscopic quality – depth and perspective are considerably reduced on a flat, colourless screen. It is therefore necessary to create sets with exaggerated depth or to use artistic tricks to create the desired impression of perspective and depth. There are several methods of constructing sets. Let us consider two main approaches. Huge, cumbersome architectural structures with as many planes, corners and recesses as possible, which create expressive light effects and a sense of depth and stereoscopy (the Bauer method). Such sets are well suited for shooting a number of scenes. However, it is best of all if each shot is not repeated, meaning that the set needs to be created so that it can be filmed from utterly different positions and viewpoints. Erecting complex architectural structures involves a significant expenditure of space, resources and especially of time (but in cinema everything is done quickly and on the spur of the moment). Let us turn to the second method of using simplified sets. The focus of such settings is based on the foreground, where the essence and the soul of a set are concentrated. In this kind of set, the other planes are not important, and are replaced with black velvet or simply darkened out. This method also has its drawbacks. A simplified set can be shot from one viewpoint only. So, what can be done if a number of scenes need to be enacted here? The solution is simple: construct different corners of the same room completely separately. Bearing in mind the ease and speed of constructing a simplified set, this will not be at all difficult.

Let us not recount all the elementary rules of colour and how it is transformed through photography and the inappropriateness of white patches in a shadowy background. Although these practices are elementary and simple, they become obvious only after long and careful practical observation. The production artist's work must not be limited to constructing sets. But I shall say more about this in the next issue.

Lev Kuleshov, 'The Tasks of the Production Artist in Cinema [1917]'[2]

In the previous issue, we discussed the work of the production artist (*kinematograficheskogo khudozhnika*) only in relation to sets and approaches to constructing them. Very large fields of work involved in creating a film picture, which logically should be the concern of the production artist (*khudozhnika*), have so far been left in the hands of the director or the actor.

Take for example costumes, which in the theatre are exclusively created by the designer (khudozhnikom). Of course, in cinema it would be very hard to make special costumes for each picture, but we can always entrust the control of this task to the production artist. Even if some actors dress themselves tastefully, then their distinctive, individual personality will be portrayed through the character of their costume and there will be no overall coherence or style to the picture. Besides, an actor cannot fully understand how colour is transformed when photographed, and each specific set requires a particular type of costume. I know of a case when the seemingly insignificant white headdress of a maid ruined the whole set, which was constructed against black velvet, wrecking the mood built up by the actors.

As well as costumes, it is also essential that the production artist is consulted on makeup. For who other than an artist, a creator of all things pictorial, should be in charge of a character's distinctive appearance or the sophisticated hairdo of a fine lady?

There still exists a belief that arranging the mise-en-scène, composing groups of actors, is a task for the director alone. But who other than the production artist is able to help the director, at least in the initial positioning of actors in the frame? In his own pictures, the pictorial artist (*khudozhnik-zhivopisets*) considers the most important task to be that of composing the people and objects depicted, creating attractive poses and groupings of figures. The beauty and expressivity of individual lines of a pose are very often more convincing than complex psychological acting.

The colouring or 'toning' of filmstrip has also never been in the hands of the production artist. But this is a very complex and interesting process that needs to be directly supervised by somebody who perfectly understands colour and tonal relationships – and that person is the production artist. Colour also is subordinate to compositional laws (i.e. the montage of a picture); and toning, like scenery, can be used to create vivid and expressive contrasts. The overall sequence of colours across a film reel many miles long has its own pictorial laws and peculiarities.

When it comes to questions of lighting, there is inevitably a battle with the camera operator. But, as mentioned in the previous issue, since light is the 'paint' of the production artist, his input is absolutely essential in matters of lighting. What the camera operator captures on film is the visible, external appearance. Are not the symbols and pictorial image of the physical world close to the production artist?

The psychological experiences of the actor, his facial expression, are also a realm open to the production artist. Do we not marvel at the astounding way that complex human psychology is conveyed in the masterpieces of Ge or Vrubel?³ Is Čiurlionis not subtle, psychological and even musical?⁴

I know what you will say, 'but what then is the director's role in creating a film picture?' Yet, if the director is not *himself an artist* (*khudozhnik*), then he cannot create a film picture, a true work of cinematic art. I do not mean to say that if a production artist works together with a director, then the latter will have nothing to do; no, only that this collaborative work is unproductive *for the production artist*, since he can only stage a picture by working independently. As an example: why is Bauer so fine? Why is it that directors who are not artists, even if they collaborate with masters of pictorial images, do not create genuinely beautiful pictures?

It is true, we very often see pictures which are not put together by a production artist and they seem pleasant enough. But this is similar to a pleasant romance performed by some Ivan Ivanovich and Maria Stepanovna in a cosy living room after tea. If you have to listen to charming Ivan Ivanovich on the stage of the Bolshoi Theatre, then, I assure you, you are not going to waste your precious time listening to tone-deaf singers.

Besides these purely technical challenges, the production artist must recognize that cinema is the most formidable, magnificent and prevalent art form, via which he will forge new pathways and attain new results, which are not possible in the spheres of fine art, sculpture and architecture.

*Sergei Iutkevich, 'We Decorate with Light' [1925]*⁵

One of the essential factors which determines one or another style of cinematography is what we call decoration in cinema.

This very term, however, is wholly uncharacteristic of the production artist's (*kinokhudozhnika*) work, and even appears at odds with it. We can apply this term precisely to things which in the majority of cases are 'uncinematographic': take, for instance, the sumptuous operatic settings of *Rosita*, the oleographic fairy tale *Baghdad*, the stylized tinsel kingdoms of *Aelita* and the cardboard expressionism of *Caligari*.⁶

The work of the true production artist lies not in painting and installing sets in a naturalistic or purely expressionistic style, but in the value of his trained eye, which coordinates the entire visual atmosphere and composition of a frame.

At present, we should think not about whether we apply to cinema 'honest' or 'left' skills, which have been borrowed from the spheres of painting or theatrical scenery, but about the production artist's method of work.

And it seems to me that the most appropriate method will be that of constructivism. Complete confusion still governs our use of this term, however. It is applied to *Caligari*, to the 'Russified' Mars of *Aelita*, to the architectural fantasies of Cavalcanti and to Léger's cubism in the films of L'Herbier.⁷

But the fundamental principle of cinema constructivism must not be how analogous a film is to named works of painting and theatre, but the way in which the authentic material of cinema is exploited.

It must similarly take into account that light and space are the fundamental material. A set must orient itself not on illusionary tinsel or decoration, but on an architectural-spatial construction, not on 'prettiness', wallpaper and ornament, but on the play of light and shade, not on 'fairy-tale flamboyance' and trifles but on the revelation of the *faktura* (texture) of real materials. We film in a way that makes real iron look like cardboard, silk like chintz and vice versa; and there is nothing to be said about the way that we film human faces and bodies (the *faktura* of which you also need to know how to display): often instead of a hero all that floats across the screen is a badly glued beard.

We have already been able to see the tendency towards cinema constructivism or the partial realization of its agenda in certain American pictures, in the films *Strike* (Stachka) (the corridor with the doors) and *The Death Ray* (Luch smerti) and we have only been able to hear about the analogical experiments of young French cinematography.[8]

Vsevolod Pudovkin, 'Concerning the Production Artist in Cinema' [1925][9]

As regards creating an absurd hotchpotch and overloading film pictures with 'artistic' details of any design imaginable, we need to hand it to our Russian production artists (*khudozhnikam*) and to the Germans, who have often shown themselves to be their equals. It is hard to imagine the naïve tenacity with which these 'artists' (who in most cases have of course come from the theatre), refuse to understand even such obvious things as, for example, if a living horse is clumsy and absurd on the theatre stage, then plywood chimneys and columns plastered over with shiny paper are equally clumsy and absurd when photographed next to real streets, real trees and real houses. This elementary requirement is grasped only with great difficulty, despite the numerous examples in the work of our Russian and American cinema set designers (*kinodekoratorov*), which contrast starkly when juxtaposed.

Harder still is instilling an understanding of the second condition with which the work of composing sets must comply. This condition is correctly working out the background. Usually, our production artists approach set design as something independent unto itself. If, let us say, the room of a penniless student is being put together, then typically everything that is associated with our conception of such a room is concentrated in a small space, surrounded by battered plywood boards. The production is conscientiously ruined. First, inevitably by motley-patterned wallpaper, then by a lumpy couch, a table with a ragged oilcloth, numerous portraits etc., until the backdrop is not dissimilar to a patchwork tapestry. If putting

together a village reading room, its walls are inevitably plastered with posters and propaganda slogans against a background of red cloth. The logic of these 'artists' is incomprehensible. You would think it obvious that the viewer is going to watch the peasants present in the reading room, follow them intently, while the posters will come out only as white patches, which annoyingly distract the viewer's attention. It is clear that the very *essence of cinematographic techniques dictates the removal of superfluous details* in order *to focus the viewer's attention* on what is important and essential (when filmmakers shoot only the head of an actor, nobody complains that in the frame they are lacking a torso or legs). It should be clear that cinema sets are before all else only a background for a particular scene, with particular actors, in particular costumes. Successfully selecting the appropriate colours for sets and understanding correctly how they will appear on large surfaces (floor, walls, ceiling) – this is three quarters of the job.

The next task is to give sets their necessary characteristic attributes through introducing certain furniture and props. This is the most hazardous part of the job. Every prop must definitely be considered in the light of how it fits into the *entire composition* of the frame. *Maximum economy leads only to maximum expressivity*; and this is an undeniable virtue. If in the village reading room posters are essential as part of the story, then let them cover one wall only: they can be shot separately as posters, with a special frame dedicated to them – this is cinema. The peasants can be filmed in that same reading room, but against another wall, where there are no posters – this is also cinema.

To shoot a scene that mixes all manner of miscellaneous things into a single pile and to present it to the viewer with minimal time for them to make sense of this complete chaos – this is not cinema, but the most low-grade 'naturalism', which was once fed to us by the Drankov and Ermol´ev studios. To make sets with a calm background that does not distract the eye – this is the task of the true production artist (*khudozhnika kino*). This is something that is so often achieved by the Americans, but so woefully ignored by our own filmmakers.

Sergei Kozlovskii, 'The Rights and Responsibilities of the Production Artist (kino-khudozhnika)' [1925][10]

In our press, articles have already appeared defending the rights of production artists (*khudozhnikov*) in cinema but in real life, during the production process, their situation remains the same. Rare are those production artists who work independently, in the majority of cases they are entirely reliant on the director.

The director briefly outlines the task. The production artist delivers the sets. Receiving the sets in their finished state, the director unexpectedly finds that there needs to be a door over here, stairs over there and a new window in yet another place. His 'free creation' is often without limits. If we consider that a number of our directors are insufficiently trained, then it will be completely

understandable how in even the humblest middle-class room we see on the screen such marvellous props as extraordinary candlesticks and vases.

The production artist can protect himself. That is true. But the director is a dictator. You have to submit to his stubborn will. It happens that in such cases our production artists simply wave their hands hopelessly.

Once the sets have been delivered, the production artist absolutely must not step back. It is essential that he also takes part in arranging the lighting, because it is impossible to trust the camera operator and lighting technicians. We have only two or three camera operators who know lighting technology well; the rest are only just beginning to learn about it. The lighting technician can only suggest a type of illumination. The final decision must be approved by the collective of the director, production artist and camera operator.

This collective, to which should also be added the scenarist, must, if it is a close-knit group, carry out the production together. After all, everyone will carry out their own work, guided by their specific experience. The scenarist, when referring to one or another setting, has a certain perception of it, which is guided by something. The material he has developed can and will come in handy. The voices of the production artist and camera operator are all the more helpful.

Sets act only as a background in those instances when absolute attention must be directed towards the actor. Here set design must be approached very carefully. The viewer must not, even for a minute, be distracted by anything extraneous. If in the most important moments of the actor's scene the viewer is involuntarily distracted by some statuette, for example, then it detracts from the work of the entire filmmaking team, and first of all of the production artist. The set backdrop must be passive, understated and true to life. Nothing must stand out, unless that is required by the production.

In linking scenes, by contrast, sets make up for the lack of action. Here the main stress is upon the sets.

When making a plan of the production, the director must already have an understanding of its arrangement, and progressively work out and define the sets. It is impossible to make a person take in everything, take everything into account immediately, but in each set there must be something striking. It is important to make the setting in advance and it is essential that the film collective agree on the installation, the staging, the lighting and in general the 'little things'.

Having installed the sets, it is necessary to elaborate on them, once again collaboratively: select the frames, achieving maximum veracity and effect.

These requirements concern mainly the director and the whole filmmaking collective; the production artist must also face a whole range of demands. Complaints by directors about the slovenly work of the production artist, poor '*faktura*' (texture), the ineffective selection of material, are undoubtedly often justified.

In Germany, they embark upon painstaking explorations in the field of cinema design in order to do the job better and more cheaply. The production artist must have love and patience in order to achieve positive results in working on the selection of material. He must study everything himself. It is insufficient,

for example, to entrust an auxiliary worker (typically a painter) with painting something to look like 'iron' in order to make it possible to cheat the camera during filming and make plywood appear as if it were real iron.

The second demand presented to the production artist is that of versatility. He is an architect, a painter and an applied artist. He must know almost all crafts. There is no field of work that he does not interact with when making films: the world of the mechanic, the cobbler, brick works, mines, commercial industry, etc. However, I shall make the proviso that there must be some sort of boundaries for him: so, for example, a production artist must not be forced to work also on the costumes for large-scale historical films. In a typical film he can check the clothes, but in such films as Sten'ka Razin, which is currently in production, it is necessary to have a special artist with specific qualifications for the costumes.

The next responsibility of the production artist is to have a full, not a dilettante's knowledge of lighting technology, to know it no worse than the camera operator. It is important, moreover, that the production artist always knows precisely the angle from which the film will be shot. The construction of sets cannot be fortuitous. There are often cases when in adjusting sets to a 35-degree angle, they are distorted at 50 degrees. The difference this has on the impression of perspective is very significant. The foreground must be determined precisely; sets in the foreground are always worked out meticulously so that plywood does not jut out and that there is no sloppiness in the finishing, etc.

The responsibilities of the production artist in cinema are so complicated that they demand special preparation, special training of his attention. It is no wonder that we witness many designers from the theatre failing in cinema. Constructing sets as if they were a box in the front of the frame is one such mistake. We were expecting new production artists to come from GIK; but while camera operators, lighting specialists and actors have come to us from there, we still await one production artist. Clearly, they are going to receive their training by working in the industry.

I see the improvement of their technical expertise as well as the possibility of defending their rights, as coming through uniting all production artists in a special section of ARK where it would be possible to discuss those 'secret recipes', which it has long since been time that we shared with one another.

Aleksandr Rodchenko, 'The Production Artist and the Material Environment in Fiction Film' [1927][11]

I do not believe that the production artist's (*khudozhnika*) place in cinema can be reduced to that of a 'decorator' (*dekoratoru*) ... For everything must be of interest to him and he must be involved in everything ... Walls, the beards of actors, the way the floor is varnished and how buttons are fastened – all of this

is equally important to the production artist, since all of this is the 'material environment', the material with which he works.

Even in the environment of a fiction film – an environment which is primarily associated with the director – the production artist confronts the director and claims his right to exert himself on a more extensive approach to the material.

Our practice is for the production artist (*kino-khudozhnik*) to put together sets, throw furniture into place and then leave to drink tea. This production artist is reliant on the director. For him, it's not important which objects are piled upon the table. However, for the viewer, often in a frame a single glass cup is of more importance than all the walls and furniture together.

When the production artist receives a script, he must make a plan of the settings where the people in the picture are going to live. But not as has been done formerly, making a sketch with all the small details.

Having made the plan, he understands the proportions, the difference between the various film settings where the action takes place and how they relate to one another.

Usually, the production artist says something along these lines: in the picture, I'm going to have a newsroom that will be 'staged', but the bedroom of Khokhlova will not be 'staged'.

This is wrong. Everything demands equal attention, equal precision and careful work. Moreover, in order to create an impressive effect, the production artist must exert more energy and attention on a small ordinary room than on 'showy' sets.

Very often things are worked out in two 'halls', but the rest is just loaded with junk. This is the result of total illiteracy in treating material, a lack of the culture of the thing, which is one of the main factors in creating a film.

Then comes the second stage of work: drafting the plan of the settings according to cinematographic relations – the distribution of walls, doors and recesses, the combination of places for lighting, the identification of angles for filming. This is the most complex part of the production artist's work.

You have to do things in such a way that everything appears to be real, whereas in reality, everything works according to conventions.

At this point the large structures are also determined – the stairs, the banister, the heavy furniture – *because they are what are organic to a room*.

'It cannot be done like this', I thought and removed the table. The table is very specific to the cast-iron works in *Your Acquaintance* (Vasha Znakomaia); *you must not take it out* of the room, as it is what makes the room a meeting room. In the lodgings of the character Vasil'chikov (in *Your Acquaintance*), we might consider whether to leave one or two bookshelves or four or five chairs, but the main things – the folding bed, the multi-purpose writing desk and the dining table – the things that characterize the Soviet reporter, the things that agitate for a new material everyday life, these cannot be removed.

Every object which is filmed, even the most insignificant thing, must be absolutely essential and must absolutely be used.

In cinema it is important to know how to get rid of things that do not work. Cinema cannot stand realism 'as it is in life'. In life, so many things are thrown together that if you film it like that, then you would spend two days trying to work out what is in the frame. Cinema cannot stand it when on the screen there are eleven bottles and the characters only drink from two; the viewer will not see the others anyway.

Our practice is to bring in all sorts of props, hang them up, strew them around and then take them away in wheelbarrows. There is no guidance in terms of the number of objects that should be included in the frame.

There are things which are not set out in the scenario, but which can be relevant if they are used correctly. For example: we needed to create an appropriate room for a 'frivolous girl'. Usually with such a room, little pictures are tacked to the walls and there are flowers, vases and shells. I went to look for props and I also picked up two vases, but then my eye caught a glass elephant. Positioned on the shelf, this single tacky elephant got across the full character of the room's inhabitant to such a degree that all the other props were unnecessary. Of course, it was lit accordingly so that everything worked 100%. Subsequently, we added a flower vase and put it not in the normal place but on the sofa, and instead of flowers we placed a coat hanger in it.

It is important that the production artist finds a characteristic object which has not been filmed before and shows this ordinary thing from a new point of view, as it has not been shown before.

In cinema it is important to have a sense of *limits*. Cinema is not life and nor is it theatre. In cinema you are restricted by the plot which is unfolding. In the best cases, you will not see anything that is superfluous, but in other cases, the superfluous will distract you. In the example I have given, out of ten decanters you will remember only four or five, so why the rest?

In theatre you are going to look at all the decanters while the hero persuades the lady to kiss him. In real life and in paintings, you'll look at even more. You can sit as long as you wish and consider all the details.

One more observation: in cinema, since visual reaction time is very short, many things need to be either exaggerated or minimalized. In order to show that the news room was messy, we had to litter it with considerably more things than is the case in life. And in order to show that a floor has been cleaned, it needs to be polished to an exceptional standard – then it will perform its function.

Similarly, with location filming: the rough sea needs to be filmed on the most stormy day. In life, a person's perception while watching the sea is amplified by the noise of waves and the surrounding masses of space. In cinema, only a part of this is taken and it has to be strengthened.

It is a mistake to make special things in order to *demonstrate* the 'emotional state of the protagonist'; any building can be made to look horrifying and vice versa, depending on the task at hand. Remember how in the midst of revolution the palace changes when the electricity goes out and the telephone ceases to work etc...

In a non-fiction film, the work of the production artist is even more complex and it must be connected even more closely with the functions of the director and the camera operator. Here, the director, the production artist and the camera operator merge into a single whole and the demarcations of their functions is less noticeable.

Andrei Burov, 'Architecture and Cinema' [1929][12]

It is difficult to talk about the 'architect' (*arkhitektore*) as a 'decorator' (*dekoratore*) in cinema because their work cannot and must not be called 'decorative' in the generally accepted meaning of the term.

And here is why: cinema reveals possibilities for the architect and for all of us to fulfil such tasks that until now could not be realized in life because of a whole range of circumstances. Therefore, the architect works in cinema not as a decorator, but as an architect.

I will provide as an example the time when I was given the task of designing the architectural setting of the collective farm for the film *The General Line*, which I was invited by Eizenshtein to work on.[13] The starting point of my work was not to create decorative effects as a goal in itself, but the desire to use the film to bring to life new methods of industrialized agricultural production by building sets based on new material and construction techniques.

The mechanization of food preparation and new methods for feeding livestock determined the new forms of the barns. The rejection of old stalls for the animals and their replacement with a metal structure, with fully mechanized equipment for feeding and cleaning livestock, processing and storing produce, weighing and transporting it via conveyor systems and the demand for the highest hygiene standards necessitated a new approach to architectural forms and opened up entirely new possibilities in addressing the task given to me.

In cinema, it might be possible to show an ideal living space if it is furnished inside not with bookcases and couches jumbled together, but rather if it is conceived as a complex of inextricably linked elements. The connection of these elements, whether in the interior of a home, a club or some other building, must be as inseparable as an engine from a car or a machine from a factory. Forms must be inextricably connected so that everything is coordinated towards the processes of everyday life, which circulates inside these spaces and over the city's terrain.

And now to my thoughts on Comrade Baizengerts' article in No. 33 of *Sovetskii ekran* (Soviet Screen).[14] I completely disagree with his argument that 'above all else we need poets with the spirit of fantasy and a healthy psyche and that those poets must study the film camera before writing scenarios'. I look much more seriously at cinema and see it, first of all, as an immense instrument for instructing the masses in all the great ideas of our age. I therefore affirm that above all we need not poets who have to study the camera but people building

new things. Cinema must be used not to create lyrical sentiments, but to show life as it is and as it ought to be.

Vladimir Egorov, 'The Artist of the Theatre Stage and the Artist of the Film Picture – Masters of Decorative Scenery' [1952, unpublished][15]

We are familiar with theatre performances and cinema, and the decorative design of both...

Theatre and cinema are two types of visual art: although they are perceived as a spectacle in almost the same way, they are two different methods of showing a person and their actions in life and in the surrounding environment.

This 'surrounding environment' (i.e. the background for a person's actions and their lived existence) immediately determines the character and place of action, in both a theatre play and the frame of a film picture. For it to be styled artistically demands the creative work of a master artist (*khudozhnik*), a director and an actor.

There is no difference in the creative work of these figures – this is first and foremost; they must be creative figures, who solve artistic problems. Of course, some can be weaker than others, and the results that follow from their work depend on the strength of the masters.

The work of a master consists of the task of showing ideas and themes in artistic form and finding an overall look for the entire picture. This is the same for the theatre stage as it is for cinema.

This 'overall look', this demonstration of a proposal for a future artistic production, is expressed in the work of the sketch.

The sketch, as for cinema as for the theatre stage, besides its value as an artistic work has the goal of giving a clear expression of a vision and plan of the proposed design, and through characteristic details shows the result of the work of an artist-composer (*khudozhnik-kompozitora*).

Through the sketch, it is possible to identify what task a master has set himself.

There is almost no difference between the sketch of the proposed sets for the theatre stage and the film picture (*kino-kartin*). The difference is obvious, however, in the floor plan of sets; this difference depends on the features of the place, the physical space and the technical conditions.

The most important thing in preparing proposed sets is the floor plan.

Konstantin Stanislavskii, while working on the floor plan, would first of all draw a circle at the stage footlights which would be the prompt box. Then he would place crosses for actors and arrows for entrances and exits, and gradually the whole stage would be covered in symbols, with the centre of the stage, footlights and the prompt box. The centre of the stage is visible from all positions in the theatre auditorium, from the eye of the viewer in the stalls, the

boxes and the gallery; thousands of eyes and thousands of lines of sight are directed at the square of the stage floor.

And so this is how we plan according to the conditions of the theatre stage.

The main thing is that the stage, the footlights and the many lines of sight of the many viewers in different places must all be anticipated by the artist of the stage.

As an example of how to lay out sets in the theatre, let us take the famous picture by the artist Kivshenko *Military Council at Fili*.[16] Let us look at how this picture could be staged as a theatre set. We all remember the picture: the interior of an *izba*, log walls, a table with generals sitting around it, a stove...

Let us mark out the footlights and the centre of the prompt box, the lines of the walls, the red corner with lubok pictures, the table and benches, crosses symbolising the actors, the generals and, to the right of the backstage curtain, the stove. That's all. So that everyone can see everything, the scene is frontally staged.

This is the plan for staging the theatrical set for *A Hut in Fili*.

The artist's task is to construct Kivshenko's painting on the stage in real form. The footlights and the proscenium will play the role of the painting's frame.

The lines of sight from the various places of the theatre auditorium are as many as there are viewers.

The floorplan for filming is different, however. If it was done exactly as it is in theatre, then the camera would have to be placed very far away in order to capture all the footlights, and the figures of the actors would come out very small. There would be no way of hiding the ceiling of the sets and the floor would be empty. This means we need to use a different viewpoint, the viewpoint from the corner behind Barklay,[17] and shift the set over sideways.

[...].

Having familiarized ourself with the details of the set layout, for both the theatre and the cinema, we can see their difference and their specific characteristic features.

First of all and most importantly – the stage – the place for sets of the theatre stage – the footlights, the mid-line of the prompt box, the backdrop, the curtain and foot of the stage – these act as the frame of the painting; the number of lines of vision are as many as the number of viewers positioned in various places of the theatre auditorium.

The layout for the construction of cinema sets is a different matter. Here there are not thousands of lines of vision directed at the proposed construction, but one viewpoint; this is the eye of the camera operator, the eye of the camera lens.

The line of vision of the camera apparatus spreads out in space in the shape of a cone. It forms a triangle with the pinnacle at the point of the camera lens. This triangle is the place where the future corner of the walls and arches will be and the place of action of the actors.

This knowledge of the main specificities of space, and the difference of the stage with footlights and triangle for the camera is the main essential requirement for composing sketches and plans for each of them.

There have been instances when very talented artists of the theatre, without the knowledge of the main principle of the specificities of the film camera, wasted much time and effort, and got tangled up in columns and arches, and the walls of structures hid one another and a lot of things were set up unnecessarily.

The artist of the theatre has one great advantage: colour, paints and the principles of easel painting. Our great theatre artists – Korovin, Golovin and Benois – were complete masters of the stage.[18] Their works on the overall composition with actors and costumes were not afraid of the 'light' of the camera operator. Everything was constructed through colour and painting.

In cinema, despite the fact that it is in colour, everything depends – or a lot depends – on the cultural awareness of the camera operator, his taste and his collaboration with the production artist. He, the camera operator, on occasions pursues only light and what is captured on the film strip. He floods the place with light and shadow, shining on the face of the actor, 'up his nostrils', and not working out the ensemble. Very few production artists have been completely satisfied with their collaborative work, and when looking at their work on the screen, they did not recognize what they had conceived.

Of course, camera operators can say the same thing about production artists. This means that the creative, collective work of the director, the camera operator and the production artist for the screen is so closely connected; they touch one another, complement one another, so that you would wish that these three creative wills are united as one, so that they are one creator, who is director, production artist and lighting specialist. But this is not how it is or how it will be.

[…].

It is possible to point out the beneficial aspects of filming, the possibilities of transmitting through the camera everything that is accessible to photograph. It is possible to speak of the sensitivity of the camera eye to the limitations in implementing details and to say that things which you can get away with in stage sets and in painting, since they get lost in the general picture, are starkly revealed as false and deficient by the apparatus and the eye of the camera, which do not tolerate bad props and false costumes and make-up.

The paper flowers of the spell of 'Faust' are intolerable to the camera eye. Of course, I do not think that I have pointed out all the differences between these two artists. The artist in each of these fields can only be a talented composer and experienced master in their practice.

NOTES

Introduction

1 Aleksandr Rodchenko, 'Khudozhnik i material′naia sreda v igrovoi fil′me', *Sovetskoe kino* 5–6 (1927): 14–15.
2 For the Khanzhonkov studio's *A Sixteenth-Century Russian Wedding* (*Russkaia svad′ba XVI stoletiia*, 1908), V. Fester was credited as the *khudozhnik*. This is the first film for which an individual is credited as having taken on this role. The film is typically dated to 1908, but was released on 25 April 1909. See Veniamin Vishnevskii, *Khudozhestvennye fil′my dorevoliutsionnoi Rossii: Fil′mograficheskoe opisanie* (Moscow: Goskinoizdat, 1945) and V. Ivanova, V. Myl′nikova, S. Skovorodnikova, Iu. Tsiv′ian and R. Iangirov (eds), *Velikii kinemo: Katalog sokhranivshikhsia igrovykh fil′mov Rossii 1908–1919* (Moscow: Novoe literaturnoe obozrenie, 2002), 16.
3 For discussion of the use of different terminology for production artists in Russian cinema, see Eleanor Rees, 'From the Cinema "Dekorator" to the Cinema "Arkhitektor": Set Design, Medium Specificity and Technology in Russian Cinema of the Silent Era', *Journal of Design History* 34, no. 4 (December 2021): 297–315. The existence of alternative titles by which production artists could have been known is highlighted by the fact that Oleg Teptsov's 1988 film about a production artist in the late-Imperial era was entitled *Gospodin oformitel′* (Mr. Designer).
4 Emma Widdis, *Socialist Senses: Film, Feeling, and the Soviet Subject, 1917–1940* (Bloomington, IN: Indiana University Press, 2017), 51.
5 David Bordwell, Janet Staiger and Kristin Thompson, *The Classical Hollywood Cinema: Film Style and Mode of Production to 1960* (London: Routledge, 1985) and Maria Belodubrovskaya, *Not According to Plan: Filmmaking under Stalin* (Ithaca, NY: Cornell University Press, 2017).
6 See Belodubrovskaya, 'The Masters: The Director-Centred Mode of Production and the Tradition of Quality' in her *Not According to Plan*, 90–129.
7 Philip Cavendish, 'The Hand that Turns the Handle: Camera Operators and the Poetics of the Camera in Pre-Revolutionary Russian Film', *Slavonic and East European Review* 82, no. 2 (2004): 201–45 and his *The Men with the Movie Camera: The Poetics of Visual Style in Soviet Avant-Garde Cinema of the 1920s* (London and New York: Berghahn Books, 2013); Anna Kovalova, 'Symbolism in Early Russian Cinema and the Ghostwriter Aleksandr Kursniskii', *The Russian Review* 79, no. 3 (2014): 366–88 and

her 'Aleksandr Voznesenskii, the "Kinemo-Shakespeare": Notes on the First Russian Cinema Dramatist', *The Slavonic and East European Review* 96, no. 2 (2018): 208–43; and Belodubrovskaya, *Not According to Plan*.

8 Maria Gough, *The Artist as Producer: Russian Constructivism in Revolution* (Berkeley, CA: University of California Press, 2005).

9 See Philip Cavendish, *Soviet Mainstream Cinematography: The Silent Era* (London: UCL Arts & Humanities Publications, 2007) and his 'Ideology, Technology, Aesthetics: Early Experiments in Soviet Color Film, 1931–1945', in *A Companion to Russian Cinema*, ed. Birgit Beumers (London: Wiley-Blackwell, 2016), 270–29; Lilya Kaganovsky, *The Voice of Technology: Soviet Cinema's Transition to Sound, 1928–1935* (Bloomington, IN: Indiana University Press, 2018); and Lilya Kaganovsky and Masha Salazkina (eds), *Sound, Speech, Music in Soviet and Post-Soviet Cinema* (Bloomington, IN: Indiana University Press, 2014).

10 See John Bowlt, 'Constructivism and Russian Stage Design', *Performing Arts Journal* 1, no. 3 (1977): 62–84 and Olga Hadley, *Mamontov's Private Opera: The Search for Modernism in Russian Theater* (Bloomington, IN: Indiana University Press, 2010).

11 See Martin Puchner, *Poetry of the Revolution: Marx, Manifestos, and the Avant-Gardes* (Princeton, NJ: Princeton University Press, 2006), 99–100.

12 K. Gazdenko, 'Sovetskii byt na sovetskom ekrane', *Kino-front* 1 (1927): 9–10 (9).

13 Examples of industry guides on set design include Robert Mallet-Stevens, *Le Décor moderne au cinéma* (Paris: Charles Massin, 1928); Edward Carrick, *Designing for Moving Pictures* (London and New York: The Studio Publications, 1941); Ward Preston, *What an Art Director Does: An Introduction to Motion Picture Production Design* (Los Angeles, CA: Silman-James Press, 1994); Robert L. Olsen, *Art Direction for Film and Video* (New York: Focal Press, 1998); Peter Ettedgui, *Screencraft: Production Design and Art Direction* (Crans-près-Céligny: Roto-Vision, 1999); Michael Rizzo, *The Art Direction Handbook for Film* (Oxford: Focal Press, 2005); and Vincent LoBrutto, *The Filmmaker's Guide to Production Design* (London: Faber and Faber, 2006).

14 Charles Affron and Mirella Jona Affron, *Sets in Motion: Art Direction and Film Narrative* (New Brunswick, NJ: Rutgers University Press, 1995).

15 Charles Tashiro, *Pretty Pictures: Production Design and the History of Film* (Austin, TX: University of Texas Press, 1998) and Sarah Street, 'Sets of the Imagination: Lazare Meerson, Set Design and Performance in Knight Without Armour (1937)', *Journal of British Cinema and Television* 2 (2005): 18–35.

16 Tashiro, *Pretty Pictures*, 6.

17 Street, 'Sets of the Imagination', 27–35.

18 Giuliana Bruno, *Atlas of Emotion: Journeys in Art, Architecture, and Film* (New York: Verso, 2002).

19 Juhani Pallasmaa, *The Architecture of the Image: Existential Space in Cinema*, trans. Michael Wynne-Ellis (Helsinki: Rakennustieto, 2001), 17.
20 Antonia Lant, 'Haptical Cinema', *October* 74 (1995): 45–73 and Peter Wollen, 'Architecture and Film: Places and Non-Places', in *Paris Hollywood: Writings on Film* (London and New York: Verso, 2002), 199–215.
21 Donald Albrecht, *Designing Dreams: Modern Architecture in the Movies* (Santa Monica, CA: Hennessy and Ingalls, 1986) and Sabine Hake, 'Cinema, Set Design and the Domestication of Modernism', in *Popular Cinema of the Third Reich* (Austin, TX: University of Texas Press, 2001), 46–57.
22 Tim Bergfelder, Sue Harris and Sarah Street, *Film Architecture and the Transnational Imagination: Set Design in 1930s European Cinema* (Amsterdam: Amsterdam University Press, 2007) and Lucy Fischer (ed.), *Art Direction & Production Design* (London and New York: I.B. Tauris, 2015).
23 Léon Barsacq, *Caligari's Cabinet and Other Grand Illusions: A History of Film Design*, trans. Michael Bullock (Boston, MA: New York Graphic Society, 1976).
24 Ibid., 47.
25 Catherine de la Roche, 'Scenic Design in the Soviet Cinema', *The Penguin Film Review* 3 (1947): 76–81.
26 Thorold Dickinson and Catherine de la Roche, *Soviet Cinema* (London: Falcon Press, 1948).
27 For example, see: Semen Ginzburg, *Kinematografiia dorevoliutsionnoi Rossii* [1963] (Moscow: Agraf, 2007); Denise J. Youngblood, *Soviet Cinema in the Silent Era, 1918–1935* (Austin, TX: University of Texas Press, 1991) and her *The Magic Mirror: Moviemaking in Russia, 1908–1918* (Madison, WI: University of Wisconsin Press, 1999); Peter Kenez, *Cinema and Soviet Society: From the Revolution to the Death of Stalin* (London and New York: I.B. Tauris, 2001); and Jamie Miller, *Soviet Cinema: Politics and Persuasion under Stalin* (London and New York: I.B. Tauris, 2010).
28 Elena Rakitina, *Anatolii Afanas´evich Arapov* (Moscow: Sovetskii khudozhnik, 1965); Valentina Kuznetsova, *Evgenii Enei* (Leningrad and Moscow: Iskusstvo, 1966); Evgenii Gromov, *Khudozhnik kino: Vladimir Egorov* (Moscow: Biuro propagandy sovetskogo kinoiskusstva, 1973); and Tat´iana Tarasova-Krasina, *Iosif Shpinel´: Put´ khudozhnika* (Moscow: Iskusstvo, 1979).
29 Gennadii Miasnikov, *Ocherki istorii russkogo i sovetskogo kinodekoratsionnogo iskusstva, 1908–1917* (Moscow: VGIK, 1973), his *Ocherki istorii sovetskogo kinodekoratsionnogo iskusstva, 1918–1930* (Moscow: VGIK, 1975) and his *Ocherki istorii sovetskogo kinodekoratsionnogo iskusstva, 1931–1945* (Moscow: VGIK, 1979).

30 See Emma Widdis, '*Faktura*: Depth and Surface in Early Soviet Set Design', *Studies in Russian and Soviet Cinema* 3, no. 1 (2009): 5–32 and her 'Cinema and the Art of Being', in *A Companion to Russian Cinema*, ed. Birgit Beumers (London: Wiley-Blackwell, 2016), 314–36.
31 Ibid.
32 Ibid., 332.
33 See, for example, Ian Christie, 'Down to Earth: *Aelita* Relocated', in *Inside the Film Factory: New Approaches to Russian and Soviet Cinema*, ed. Richard Taylor and Ian Christie (London: Routledge, 1991), 81–102; Youngblood, *Soviet Cinema in the Silent Era, 1918–1935*, 30–1; David Gillespie, *Early Soviet Cinema: Innovation, Ideology and Propaganda* (London: Wallflower, 2000), 11; and Julia Sutton-Mattocks, 'Cycles of Conflict and Suffering: Aleksandr Dovzhenko's *Arsenal*, and the Influence of Käthe Kollwitz and Willy Jaeckel', *Studies in Russian and Soviet Cinema* 10, no. 1 (2016): 1–32.
34 Neia Zorkaia, 'Russkii modern i revoliutsionnyi avangard (na materiale kino)', in *Russkii avangard v krugu evropeiskoi kul´tury*, ed. V. Ivanov, T. Kniazevskaia, A Parnis, D. Sarab´ianov, T. Shakh-Azizova and T. Tsiv´ian (Moscow: Radiks, 1994), 232–49; Yuri Tsivian [Iurii Tsiv´ian], 'Two "Stylists" of the Teens: Franz Hofer and Yevgenii Bauer', in *A Second Life: German Cinema's First Decades*, ed. Thomas Elsaesser and Michael Wedel (Amsterdam: Amsterdam University Press, 1996), 264–76; Valentina Kuznetsova, 'Aleksandr Benua i Leningradskaia shkola khudozhnikov kino', in *Vek peterburgskogo kino: Sbornik nauuchnykh trudov*, ed. Aleksandr L. Kazin (Saint Petersburg: Rossiiskii institut istorii iskusstv, 2007), 132–51; and Oksana Chefranova, 'From Garden to Kino: Evgenii Bauer, Cinema, and the Visuality of Moscow Amusement Culture, 1885–1917' (PhD diss., New York University, New York, 2014).
35 Yuri Tsivian [Iurii Tsiv´ian], 'Portraits, Mirrors, Death: On Some Decadent Clichés in Early Russian Films', *Iris* 14–15 (Autumn 1992): 67–83, his *Early Cinema in Russia and Its Cultural Reception*, ed. Richard Taylor and trans. Alan Bodger (London and New York: Routledge, 1994) and his Two "Stylists" of the Teens'; Rachel Morley, 'Gender Relations in the Films of Evgenii Bauer', *Slavonic and East European Review* 81, no. 1 (2003): 32–69 and her *Performing Femininity: Woman as Performer in Early Russian Cinema* (London: I.B. Tauris, 2017); Mikhail Iampolski [Iampol´skii], 'Russia: The Cinema of Anti-modernity and Backward Progress', in *Theorising National Cinema*, ed. Valentina Vitali and Paul Willemen (London: BFI Publishing, 2006), 72–87; Alyssa DeBlasio, 'Choreographing Space, Time, and "Dikovinki" in the Films of Evgenii Bauer', *Russian Review* 66, no. 4 (2007): 671–92.
36 Widdis, '*Faktura*' and her *Socialist Senses*.

37 See Eleanor Rees, 'Design, Creativity and Technology: The *Khudozhnik* in Russian Cinema of the Silent Era', *Film History* 32, no. 4 (2020): 60–90; 'Comfort and the Domestic Interior in Early Soviet Cinema' in *Screen Interiors: From Country House to Cosmic Heterotopias*, ed. Pat Kirkham and Sarah Lichtman (London: Bloomsbury Academic, 2021), 31–48; and 'From the Cinema 'Dekorator' to the Cinema 'Arkhitektor'.
38 For discussion of the various terms used for the profession in the US film industry, see Fischer (ed.), *Art Direction & Production Design*, 2–3.
39 See Tsivian, *Early Cinema in Russia and Its Cultural Reception*; Morley, *Performing Femininity*; and Widdis, 'Faktura' and her *Socialist Senses*.
40 Bergfelder, Harris and Street, *Film Architecture and the Transnational Imagination*, 12.
41 For discussion of how design developed as a profession in Russia, see Tom Cubbin, *Soviet Critical Design: Senezh Studio and the Communist Surround* (London: Bloomsbury, 2019) and Yulia Karpova, *Comradely Objects: Design and Material Culture in Soviet Russia, 1960s–80s* (Manchester: Manchester University Press, 2020), 9–15.
42 Cubbin, *Soviet Critical Design*, 9.
43 The first Soviet sound films went into production in 1930, but silent films continued to be produced until 1935. Kaganovsky, 'Learning to Speak Soviet', 292–313.
44 Ibid., 294.
45 Aleksandr Razumnyi, *U istokov: Vospominaniia kinorezhissera* (Moscow: Iskusstvo, 1975), 54.

Chapter 1

1 See Sergei Kozlovskii, 'Prava i obiazannosti kino-khudozhnika', *Kino-zhurnal ARK* 11–12 (1925): 16–17 and his 'Sistema fundusov v kino-dekoratsiiakh', *Kino front* 4 (1928): 4–5; and Nikolai Kolin and Sergei Kozlovskii, *Khudozhnik-arkhitektor v kino* [1930], reprinted in *Kinovedcheskie zapiski* 99 (2009): 378–422 (395).
2 Denise J. Youngblood notes that early-Russian film directors had previously worked as actors and directors in the theatre. See Denise J. Youngblood, *The Magic Mirror: Moviemaking in Russia, 1908–1918* (Madison: University of Wisconsin Press, 1999), 53–6. According to Philip Cavendish, the majority of first-generation camera operators had worked as professional still photographers and actuality makers. See Philip Cavendish, 'The Hand That Turns the Handle: Camera Operators and the Poetics of the Camera in Pre-Revolutionary Russian Film', *Slavonic and East European Review* 82, no. 2 (2004): 201–45 (207).
3 Tim Bergfelder, Sue Harris and Sarah Street, *Film Architecture and the Transnational Imagination: Set Design in 1930s European Cinema* (Amsterdam: Amsterdam University Press, 2007), 35.

4 These figures include Viktor Agden (1880–1942), Dmitrii Kolupaev (1883–1954), Petr Mosiagin (1880–1960), and Ivan Stepanov (1887–1953).
5 Kozlovskii acknowledged the importance of the World of Art to the sphere of set design. See Russian State Archive of Literature and Arts (RGALI), Moscow, Russia. f. 2394, op. 1, ed. khr. 72.
6 Vladimir Kruglov (ed.), *Konstantin Korovin, 1861–1939: K 150-letiu so dnia rozhdeniia* (Saint Petersburg: Palace Editions, 2011).
7 Sergei Kozlovskii, 'Mir iskusstva'. Undated and unpublished. RGALI f. 2394, op. 1, ed. khr. 72.
8 Emma Widdis, '*Faktura*: Depth and Surface in Early Soviet Set Design', *Studies in Russian and Soviet Cinema* 3, no. 1 (2009): 5–32 (7).
9 For information on *russkii modern*, see Elena Borisova and Grigory Sternin, *Russian Art Nouveau* (New York: Rizzoli, 1988).
10 Yuri Tsivian [Iurii Tsiv´ian], 'Two "Stylists" of the Teens: Franz Hofer and Yevgenii Bauer', in *A Second Life: German Cinema's First Decades*, ed. Thomas Elsaesser and Michael Wedel (Amsterdam: Amsterdam University Press, 1996), 264–76; and Emma Widdis, 'Cinema and the Art of Being: Towards a History of Early Soviet Set Design', in *A Companion to Russian Cinema*, ed. Birgit Beumers (London: Wiley-Blackwell, 2016), 314–36 (315–16). For discussion of the influence of *russkii modern* on Egorov's designs for Vsevolod Meierkhol´d's 1915 adaptation of Oscar Wilde's *The Picture of Dorian Gray* (1890), see Anna Kovalova, 'The Picture of Dorian Gray painted by Meyerhold', *Studies in Russian and Soviet Cinema* 13, no. 1 (2019): 59–90.
11 For discussion of Zinaida Morozova's Moscow mansion, see Borisova and Sternin, *Russian Art Nouveau*, 74.
12 Neia Zorkaia, 'Russkii modern i revoliutsionnyi avangard', in *Russkii avangard v krugu evropeiskoi kul´tury*, ed. Viacheslav Ivanov (Moscow: Radiks, 1994), 232–49.
13 Viktor Simov (1858–1935) exhibited alongside the Wanderers in the 1880s and 1890s; Anatolii Arapov (1876–1948) participated in the Blue Rose's landmark 1907 exhibition; and the Impressionist-style paintings of Iosif Shpinel´ (1892–1980) and Dmitrii Kolupaev were acquired by museums for their contemporary collections.
14 Kozlovskii, 'Smysl moei zhizni', in *Iz istorii kino* 7 (Moscow: Iskusstvo, 1968), 63–90 (87).
15 Ibid., 88.
16 Sergei Iutkevich, *Sobranie sochinenii v trekh tomakh*, vol. 1 (Molodost´) (Moscow: Iskusstvo, 1990), 40.
17 Nikolai Suvorov, 'Dva interv´iu Nikolaia Suvorova' [19 March 1969], *Kinovedcheskie zapiski* 99 (2009): 323–4.
18 Ibid.; Iutkevich, *Sobranie sochinenii v trekh tomakh*, vol. 1, 305; and Kozlovskii, 'Smysl moei zhizni', 90.
19 Kozlovskii, 'Smysl moei zhizni', 90.

20 Arapov, Egorov, Evgenii Enei (1890–1971), Kozlovskii, and Shpinel' all had architectural training. Those with experience in the graphic arts include Arapov, Isaak Makhlis (1893–1958), Vasilii Kamardenkov (1897–1973), Kolupaev and Iutkevich. Makhlis contributed to the journals *Krokodil* and *Teatr*, Stepanov worked as a graphic artist, Arapov contributed to the journals *Vesy* and *Zolotoe runo*, Kamardenkov worked as a poster designer and Kolupaev designed posters for the ROSTA agency. See Gennadii Miasnikov, *Ocherki istorii sovetskogo kinodekoratsionnogo iskusstva, 1918–1930* (Moscow: VGIK, 1975), 78–99.
21 Iutkevich, *Sobranie sochinenii*, vol. 1, 41.
22 Vladimir Gardin, *Vospominaniia*, vol. 1 (Moscow: Goskinoizdat, 1952), 109.
23 Widdis, 'Cinema and the Art of Being', 322.
24 RGALI. f. 2605, op. 1, ed. khr. 27.
25 Widdis, 'Cinema and the Art of Being', 321.
26 Kazimir Malevich, 'Khudozhnik i kino', *Kino-zhurnal ARK* 2 (1926): 15–17; Kozlovskii, 'Prava i obiazannosti kino-khudozhnika', 16; 'Rezoliutsiia sektsii khudozhnikov arkhitektorov', *Kino-front* 2 (1928): 13; and Lesnaia, 'Khudozhnik v kino', *Sovetskii ekran* 38 (1929): 9.
27 Kolin and Kozlovskii, Khudozhnik-arkhitektor v kino, 394.
28 Miletsa N. Pozharskaia, *Russkoe teatral'no-dekoratsionnoe iskusstvo, kontsa XIX nachala XX veka* (Moscow: Iskusstvo, 1970), 86–7.
29 Miasnikov, *Ocherki istorii sovetskogo kinodekoratsionnogo iskusstva, 1918–1930*, 78–99.
30 Nekhoroshev, *Dekorator Khudozhestvennogo teatra Viktor Andreevich Simov*, 5.
31 See Nick Worrall, *The Moscow Art Theatre* (London: Routledge, 2003), 16–18.
32 Pozharskaia, *Russkoe teatral'no-dekoratsionnoe iskusstvo*, 88.
33 Rachel Morley, 'Gender Relations in the Films of Evgenii Bauer', *Slavonic and East European Review* 81, no. 1 (2003): 32–69 (43).
34 Nekhoroshev, *Dekorator Khudozhestvennogo teatra Viktor Andreevich Simov*, 65.
35 Evgenii Kuman'kov, *Vladimir Evgen'evich Egorov* (Moscow: Sovetskii khudozhnik, 1965); and Evgenii Gromov, *Khudozhnik kino: Vladimir Egorov* (Moscow: Biuro propagandy sovetskogo kinoiskusstva, 1973).
36 Gromov, *Khudozhnik kino*, 14; and Viktor Voevodin, 'Vladimir Evgen'evich Egorov', in *Silent Witnesses: Russian Films 1908–1919*, ed. Paolo Cherchi Usai et al. (London: BFI Publishing, 1989), 560–2.
37 Voevodin, 'Vladimir Evgen'evich Egorov', 560.
38 Lev Kuleshov, *The Art of Cinema* [1929], in *Kuleshov on Film: Writings*, ed. and trans. Ronald Levaco (Berkeley: University of California Press, 1974), 69.
39 See Morley, 'Gender Relations in the Films of Evgenii Bauer', 38 and her *Performing Femininity: Woman as Performer in Early Russian Cinema*

(London: I.B. Tauris, 2017), 54–5; and Cavendish, 'The Hand That Turns the Handle', 215.

40 Romil Sobolev, *Liudi i fil′my russkogo dorevoliutsionnogo kino* (Moscow: Iskusstvo, 1961), 51–7; Worrall, *The Moscow Art Theatre*, 18; and Jean Benedetti, *Stanislavskii: An Introduction* (London: Bloomsbury, 2016), 3–5.

41 Nekhoroshev, *Dekorator Khudozhestvennogo teatra Viktor Andreevich Simov*, 226. Several of Simov's models are preserved at the Moscow Art Theatre Museum in Moscow.

42 Cited in Pozharskaia, *Russkoe teatral′no-dekoratsionnoe iskusstvo*, 93.

43 Moisei Aleinikov, *Puti sovetskogo kino i MKhAT* (Moscow: Goskinoizdat, 1947), 52.

44 Ibid.

45 For discussion of MKhT's influence on acting techniques, see Yuri Tsivian [Iurii Tsiv′ian], 'New Notes on Russian Film Culture between 1908 and 1919', in *The Silent Cinema Reader*, ed. Lee Grieveson and Peter Kramer (London: Routledge, 2004), 342–3; and Booth Wilson, 'From Moscow Art Theatre to Mezhrabpom-Rus′: Stanislavskii and the Archaeology of the Director in Russian Silent Cinema', *Studies in Russian and Soviet Cinema* 11, no. 2 (2017): 118–33.

46 Fester worked on a number of films for the Khanzhonkov studio from 1908 to 1912. However, very little information on Fester survives, including accurate information about his full name or background.

47 Veniamin Vishnevskii, *Khudozhestvennye fil′my dorevoliutsionnoi Rossii: Fil′mograficheskoe opisanie* (Moscow: Goskinoizdat, 1945), 7–8.

48 Aleksandr Khanzhonkov, *Pervye gody russkoi kinematografii* [1937] (Moscow: Liteo, 2016), 80.

49 Anon., *Russkoe slovo*, no. 176 (1912): 4 and Anon., *Vestnik kinematografii*, no. 40 (1912): 18. For information on the exhibition, see Andrei Lebedev (ed.), *Vasilii Vereshchagin: Zhizn′ i tvorchestvo* (Moscow: Iskusstvo, 1958), 420.

50 *Zhivoi ekran*, no. 12 (1913): 1.

51 For discussion of the success of foreign produced and imported films in Russia and their influence on the development of a native cinema industry, see Richard Abel, 'Pathé's Stake in Early Russian Cinema', *Griffithiania*, no. 38–9 (1990): 243–7.

52 Sergei Gorodetskii, 'Zhiznopis′', *Vestnik kinematografii*, no. 2 (1915): 3–4 (4).

53 Valentin Turkin, 'E. Bauer i russkaia kinematografiia', *Kino-gazeta*, no. 31 (1918): 2–5 (2).

54 Vladimir Egorov, 'Khudozhnik stseny teatra i khudozhnik kadra kino – mastera dekorativnogo oformleniia' [unpublished]. RGALI. f. 2710, op. 1, khr. ed. 59, 1–13 and 39–45.

55 Ibid., 3.

56 Ibid., 4–12.

57 Youngblood, *Magic Mirror*, 64–6.
58 Iakov Protazanov, *Na zare kinematografa* [1945], in Cherchi Usai et al., *Silent Witnesses*, 162.
59 Vladimir Balliuzek, 'Na s′′emkakh "Pikovoi damy"', in *Iz istorii kino* 7 (Moscow: Iskusstvo, 1968), 99–103 (99–100).
60 Gardin, *Vospominaniia*, 109.
61 For example, see publicity material for *Venetsianskii istukan* (Venetian idol) in *Sine-fono* 13 (1915): 6–7. Kovalova also notes that from 1914 to 1915 cinema journals began to use outlandish marketing slogans for films. See Anna Kovalova, 'World War I and Pre-Revolutionary Russian Cinema', *Studies in Russian and Soviet Cinema* 11, no. 2 (2017): 98.
62 Advertisement, *Sine-fono* 14–15 (1915): 11.
63 See 'Khudozhnik kino: Aleksei Utkin', *Kino-gazeta* 26 (1918): 11; 'Khudozhnik kino: Aleksandr Loshakov', *Kino-gazeta* 29 (1918): 7; 'Khudozhnik kino: Lev Kuleshov', *Kino-gazeta* 31 (1918): 9; and 'Khudozhnik kino: Vladimir Egorov', *Kino-gazeta* 34 (1918): 3.
64 Miasnikov, *Ocherki istorii sovetskogo kinodekoratsionnogo iskusstva, 1918–1930*, 8.
65 'Rezoliutsiia sektsii khudozhnikov arkhitektorov', 12–13.
66 Mikhin notes that growing tensions over pay, as well as Antonina Khanzhonkova's interference with his set design, forced him to leave for the Taldykin studio. Boris Mikhin, 'Otryvki iz proshlogo' [1946, unpublished], in *Velikii kinemo: Katalog sokhranivshikhsia igrovykh fil′mov Rossii 1908–1919*, ed. V. Ivanova, V. Myl′nikova, S. Skovorodnikova, Iu. Tsiv′ian and R. Iangirov (Moscow: Novoe literaturnoe obozrenie, 2002), 164–5.
67 Youngblood, *Magic Mirror*, 28. The Russian suffix -shchina carries a negative connotation.
68 Alyssa DeBlasio, 'Choreographing Space, Time, and "Dikovinki" in the Films of Evgenii Bauer', *Russian Review* 66, no. 4 (2007): 671–92 (674).
69 Lev Kuleshov, 'O zadachakh khudozhnika v kinematografe' [1917] in his *Sobranie sochinenii v trekh tomakh*, vol. 1 (Moscow: Iskusstvo, 1987–8), 57–60.
70 Tsivian, 'New Notes on Russian Film Culture between 1908 and 1919' and Morley, 'Gender Relations in the Films of Evgenii Bauer'.
71 Gardin, *Vospominaniia*, 110.
72 Balliuzek, 'Na s′′emkakh "Pikovoi damy"', 103.
73 For Balliuzek's contracts with various studios, see RGALI f. 2637, op.1, ed. khr. 34.
74 Robert Bird, 'Lenfilm: The Birth and Death of an Institutional Aesthetic', in *A Companion to Russian Cinema*, ed. Beumers (Wiley Blackwell, 2016), 66–91 (68).
75 Kozlovskii, 'Smysl moei zhizni', 81.

76 In addition to FEKS, these alliances included the collaboration of the production artist Semen Meinkin with the director Evgenii Cherviakov and the camera operator Sviatoslav Beliaev, and that of the production artist Nikolai Suvorov with the director Vladimir Petrov and the camera operator Viacheslav Gordanov.

77 Petr Bagrov, 'Osnovnye tendentsii leningradskogo kinoavangarda 1920-kh gg'. (PhD diss., Nauchno-issledovatel'skii institut kinoiskusstva, Moscow, 2011), 27.

78 For discussion of the aesthetic styles of various production teams in 1920s Soviet Russia, see Philip Cavendish, *The Men with the Movie Camera: The Poetics of Visual Style in Avant-Garde Cinema of the 1920s* (London: Berghahn Books, 2013).

79 'Rezoliutsiia sektsii khudozhnikov arkhitektorov', 13.

80 Bl. F., 'Rol' kino-khudozhnika v kino proizvodstve', 72.

81 See Makhlis, 'Rol' khudozhnika v kino', 15–16; and Kolupaev, 'Khudozhnik v kino-proizvodstve', 18.

82 Suvorov, 'Khudozhnik v kino', 301.

83 Sergei Iutkevich, *Chelovek na ekrane: Chetyre besedy o kinoiskusstve: Dnevnik rezhissera* (Moscow: Goskinoizdat, 1947), 135.

84 Cited in Miasnikov, *Ocherki istorii sovetskogo kinodekoratsionnogo iskusstva, 1918–1930*, 18.

85 Ibid., 88.

86 Ibid., 18.

87 Widdis, 'Cinema and the Art of Being', 315.

88 Kozlovskii, 'Smysl moei zhizni', 82.

89 Ibid.

90 For discussion of FEKS's aesthetic approach to filmmaking, see Cavendish, *The Men with the Movie Camera*, 196–240.

91 Khanzhonkov, *Pervye gody russkoi kinematografii*, 86; Mikhin, 'Rozhdenie fundusa', 150; Razumnyi, *U istokov*, 24–6; and Cheslav Sabinskii, 'Iz zapisok starogo kinomastera', *Iskusstvo kino* 5 (1936): 60–63.

92 Sabinskii, 'Iz zapisok starogo kinomastera', 60.

93 See Khanzhonkov, *Pervye gody russkoi kinematografii*, 41–2.

94 Mikhin, 'Rozhdenie fundusa', 148.

95 Mikhin, 'Rozhdenie fundusa'; and Sabinskii, 'Iz zapisok starogo kinomastera', 60.

96 Writing in 1926, Agden noted that the *fundus* system reduced production time from roughly three days to four hours. See Agden, 'Khudozhnik na zapade i v SSSR', 17.

97 Props were specially adapted for films through being painted in particular colours that would come out well in film or acquired from photography studios, where they were already adapted to being photographed in black and white.

98 Balliuzek, 'Na s''emkakh "Pikovoi damy"', 99–100.

99 Sergei Kozlovskii, 'Smysl moei zhizni', 72 and Razumnyi, *U istokov*, 20.
100 Sabiński recalls that it was common for studios to produce up to thirty films a year and he was expected to construct sets in days, or sometimes even hours. Sabinskii, 'Iz zapisok starogo kinomastera', 60.
101 Razumnyi, *U istokov*, 21 and Kozlovskii, 'Smysl moei zhizni', 90.
102 RGALI f. 2394, op. 1, ed. khr. 165.
103 Sabinskii, 'Iz zapisok starogo kinomastera', 60.
104 Sergei Kozlovskii, 'Tridtsat´ let raboty khudozhnikov v sovetskoi kinematografii', [1949] RGALI f. 2394, op. 1, ed. khr. 69.
105 Razumnyi, *U istokov*, 24-5.
106 Rashit Yangirov, 'Czeslaw Genrikhovich Sabinski', in *Silent Witnesses*, 582-4.
107 See Rashit Iangirov, 'Boris Mikhin', in *Velikii kinemo*, 509-10.
108 Kozlovskii, 'Smysl moei zhizni', 68-9.
109 Examples include Kozlovskii, 'Prava i obiazannosti kino-khudozhnika', 16-17; Lev Kuleshov, 'Zadachi khudozhnika v kinematografe'; and Makhlis, 'Rol´ khudozhnika v kino', 15-16.
110 Vsevolod Meierkhol´d, 'Portret Doriana Greia' [date unknown], *Iz istorii kino* 6 (Moscow: Iskusstvo, 1965), 19.
111 Ibid.
112 Bergfelder, Harris and Street, *Film Architecture*, 88. For Egorov's sketches, see Egorov, 'Khudozhnik stseny teatra i khudozhnik kadra kino ... kakaia raznitsa?', RGALI f. 2710, op.1, ed. khr. 59, 1-13, 39-45.
113 Kuleshov, *The Art of Cinema*, 206.
114 Miasnikov, *Ocherki istorii russkogo i sovetskogo kinodekoratsionnogo iskusstva, 1908-1917*, 58.
115 Kozlovskii, 'Smysl moei zhizni', 68-9.
116 Kozlovskii recommended Zheliabuzhskii for this position. See Kozlovskii, 'Smysl moei zhizni', 69.
117 Ibid., 81.
118 Cavendish notes that it was Mikhin who recommended Eduard Tisse as a camera operator to Sergei Eizenshtein in 1923. See Cavendish, *The Men with the Movie Camera*, 58-9.
119 See, for example, Youngblood, *The Magic Mirror*, 45 and Louise McReynolds, 'Demanding Men, Desiring Women and Social Collapse in the Films of Evgenii Bauer, 1913-17', *Studies in Russian and Soviet Cinema* 3, no. 2 (2009): 145-56.
120 Razumnyi, *U istokov*, 81; and Sabinskii, 'Iz zapisok starogo kinomastera', 60-3.
121 Lev Kuleshov, 'O zadachakh khudozhnika v kinematografe', *Vestnik kinematografii* 126 (1917): 15-16.
122 Ibid., 15.
123 Ibid.
124 Lev Kuleshov, 'Iskusstvo svetotvorchestva' [1918] in Lev Kuleshov, *Stat'i. Materialy* (Moscow: Iskusstvo, 1979), 153-5 (153).

125 See Maria Gough, *The Artist as Producer: Russian Constructivism in Revolution* (Berkeley, CA: University of California Press, 2005), 31–8.
126 For discussion of the significance of *faktura* as an artistic concept, see Maria Gough, 'Faktura: The Making of the Russian Avant-Garde', *RES: Journal of Anthropology and Aesthetics* 36 (1999): 32–59.
127 For discussion of INKhUK, see Gough, *The Artist as Producer*, 6–7.
128 For a discussion of the explicit criteria of essential materials outlined by Constructivists at INKhUK, see Kristin Romberg, *Gan's Constructivism: Aesthetic Theory for an Embedded Modernism* (Berkeley: CA, University of California Press, 2018), 72.
129 Gough, 'Faktura: The Making of the Russian Avant-Garde', 53.
130 Sergei Iutkevich, 'Dekoriruem svetom', *Sovetskii ekran* no. 29 (1925): 43.
131 Ibid., 304.
132 Bl. F., 'Rol´ kino-khudozhnika v kino-proizvodstve', 72.
133 Examples of other Soviet films which critics praised for their stark sets include *Mother* (Mat´, 1926) and *The End of St. Petersburg* (Konets Sankt-Peterburga, 1927), both of which Sergei Kozlovskii worked on as the production artist.
134 Vsevolod Pudovkin, 'O khudozhnike v kino', *Kino-gazeta*, no. 10 (1925): 2.
135 Ibid.
136 Ibid.
137 Rodchenko, 'Khudozhnik i material´naia sreda v igrovoi fil´me'.
138 Ibid., 15.
139 Aleksandr Rodchenko, *Opyty dlia budushchego. Dnevniki, stat´i, pis´ma, zapiski* (Moscow: Grant, 1996), 230–1.
140 The film and photo section of *Sovestkoe kino*, which Rodchenko edited between 1926 and 1928, also demonstrates this aesthetic, with the inclusion of photographs and frame stills that show objects shot from unfamiliar angles.
141 See, for example, Bl. F, 'Rol´ kino-khudozhnika v kino proizvodstve'; D. Kolupaev, 'O dekoratsiiakh', Kino-zhurnal ARK 2 (1925): 34; Makhlis, 'Rol´ khudozhnika v kino', 15–16; Kozlovskii, 'Prava i obiazannosti kino-khudozhnika', 16–17; Agden, 'Kino-khudozhnik na zapade i v SSSR'; and D. Kolupaev, 'Khudozhnik v kino-proizvodstve', 18.
142 S. Kozlovskii, 'Tekhnika kinoatel´e', 57–9.
143 See Bl. F, 'Rol´ kino-khudozhnika v kino proizvodstve'; Kolupaev, 'O dekoratsiiakh'; Makhlis, 'Rol´ khudozhnika v kino'; and Kolupaev, 'Khudozhnik v kino-proizvodstve'.
144 For discussion of the Regime of Economy Campaign, see Denise J. Youngblood, *Soviet Cinema in the Silent Era, 1918–1935* (Austin, TX: University of Texas Press, 1991), 64–8.
145 Kozlovskii, 'Tekhnika kinoatel´e', 57–9; and Kolin and Kozlovskii, *Khudozhnik-arkhitektor v kino*, 417–19. Improvements to the *fundus* include the use of special clamps to improve the ease in assembling and

disassembling set parts as well as reducing the wear and tear on the system.
146 Aleksandr Rodchenko, 'M-R. 80x100. S-Zh', *Sovetskoe kino* 8-9 (1927): 19.
147 Varvara Stepanova, *Chelovek ne mozhet zhit' bez chuda* (Moscow: Sfera, 1994), 257.
148 See, for example, Kolupaev, 'O dekoratsiiakh'; Genri, 'Kartonnyi domik (na fabrike "Mezhrabpom-Rus'")' *Sovetskii ekran* 8 (1928): 56; A. Anostschenko, 'Metodika kinooformleniia', *Kino i kul'tura* 5 (1929): 21-4; G. Kedrov, 'Put' dekoratsii', *Sovetskii ekran* 29 (1929): 5; and G. Baizengerts, 'Kino-arkhitektura segodnia i zavtra', *Kino i kul'tura* 3 (1929): 6.
149 Anon., 'Khudozhnik v kino. Beseda s khudozhnikom S. M. Kozlovskim, avtorom fundusnoi sistemy dekoratsii', *Sovetskoe kino* 8-9 (1927): 18-19.
150 An example of this is the furniture that Rodchenko made for the Soviet pavilion's installation of a workers' club at the Paris 1925 International Exhibition of Modern Decorative and Industrial Arts.
151 Romberg, *Gan's Constructivism*, 150.
152 Gough, *The Artist as Producer*.
153 Osip Brik cited ibid., 101.
154 Nikolai Tarabukin, *Ot tol'berta k mashine* (Moscow: Rabotnik prosveshcheniia, 1923), 33. In a series of lectures, published in *Lef*, the production theorist Boris Kushner also argued that artists must direct their attention to improving production systems. See Boris Kushner, 'Organizatory proizvodstva', *Lef* 3 (1923): 97-103.
155 Tarabukin, *Ot tol'berta k mashine*, 32.
156 Jamie Miller, 'Soviet Politics and Mezhrabpom Studios in the Soviet Union during the 1920s and 1930s', *Historical Journal of Film, Radio and Television* 32 (2012): 527.
157 Kolin and Kozlovskii, *Khudozhnik-arkhitektor v kino*, 407-10.
158 Examples include Kozlovskii, 'Prava i obiazannosti kino-khudozhnika', 16-17; Makhlis, 'Rol' khudozhnika v kino', 15-16; and Kolupaev, 'Khudozhnik v kino-proizvodstve', 18.
159 Kolin and Kozlovskii, *Khudozhnik-arkhitektor v kino*, 407.
160 Suvorov, 'Khudozhnik v kino', 301.
161 Kozlovskii, 'Tekhnika kinoatel'e', 59.
162 'Rezoliutsiia sektsii khudozhnikov arkhitektorov', 12-13.
163 Kolin and Kozlovskii, *Khudozhnik-arkhitektor v kino*, 378-422.
164 Kolin and Kozlovskii, *Khudozhnik-arkhitektor v kino*, 385-6.
165 Andrei Burov, 'Arkhitektura i kino' [unpublished, 1929]. RGALI. f. 1925, op. 1, khr. ed. 1862.
166 Burov launched his attack specifically against the production artist G. Baizengerts's article, 'Cinema-Architecture Today and Tomorrow' (Kino-arkhitektura segodnia i zavtra), *Sovetskii ekran* 33 (1927): 6. In this article

Baizengerts promoted the view that the production artist should be a poet who worked with light and camera optics to create expressive effects.
167 Nikolai Lukhmanov, 'Zhizn´ kak ona dolzhna byt´', *Sovetskii ekran* 15 (1928): 6 and 'Zhizn´ kak ona dolzhna byt´', *Kino i kul´tura* 1 (1929): 29–37. Lukhmanov also argued that the non-fiction kul´turfil´m *How You Live* (Kak ty zhivesh´, 1927) [non-extant] was exemplary for representing a rational solution to questions of domestic life.
168 Lukhmanov, 'Zhizn´ kak ona dolzhna byt´', 37.

Chapter 2

1 For discussion of early-Russian film studios and their technological resources, see Gennadii Miasnikov, *Ocherki istorii russkogo i sovetskogo kinodekoratsionnogo iskusstva, 1908–1917* (Moscow: VGIK, 1973), 20–1.
2 Aleksandr Khanzhonkov, *Pervye gody russkoi kinematografii* [1937] (Moscow: Liteo, 2016), 39.
3 Boris Mikhin, 'Rozhdenie fundusa' [date unknown], in *Iz istorii kino* 9 (Moscow: Iskusstvo, 1965), 148–54 (150–1). See also Lui Forest´e [Louis Forestier], *Velikii nemoi: Vospominaniia kinooperatora* (Moscow: Goskinoizdat, 1945), 29.
4 Mikhin, 'Rozhdenie fundusa', 151.
5 Cited and translated in Yuri Tsivian [Iurii Tsiv´ian], 'Early Russian Cinema: Some Observations', in *Inside the Film Factory: New Approaches to Russian and Soviet Cinema*, ed. Richard Taylor and Ian Christie (New York: Routledge, 1991), 7–30 (11–12).
6 See Vera Tolz, *Russia: Inventing the Nation* (London: Bloomsbury Academic, 2001).
7 Richard Abel, 'Pathé's Stake in Early Russian Cinema', *Griffithiania* 38–9 (1990): 243–7 (244).
8 Abel notes that at this time Pathé was also embarking on a strategy to produce culturally specific films at its national affiliates in France, Italy and America. Ibid.
9 Jay Leyda, *Kino: A History of the Russian and Soviet Film* (Princeton, NJ: Princeton University Press, 1960), 31.
10 For discussion of the film's contemporary reception, see Rachel Morley, *Performing Femininity: Woman as Performer in Early Russian Cinema* (London: I.B. Tauris, 2017), 13–14.
11 Abel, 'Pathé's Stake in Early Russian Cinema', 244.
12 Samuil Lur´e, *Sine-fono* [1909] in *Velikii kinemo: Katalog sokhranivshikhsia igrovykh fil´mov Rossii 1908–1919*, ed. V. Ivanova, V. Myl´nikova, S. Skovorodnikova, Iu. Tsiv´ian and R. Iangirov (Moscow: Novoe literaturnoe obrazrenie, 2002), 39–40.
13 Ibid., 39.

14 For example, see *Sine-fono* 29 (1909): 8.
15 The film is variously attributed to the directors Kai Hansen, Moris Gash [Maurice Gache], Vasilii Goncharov and Mikhail Novikov. For biographical information on Kozhin, see Pavel Isaev, *Stroganovka 1825–1918: Biograficheskii slovar'*, vol. 2 (Moscow: Labirint, 2004), 181.
16 *Sine-fono* [1909] in Ivanova et al., *Velikii kinemo*, 33–4.
17 *Kine-zhurnal* [1910], ibid., 33.
18 Lur'e, *Sine-fono*, 40.
19 V. Fester worked as the production artist on *Boiarin Orsha* and *Mazepa*. Very little information exists on Fester, including accurate references to his first name. See Khanzhonkov, *Pervye gody russkoi kinematografii*, 41.
20 For discussion of Shekhtel''s interest in Russian folk art, see James Cracraft and Daniel Bruce Rowland (eds), *Architectures of Russian Identity, 1500 to the Present* (London and Ithaca, NY: Cornell University Press, 2003), 77.
21 Olga Haldey, *Mamontov's Private Opera: The Search for Modernism in Russian Theater* (Bloomington, IN: Indiana University Press, 2010), 173–6.
22 See N. G. Zograf, *Malyi teatr v kontse deviatnadtsatogo – nachale dvadtsatogo veka* (Moscow: Nauka, 1966).
23 Ivanova et al., *Velikii kinemo*, 39.
24 Yuri Tsivian [Iurii Tsiv'ian], '«Sten'ka Razin» («Ponizovaia vol'nitsa»), Rossiia (1908)', *Iskusstvo kino* 7 (1988): 93–6 (95).
25 Cheslav Sabinskii [Czesław Sabiński], 'Iz zapisok starogo kinomastera', *Iskusstvo kino* 5 (1936): 60–3 (60).
26 Rashit Yangirov [Iangirov], 'Czeslaw Genrikhovich Sabinski', in *Silent Witnesses: Russian Film 1908–1918*, ed. Paolo Cherchi Usai, Lorenzo Codelli, Carlo Montanaro and David Robinson, research and coordination by Yuri Tsivian (Pordenone and London: Edizioni dell'immagine and British Film Institute, 1989), 582.
27 Nick Worrall, *The Moscow Art Theater* (London: Routledge, 2003), 86.
28 *Sine-fono* [1911] in Ivanova et al., *Velikii kinemo*, 101.
29 Cherchi Usai et al., *Silent Witnesses*, 102.
30 Ibid.
31 Ibid.
32 See Yangirov, 'Czeslaw Genrikhovich Sabinski', 582. In particular, contemporary filmmakers remarked on the quality of the models that Sabiński made for *The Year 1812* (1812 God, 1912).
33 The sets for the Khanzhonkov studio's *The Water Nymph* (Rusalka, 1910), which were designed by Fester, also play with exaggerated scales to convey a sense of magic. For example, in the scenes in which the water nymphs dance under the sea, shells and seaweed take on enormous proportions, emphasizing the fairy-tale quality of this 'underwater kingdom' in comparison to the other spaces in the film. For a still from this sequence see, Cherchi Usai et al., *Silent Witnesses*, 113.

34 Morley, *Performing Femininity*, 42.
35 Neia Zorkaia, 'Sten´ka Razin pod Peterburgom', http://www.portal-slovo.ru/art/35956.php (accessed 15 April 2017).
36 In this way, the sequence recalls the opening sequences of *Sten´ka Razin* (1908) in which the river dominates the frame, conveying the force that Mother Russia has over Sten´ka Razin and his men. For discussion of the significance of the river in *Sten´ka Razin*, see Morley, *Performing Femininity*, 22–3.
37 For analysis of these scenes, see ibid., 42–3. *Snokhachestvo* was a custom traditionally practised in which a wife was pressured by her husband's family to engage in a sexual relationship with her father-in-law as an act of submission to the patriarch.
38 Ibid., 43.
39 See Rosalind P. Gray [Blakesley], *Russian Genre Painting in the Nineteenth Century* (Oxford: Clarendon Press, 2000), 152–77.
40 See, for example, Anon., *Vestnik kinematograf* [1912] in Ivanova et al., *Velikii kinemo*, 123–4 and Anon., *Vestnik kinematograf* [1912], ibid., 118.
41 Anon., *Vestnik kinematograf* [1916], ibid., 324–5 (324).
42 Ibid., 324–5.
43 Ibid.
44 Ibid., 325.
45 A. Kepp [1923] in Ivanova et al., *Velikii kinemo*, 490–1 (490).
46 Denise J. Youngblood, *Movies for the Masses: Popular Cinema and Soviet Society in the 1920s* (Cambridge: Cambridge University Press, 1992), 164.
47 For discussion of the collaboration, see Moisei Aleinikov, *Puti sovetskogo kino i MKhAT* (Moscow: Goskinoizdat, 1947), 54–72.
48 Sergei Kozlovskii, 'Smysl moei zhizni' [date unknown], *Iz istorii kino* 7 (Moscow: Iskusstvo, 1968), 63–90 (68–9).
49 Veronin, *Kino* [1922] in Ivanova et al., *Velikii kinemo*, 488.
50 Ibid.
51 Kepp, ibid., 490–1.
52 For discussion of the resources available, see Moisei Aleinikov, *Puti sovetskogo kino i MKhAT*, 62–3.
53 Iu. I. Nekhoroshev, *Dekorator Khudozhestvennogo teatra Viktor Andreevich Simov* (Moscow: Sovetskii khudozhnik, 1984), 49.
54 Ibid.
55 Aleinikov, *Puti sovetskogo kino i MKhAT*, 52.
56 Béla Balázs, 'Der sichtbare Mensch', [1924] in *Béla Balázs: Early Film Theory: The Visible Man and The Spirit of Film*, ed. Erica Carter, trans. Roy Livingstone (New York and Oxford: Berghahn Books, 2010), 49.
57 Ibid., 53.
58 Ibid., 49.
59 'Rezoliutsiia obshchego sobraniia proizvodstvennoi sektsii ARK k kartine "Po zakonu"', *Kino-front* 9–10 (1926): 31.

60 Philip Cavendish, *Soviet Mainstream Cinematography: The Silent Era* (London: UCL Arts & Humanities Publications, 2007), 66.
61 Lev Kuleshov, *Selected Works: Fifty Years in Films*, translated by Dmitri Agrachev and Nina Belenkaya (Moscow: Raduga Publishers, 1987), 67.
62 Ibid.
63 Julie Cassiday, *The Enemy on Trial: Early Soviet Courts on Stage and in the Cinema* (DeKalb, IL: Northern Illinois University Press, 2000), 146 and Rosemari Baker, 'Shklovsky in the Cinema, 1926-1932' (MA diss., University of Durham, 2010), 21.
64 Cavendish, *Soviet Mainstream Cinematography*, 67.
65 Kuleshov, *Selected Works: Fifty Years in Films*, 228 and Youngblood, *Soviet Cinema in the Silent Era*, 94.
66 Ibid.
67 For example, a special feature in *Cinema-Front* categorized films by their production costs. See Ippolit Sokolov, 'Stoimost´ proizvodstva', *Kino-front* 1 (1926): 11-12.
68 Sergei Kozlovskii, 'Prava i obiazannosti kino-khudozhnika', *Kino-zhurnal ARK* 11-12 (1925): 16-17 and Isaak Makhlis, 'Rol´ khudozhnika v kino', *Kino-zhurnal ARK* 11-12 (1925): 15-16.
69 Kuleshov, *Selected Works: Fifty Years in Films*, 228.
70 Ibid.
71 Ibid.
72 Lev Kuleshov, 'Mr West – Ray – By the Law' [1926], ibid., 66-7 (67).
73 Ibid.
74 For discussion of Li's infatuation with Gzhatskii, see Rachel Morley, 'Gender Relations in the Films of Evgenii Bauer', *Slavonic and East European Review* 81, no. 1 (2003): 32-69 (46).
75 Baker, 'Shklovsky in the Cinema, 1926-1932', 50.
76 Evgenii Gromov, *Lev Vladimirovich Kuleshov* (Moscow: Iskusstvo, 1984), 186.
77 Kuleshov, *Selected Works: Fifty Years in Films*, 228.
78 Gromov, *Lev Vladimirovich Kuleshov*, 188.
79 Ibid.
80 Kuleshov, *Selected Works: Fifty Years in Films*, 229.
81 Cavendish, *Soviet Mainstream Cinematography*, 67.
82 Kuleshov, *Selected Works: Fifty Years in Films*, 229.
83 Gromov, *Lev Vladimirovich Kuleshov*, 187.
84 Aleinikov, *Puti sovetskogo kino i MKhAT*, 50.
85 Cited and translated in Youngblood, *Soviet Cinema in the Silent Era*, 93.
86 A. Arsen, 'Sotsial´noe znachenie kartiny "Po zakonu"', *Kino-front* 9-10 (1926): 28-31 (31).
87 Youngblood, *Soviet Cinema in the Silent Era*, 93-4.
88 Philip Cavendish, *The Men with the Movie Camera: The Poetics of Visual Style in Avant-Garde Cinema of the 1920s* (London: Berghahn Books, 2013), 105.

89 For discussion of the production process, see 'General´naiia liniia (beseda s S. M. Eizenshteinom)', *Kino-front* 4 (1927): 29-30.
90 Cavendish, *The Men with the Movie Camera*, 105.
91 Noël Carroll, 'Cinematic Nation Building: Eisenstein's The Old and The New', in *Engaging the Moving Image* (New Haven, CT: Yale University Press, 2003): 303-22 (305).
92 Sergei Eisenstein [Sergei Eizenshtein], *Nonindifferent Nature* [1948], trans. Herbert Marshall (Cambridge: Cambridge University Press, 1987), 39.
93 For example, see Nikolai Aseev, *Sovetskii ekran* [1926], cited in Richard Taylor, *The Battleship Potemkin: The Film Companion* (London and New York: I.B. Tauris, 2000), 72 and Nikolai Volkov in *Trud* [1926], cited ibid., 69-72.
94 Aleksei Gvozdev in *Zhizn´ iskusstva* [1926], cited ibid., 76-7.
95 For example, see Nikolai Lukhmanov, 'Zhizn´ kak ona dolzhna byt´', *Sovetskii ekran* 15 (1928), 6 and his 'Zhizn´ kak ona dolzhna byt´', *Kino i kul´tura* 1 (1929): 29-37; Eduard Tisse, 'Na s´´emkakh 'General´noi', *Sovetskii ekran* 8 (1929): 13; and V. Kolomarov, 'Veshch´ v kino', *Kino i kul´tura* 9-10 (1929): 29-37 (35-37).
96 Anne Nesbet, *Savage Junctures: Sergei Eisenstein and the Shape of Thinking* (London: I.B. Tauris, 2007): 98-9.
97 'General´naiia liniia (beseda s S. M. Eizenshteinom)', 29-30.
98 Widdis, *Socialist Senses*, 133.
99 For example, see Iurii Tarich, 'Na s´´emke derevenskoi fil´my (Kino-ekspeditsiia v podmoskovskuiu derevniu)', *Kino-zhurnal ARK* 8 (1925): 30; Dm. Bassalygo, 'Kino-ekspeditsii i rezhim ekonomiki', *Kino-front* 1 (1926): 3; Leo Mur, S., ´´emki na nature i v atel´e', *Kino-front* 2 (1926): 2-7; A. Cherkisov, 'Nuzhny li ekspeditsii', *Kino-front* 4 (1927): 3-6; and V. Mikhailov, 'Vnimanie kinoekspeditsiiam', *Sovetskii ekran* 23 (1929): 1-2.
100 Viktor Shklovskii, 'Sherst´, steklo i kruzheva', *Kino* 32 (1927): 2. Iurii Tarich similarly argued that films of provincial life must show the local character of villages. See Tarich, 'Na s´´emke derevenskoi fil´my', 30
101 Shklovskii, 'Sherst´, steklo i kruzheva', 2.
102 Anon., 'Na naturu!', *Sovetskii ekran* 6 (1925): 3.
103 Ibid.
104 Emma Widdis, *Visions of a New Land: Soviet Film from the Revolution to the Second World War* (New Haven, CT: Yale University Press), 103.
105 Nesbet, *Savage Junctures*, 99.
106 Ibid.
107 Ibid.
108 Carroll, 'Cinematic Nation Building', 310.
109 Eisenstein, *Nonindifferent Nature*, 39.
110 Ibid., 50-3.
111 Ibid., 44.

112 Andrei Burov, *Arkhitektura i kino* [1929, unpublished]. RGALI f. 1925, op. 1, ed. khr. 1862.
113 Burov had met Le Corbusier in Paris and acted as his translator when he visited the Soviet Union in the 1920s. Selim O. Khan-Magomedov, *Andrei Burov* (Moscow: Russkii avangard, 2009), 45–56.
114 The brilliant white surfaces of the dairy farm prefigure the hyperbolic use of white in Socialist Realist art and in films of the1930s, including Grigorii Kozintsev and Leonid Trauberg's *Alone* (Odna, 1931), Abram Room's *A Strict Young Man* (Strogii iunosha, 1936) and Eizenshtein's *Aleksandr Nevskii* (1938).
115 Burov, *Arkhitektura i kino*, RGALI f. 1925, op. 1, ed. khr. 1862.
116 Katerina Clark, *Moscow, the Fourth Rome: Stalinism, Cosmopolitanism, and the Evolution of Soviet Culture, 1931–1941* (Cambridge, MA: Harvard University Press, 2011), 124.
117 For discussion of Burov's architectural practice, see Khan-Magomedov, *Andrei Burov*.
118 See 'Arkhitekturnye kadry kino-kartiny "General'naia linia" Sovkino v postanovke S. M. Eizenshteina. Arkhitektura A. K. Burova', *Sovremennaia arkhitektura* 5–6 (1926): 136–7.
119 Lukhmanov, 'Zhizn' kak ona dolzhna byt'' (1928): 6 and his 'Zhizn' kak ona dolzhna byt'' (1929): 29–37.
120 Anthony Vanchu, 'Technology as Esoteric Cosmology in Early Soviet Literature', in *The Occult in Russian and Soviet Culture*, ed. Bernice Glatzer Rosenthal (Ithaca, NY: Cornell University Press, 1997), 203–24 (204).
121 Ibid., 203–24.
122 Ibid., 204.
123 Viktor Shklovskii, 'Pogranichnaia liniia' [1927] in *Za 60 let. Raboty o kino* (Moscow: Iskusstvo, 1985), 110–13.
124 Ibid., 111.
125 See James Goodwin, *Eisenstein, Cinema, and History* (Urbana, IL: University of Illinois Press, 1993), 111–15 and Carroll, 'Cinematic Nation Building', 310.
126 Widdis, *Socialist Senses*, 141.
127 Ibid., 142.
128 Penny Harvey and Hannah Knox, 'The Enchantments of Infrastructure', *Mobilities* 7, no. 4 (2012): 521–36.
129 Ibid.
130 Ibid., 534.
131 Bill Brown, 'Thing Theory', *Critical Inquiry* 28, no. 1 (Autumn 2001): 1–22.
132 See *Sovetskii ekran* 26 (1929): front cover.
133 Widdis argues that the film represents this split in terms of younger and older generations and their different relationship with the world. See Widdis, *Socialist Senses*, 117.

134 Widdis, *Visions of a New Land*, 40.
135 Examples of films that show train travel between the city and the provinces include *Bed and Sofa* (Tret'ia Meshchanskaia, 1927), *The Girl with a Hatbox* (Devushka s korobkoi, 1927) and *The House on Trubnaia* (Dom na Trubnoi, 1928).
136 Lewis H. Siegelbaum, *Cars for Comrades: The Life of the Soviet Automobile* (Ithaca, NY: Cornell University Press, 2008), 17.
137 Widdis, *Visions of a New Land*, 51–2.
138 For discussion of Popov's career in the theatre, see Neia Zorkaia, *Aleksei Popov* (Moscow: Iskusstvo, 1983), 97–150.
139 Ibid., 103. Zorkaia does not provide a precise date for the MKhT production of *Vii*.
140 Sketches are reprinted ibid.
141 Miasnikov, *Ocherki istorii sovetskogo kinodekoratsionnogo iskusstva, 1918–1930*, 95–6.
142 Ibid. Kolupaev participated in the Peredvizhniki exhibition of 1923.
143 Dmitrii Kolupaev, 'O dekoratsiiakh', *Kino-zhurnal ARK* 2 (1925): 34.
144 Widdis, *Socialist Senses*, 95. Widdis notes that in 1927 Vishnevskaia also worked as a consultant on *Whirpool* (Vodovorot, non-extant). See ibid., 120.
145 Widdis, *Visions of a New Land*, 184.
146 Zorkaia, *Aleksei Popov*, 156–7.
147 Widdis, *Socialist Senses*, 117.
148 Ibid. In *A Ticket to Life* (Putevka v zhizn', 1931), the construction of a new railroad also functions as a collective project for a labour commune.
149 Ibid., 116–17.

Chapter 3

1 Richard Stites, *Russian Popular Culture: Entertainment and Society Since 1900* (Cambridge: Cambridge University Press, 1992), 32.
2 Examples of historical revolutionary films made between 1919 and 1923 include *The Locksmith and the Chancellor* (Slesar' i Kantsler, 1923) and *The Palace and the Fortress* (Dvorets i krepost', 1923).
3 See Barbara Engel, 'Patriarchy and Its Discontents' in her *Between the Fields and the City: Women, Work, and Family in Russia, 1861–1914* (Cambridge: Cambridge University Press, 1996), 7–33.
4 Louise McReynolds, 'Home Was Never Where the Heart Was: Domestic Dystopias in Russia's Silent Movie Melodramas', in *Imitations of Life: Two Centuries of Melodrama in Russia*, ed. Louise McReynolds and Joan Neuberger (Durham, NC: Duke University Press, 2002), 127–51 (127).

5 The entry for The Little House in Kolomna in Both Silent Witnesses: Russian Films 1908–1919 and Velikii kinemo: Katalog sokhranivshikhsia igrovykh fil'mov Rossii 1908–19 suggests that Starewicz also contributed to the set design. See Paolo Cherchi Usai, Lorenzo Codelli, Carlo Montanaro and David Robinson (eds), Silent Witnesses, research and co-ordination by Yuri Tsivian (London: BFI Publishing, 1989), 180 and V. Ivanova, V. Myl'nikova, S. Skovorodnikova, Iu. Tsiv'ian and R. Iangirov (eds), Velikii kinemo (Moscow: Novoe literaturnoe obrazrenie, 2002), 153. In 1913, Mikhin worked on four other films for the Khanzhonkov studio, all of which incorporate domestic interiors: *The Sorrows of Sarra* (Gore Sarry), Uncle's Apartment (Diadiushkina kvartira), *Behind the Drawing-Room Doors* (Za dveriami gostinoi) and *Princess Butyrskaia* (Kniaginia Butyrskaia).

6 Joost Van Baak, *The House in Russian Literature: A Mythopoetic Exploration* (Amsterdam and New York: Rodopi, 2009), 126.

7 See, for example, *Kine-zhurnal* [1913] and *Vestnik kinematograf* [1913] in Ivanova et al., *Velikii kinemo*, 153.

8 Denise J. Youngblood, *The Magic Mirror: Moviemaking in Russia, 1908–1918* (Madison, WI: University of Wisconsin Press, 1999), 109–10.

9 Boris Mikhin, 'Rozhdenie fundusa' [date unknown], in *Iz istorii kino* 9 (Moscow: Iskusstvo, 1965), 148–54 (148).

10 Philip Cavendish, 'The Hand That Turns the Handle: Camera Operators and the Poetics of the Camera in Pre-Revolutionary Russian Film', *Slavonic and East European Review* 82, no. 2 (2004): 201–45 (214).

11 Ibid.

12 See, for example, V. Iudina, 'O domashnem rezhime (prisluga)', *Zhurnal' dlia khoziaek* 18 (1912): 2–3; Anon., 'O naime domashnei prislugi', *Zhurnal' dlia khoziaek* 14 (1913): 1; and P. Kalinina, 'Prava i obiazannosti domashnei prislugi', *Zhurnal' dlia khoziaek* 14 (1913): 2.

13 Engel, *Between the Fields and the City*, 140 and Rebecca Spagnolo, 'When Private Home Meets Public Workplace; Service, Space, and the Urban Domestic in 1920s Russia', in *Everyday Life in Early Soviet Russia; Taking the Revolution Inside*, ed. Christina Kiaer and Eric Naiman (Bloomington: Indiana University Press, 2006), 250–5 (230).

14 Engel, *Between the Fields and the City*, 141–2.

15 Catriona Kelly, *Refining Russia: Advice Literature, Polite Culture & Gender from Catherine to Yeltsin* (Oxford: Oxford University Press, 2001), 160.

16 For discussion of the way in which filmmakers in the 1920s used such ornaments and furnishings, see Julian Graffy, *Bed and Sofa: The Film Companion* (London and New York: I.B. Tauris, 2001), 26–8 and Emma Widdis, *Socialist Senses: Film, Feeling, and the Soviet Subject, 1917–1940* (Bloomington, IN: Indiana University Press, 2017), 85–94.

17 Philip Cavendish notes that since the 1900s Russian filmmakers were aware of the frame boundaries and used them to emphasize aspects of the frame composition. Cavendish, 'The Hand That Turns the Handle', 213.

18 Yuri Tsivian [Iurii Tsiv´ian], *Early Cinema in Russia and its Cultural Reception*, ed. Richard Taylor and trans. Alan Bodger (London and New York: Routledge, 1994), 185.
19 Similarly, in *Merchant Baskhirov's Daughter* (Doch´ kuptsa Bashkirova, 1913) the male patriarch is positioned in front of the doorway to the living room, separating his daughter Nadia from the external world.
20 Cavendish, 'The Hand That Turns the Handle', 222.
21 Julia Bekman Chadaga, *Optical Play: Glass, Vision and Spectacle in Russian Culture* (Evanston, IL: Northwestern University Press, 2014), 27.
22 Graffy, *Bed and Sofa*, 34–6.
23 Rachel Morley, '"Crime without Punishment": Reworkings of Nineteenth-Century Russian Literary Sources in Evgenii Bauer's *Child of the Big City*', in *Russian and Soviet Film Adaptations of Literature, 1900–2001: Screening the Word*, ed. Stephen Hutchings and Anat Vernitski (London and New York: RoutledgeCurzon, 2005), 27–43 (31).
24 Graffy, *Bed and Sofa*, 34–6.
25 Chadaga confirms that anxiety around border crossing in relation to the window also existed in Russian culture more broadly and that it was similarly associated with social or moral transgressions of some kind. She cites as examples Evgenii Bazarov in Ivan Turgenev's *Fathers and Sons* (Ottsy i deti, 1862) and the eponymous heroine in Lev Tolstoi's *Anna Karenina* (1877). Chadaga, *Optical Play*, 33–4.
26 Rachel Morley, 'Crime without Punishment', 35–6 and her *Performing Femininity: Woman as Performer in Early Russian Cinema* (London: I.B. Tauris, 2017), 123. Morley observes that in Bauer's *Child of the Big City* Mary discards her life as a seamstress to become a courtesan.
27 Rozsika Parker, *The Subversive Stitch: Embroidery and the Making of the Feminine* (London: I.B. Tauris, 1984), 11.
28 Susan K. Morrissey, *Suicide and the Body Politic in Imperial Russia* (Cambridge: Cambridge University Press, 2009), 248 and Barbara Engel, *Breaking the Ties That Bound: The Politics of Marital Strife in Late Imperial Russia* (London and Ithaca, NY: Cornell University Press, 2011), 170.
29 Nick Worrall, *The Moscow Art Theater* (London: Routledge, 2003), 18.
30 Mikhin, 'Rozhdenie fundusa', 152.
31 Yuri Tsivian [Iurii Tsiv´ian], 'Early Russian Cinema: Some Observations', in *Inside the Film Factory: New Approaches to Russian and Soviet Cinema*, ed. Richard Taylor and Ian Christie (London: Routledge, 1991), 8–30 (16).
32 Kuleshov later employed this approach to set design extensively in the films he directed, including *The Extraordinary Adventures of Mr. West in the Land of the Bolsheviks* (Neobychainye prikliucheniia mistera Vesta v strane bol´shevikov, 1924). Lev Kuleshov, 'Concerning Scenery', in *The Art of Cinema* [1929] in *Kuleshov on Film: Writings*, ed. and trans. Ronald Levaco (Berkeley, CA and London: University of California Press, 1974), 68–77 (68).

33 Morley, *Performing Femininity*, 54–9.
34 Ibid.
35 Morley notes that Bauer positions many of his female protagonists in front of mirrors to convey ideas about male objectification of women. Rachel Morley, 'Gender Relations in the Films of Evgenii Bauer', *Slavonic and East European Review* 81, no. 1 (2003): 32–69 (40–1).
36 Yuri Tsivian [Iurii Tsiv´ian], 'Two "Stylists" of the Teens: Franz Hofer and Yevgenii Bauer', in *A Second Life: German Cinema's First Decades*, ed. Thomas Elsaesser and Michael Wedel (Amsterdam: Amsterdam University Press, 1996), 264–76 (269).
37 Ibid.
38 Yuri Tsivian [Iurii Tsiv´ian], 'Portraits, Mirrors, Death: On Some Decadent Clichés in Early Russian Films', *Iris* 14–15 (1992): 67–83 (70).
39 For biographical information on Mikhin, see Mikhin, 'Rozhdenie fundusa', 148–54.
40 Morley, *Performing Femininity*, 97.
41 For discussion of the theme of marriage in Bauer's films, see Morley, 'Gender Relations in the Films of Evgenii Bauer', 33–6.
42 For example, see Barbara Engel, *Breaking the Ties That Bound*, 157–200.
43 Barbara Engel, *Women in Russia, 1700–2000* (Cambridge: Cambridge University Press, 2004), 123.
44 For example, see A. S., 'Novaia zhenshchina', *Zhurnal´ dlia khoziaek* 21 (1913): 19–21 and N. Speranskaia, 'Samostoiatel´nost´ i zhenstvennost´', *Zhurnal´ dlia khoziaek* 24 (1913): 19–20.
45 For detailed discussion of Bauer's pre-cinema career, see Oksana Chefranova, 'From Garden to Kino: Evgenii Bauer, Cinema, and the Visuality of Moscow Amusement Culture, 1885–1917' (PhD dissertation, New York University, New York, 2014).
46 Morley, *Performing Femininity*, 53–4.
47 Alyssa DeBlasio, 'Choreographing Space, Time, and "Dikovinki" in the Films of Evgenii Bauer', *Russian Review* 66, no. 4 (2007): 671–92 (673) and Emma Widdis, '*Faktura*: Depth and Surface in Early Soviet Set Design', *Studies in Russian and Soviet Cinema* 3, no. 1 (2009): 5–32 (9).
48 Morley, 'Gender Relations in the Films of Evgenii Bauer', 68–9.
49 McReynolds, 'Home Was Never Where the Heart Was', 129.
50 Morley, *Performing Femininity*, 126.
51 Although the rape is not depicted in the film, it is clear from Mariia's reactions and appearance that it has occurred.
52 Examples of other Bauer films that express this duality include *Twilight of a Woman's Soul* and *In Pursuit of Happiness* (Za schast´em, 1917). Youngblood, *The Magic Mirror*, 130.
53 For discussion of the rise of consumer culture in late-Imperial Russia, see Catriona Kelly and Steve Smith with additional material by Louise McReynolds, 'Commercial Culture and Consumerism', in *Constructing*

Russian Culture in the Age of Revolution: 1881–1940, ed. Catriona Kelly and David Shepherd (Oxford: Oxford University Press, 1998), 106–64 and Marjorie L. Hilton, 'Visions of Modernity: Gender and the Retail Marketplace, 1905-1914', in *Selling to the Masses: Retailing in Russia, 1880–1930* (Pittsburgh, PA: University of Pittsburgh Press, 2012), 110–32.

54 Morley, *Performing Femininity*, 123.
55 See Lev Kuleshov, 'Evgenii Frantsevich Bauer', in Kuleshov, *Sobranie sochinenii v trekh tomakh*, vol. 2 (Moscow: Iskusstvo, 1988), 403–9 (406).
56 Morley, 'Gender Relations in the Films of Evgenii Bauer', 45–6.
57 Morley, *Performing Femininity*, 123.
58 Widdis, *Socialist Senses*, 119.
59 *Teatral´naia gazeta* [1915] in Ivanova et al., *Velikii kinemo*, 239.
60 M. A. G., *Kine-zhurnal* [1914], ibid., 194–5 (194).
61 Anon., *Proektor* [1916] in Ivanova et al., *Velikii kinemo*, 315.
62 Morley, *Performing Femininity*, 170.
63 The film is preserved without intertitles. For a synopsis of the scenario, see Ivanova et al., *Velikii kinemo*, 294.
64 Lucy Fischer, *Cinema by Design: Art Nouveau, Modernism, and Film History* (New York: Columbia University Press, 2017), 86.
65 Cavendish, 'The Hand That Turns the Handle', 242.
66 Ibid., 240–2.
67 For discussion of this technique in European painting, see Victor I. Stoichita, *The Self-Aware Image: An Insight into Early Modern Meta-Painting* (London: Harvey Miller Publishers, 2015), 44–55
68 Oksana Chefranova, 'From Garden to Kino', 562–3.
69 Ibid., 563.
70 Cavendish, 'The Hand That Turns the Handle', 240.
71 Sarah Street, 'Sets of the Imagination: Lazare Meerson, Set Design and Performance in *Knight without Armour* (1937)', *Journal of British Cinema and Television* 2 (2005): 18–35.
72 Ibid., 30–1.
73 Ibid.
74 Cavendish, 'The Hand That Turns the Handle', 242.
75 A. Ostroumov, *Kinogazeta* [1918] in Ivanova et al., *Velikii kinemo*, 429–30.
76 Ibid.
77 For example, see Bl. F., 'Rol´ khudozhnika v kino-proizvodstve', *Sovetskii ekran* 10 (1925): 72.
78 Such features also appear in the aristocratic interiors that Balliuzek and Vladimir Egorov designed for *The Gentleman and the Cockerel* (Dzhentl´men i petukh, 1928), a film which tells the story of a Count who lives on a country estate on the Soviet and Polish border in the Civil War years.
79 Genadii Miasnikov, *Ocherki istorii sovetskogo kinodekoratsionnogo iskusstva, 1918–1930* (Moscow: VGIK, 1975), 87–8.

80 Widdis, 'Faktura', 9.
81 For information on Balliuzek's former training, see Miasnikov, *Ocherki istorii sovetskogo kinodekoratsionnogo iskusstva, 1918–1930*, 87–8.
82 Widdis, 'Faktura', 23.
83 Vladimir Balliuzek, *Zhivopisno-maliarnye raboty na kinoproizvodstve: Posobie dlia rabochikh otdelochnogo tsekha kinostudii* (Moscow: Goskinoizdat, 1948).
84 Aleksandr Loshakov employs opaque screens extensively in his sets for films such as *The Song of Triumphant Love* (Le Chant de l'amour triumphant, 1923), produced by Films Albatros in Paris. François Albéra notes Balliuzek's influence on Loshakov and suggests that Loshakov may have assisted Balliuzek on *The Maidservant Jenny*. François Albéra, *Albatros: Des russes à Paris* (Milan: Mazzotta, 1995), 37.
85 Widdis, *Socialist Senses*, 69.
86 Ibid., 69–70.
87 For detailed discussion of Iutkevich's sets for *The Traitor*, see Widdis, 'Faktura', 14–24 and her *Socialist Senses*, 63–70.
88 Ibid.
89 Sergei Iutkevich, 'Dekorativnoe oformlenie fil´ma' [1926] in *Sobranie sochinenii v trekh tomakh*, vol. 1 (*Molodost´*) (Moscow: Iskusstvo, 1990), 315.
90 Anon., 'Predatel´', *Sovetskoe kino* 8 (1926), 30.
91 Graffy, *Bed and Sofa*, 41.
92 Ibid.
93 Cited and translated in Widdis, *Socialist Senses*, 65.
94 I. Urazov, 'Ekonomiia sredstv, no ne ekonomiia vydumki', *Sovetskii ekran* 17–18 (1926), 3.
95 As Widdis notes, the filmmakers used thirty specially constructed sets, which was a large number for contemporary films. Widdis, 'Faktura', 20.
96 Widdis, *Socialist Senses*, 85–6.
97 Leo Mur, 'S´´emki na nature i v atel´e', *Kino-front* 5–6 (1926), 2–7 (2).
98 For discussion of NEP housing conditions, see Lynne Attwood, *Gender and Housing in Soviet Russia: Private Life in a Public Space* (Manchester: Manchester University Press, 2010), 40–61.
99 Others include *Aelita* (1924), *Kat´ka's Reinette Apples*, *Bed and Sofa*, *In the Big City* (V bol´shom gorode, 1927) and *The House on Trubnaia*.
100 Gosfil´mofond Rossii. 1. 2. 1. 228, 116.
101 Attwood, *Gender and Housing in Soviet Russia*, 47.
102 The original screenplay is housed at Gosfil´mofond Rossii. 1. 2. 1. 228, 13–42.
103 Ibid.
104 Emma Widdis, 'Cinema and the Art of Being: Towards a History of Early Soviet Set Design', in *A Companion to Russian Cinema*, ed. Birgit Beumers (London: Wiley-Blackwell, 2016), 314–36 (315).
105 Nikolai Kolin and Sergei Kozlovskii, *Khudozhnik-arkhitektor v kino* [1930], *Kinovedcheskie zapiski* 99 (2009): 378–422 (389–92).

Notes

106 Osip Brik, 'Fiksatsiia fakta', *Novyi LEF* 11-12 (1927): 44-50.
107 Aleksandr Rodchenko, 'Khudozhnik i material′naia sreda v igrovoi fil′me', *Sovetskoe kino* 5-6 (1927): 14-15 (14).
108 Alina Payne, *From Ornament to Object: Genealogies of Architectural Modernism* (New Haven, CT: Yale University Press, 2012), 197.
109 Cited ibid., 243.
110 Cited ibid., 257.
111 Victor Buchli, *An Archaeology of Socialism* (London: Bloomsbury Academic, 1999), 43-4.
112 Ibid., 44.
113 For example, see Walter Benjamin, Benjamin's notion of 'destructive dwelling', in Theodor W. Adorno and Walter Benjamin, *The Complete Correspondence, 1928-1940*, ed. Henri Lonitz and trans. Nicholas Walker (Cambridge, MA: Harvard University Press), 104. For Benjamin's impressions of his time in Moscow, see Walter Benjamin, 'Moscow', in *Selected Writings, vol. 2, 1927-1934*, ed. Marcus Bullock and Michael W. Jennings (Cambridge, MA: Harvard University Press, 1996), 22-47.
114 Widdis, *Socialist Senses*, 108-10.
115 Widdis, 'Cinema and the Art of Being', 325.
116 Ibid., 328.
117 Buchli, *An Archaeology of Socialism*, 56-7.
118 Cited and translated in Graffy, *Bed and Sofa*, 11.
119 Viktor Shklovskii, 'Pogranichnaia liniia', [1927] in his *Za 60 let. Raboty o kino* (Moscow: Iskusstvo, 1985), 110-13.
120 The sequences that depict Trager's clumsiness with objects recall Iurii Olesha's novel *Envy* (*Zavist′* 1927), published the same year that *The Girl with a Hatbox* was released. In the novel, various pieces of furniture rebel against the petit-bourgeois Nikolai Kavalerov, who refuses to accept new socialist ways of life, and try to trip him up, bite him and laugh at his expense.
121 Boris Arvatov, 'Byt i kul′tura veshchi' [1925], translated by Christina Kiaer as 'Everyday Life and the Culture of the Thing', *October* 81 (1997): 119-28.
122 Ibid., 123.
123 Ibid., 126.
124 Svetlana Boym, *Common Places: Mythologies of Everyday Life in Russia* (Cambridge, MA: Harvard University Press, 1994), 64.
125 For discussion of the significance of acts of homemaking in Soviet cinema, see Widdis, *Socialist Senses*, 109-19.
126 Gosfil′mofond Rossii. 1. 2. 1. 228, 13-14.
127 Ibid., 13-42.
128 Arvatov, 'Byt i kul′tura veshchi', 119-28.
129 For discussion of how this is achieved in *Bed and Sofa*, see Philip Cavendish, *Soviet Mainstream Cinematography: The Silent Era* (London: UCL Arts & Humanities Publications, 2007), 74-6.

130 This recalls the mise-en-scène of Kolia and Liuda's flat in *Bed and Sofa*: in an early sequence a copy of *Workers' Newspaper* (Rabochaia gazeta) rests on the table next to ornate china kitchenware.
131 V. Kolomarov, 'Veshch´ v kino', *Kino i kul´tura* 9–10 (1929): 29–37.
132 Ibid.
133 For example, see Sergei Tret´iakov, 'Otkyda i kyda', [1923] in *Literaturnye manifesty. Ot simvolizma k Oktiabriu*, ed. Nikolai Brodsky (Munich: Fink, 1969), 238–45 and his 'The Biography of the Object' [1929] in *October* 118 (2006): 57–62.
134 See Boym, *Common Places*, 63–4.
135 For discussion of *ostranenie* in early-Soviet cinema more generally, see Annie van den Oever, 'Ostrannenie, "The Montage of Attractions" and Early Cinema's "Properly Irreducible Alien Quality"', in *Ostrannenie: On 'Strangeness' and the Moving Image: The History, Reception, and Relevance of a Concept*, ed. Annie van den Oever (Amsterdam: Amsterdam University Press, 2010), 33–60. Van den Oever claims that Viktor Shklovskii erroneously spelt the term 'ostrannenie' as 'ostranenie' in his 1917 essay 'Art as Device' (Iskusstvo kak priem).
136 For detailed discussion of the flashback images, see Cavendish, *Soviet Mainstream Cinematography*, 93.
137 Widdis, *Socialist Senses*, 119.
138 Denise J. Youngblood, *Movies for the Masses: Popular Cinema and Soviet Society in the 1920s* (Cambridge: Cambridge University Press, 1992), 92. A number of other films set in the domestic environment were conceived as problem films, including *Bed and Sofa*.
139 See Widdis, *Socialist Senses*, 212.
140 Ibid., 205.
141 Nikolai Lukhmanov, 'Zhizn´ kak ona dolzhna byt´', *Kino i kul´tura* 1 (1929): 29–37.
142 Widdis, *Socialist Senses*, 205.

Chapter 4

1 For example, see Victoria Bonnell, 'The Iconography of the Worker in Soviet Political Art', in *Making Workers Soviet: Power, Class and Identity*, ed. Lewis H. Siegelbaum and Ronald Grigor Suny (Ithaca, NY and London: Cornell University Press, 1994), 341–75; Marie Collier, 'Socialist Construction and the Soviet Periodical Press during the First Five Year Plan (1928–1932)', in *Under Construction: Building the Material and Imagined World*, ed. Eike-Christian Heine (Berlin: Verlag, 2015), 25–42; and Barbara Wurm, 'Factory', in *Revoliutsiia! Demonstratsiia!: Soviet Art Put to the Test*, ed. Matthew S. Witkovsky, Devin Fore and Maria Gough (Chicago, IL: Art Institute of Chicago, 2017), 219–49.

2 Mark D. Steinberg, *Proletarian Imagination: Self, Modernity, and the Sacred in Russia, 1910–1925* (Ithaca, NY: Cornell University Press, 2002), 1–2.
3 This contrasts with Russian avant-garde painting in the 1910s and 1920s; a number of artists, such as Kazimir Malevich and Natal´ia Goncharova, incorporated elements of industrial environments and working practices in their pictures.
4 Victoria Rosner, *Modernism and the Architecture of Private Life* (New York: Columbia University Press, 2005), 100.
5 Ibid., 94.
6 An exception to this is *A Life for a Life* (Zhizn´ za zhizn´, 1916), in which the wealthy widowed businesswoman Khromova is shown to occupy a study.
7 For discussion of the ways in which Bauer explores gender relations in his films, see Rachel Morley, 'Gender Relations in the Films of Evgenii Bauer', *Slavonic and East European Review* 81, no. 1 (2003): 32–69.
8 Bauer had also used the private study to explore gender and class relations in *Child of the Big City* (Ditia bol´shogo goroda, 1914), which was released one month earlier than *Silent Witnesses*. See Rachel Morley, '"Crime without Punishment": Reworkings of Nineteenth-century Russian Literary Sources in Evgenii Bauer's *Child of the Big City*', in *Russian and Soviet Film Adaptations of Literature, 1900–2001: Screening the Word*, ed. Stephen Hutchings and Anat Vernitski (London and New York: Routledge, 2005), 27–43.
9 Anon., *Vestnik kinematograf* [1914] in *Velikii kinemo: Katalog sokhranivshikhsia igrovykh fil´mov Rossii 1908–1919*, ed. V. Ivanova, V. Myl´nikova, S. Skovorodnikova, Iu. Tsiv´ian and R. Iangirov (Moscow: Novoe literaturnoe obrazrenie, 2002), 211.
10 Rachel Morley, *Performing Femininity: Woman as Performer in Early Russian Cinema* (London: I.B. Tauris, 2017), 108.
11 Sabine Hake notes that Weimar films of the 1920s and 1930s, such as *Metropolis* (1927) and *The Tunnel* (Der Tunnel, 1933), also used spatial hierarchies to convey power relations, with workers located underground and patriarchal figures occupying 'the upper world of privilege'. Sabine Hake, 'Cinema, Set Design and the Domestication of Modernism', in *Popular Cinema of the Third Reich* (Austin, TX: University of Texas Press, 2001), 46–57 (56).
12 Morley, *Performing Femininity*, 108.
13 Alyssa DeBlasio, 'Choreographing Space, Time, and "Dikovinki" in the Films of Evgenii Bauer', *Russian Review* 66, no. 4 (2007): 671–92 (685).
14 Louise McReynolds, 'Demanding Men, Desiring Women and Social Collapse in the Films of Evgenii Bauer, 1913–17', *Studies in Russian and Soviet Cinema* 3, no. 2 (2009): 145–56 (153).
15 A number of contemporary critics commented on the realist aesthetics of *Silent Witnesses*. See Anon., *Vestnik kinematograf* [1914] in *Velikii kinemo*, Ivanova et al., 211.

16 V. Akhramovich, *Teatral'naia gazeta* [1917], ibid., 390.
17 Ivan Perestiani, *75 let zhizn' v iskusstve* [1962], ibid., 392.
18 See David Bordwell, 'Observations on Film Art', http://www.davidbordwell.net/blog/category/directors-bauer/ (accessed 2 February 2019) (para. 30–4 of 48). Bauer had previously used black backgrounds in 1916 in *Iurii Nagornyi*, as discussed in Chapter 3.
19 See Donald Posner, 'The Swinging Women of Watteau and Fragonard', *The Art Bulletin* 64, no. 1 (1982): 75–88.
20 Examples include *Strike* (Stachka 1925), *Mother* (Mat', 1926), *The End of Saint Petersburg* (Konets Sankt-Peterburga, 1927), *Counterplan* (Vstrechyi, 1932) and *Outskirts* (Okraina, 1933).
21 As we recall from Chapter 2, in the 1920s Kuleshov continued to use interior and exterior settings to explore the contradiction between human urges and desires and social responsibility, for example in *By the Law* (Po zakonu, 1926).
22 Anon., *Proektor* [1917] in *Velikii kinemo*, Ivanova et al., 389–90 (389).
23 See ibid., and Anon., *Artist i zritel'* [1917], ibid., 391.
24 For discussion of the popularity of science fiction in early-Soviet culture, see Anindita Banerjee, *We Modern People: Science Fiction and the Making of Russian Modernity* (Middletown, CT: Wesleyan University Press, 2013) and Anindita Banerjee (ed.), *Russian Science Fiction Literature and Cinema: A Critical Reader* (Brighton, MA: Academic Studies Press, 2018).
25 Ian Christie, 'Down to Earth: *Aelita* relocated', in *Inside the Film Factory: New Approaches to Russian and Soviet Cinema*, ed. Richard Taylor and Ian Christie (London: Routledge, 1991), 81–102 (82).
26 See Jamie Miller, 'Soviet Politics and Mezhrabpom Studios in the Soviet Union during the 1920s and 1930s', *Historical Journal of Film, Radio and Television* 31 (2012): 521–35.
27 'Aelita', *Kino-nedelia* 35 (1924): 12–13 (12). For clarity, I cite the article and journal title in future references to this source.
28 Sergei Kozlovskii, 'Smysl moei zhizni' [date unknown], *Iz istorii kino* 7 (Moscow: Iskusstvo, 1968), 63–90 (78–9).
29 'Aelita', *Kino-nedelia*, 12. Rabinovich was known for his abstract modernist theatre sets. The *Aelita* models were displayed in an exhibition of Rabinovich's work in Moscow in 1924.
30 Ibid.
31 Mikhail Arlazorov, *Protazanov* (Moscow: Iskusstvo, 1973), 119.
32 Ibid. and Kozlovskii, 'Smysl moei zhizni', 78–9.
33 The German camera operator Emil Schünemann was also hired to assist Zheliabuzhskii.
34 Moisei Aleinikov notes that the original sets had to be reduced in scale and cost. Mosei Aleinikov, *Iakov Protazanov: Sbornik statei i materialov* (Moscow: Goskinoizdat, 1948), 40.
35 Anon., 'Rabochie, delavshie "Aelita"', *Kino-nedelia* 35 (1924): 11.

36 For example, see the various reviews in 'Chto govoriat i chto pishut ob "Aelite"', *Kino-nedelia* 38 (1924): 12–13.
37 Anon., 'Aelita', *Pravda* (1 October 1924): 5.
38 Anon., 'Aelita', *Novyi zritel'* 39 (1924): 5.
39 Cited in Christie, 'Down to Earth', 85.
40 Ibid., 100–1.
41 Philip Cavendish, *Soviet Mainstream Cinematography: The Silent Era* (London: UCL Arts & Humanities Publications, 2007), 128.
42 Robert Bird, 'How to Keep Communism Aloft: Labor, Energy, and the Model Cosmos in Soviet Cinema', *e-flux* 88 (February 2018), https://www.e-flux.com/journal/88/172568/how-to-keep-communism-aloft-labor-energy-and-the-model-cosmos-in-soviet-cinema/ (accessed 5 February 2019): para. 9 of 28.
43 See Karl Marx, *Das Kapital* [1867] in *The Marx-Engels Reader*, ed. Robert C. Tucker (London and New York: W. W. Norton & Company, 1972), 344–5.
44 Nikolai Chuzhak, 'Pod znakom zhiznestroeniia', *LEF* 1 (1923): 35.
45 For an overview of VKhUTEMAS's curriculum, see Selim O. Khan-Magomedov, *VKhUTEMAS: tekstil', skul'ptura, zhivopis', grafika, keramika, metal, derevo, arkhitektura, 1920–1930*, vol. 2 (Moscow: Izdatel'stvo Lad'ia, 1995).
46 For discussion of these debates, see Maria Gough, *The Artist as Producer: Russian Constructivism in Revolution* (Berkeley, CA: University of California Press, 2005), 102–20.
47 As we recall from the symbolic significance of sewing in Chapter 3, Masha's association with this activity casts her as a productive member of society.
48 Julian Graffy, *Gogol's The Overcoat* (London: Bristol Classical Press, 2000), 43 and Philip Cavendish, *The Men with the Movie Camera: The Poetics of Visual Style in Avant-Garde Cinema of the 1920s* (London: Berghahn Books, 2013), 211–12.
49 Rachel Morley, '"Crime without punishment"'.
50 This notably departs from Bauer's representation of the city in *Child of the Big City*, which focuses on the allure of materialism that was also a theme of Gogol''s *Nevskii Prospect*. For analysis of Bauer's representation of the city in relation to literary sources, see ibid., 29–30.
51 Emma Widdis, *Socialist Senses: Film, Feeling, and the Soviet Subject, 1917–1940* (Bloomington, IN: Indiana University Press, 2017), 62–3.
52 For discussion of the cinematography and different lens effects used in this sequence, see Cavendish, *The Men with the Movie Camera*, 214–15.
53 A number of 1920s Soviet films incorporated statues to symbolize authoritarian power. As Mikhail Iampol'skii notes, in Vasilii Kovringin's designs for Sergei Eizenshtein's *October* (Oktiabr', 1928) images showing the destruction of imperial monuments symbolize that of the pre-revolutionary social and political order. See Mikhail Iampol'skii, 'Razbityi pamiatnik', *Kinovedcheskie zapiski* 1 (1988): 6–11.

54 Valentina Kuznetsova, 'Aleksandr Benua i leningradskaia shkola khudozhnikov kino', in *Vek peterburgskogo kino: Sbornik nauchnykh trudov*, ed. Aleksandr L. Kazin (Saint Petersburg: Rossiiskii institut istorii iskusstv, 2007), 132–51.
55 Cavendish, *Soviet Mainstream Cinematography*, 50.
56 Robert Bird, 'The Poetics of Peat in Soviet Literary and Visual Culture, 1918–1959', *Slavic Review* 70, no. 3 (2011): 591–614. Bird notes that, at the Eighth Conference of the Soviets in 1920, Lenin encouraged delegates to screen films about peat production and commissioned twelve films on the subject.
57 Ibid., 594.
58 Lev Kuleshov and Aleksandra Khokhlova, *Fifty Years in Films* [1975], reprinted in *Lev Kuleshov: Selected Works: Fifty Years in Films*, compiled and annotated by Ekaterina Khokhlova and translated by Nina Shcherbakova (Raduga: Moscow, 1987): 208.
59 Ibid.
60 Cavendish, *Soviet Mainstream Cinematography*, 51.
61 Kuleshov, *Fifty Years in Films*, 209.
62 Ibid., 208–9.
63 For example, see Anne Nesbet, 'Beyond Recognition: *Strike* and the Eye of the Abattoir', in *Savage Junctures: Sergei Eisenstein and the Shape of Thinking* (London and New York: I.B. Tauris, 2007), 21–48 and David Bordwell, *The Cinema of Eisenstein* (London: Routledge, 2016), 50–60.
64 Cavendish, *The Men with the Movie Camera*, 74.
65 Sergei Iutkevich, 'Dekoriruem svetom', *Sovetskii ekran* 29 (1925): 43.
66 Bl. F., 'Rol´ kino-khudozhnika v kino proizvodstve', 72.
67 Widdis, *Socialist Senses*, 63–70. For example, many of the works exhibited by Constructivist artists at the 1921 5x5=25 exhibition in Moscow explored pictorial understandings of space, line and form. See Gough, *The Artist as Producer*, 61–101.
68 For discussion of the disorientating sense of perspective in Lisitskii's *Prouns*, see Yve-Alain Bois, 'El Lissitzky: Radical Reversibility', *Art in America* (April 1988), 161–80.
69 In the early 1920s, Eizenshtein studied under Meierkhol´d at the State Advanced Workshops for Directors (Gosudarstvennye vysshie rezhisserskie masterskie, GVYRM) and he was named the chief set designer of the Proletkul´t theatre in 1921. For discussion of Eizenshtein's practice as a theatre set designer, see Robert Leach, 'Eisenstein's theatre work', in *Eisenstein Rediscovered*, ed. Ian Christie and Richard Taylor (London and New York: Routledge, 1993), 105–19.
70 See Nick Worrall, 'Meyerhold's Production of "The Magnificent Cuckold"', *The Drama Review* 17, no. 1 (1973): 14–34 and Julia Vaingurt, *Wonderlands of the Avant-Garde: Technology and the Arts in Russia of the 1920s* (Evanston, IL: Northwestern University Press, 2013), 69–76.

71 Lev Kuleshov, 'Volia: Uporstvo: Glaz' [1926] in his *Sobranie sochinenii v trekh tomakh*, vol. 1, 111-13.
72 Kozlovskii also incorporated intangible elements into his sets for *The End of St. Petersburg* to convey a sense of instability.
73 Nesbet, *Savage Junctures*, 25 and Cavendish, *The Men with the Movie Camera*, 73.
74 For discussion of Goncharova and Larionov's Rayonist works, see Tim Harte, *Fast Forward: The Aesthetics and Ideology of Speed in Russian Avant-Garde Culture, 1910-1930* (Madison, WI: University of Wisconsin Press, 2009), 101-9.
75 Nesbet, *Savage Junctures*, 41.
76 Kuleshov notes that Rodchenko was involved in the framing of scenes. See 'Vasha znakomaia: beseda s L. V. Kuleshovym', *Sovetskoe kino* 2 (1927): 6.
77 See Lev Kuleshov, 'Iskusstvo kino' [1929] in his *Sobranie sochinenii v trekh tomakh*, 161-227 (150-3) and Aleksandr Rodchenko, 'Khudozhnik i material′naia sreda v igrovoi fil′me', *Sovetskoe kino* 5-6 (1927): 14-15.
78 Lev Kuleshov, 'Vasha znakomaia' in his *Sobranie sochinenii*, vol. 2, 397-8 (397).
79 Cited in Widdis, 'Faktura', 24.
80 Kuleshov, 'Vasha znakomaia: beseda s L. V. Kuleshovym', 6.
81 Production records for *Your Acquaintance* are held at Gosfil′mofond Rossii. 1.2.1.86.
82 Widdis, 'Faktura', 24.
83 Gosfil′mofond Rossii. 1.2.1.86.
84 Widdis, *Socialist Senses*, 216.
85 Widdis, 'Faktura', 25-7.
86 Widdis, *Socialist Senses*, 219.
87 Widdis, 'Faktura', 25.
88 Kuleshov, 'Iskusstvo kino', 161-227 (149).
89 Ibid., 151.
90 Widdis, *Socialist Senses*, 219.
91 Sarah Street, 'Sets of the Imagination: Lazare Meerson, Set Design and Performance in *Knight without Armour* (1937)', *Journal of British Cinema and Television* 2 (2005): 18-35.
92 Julia Bekman Chadaga, *Optical Play: Glass, Vision and Spectacle in Russian Culture* (Evanston, IL: Northwestern University Press, 2014), 41.
93 N. Kaufman, 'Veshch′ na ekrane', *Sovetskii ekran*, no. 15 (1928): 10.
94 Viktor Shklovskii, 'Sherst′, steklo i kruzheva', *Kino* 32 (1927): 2. Shklovskii marked out *Lace* (Kruzheva, 1928) and *Potholes* (Ukhaby, 1928) for their photogenic representation of material. For discussion of these films, see Emma Widdis, 'Socialist Senses: Film and the Creation of Soviet Subjectivity', *Slavic Review* 71, no. 3 (2012): 590-618 (599-612).

95 Rodchenko, 'Khudozhnik i material′naia sreda v igrovoi fil′me', 14.
96 These photographs are similar to those that Rodchenko took from the mid-1920s of Soviet everyday life. See Margarita Tupitsyn (ed.), *Aleksandr Rodchenko: The New Moscow: Photographs from the L. and G. Tatunz Collection* (Munich: Schirmer Art Books, 2000).
97 Shklovskii, 'Sherst′, steklo i kruzheva', 2. Other Soviet fiction films that represented the press industry include *The Parisian Cobbler* (Parizhskii sapozhnik, 1927) and *Amerikanka* (1930), the title of which refers to a printing press.
98 Nikolai Lukhmanov, 'Zhizn′ kak ona dolzhna byt′', *Kino i kul′tura* 1 (1929): 29–37.
99 Ibid., 32–3.
100 Aleksandr Lavrent′ev, 'Experimental Furniture Design in the 1920s', *The Journal of Decorative and Propaganda Arts* 11, no. 2 (1989): 142–67 (157). The scenes set in the journalist's study do not survive, but production stills give a sense of the type of furniture that was used. Production stills are republished in Selim O. Khan-Magomedov, *Rodchenko: The Complete Work* (London: Thames and Hudson, 1986), 190–1.
101 Ibid., 174 and 180. See also Lavrent′ev, 'Experimental Furniture Design in the 1920s', 163–7.
102 For discussion of Rodchenko's designs for the workers' club, see Christina Kiaer, *Imagine No Possessions: The Socialist Objects of Russian Constructivism* (Cambridge, MA: MIT Press, 2005), 199–243.
103 Lavrent′ev, 'Experimental Furniture Design in the 1920s', 157.
104 Widdis, *Socialist Senses*, 215.
105 Gosfil′mofond Rossii. 1.2.1.86. The filmmakers spent fifty rubles on the waste paper, a similar amount that they spent on other significant props, including Khokhlova's scarf.
106 V. Kolomarov, 'Veshch′ v kino', *Kino i kul′tura* 9–10 (1929): 29–37 (35).
107 Oksana Bulgakova [Bulgakowa], '*Novyi LEF* i kinoveshch′', *Russian Literature* 103–5 (2019): 61–94 (66).
108 Rodchenko, 'Khudozhnik i material′naia sreda v igrovoi fil′me', 14.
109 Viktor Pertsov, 'Direktsii Moskovskoi ob′′edinennoi fabrike Sovkino' [1927]. Gosfil′mofond Rossii. 1.2.1.86.
110 Widdis, 'Faktura', 25.
111 For discussion of Khokhlova's modern costumes and aesthetic, see Djurdja Bartlett, 'Stars on Screen and Red Carpet', *A Companion to Russian Cinema*, ed Beumers, 337–63 (346–47).
112 'Vasha znakomaia: beseda s L. V. Kuleshovym', 6.
113 Aleksandr Rodchenko, 'M-R. 80x100. S-Zh' [1927], *Kinovedcheskie zapiski* 32 (1996/97): 19.
114 Kuleshov, 'Vasha znakomaia', 397.
115 Ibid.
116 For discussion of the distinguishing features of Socialist Realist narratives and the 'coming to political consciousness' trope, see Katerina Clark,

The Soviet Novel: History as Ritual (Chicago, IL and London: University of Chicago Press, 1981).
117 Widdis, *Socialist Senses*, 227. For in-depth discussion of this shift in cinema, see ibid., 227–65.
118 For discussion of these sequences, see ibid., 154–5.
119 Nikolai Suvorov, 'Dva interv´iu Nikolaia Suvorova' [19 March 1969], *Kinovedcheskie zapiski* 99 (2009): 322–5 (323–4). Several scholars have noted the influence of Käthe Kollwitz on Soviet filmmakers. For discussion of her influence on Fridrikh Ermler, see Cavendish, *Soviet Mainstream Cinematography*, 94–5. And for discussion of her influence on Aleksandr Dovzhenko, see Julia Sutton-Mattocks, 'Cycles of Conflict and Suffering: Aleksandr Dovzhenko's *Arsenal*, and the Influence of Käthe Kollwitz and Willy Jaeckel', *Studies in Russian and Soviet Cinema* 10, no. 1 (2016): 1–32
120 For discussion of the working partnership between Enei and Suvorov, see 'Dva interv´iu Nikolaia Suvorova', 323–5.
121 For discussion of the innovation of sound technology in the film, see Joan Titus, '*Golden Mountains* (1931) and the New Soviet Sound Film', in *The Early Film Music of Dmitry Shostakovich* (New York and Oxford: Oxford University Press, 2016), 69–98.
122 Ibid., 77.
123 Lilya Kaganovsky, 'The Voice of Technology and the End of Soviet Silent Film: Grigorii Kozintsev and Leonid Trauberg's *Alone*', *Studies in Russian and Soviet Cinema* 1, no. 3 (2007): 265–81.
124 For discussion of Ryndin's sets, see D. Posner, 'America and the Individual: The Hairy Ape and Machinal at the Moscow Kamerny Theatre', *New Theatre Quarterly* 34 (2018): 3–15.
125 Margarita Tupitsyn, 'The Grid as a Checkpoint of Modernity', *Tate Papers* 12 (Autumn 2009), https://www.tate.org.uk/research/publications/tate-papers/12/the-grid-as-a-checkpoint-of-modernity (accessed 3 February 2019): para. 5 of 16.

Chapter 5

1 Louise McReynolds, *Russia at Play: Leisure Activities at the End of the Tsarist Era* (Ithaca, NY and London: Cornell University Press, 2003), 265–66.
2 Susan Felleman, *Art in the Cinematic Imagination* (Austin, TX: University of Texas Press, 2006), 3.
3 See, for example, Benjamin Buchloh, 'From Faktura to Factography', *October* 30 (1984): 83–119; John E. Bowlt and Olga Matich (eds), *Laboratory of Dreams: The Russian Avant-Garde and Cultural Experiment* (Stanford, CA: Stanford University Press, 1996); and Maria Gough, *The Artist as Producer: Russian Constructivism in Revolution* (Berkeley, CA: University of California Press, 2005).

4 For discussion of the representation of artists' studios in paintings across the tradition of European art history, see Gileş Waterfield (ed.), *The Artist's Studio* (London: Hogarth Arts, 2009) and Victor I. Stoichita, *The Self-Aware Image: An Insight into Early Modern Meta-Painting* (London: Harvey Miller Publishers, 2015), 229–90.
5 Rosalind P. Gray [Blakesley], *Russian Genre Painting in the Nineteenth Century* (Oxford: Clarendon Press, 2000), 94.
6 Ibid., 94–5.
7 For a synopsis of the scenario, see *Vestnik kinematograf* 17 (1913): 39–40.
8 John Walker notes that a number of early-American and European films about artists used the theme of the jealous model, including Robert William Paul's *The Sculptor's Jealous Model* (1904) and A. E. Coleby's *The Sculptor's Dream* (1910). See John Walker, *Art & Artists on Screen* (Manchester and New York: Manchester University Press, 1993), 91.
9 See S. Goslavskaia [1974] in V. Ivanova, V. Myl'nikova, S. Skovorodnikova, Iu. Tsiv'ian and R. Iangirov (eds), *Velikii kinemo: Katalog sokhranivshikhsia igrovykh fil'mov Rossii 1908–1919* (Moscow: Novoe literaturnoe obozrenie, 2002), 158 and Anna Kovalova, 'The Picture of Dorian Gray painted by Meyerhold', *Studies in Russian and Soviet Cinema* 13, no. 1 (2019): 59–90 (75–6).
10 Liudmila Miasnikova notes that Vladimir Egorov also frequently used this strategy in his cinema set designs in the 1910s and 1920s. See Liudmila Miasnikova, 'Vladimir Egorov: uchenyi risoval'shchik, stavshii "kinoshnikom"', *Dekorativnoe iskusstvo i predmetno-prostranstvennaia sreda, Vestnik MGKhPA* (April 2015): 316–36 (319).
11 On the mythology relating to Hera, see Philip E. Slater, *The Glory of Hera: Greek Mythology and the Greek Family* (Princeton, NJ: Princeton University Press, 1968), 125–37.
12 Nikolai Kolin and Sergei Kozlovskii, *Khudozhnik-arkhitektor v kino* [1930], *Kinovedcheskie zapiski* 99 (2009): 378–422 (388).
13 On Aivazovskii, see Gianni Caffiero and Ivan Samarine, *Light, Water and Sky: The Paintings of Ivan Aivazovsky* (London: Laurence King Publishing, 2012).
14 On Renoir's portraits, see Colin B. Bailey (ed.), *Renoir's Portraits: Impressions of an Age* (New Haven, CT: Yale University Press, 1997).
15 See Stoichita, *The Self-Aware Image*, 142–8.
16 Monet's painting also includes in its group of bourgeois lunchers the Realist painter Gustave Courbet, thereby associating artists with the lifestyle of a particular social class.
17 For information on Morozov and Shchukin's collections of Renoir's works, see Beverly Whitney Kean, *French Painters, Russian Collectors: The Merchant Patrons of Modern Art in Pre-Revolutionary Russia* (London: Hodder & Stoughton, 1994), 99–100. On Shchukin's Renoirs, see Natalya Semenova, with André Delocque, *The Collector: The Story of Sergei Shchukin and His Lost Masterpieces* (London and New Haven: Yale University Press, 2020).

18 For example, Leah Clark notes that Renaissance artists used this tactic in the fifteenth century. Leah R. Clark, *Collecting Art in the Italian Renaissance Court: Objects and Exchanges* (Cambridge: Cambridge University Press, 2018), 116–56.
19 For a bibliography of surviving sources on the film, see Kovalova, '*The Picture of Dorian Gray* painted by Meyerhold', 88–90.
20 Philip Cavendish, 'The Hand That Turns the Handle: Camera Operators and the Poetics of the Camera in Pre-Revolutionary Russian Film', *Slavonic and East European Review* 82, no. 2 (2004): 201–45 (232).
21 Kovalova, '*The Picture of Dorian Gray* painted by Meyerhold', 59.
22 Ibid., 85.
23 Cited and translated ibid., 74.
24 Republished ibid., 64.
25 Ibid., 81.
26 Vsevolod Meierkhol'd, 'Balagan' [1912], in *V. Meierkhol'd. Stat'i. Pis'ma, Rechi. Besedy*, ed. Aleksandr V. Fevral'skii and B. I. Rostotskii, vol. 1 (Moscow: Iskusstvo, 1968), 207–29 (222).
27 Vsevolod Meierkhol'd, 'V. E. Meierkhol'd o kinematografe' [1915], translated as 'Vsevolod Meyerhold: On Cinema', in *The Film Factory: Russian and Soviet Cinema in Documents, 1896–1939*, ed. Richard Taylor and Ian Christie (London: Routledge, 1988), 39.
28 See, for example, S. V. Lur'e, 'Sredi novinok', *Sine-fono* 2 (1915), 48; Anon., 'Kriticheskoe obozrenie', *Zhivoi ekran* 19–20 (1915): 28–9; Viktor Voevodin, 'V. Egorov: Khudozhnik fil'ma V. Meierkhol'da "Portret Doriana Greia"', *Kinovedcheskie zapiski* 13–14 (1992): 214–24 (216–17); and Kovalova, '*The Picture of Dorian Gray* painted by Meyerhold', 74–5.
29 Sergei Iutkevich, 'V. E. Meierkhol'd i teoriia kinorezhissury', *Iskusstvo kino* 8 (1975): 74–82 (75).
30 Republished in Kovalova, '*The Picture of Dorian Gray* painted by Meyerhold', 62.
31 Yuri Tsivian [Iurii Tsiv'ian], 'Portraits, Mirrors, Death: On Some Decadent Clichés in Early Russian Films', *Iris* 14–15 (1992): 67–83 (68). For discussion of how mirrors are used in paintings for this effect, see Stoichita, *The Self-Aware Image*, 183–228.
32 RGALI f. 2710, op. 1, ed. khr. 59, 1–45.
33 Ibid., 8.
34 Tsivian, 'Portraits, Mirrors, Death', 70–1.
35 For discussion of the theme of doubling in Wilde's text, see Christopher Craft, 'Come See About Me: Enchantment of the Double in *The Picture of Dorian Gray*', *Representations* 91, no. 1 (2005): 109–36.
36 Anon., *Teatral'naia gazeta* 1 (1916): 17.
37 For discussion of Egorov's theatre designs, see Evgenii Kuman'kov, *Vladimir Evgen'evich Egorov* (Moscow: Sovetskii khudozhnik, 1965).
38 Ibid., 26–9.
39 Ibid., 28.

40 Viktor Voevodin, 'Vladimir Evgen´evich Egorov', in *Silent Witnesses: Russian Films 1908-1919*, ed. Paolo Cherchi Usai, Lorenzo Codelli, Carlo Montanaro and David Robinson, research co-ordinated by Yuri Tsivian (London: British Film Institute, 1989), 560.
41 On Fokin's *The Dying Swam*, see Tim Scholl, 'Ballet Russe: The Dying Swan' in *From Petipa to Balanchine: Classical Revival and the Modernisation of Ballet* (London and New York: Routledge, 1994), 37-53.
42 On Andreev's interest in death, see Frederick H. White, *Degeneration, Decadence and Disease in the Russian Fin de Siècle: Neurasthenia in the Life and Work of Leonid Andreev* (Manchester: Manchester University Press, 2015). The members of the *Blue Rose* met at the Moscow College of Painting, Sculpture and Architecture in the early 1900s, at the same time that Bauer briefly studied there. For information on the *Blue Rose*, see John E. Bowlt, *Russian Art, 1875-1975: A Collection of Essays* (New York: MSS Information Corp., 1976), 63-93.
43 Rachel Morley, *Performing Femininity: Woman as Performer in Early Russian Cinema* (London: I.B. Tauris, 2017), 156.
44 Bowlt, *Russian Art, 1875-1975*, 83. Munch's works gained popularity in late-Imperial Russia following their inclusion in Sergei Diagilev's exhibitions of Scandinavian art in the late 1890s and early 1900s in Saint Petersburg. See Dariusz Konstantynow, 'Light from the North: The Reception of Scandinavian Art in the Circle of Russian Modernists', in *Totenmesse: Modernism in the Culture of Northern and Central Europe* (Warsaw: Institute of Art, Polish Academy of Sciences, 1996), 169-85.
45 Yuri Tsivian [Iurii Tsiv´ian], 'Two "Stylists" of the Teens: Franz Hofer and Yevgenii Bauer', in *A Second Life: German Cinema's First Decades*, ed. Thomas Elsaesser and Michael Wedel (Amsterdam: Amsterdam University Press, 1996), 264-76 (266).
46 Leon Battista Alberti, *On Painting: A New Translation and Critical Edition*, ed. and trans. Rocco Sinisgalli (Cambridge: Cambridge University Press, 2013), 44.
47 Morley notes that in *Daydreams* and *After Death* the male protagonists use paintings and photographs to revive the presence of absent women. See Morley, *Performing Femininity*, 149-50 and 190-2.
48 Ibid., 200-3.
49 On the Union of Youth's break with mimetic representation, see Jeremy Howard, *The Union of Youth: An Artists' Society of the Russian Avant-Garde* (Manchester and New York: Manchester University Press, 1992) and Bowlt and Matich (eds), *Laboratory of Dreams*.
50 Morley, *Performing Femininity*, 157-8.
51 Bowlt, *Russian Art, 1875-1975*, 83.
52 Ibid.
53 Cited and translated ibid., 84.
54 Morley, *Performing Femininity*, 158-9.

55 Ibid., 158.
56 Ibid. Morley argues that in *Child of the Big City* Bauer similarly frames the Salome dancer sequence in a way that shuns verisimilitude to suggest its extra-diegetic status. See ibid., 82–6.
57 Ibid., 159.
58 Oksana Chefranova also notes similarities between Fuller's *Serpentine Dance* and Gizella's performance in Bauer's film. Oksana Chefranova, 'From Garden to Kino: Evgenii Bauer, Cinema, and the Visuality of Moscow Amusement Culture, 1885–1917' (PhD diss., New York University, New York, 2014), 190. On Fuller's *Serpentine Dance*, see Tom Gunning, 'Loie Fuller and the Art of Motion', in *Camera Obscura, Camera Lucida: Essays in Honour of Annette Michelson*, ed. Richard Allen and Malcolm Turvey (Amsterdam: Amsterdam University Press, 2003) 75–9.
59 Morley, *Performing Femininity*, 159–60.
60 A number of films in the 1920s do, however, depict individuals pursuing creative practices and craftwork in their homes, including *In the Big City* (V bol´shom gorode, 1927), *Two Friends, a Model and a Girlfriend* (Dva druga, model´ i podruga, 1927) and *The Girl with a Hatbox* (Devushka s korobkoi, 1927).
61 For discussion of debates about painting's role in revolutionary society and art's social function, see Buchloh, 'From Faktura to Factography', 83–119 and Gough, *The Artist as Producer*.
62 Osip Brik, 'Ot kartiny k sittsu', *LEF* 2 (1924): 27–34.
63 Boris Arvatov, *Art and Production* [1926], trans. Shushan Avagyan and ed. John Roberts and Alexei Penzin (Pluto Press: London, 2017), 50–4.
64 Lev Kuleshov, 'Iskusstvo, sovremennaia zhizn´ i kinematografiia', *Kino-fot* 1 (1922): 2.
65 Osip Brik, 'Foto i kino', *Sovetskoe kino*, no. 4–5 (1926): 23.
66 Other late 1920s films that feature filmmaking environments as settings include *The Bell Ringer's Film Career* (Kinokar´era zvonaria, 1927) and the animation film (*mul´tfil´m*) *One of Many* (Odna iz mnogikh, 1927).
67 For information regarding the cast and filmmakers who worked on the film, see Ivanova et al., *Velikii kinemo*, 386 and Aleksandr Deriabin 'Kino o kino', *Katalog kinofestivalia 'Belye stolby 2016'* (Belye stolby: Gosfil´mofond Rossii, 2016), 8–29 (9–10).
68 It is reasonable to assume that Vladimir Balliuzek worked as the production artist given that he designed the sets for most of the Ermol´ev studio's films in the late 1910s.
69 For alternative interpretations of the film's scenario, see Deriabin 'Kino o kino', 10.
70 Tsiv´ian notes that the use of mirrors that extend beyond the frame is unique to early-Russian films. Tsivian, 'Portraits, Mirrors, Death', 75.
71 Vladimir Balliuzek worked as the production artist for both *The Queen of Spades* and *Father Sergius*, supporting the speculation that he designed the sets for *Behind the Screen*.

72 Deriabin 'Kino o kino', 10. Mozzhukhin's costume also resembles the one he wears as Germann in this scene in *The Queen of Spades*. The scene attracted considerable attention in the contemporary cinema press with a full-page article dedicated to it in *Kino-gazeta*. See Anon., 'Germann i ego "ten'"', *Kino-gazeta* no. 10 (1918): 9.

73 Steven Jacobs, *Framing Pictures: Film and the Visual Arts* (Edinburgh: Edinburgh University Press, 2011), 139.

74 Philip Cavendish also notes that a number of the same personnel worked on both *Aelita* and *The Cigarette Girl from Mossel'prom*. See Philip Cavendish, *Soviet Mainstream Cinematography: The Silent Era* (London: UCL Arts & Humanities Publications, 2007), 130

75 See, for example, Denise J. Youngblood, S*oviet Cinema in the Silent Era, 1918–1935* (Austin, TX: University of Texas Press, 1991), 33–4; Emma Widdis, *Visions of a New Land: Soviet Film from the Revolution to the Second World War* (New Haven, CT: Yale University Press, 2003), 81–2; and Cavendish, *Soviet Mainstream Cinematography*, 130.

76 For discussion of the everyday life genre, see Denise J. Youngblood, *Movies for the Masses: Popular Cinema and Soviet Society in the 1920s* (Cambridge: Cambridge University Press, 1992), 74–6.

77 Examples of films that incorporate such props include *Child of the Big City* (1914), *Iurii Nagornyi* (1916) and *The Maidservant Jenny* (1918).

78 For discussion of the non-objective compositions of Russian Constructivist artists, see Gough, *The Artist as Producer*, 61–100.

79 For example, see Sergei Kozlovskii, 'Tekhnika kinoatel´e', *Kino i kul´tura*, no. 5 (1925), 57–9 and Kolin and Kozlovskii, *Khudozhnik-arkhitektor v kino*, 378–422.

80 The anthropomorphizing of the camera anticipates the way in which Dziga Vertov would represent the camera in the documentary film *The Man with the Movie Camera* (Chelovek s kinoapparatom 1929). For discussion of the representation of the camera in that film, see Vlada Petrić, *Constructivism in Film: The Man with the Movie Camera: A Cinematic Analysis* (Cambridge: Cambridge University Press, 2012), 81–2. For discussion of representations of the camera operator as an iconic figure in the 1920s, see Philip Cavendish, *The Men with the Movie Camera: The Poetics of Visual Style in Avant-Garde Cinema of the 1920s* (London: Berghahn Books, 2013), 18–21.

81 The publishers Kinopechat´ dedicated a booklet to Fairbanks and Pickford's visit. During their tour of Moscow, the Hollywood stars visited the Mezhrabpom-rus´ studio and met Igor´ Il´inskii, who plays Goga Palkin in the film. On their visit to the Soviet Union, see Jeffrey Brooks, 'The Press and Its Message: Images of America in the 1920s and 1930s', in *Russia in the Era of NEP: Explorations in Soviet Society and Culture*, ed. Sheila Fitzpatrick, Alexander Rabinowitch and Richard Stites (Bloomington, IN: Indiana University Press, 1991), 237 and Alan Ball,

Imagining America: Influence and Images in Twentieth-Century Russia (Oxford: Rowman & Littlefield, 2003), 92–4.
82 Yuri Tsivian [Iurii Tsiv´ian], *Early Cinema in Russia and its Cultural Reception*, ed. Richard Taylor and translated by Alan Bodger (London and New York: Routledge, 1994), 9–10 and Lucy Fischer, 'Invisible by Design: Reclaiming Art Nouveau for the Cinema', *Film History* 25, no. 1–2 (2013): 55–69 (56).
83 Ibid., 56–7.
84 The cinema foyer sets recall an illustration of the cinema entrance hall in *Sovetskii ekran*. See Virganskii, 'V foie kino', *Sovetskii ekran*, no. 24 (1926): 1.
85 This recalls the way in which Bauer uses statuettes, painted portraits and photographs in the studies of his male protagonists to comment on their fantasist nature, as discussed in Chapter 4. In *Twilight of a Woman's Soul* (Sumerki zhenskoi dushi, 1913), Bauer also includes publicity photographs of the female protagonist Vera as a stage performer. See Morley, *Performing Femininity*, 65.
86 See Andrew Horton, *Inside Soviet Film Satire: Laughter with a Lash* (Cambridge: Cambridge University Press, 2005), 48–57.
87 Douglas Clayton, *Pierrot in Petrograd: The Commedia dell'Arte/Balagan in Twentieth-Century Russian Theatre and Drama* (Montreal: Mc-Gill-Queen's University Press, 2014).
88 See Grigorii Kozintsev, 'Glubokii ekran' [1971], in *Sobranie sochinenii v piati tomakh*, vol. 1 (Leningrad: Iskusstvo, 1982), 17–292 (55).
89 Philip Cavendish, 'From "Lost" to "Found": The "Rediscovery" of Sergei Eisenstein's *Glumov's Diary* and its avant-garde context', *KinoKultura* 41 (2013), http://www.kinokultura.com/2013/41-cavendish.shtml (accessed 15 September 2019) (para. 1 of 33).
90 Burenina-Petrova, *Tsirk v prostranstve kul´tury*, 195.
91 Viktor Shklovskii, *Knight's Move* [1923], trans. and intro. Richard Sheldon (London: Dalkey Archive Press, 2005), 86–7.
92 Lev Kuleshov, 'Circus-Cinema-Theatre' [1925], trans. Dmitri Agrachev and Nina Belenkaya in Lev Kuleshov, *Selected Works: Fifty Years in Films* (Moscow: Raduga Publishers, 1987), 62–3.
93 Cavendish, 'From "Lost" to "Found"', para. 4 of 33.
94 Ibid.
95 See Anon., 'Sovetskie fil´my', *Izvestiia* (18 November 1929): 5 and Anon., '2-Bul´di-2', *Kino i zhizn´*, no. 32–3 (1930): 5.
96 Kozlovskii and Balliuzek would collaborate once more, on Mezhrabpom-fil´m's *The Feast of St. Jorgen* (Prazdnik sviatogo Iorgena, 1930).
97 Brik was a close associate of Tret´iakov, working alongside him as a contributor and editor of *LEF* and *Novyi LEF*, and he may well have drawn on Tret´iakov's adaptation of *Enough Stupidity in Every Wise Man* when writing the scenario for *The Two Bul´dis*.

98 Alastair Renfrew, 'Facts and Life: Osip Brik in the Soviet Film Industry', *Studies in Russian and Soviet Cinema* 7, no. 2 (2013): 165–88 (175–7).
99 Ibid.
100 For discussion of the first All-Union Party Cinema Conference, see Youngblood, *Soviet Cinema in the Silent Era*, 157–88.
101 For an overview of the decrees passed by TsUGTs, see Miriam Neirich, *When Pigs Could Fly and Bears Could Dance: A History of the Soviet Circus* (Madison, WI: University of Wisconsin Press, 2012), 62–3.
102 Ibid., 33–42 and Burenina-Petrova, *Tsirk v prostranstve kul´tury*, 195–7.
103 Ibid., 195.
104 Anatolii Lunarcharskii, 'Piat´ let gosudarstvennykh tsirkov', *Tsirk* 3 (1925): 3.
105 During the 1930s, the drive to modernize and Sovietize the circus continued to be a concern and it was addressed in Mosfil´m's *Circus* (Tsirk, 1936), which follows the attempt to create an ideologically appropriate Soviet act, 'Flight to the Stratosphere' (*Polet v stratosferu*), to replace pre-revolutionary and Western circus repertoires.
106 Sergei Sokolov, 'Za sovetizatsiiu tsirka', *Tsirk i estrada* 14 (1929): 8.
107 On this traditional circus partnership, see Neirich, *When Pigs Could Fly and Bears Could Dance*, 38–9.
108 Donald McManus, *No Kidding: Clown as Protagonist in Twentieth-Century Theater* (Newark, DE: University of Delaware Press, 2003), 16–17.
109 Annie Gérin, *Devastation and Laughter: Satire, Power, and Culture in the Early Soviet State, 1920s–1930s* (London and Toronto: University of Toronto Press, 2018), 77.
110 Ibid., 80.
111 For example, see Sergei Tret´iakov, 'Na kolkhozy!', *Novyi LEF* 11 (1928): 9, his 'Ot redaktsii', *Novyi LEF* 12 (1928): 1 and his 'Prodolzhenie sleduet', *Novyi LEF* 12 (1928): 1–4.
112 Donald McManus notes that in a number of national twentieth-century theatres the circus clown was associated with critiquing authority and thus functioned as a political metaphor. McManus, *No Kidding*, 15–16.
113 Iurii Annenkov, 'Veselyi sanatorii', *Zhizn´ iskusstva* 282–3 (1919): 5.
114 Neirich, *When Pigs Could Fly and Bears Could Dance*, 37–8.
115 Shklovskii, *Knight's Move*, 8.
116 Preobrazhenskaia and Pravov directed *The Last Act* immediately after their work on *Peasant Women of Riazan* (*Baby riazanskie*, 1927), which also used location filming rather than studio sets.
117 Neirich, *When Pigs Could Fly and Bears Could Dance*, 33.
118 Copies of Deni's agitational posters are housed in the David King Collection, Tate, London, https://www.tateimages.com/results.asp?newsearch=true&txtkeys1=Viktor%20Deni&pixperpage=10 (accessed 27 June 2019).

119 Shklovskii, *Knight's Move*, 26.
120 For a translation of the decree, see Richard Taylor and Ian Christie (eds), *The Film Factory: Russian and Soviet Cinema in Documents, 1896–1939* (London: Routledge, 1988), 127.
121 Buchloh, 'From Faktura to Factography', 83–119.

Conclusion

1 See, for example, Boris Dubrovskii-Eshke, 'Rol´ khudozhnika-arkhitektora', *Kino* (16 March 1933): 2; Bela Balash [Béla Balázs], 'Zadachi kinokhudozhnika', *Kino* (28 August 1933): 3; Moisei Levin, 'Khudozhnik v kinoatel´e', *Sovetskoe kino* 11 (1935): 44–9; Natan Al´tman, 'Khudozhnik v kino', *Iskusstvo kino* 3 (1936): 22; Boris Dubrovskii-Eshke, 'Voprosy dekoratsionnoi tekhniki', *Iskusstvo kino* 6 (1937): 60–4; and Sergei Iutkevich, 'Rezhisser i khudozhnik v kino', *Iskusstvo kino* 7 (1939): 14–21.
2 Vladimir Kaplunovskii, 'Khudozhnik v kino', *Iskusstvo kino* 1 (1936): 38–9 (38).
3 Ibid., 38.
4 See Lev Kuleshov, 'O zadachakh khudozhnika v kinematografe', *Vestnik kinematografii* 126 (1917): 15–16 and 'Zadachi khudozhnika v kinematografe', *Vestnik kinematografii* 127 (1917): 37–8.
5 Gennadii Miasnikov, *Ocherki istorii sovetskogo kinodekoratsionnogo iskusstva, 1931–1945* (Moscow: VGIK, 1979), 3–8.
6 Lilya Kaganovsky, *The Voice of Technology: Soviet Cinema's Transition to Sound, 1928–1935* (Bloomington: Indiana University Press, 2018), 22.
7 For discussion of how production artists responded to the technical challenges of sound film, see Dubrovskii-Eshke, 'Voprosy dekoratsionnoi tekhniki'.
8 See, for example, Tim Bergfelder, Sue Harris and Sarah Street, *Film Architecture and the Transnational Imagination: Set Design in 1930s European Cinema* (Amsterdam: Amsterdam University Press, 2007), 25–6.
9 On Socialist Realism, see Katerina Clark, *The Soviet Novel: History as Ritual* (Chicago: Chicago University Press, 1981); Régine Robin, *Socialist Realism: An Impossible Aesthetic*, trans. Catherine Porter (Stanford: Stanford University Press, 1992); Evgeny Dobrenko, *Political Economy of Socialist Realism* (New Haven: Yale University Press, 2007).
10 *Pervyi vsesoiuznyi s´´ezd sovetskikh pisatelei: Stenograficheskii otchet* [1934] (repr., Moscow: Sovetskii pisatel´, 1990), 712.
11 Nikolai Suvorov, 'Khudozhnik v kino' [1938], *Kinovedcheskie zapiski* 99 (2009): 301–3 (303).
12 Ibid., 301–2.

13 Philip Cavendish, 'The Hand That Turns the Handle: Camera Operators and the Poetics of the Camera in Pre-Revolutionary Russian Film', *Slavonic and East European Review* 82, no. 2 (2004): 201–45 and his *The Men with the Movie Camera: The Poetics of Visual Style in Avant-Garde Cinema of the 1920s* (London: Berghahn Books, 2013).

14 Enei worked on the following silent-era films with the FEKS directors Grigorii Kozintsev and Leonid Trauberg: *Mishki against Iudenich* (Mishki protiv Iudenicha, 1925); *The Devil's Wheel* (Chertovo koleso, 1926); *The Overcoat* (Shinel´, 1926); *Little Brother* (Bratishka, 1927); *The Union of the Great Cause* (Soiuz velikogo dela, 1927); *New Babylon* (Novyi Vavilon, 1929). Enei continued to work with FEKS directors into the 1960s and in 1964 he collaborated with Kozintsev on *Hamlet* (Gamlet).

15 Vladimir Egorov, 'Khudozhnik stseny teatra i khudozhnik kadra kino' [20 April 1952, unpublished]. RGALI f. 2710, op. 1, ed. khr. 59.

16 Aleksandr Rodchenko, 'Khudozhnik i material´naia sreda v igrovoi fil´me', *Sovetskoe kino* 5–6 (1927): 14–15.

17 Cited in Aleksandr Razumnyi, *U istokov: Vospominaniia kinorezhissera* (Moscow: Iskusstvo, 1975), 41–3.

18 Cited in Sergei Iutkevich, *Sobranie sochinenii v trekh tomakh*, vol. 1 (Moscow: Iskusstvo, 1990), 322.

19 Emma Widdis, *Socialist Senses: Film, Feeling, and The Soviet Subject, 1917–1940* (Bloomington, IN: Indiana University Press, 2017).

20 N. K., 'Byt "ideologicheskii", byt "kassovyi", byt "zhivoi"', *Sovetskii ekran* 27 (1928): 5.

Appendix

1 Lev Kuleshov, 'On the Tasks of the Production Artist in Cinema [O zadachakh khudozhnika v kinematografe]', *Vestnik kinematografii* 126 (1917): 15–16.

2 Lev Kuleshov, 'The Tasks of the Production Artist in Cinema [Zadachi khudozhnika v kinematografe]', *Vestnik kinematografii* 127 (1917): 37–8.

3 Kuleshov is referring to the Russian painters Nikolai Ge (1831–94) and Mihkail Vrubel´ (1856–1910).

4 Mikalojus Čiurlionis (1875–1911) was a Lithuanian painter and writer associated with symbolist and art nouveau movements.

5 Sergei Iutkevich, 'Dekoriruem svetom', *Sovetskii ekran* no. 29 (1925): 43.

6 Iutkevich is referring to the American film *Rosita* (1923), directed by Ernst Lubitsch and with sets by William Cameron Menzies, the American film *The Thief of Baghdad* (1924), directed by Raoul Walsh and with sets also by William Cameron Menzies, the Soviet film *Aelita* (1924), directed by Iakov Protazanov and with sets by Sergei Kozlovskii and Viktor Simov, and the Weimar film *The Cabinet of Dr. Caligari* (1920), directed by Robert Wiene and with sets by Walter Reimann and Walter Röhrig.

7 Here, Iutkevich is referring to the filmmaker and interior designer Alberto Cavalcanti and to Fernand Léger, who designed the cubist inspired interiors for Marcel L'Herbier's *The Inhuman Woman* (L'Inhumaine, 1924).
8 The references here are to *Strike* (Stachka, 1925), directed by Sergei Eizenshtein and with sets by Vasilii Rakhal's and *The Death Ray* (Luch smerti, 1925), directed by Lev Kuleshov and with sets also by Vasilii Rakhal's.
9 V. Pudovkin, 'O khudozhnike v kino', *Kino-gazeta* no. 10 (1925): 2.
10 Sergei Kozlovskii, 'Prava i obiazannosti kino-khudozhnika]', *Kino-zhurnal ARK* no. 11–12 (1925): 16–17.
11 Aleksandr Rodchenko, 'Khudozhnik i material'naia sreda v igrovoi fil'me', *Sovetskoe kino* no. 5–6 (1927): 14–15.
12 Andrei Burov, 'Arkhitektura i kino' [1929, unpublished]. RGALI f. 1925, op. 1, ed. khr. 1862.
13 As discussed in Chapter 2, Burov worked as a production artist alongside Vasilii Rakhal's and Vasilii Kovrigin on *The General Line*, later released as *The Old and The New* (1929).
14 This refers to an article by the production artist G. Baizengerts 'Film-architecture of today and tomorrow (kino-arkhitektura segodnia i zavtra)', *Sovetskii ekran* no. 33 (1927): 6. In this article, Baizengerts claimed that production artists needed to study the laws of camera optics, lighting and scriptwriting so as to create sets that responded to the specific artistic features of cinema.
15 Vladimir Egorov, 'Khudozhnik stseny teatra i khudozhnik kadra kino – mastera dekorativnogo oformleniia' [20 April 1952, unpublished]. RGALI f. 2710, op. 1, ed. khr. 59.
16 Egorov is referring to the Russian artist Aleksei Kivshenko's well-known painting *Military Council at Fili* (1880). The council was convened on 13 September 1812 after the Battle of Borodino during the French invasion of Russia.
17 This refers to General Michael Andreas Barclay de Tolly.
18 Here Egorov is referring to the painters and theatre designers associated with the World of Art (Mir iskusstva) group Konstantin Korovin, Aleksandr Golovin and Aleksandr Benois [Benua].

BIBLIOGRAPHY

Archives consulted

Cinema Museum (Muzei kino), Moscow, Russia.
State Archive of films of the Russian Federation (Gosudarstvennyi fond kinofil´mov Rossiiskoi Federatsii, Gosfil´mofond), Belye stolby, near Moscow, Russia.
State Archive of Literature and Art (Rossiiskii gosudarstvennyi arkhiv literatury i iskusstva, RGALI), Moscow, Russia.

Primary sources

Anon., 'Aelita', *Kino-nedelia* 35 (1924): 12–13.
Anon., 'Fon bez dekoratsii', *Sovetskii ekran* no. 4 (1925): 23.
Anon., 'Byt v zagranichnykh fil´makh', *Sovetskii ekran* no. 5 (1925): 30.
Anon., 'Na naturu!', *Sovetskii ekran* no. 6 (1925): 37.
Anon., 'Arkhitekturnye kadry kino-kartiny "General´naia liniia" Sovkino v postanovke S. M. Eizenshteina. Arkhitektura A. K. Burova', *Sovremennaia arkhitektura* 5–6 (1926): 136–7.
Anon., 'Rezoliutsiia obshchego sobraniia proizvodstvennoi sektsii ARK k kartine "Po zakonu"', *Kino-front* nos 9–10 (1926): 31.
Anon., 'General´naia liniia (beseda s S. M. Eizenshteinom)', *Kino-front* no. 4 (1927): 29–30.
Anon., 'Rezoliutsiia sektsii khudozhnikov arkhitektorov', *Kino-front* no. 2 (1928): 12–13.
Adorno, Theodor W. and Benjamin, Walter, *The Complete Correspondence, 1928–1940*, edited by Henri Lonitz and translated by Nicholas Walker. Cambridge, MA: Harvard University Press, 2003.
Agden, Viktor, 'Kino-khudozhnik na zapade i v SSSR', *Kino-zhurnal ARK* 3 (1926): 16–18.
Alberti, Leon Battista, *On Painting: A New Translation and Critical Edition*, edited and translated by Rocco Sinisgalli. Cambridge: Cambridge University Press, 2013.
Aleinikov, Moisei, *Puti sovetskogo kino i MKhAT*. Moscow: Goskinoizdat, 1947.
Aleinikov, Moisei (ed.), *Iakov Protazanov: Sbornik statei i materialov*. Moscow: Goskinoizdat, 1948.
Al´tman, Natan, 'Khudozhnik v kino', *Iskusstvo kino* 3 (1936): 22.

Anoshchenko, A., 'Metodika kinooformleniia', *Kino i kul'tura* no. 5 (1929): 21–4.

Arsen, A., 'Sotsial'noe znachenie kartiny "Po zakonu"', *Kino-front* nos 9–10 (1926): 28–30.

Arvatov, Boris, 'Byt i kul'tura veshchi' [1925], translated by Christina Kiaer as 'Everyday Life and the Culture of the Thing', *October* 81 (1997): 119–28.

Arvatov, Boris, *Art & Production*, 1926, edited by John Roberts and Alexei Penzin and translated by Shushan Avagyan. London: Pluto, 2017.

Balázs, Béla, 'Der sichtbare Mensch' 1924, in *Béla Balázs: Early Film Theory. Visible Man and The Spirit of Film*, edited by Erica Carter and translated by Roy Livingstone. New York and Oxford: Berghahn Books, 2010.

Balliuzek, Vladimir, *Maliarno-dekorativnyi tsikl*. Moscow and Leningrad: Narkompros RSFSR, 1932.

Balliuzek, Vladimir, *Zhivopisno-maliarnye raboty na kinoproizvodstve: Posobie dlia rabochikh otdelochnogo tsekha kinostudii*. Moscow: Goskinoizdat, 1948.

Balliuzek, Vladimir, 'Na s''emkakh "Pikovoi damy"', in *Iz istorii kino* 7, 99–103. Moscow: Iskusstvo, 1968.

Bassalygo, Dm., 'Kino-ekspeditsii i rezhim ekonomiki', *Kino-front* no. 1 (1926): 3.

Benjamin, Walter, 'Moscow', in *Walter Benjamin: Selected Writings*, vol. 2, *1927–1934*, edited by Marcus Bullock and Michael W. Jennings, 22–47. Cambridge, MA: Harvard University Press, 1996.

Bl. F., 'Rol' kino-khudozhnika v kino proizvodstve', *Sovetskii ekran* no. 10 (1925): 72.

Brik, Osip, 'Khudozhnik i kommuna', *Izobrazitel'noe iskusstvo* 1 (1919): 25–6.

Brik, Osip, 'Ot kartiny k sittsu', *LEF* 2 (1924): 27–34.

Brik, Osip, 'Foto i kino', *Sovetskoe kino* nos 4–5 (1926): 23.

Brik, Osip, 'Fiksatsiia fakta', *Novyi LEF* 11–12 (1927): 44–50.

Burov, Andrei, *Arkhitektura i kino*. 1929, unpublished. RGALI f. 1925, op. 1, ed. khr. 1862.

Cherkasov, A., 'Nuzhny li ekspeditsii', *Kino-front* no. 4 (1927): 3–6.

Chuzhak, Nikolai, 'Pod znakom zhiznestroeniia', *LEF* 1 (1923): 35.

Delluc, Louis, *Photogénie*. Paris: Maurice de Brunoff, 1920.

Dubrovskii, A., 'Atel'e i natura', *Sovetskii ekran* no. 4 (1925): 4–5.

Dubrovskii-Eshke, Boris, 'Voprosy dekoratsionnoi tekhniki', *Iskusstvo kino* 6 (1937): 60–4.

Egorov, Vladimir, 'Khudozhnik stseny teatra i khudozhnik kadra kino'. 1952, unpublished. RGALI f. 2710, op. 1, ed. khr. 59.

Egorov, Vladimir, 'Razlichie mezhdu khudozhnikom kino i khudozhnikom teatra', *Iskusstvo kino* 2 (1964): 36–8.

Egorov, Vladimir, 'Khudozhnik oformleniia teatral'noi stseny i khudozhnik kino kartin ... kakaia raznitsa?' [unpublished]. RGALI f. 2710, op. 1, ed. khr. 59, 1–45.

Eisenstein [Eizenshtein], Sergei, *Nonindifferent Nature*, 1948, translated by Herbert Marshall. Cambridge: Cambridge University Press, 1987.

Gardin, Vladimir, *Vospominaniia*, vol. 1. Moscow: Goskinoizdat, 1952.

Gazdenko, K., 'Sovetskii byt na sovetskom ekrane', *Kinofront* no. 1 (1927): 9.

Genri, 'Kartonnyi domik (na fabrike "Mezhrabpom-rus'")', *Sovetskii ekran* no. 8 (1928): 56.

Irkinin, 'Arkhitektura i dekoratsii', *Sovetskii ekran* no. 5 (1925): 32.

Iutkevich, Sergei, 'Dekoriruem svetom', *Sovetskii ekran* no. 29 (1925): 43.

Iutkevich, Sergei, 'Plat´e kartiny', *Sovetskii ekran* no. 39 (1925): 7.

Iutkevich, Sergei, 'Rezhisser i khudozhnik v kino', *Iskusstvo kino* 7 (1939): 14–21.

Iutkevich, Sergei, *Chelovek na ekrane: Chetyre besedy o kinoiskusstve: Dnevnik rezhissera*. Moscow: Goskinoizdat, 1947.

Kaplunovskii, Vladimir, 'Khudozhnik v kino', *Iskusstvo kino* 1 (1936): 38–9.

Kaufman, N., 'Veshch´', *Sovetskii ekran* no. 15 (1928): 10.

Kedrov, G., 'Put´ dekoratsii', *Sovetskii ekran* no. 29 (1929): 5.

Khanzhonkov, Aleksandr, *Pervye gody russkoi kinematografii*. 1937. Reprinted. Moscow: Liteo, 2016.

Kolin, Nikolai and Kozlovskii, Sergei, *Khudozhnik-arkhitektor v kino*. 1930. Reprinted in *Kinovedcheskie zapiski* 99 (2009): 378–422.

Kolomarov, V., 'Veshch´ v kino', *Kino i kul´tura* 9–10 (1929): 29–37.

Kolupaev, Dmitrii, 'O dekoratsiiakh', *Kino-zhurnal ARK* 2 (1925): 34.

Kolupaev, Dmitrii, 'Khudozhnik v kino-proizvodstve', *Kino-zhurnal ARK* 2 (1926): 18.

Kozintsev, Grigorii, 'Glubokii ekran', 1971, in *Sobranie sochinenii v piati tomakh*, vol. 1, 17–292. Leningrad: Iskusstvo, 1982.

Kozlovskii, Sergei, 'Prava i obiazannosti kino-khudozhnika', *Kino-zhurnal ARK* 11–12 (1925): 16–17.

Kozlovskii, Sergei, 'Tekhnika kinoatel´e', *Kino i kul´tura* no. 5 (1925): 57–9.

Kozlovskii, Sergei, 'Tridtsat´ let raboty khudozhnikom v sovetskoi kinematografii'. 1949, unpublished. RGALI f. 2394, op. 1, ed. khr. 69.

Kozlovskii, Sergei, 'Vchera i segodnia', *Ogonek* 50 (1949): 30–1.

Kozlovskii, Sergei, 'Smysl moei zhizni' [date unknown], *Iz istorii kino* 7, 63–90. Moscow: Iskusstvo, 1968.

Kuleshov, Lev, 'O zadachakh khudozhnika v kinematografe', *Vestnik kinematografii* 126 (1917): 15–16.

Kuleshov, Lev, 'Zadachi khudozhnika v kinematografe', *Vestnik kinematografii* 127 (1917): 37–8.

Kuleshov, Lev, *The Art of Cinema*, 1929, in *Kuleshov on Film: Writings*, edited and translated by Ronald Levaco, 68–77. Berkeley, CA and London: University of California Press, 1974.

Kuleshov, Lev, *Selected Works: Fifty Years in Films*, translated by Dmitri Agrachev and Nina Belenkaya. Moscow: Raduga Publishers, 1987.

Kuleshov, Lev, 'Evgenii Frantsevich Bauer', in *Sobranie sochinenii v trekh tomakh*, vol. 2, 403–9. Moscow: Iskusstvo, 1988.

Kuleshov, Lev, 'Khudozhnik v kino', 1920, in *Sobranie sochinenii v trekh tomakh*, vol. 1, 59–60. Moscow: Iskusstvo, 1988.

Kuleshov, Lev, *Znamia kino*, 1920, in *Sobranie sochinenii v trekh tomakh*, vol. 1, 63–87. Moscow: Iskusstvo, 1988.

Le Corbusier [Charles-Édouard Jeanneret], *The Decorative Art of Today*, 1925, translated and introduced by James I. Dunnett. London: Architectural Press, 1987.

Lesnaia, K., 'Khudozhnik v kino', *Sovetskii ekran* no. 38 (1929): 9.

Levin, Mikhail, 'Khudozhnik v kinoatel´e', *Sovetskoe kino* no. 11 (1935): 44–9.

Levitskii, Aleksandr, *Rasskazy o kinematografe*. Moscow: Iskusstvo, 1964.

Lukhmanov, Nikolai, 'Zhizn´ kak ona dolzhna byt´', *Sovetskii ekran* no. 15 (1928): 6.

Lukhmanov, Nikolai, 'Zhizn´ kak ona dolzhna byt´', *Kino i kul´tura* no. 1 (1929): 29–37.

Makhlis, Isaak, 'Rol´ khudozhnika v kino', *Kino-zhurnal ARK* 11–12 (1925): 15–16.

Malevich, Kazimir, 'Khudozhnik i kino', *Kino-zhurnal ARK* 2 (1926): 31–3.

Mallet-Stevens, Robert, *Le Décor moderne au cinema*. Paris: Charles Massin, 1928.

Meierkhol´d, Vsevolod, 'Portret Doriana Greia' [date unknown], *Iz istorii kino* 6, 15–23. Moscow: Iskusstvo, 1965.

Meierkhol´d, Vsevolod, 'Balagan', 1912, in *V. Meierkhol´d. Stat´i. Pis´ma. Rechi. Besedy*, edited by Aleksandr V. Fevral´skii and B. I. Rostotskii, vol. 1, 207–29. Moscow: Iskusstvo, 1968.

Mikhailov, V., 'Vnimanie kinoekspeditsiiam', *Sovetskii ekran* no. 23 (1929): 1–2.

Mikhin, Boris, 'Khudozhnik-chudesnik', *Iskusstvo kino* 8 (1961): 119–26.

Mikhin, Boris, 'Rozhdenie fundusa' [date unknown], *Iz istorii kino* 9, 148–54. Moscow: Iskusstvo, 1965.

Mur, Leo, 'Aktivnaia i passivnaia fotogeniia', *Kino-zhurnal ARK* 6 (1925): 4–8.

Mur, Leo, 'Fotogeniia', *Kino-zhurnal ARK* 5–6 (1925): 6–7.

Mur, Leo, 'S´´emki na nature i v atel´e', *Kino-front* 2 (1926): 2–7.

Mussinak, Leon [Moussinac, Léon], 'Proizvodstvo: Dekoratsiia i kostium v kino', *Kino-front* 1 (1928): 6–7.

Pertsov, Viktor, 'Direktsii Moskovskoi ob´´edinennoi fabriki Sovkino'. 1927. Gosfil´mofond Rossii. 1.2.1.86.

Pudovkin, Vsevolod, 'O khudozhnike v kino', *Kino-gazeta* no. 10 (1925): 2.

Razumnyi, Aleksandr, *U istokov: Vospominaniia kinorezhissera*. Moscow: Iskusstvo, 1975.

Rodchenko, Aleksandr, 'Khudozhnik i material´naia sreda v igrovoi fil´me', *Sovetskoe kino* 5–6 (1927): 14–15.

Rodchenko, Aleksandr, 'M-R. 80x100. S-Zh' [1927], in 'Nezamechennaia stat´ia Aleksandra Rodchenko'. Reprinted with notes V. V. Zabrodin, *Kinovedcheskie zapiski* 32 (1996/7): 18–24 (19).

Room, Abram, 'Kino i teatr', *Sovetskii ekran* no. 8 (1925): 56–7.

Sabinskii, Cheslav [Sabiński, Czesław], 'Iz zapisok starogo kinomastera', *Iskusstvo kino* 5 (1936): 60–3.

Shklovskii, Viktor, 'Sherst'', steklo i kruzheva', *Kino* no. 32 (1927): 2.

Shklovskii, Viktor, 'Iskusstvo kak priem', 1917, in *Russian Formalist Criticism: Four Essays*, edited and translated by Lee T. Lemon and Marion J. Reis, 3–24. Lincoln: University of Nebraska Press, 1965.

Shklovskii, Viktor, 'Pogranichnaia liniia', 1927, in *Za 60 let. Raboty o kino*, 110–13. Moscow: Iskusstvo, 1985.

Shklovskii, Viktor, *Knight's Move*, 1923, translated and introduced by Richard Sheldon. London: Dalkey Archive Press, 2005.

Shklovskii, Viktor, 'Zhurnalistka', 1926, unpublished. Gosfil'mofond Rossii. 1.2.1.86.

Shpinel', Iosif, 'Tvorcheskoe edinstvo', in *Dovzhenko v vospominaniiakh sovremennikov*, edited by Iu. I. Solntseva and L. I. Pazhitnova, 76–9. Moscow: Iskusstvo, 1982.

Stepanova, Varvara, *Chelovek ne mozhet zhit' bez chuda*. Moscow: Sfera, 1994.

Suvorov, Nikolai, *Nikolai Georgievich Suvorov*. Moscow: Khudozhnik RSFSR, 1968.

Suvorov, Nikolai, 'Dva interv'iu Nikolaia Suvorova'. 19 March 1969. Reprinted in *Kinovedcheskie zapiski* 99 (2009): 323–5.

Suvorov, Nikolai, 'Khudozhnik v kino'. 1938. Reprinted in *Kinovedcheskie zapiski* 99 (2009): 301–3.

Tarabukin, Nikolai, *Ot tol'berta k mashine*. Moscow: Rabotnik prosveshcheniia, 1923.

Tarich, Iurii, 'Na s''emke derevenskoi fil'my (Kino-ekspeditsiia v podmoskovskuiu dereviiu)', *Kino-zhurnal ARK* 8 (1925): 3.

Tisse, Eduard, 'Na s''emkakh 'General'noi', *Sovetskii ekran* no. 8 (1929): 13.

Tret'iakov, Sergei, 'Na kolkhozy!', *Novyi LEF* 11 (1928): 9.

Tret'iakov, Sergei, 'Prodolzhenie sleduet', *Novyi LEF* 12 (1928): 1–4.

Urazov, I., 'Ekonomiia sredstv, no ne ekonomiia vydumki', *Sovetskii ekran* nos 17–18 (1926): 3.

Veisenberg, E., 'V lepnoi masterskoi leningradskoi kinofabriki', *Kino i kul'tura* no. 3 (1929): 24–7.

Voinov, V., 'Arkhitektura v kino', *Kino i kul'tura* no. 3 (1929): 22–3.

Secondary sources

Abel, Richard, 'Pathé's Stake in Early Russian Cinema', *Griffithiania* 38–39 (1990): 243–7.

Affron, Charles and Affron, Mirella J., *Sets in Motion: Art Direction and Film Narrative*. New Brunswick, NJ: Rutgers University Press, 1995.

Albera, François, *Albatros: Des russes à Paris*. Milan: Mazzotta, 1995.

Albrecht, Donald, *Designing Dreams: Modern Architecture in the Movies*. Santa Monica, CA: Hennessy and Ingalls, 1987.

Arlazorov, Mikhail, *Protazanov*. Moscow: Iskusstvo, 1973.

Arnheim, Rudolf, *Film as Art*. Berkeley, CA: University of California Press, 1957.

Attwood, Lynne, *Gender and Housing in Soviet Russia: Private Life in a Public Space*. Manchester: Manchester University Press, 2010.

Bagrov, Peter [Petr], 'Osnovnye tendentsii leningradskogo kinoavangarda 1920-kh gg.'. PhD diss., Nauchno-issledovatel´skii institut kinoiskusstva, Moscow, 2011.

Baker, Rosemari, 'Shklovsky in the Cinema, 1926–1932'. MA diss., University of Durham, Durham, 2010.

Banerjee, Anindita, *We Modern People: Science Fiction and the Making of Russian Modernity*. Middletown, CT: Wesleyan University Press, 2013.

Banerjee, Anindita (ed.), *Russian Science Fiction Literature and Cinema: A Critical Reader*. Boston, CT: Academic Studies Press, 2018.

Barris, Roann, '"Inga": A Constructivist Enigma', *Journal of Design History* 6, no. 4 (1993): 263–81.

Barris, Roann, 'The Constructivist Engaged Spectator: A Politics of Reception', *Design Issues* 15, no. 1 (1999): 31–48.

Barris, Roann, 'The Life of the Constructivist Theatrical Object', *Theatre Journal* 65, no. 1 (2003): 57–76.

Barsacq, Léon, *Caligari's Cabinet and Other Grand Illusions: A History of Film Design*, translated by Michael Bullock. Boston, MA: New York Graphic Society, 1976.

Bassekhes, Al´fred, *Khudozhniki na stsene MKhAT*. Moscow: Vserossiiskoe teatral´noe obshchestvo, 1960.

Bazin, André, *What Is Cinema?*, edited and translated by Hugh Gray. Berkeley, CA: University of California Press, 2005.

Bergfelder, Tim, Harris, Sue, and Street, Sarah, *Film Architecture and the Transnational Imagination: Set Design in 1930s European Cinema*. Amsterdam: Amsterdam University Press, 2007.

Beumers, Birgit (ed.), *A Companion to Russian Cinema*. London: Wiley-Blackwell, 2016.

Bird, Robert, 'The Poetics of Peat in Soviet Literary and Visual Culture, 1918–1959', *Slavic Review* 70, no. 3 (2011): 591–614.

Bird, Robert, 'How to Keep Communism Aloft: Labor, Energy, and the Model Cosmos in Soviet Cinema', *e-flux* 88 (February 2018), https://www.e-flux.com/journal/88/172568/how-to-keep-communism-aloft-labor-energy-and-the-model-cosmos-in-soviet-cinema/ (accessed 5 February 2019).

Blakesley, Rosalind P. and Samu, Margaret (eds), *From Realism to the Silver Age: New Studies in Russian Artistic Culture*. DeKalb, IL: NIU Press, 2014.

Bois, Yve-Alain, 'El Lissitzky: Radical Reversibility', *Art in America* (April 1988): 161–80.

Bonnell, Victoria, *The Russian Worker: Life and Labor under the Tsarist Regime*. Berkeley, CA: University of California Press, 1983.
Bonnell, Victoria, 'The Iconography of the Worker in Soviet Political Art', in *Making Workers Soviet: Power, Class and Identity*, edited by Lewis H. Siegelbaum and Ronald Grigor Suny, 341–75. Ithaca, NY and London: Cornell University Press, 1994.
Bordwell, David, *The Cinema of Eisenstein*. London: Routledge, 2016.
Bowlt, John E., *Russian Art, 1875–1975: A Collection of Essays*. New York: MSS Information Corp., 1976.
Bowlt, John E., 'Constructivism and Russian Stage Design', *Performing Arts Journal* 1, no. 3 (1977): 62–84.
Bowlt, John E., *The Silver Age: Russian Art of the Early Twentieth Century and the 'World of Art' Group*. Newtonville, MA: Oriental Research Partners, 1979.
Bowlt, John E., 'The Theatre of the Russian Avant-Garde', *Studies in Theatre and Performance* 36 (2016): 209–18.
Bowlt, John E. and Matich, Olga (eds), *Laboratory of Dreams: The Russian Avant-Garde and Cultural Experiment*. Stanford, CA: Stanford University Press, 1996.
Boym, Svetlana, *Common Places: Mythologies of Everyday Life in Russia*. Cambridge, MA and London: Harvard University Press, 1994.
Brewster, Ben and Jacobs, Lea, *Theatre to Cinema: Stage Pictorialism and the Early Feature Film*. Oxford: Oxford University Press, 1997.
Brooks, Jeffrey, 'Public and Private Values in the Soviet Press, 1921–1928', *Slavic Review* 48, no. 1 (1989): 16–35.
Brooks, Jeffrey, 'Russian Cinema and Public Discourse, 1900–1930', *Historical Journal of Film, Radio and Television* 11, no. 2 (1991): 141–8.
Brooks, Jeffrey, 'The Gothic Tradition in Russian and Early Soviet Culture', *Russian Literature* 106 (2019): 11–32.
Brown, Bill, 'Thing Theory', *Critical Inquiry* 28, no. 1 (Autumn 2001): 1–22.
Bruno, Giuliana, *Atlas of Emotion: Journeys in Art, Architecture, and Film*. New York: Verso, 2002.
Buchli, Victor, *An Archaeology of Socialism*. London: Bloomsbury Academic, 1999.
Buchloh, Benjamin, 'From Faktura to Factography', *October* 30 (1984): 83–119.
Bulgakowa [Bulgakova], Oksana, '*Novyi LEF* i kinoveshch*''*', *Russian Literature* 103–5 (2019): 61–94.
Burenina-Petrova, Ol´ga, *Tsirk v prostranstve kul´tury*. Moscow: Novoe literaturnoe obozrenie, 2015.
Carrick, Edward, *Designing for Moving Pictures*. London: Studio Publications, 1941.
Carroll, Noël, *Engaging the Moving Image*. New Haven, CT: Yale University Press, 2003.
Cassiday, Julie, *The Enemy on Trial: Early Soviet Courts on Stage and in the Cinema*. DeKalb, IL: Northern Illinois University Press, 2000.

Cavendish, Philip, 'The Hand That Turns the Handle: Camera Operators and the Poetics of the Camera in Pre-Revolutionary Russian Film', *Slavonic and East European Review* 82, no. 2 (2004): 201–45.

Cavendish, Philip, *Soviet Mainstream Cinematography: The Silent Era*. London: UCL Arts & Humanities Publications, 2007.

Cavendish, Philip, *The Men with the Movie Camera: The Poetics of Visual Style in Avant-Garde Cinema of the 1920s*. London: Berghahn Books, 2013.

Cavendish, Philip, 'From "Lost" to "Found": The "Rediscovery" of Sergei Eisenstein's *Glumov's Diary* and Its Avant-Garde Context', *KinoKultura* 41 (2013), http://www.kinokultura.com/2013/41cavendish.shtml (accessed 15 September 2019).

Chadaga, Julia Bekman, *Optical Play: Glass, Vision and Spectacle in Russian Culture*. Evanston, IL: Northwestern University Press, 2014.

Chefranova, Oksana, 'From Garden to Kino: Evgenii Bauer, Cinema, and the Visuality of Moscow Amusement Culture, 1885–1917'. PhD diss., New York University, New York, 2014.

Cherchi Usai, Paolo, Codelli, Lorenzo, Montanaro, Carlo and Robinson, David (eds), *Silent Witnesses: Russian Films 1908–1919*, research and co-ordination by Yuri Tsivian. London: BFI Publishing, 1989.

Christie, Ian, 'Down to Earth: *Aelita* Relocated', in *Inside the Film Factory: New Approaches to Russian and Soviet Cinema*, edited by Richard Taylor and Ian Christie, 81–102. London: Routledge, 1991.

Clark, Katerina, *The Soviet Novel: History as Ritual*. Chicago, IL and London: University of Chicago Press, 1981.

Clayton, Douglas, *Pierrot in Petrograd: The Commedia dell'Arte/Balagan in Twentieth-Century Russian Theatre and Drama*. Montreal: Mc-Gill-Queen's University Press, 2014.

Cooke, Catherine, *Russian Avant-Garde: Theories of Art, Architecture and the City*. London: Academy Editions 1995.

Cooke, Catherine, 'Beauty as a Route to "the Radiant Future": Responses of Soviet Architecture', *Journal of Design History* 10 (1997): 137–60.

Crowley, David and Reid, Susan E. (eds), *Pleasures in Socialism: Leisure and Luxury in the Eastern Bloc*. Evanston, IL: Northwestern University Press, 2010.

Cvetkovski, Roland and Hofmeiter, Alexis (eds), *An Empire of Others: Creating Ethnographic Knowledge in Imperial Russia and the USSR*. Budapest and New York: Central European University Press, 2014.

DeBlasio, Alyssa, 'Choreographing Space, Time, and "Dikovinki" in the Films of Evgenii Bauer', *Russian Review* 66, no. 4 (2007): 671–92.

de la Roche, Catherine, 'Scenic Design in the Soviet Cinema', *The Penguin Film Review* 3 (1947): 76–81.

Dickinson, Thorold and de la Roche, Catherine, *Soviet Cinem*. London: Falcon Press, London, 1948.

Elliott, David (ed.), *Photography in Russia 1840–1940*. London: Thames and Hudson, 1992.

Elsaesser, Thomas (ed.), with Adam Barker, *Early Cinema: Space, Frame, Narrative*. London: BFI Publishing, 1990.

Engel, Barbara, *Between the Fields and the City: Women, Work, and Family in Russia, 1861–1914*. Cambridge: Cambridge University Press, 1996.

Engel, Barbara, *Women in Russia, 1700–2000*. Cambridge: Cambridge University Press, 2004.

Engel, Barbara, *Breaking the Ties That Bound: The Politics of Marital Strife in Late Imperial Russia*. Ithaca, NY and London: Cornell University Press, 2011.

Felleman, Susan, *Art in the Cinematic Imagination*. Austin, TX: University of Texas Press, 2006.

Fischer, Lucy, *Designing Women: Cinema, Art Deco and the Female Form*. New York: Columbia University Press, 2003.

Fischer, Lucy, 'Invisible by Design: Reclaiming Art Nouveau for the Cinema', *Film History* 25, no. 1–2 (2013): 55–69.

Fischer, Lucy (ed.), *Art Direction & Production Design*. New Brunswick, NJ: Rutgers University Press, 2015.

Fischer, Lucy, *Cinema by Design: Art Nouveau, Modernism, and Film History*. New York: Columbia University Press, 2017.

Fitzpatrick, Sheila, *Everyday Stalinism: Ordinary Life in Extraordinary Times: Soviet Russia in the 1930s*. New York and Oxford: Oxford University Press, 1999.

Fitzpatrick, Sheila, Rabinowitch, Alexander and Stites, Richard (eds), *Russia in the Era of NEP: Explorations in Soviet Society and Culture*. Bloomington, IN: Indiana University Press, 1991.

Fowler, Catherine and Helfield, Gilian (eds), *Representing the Rural: Space, Place and Identity in Films about the Land*. Detroit, MI: Wayne State University Press, 2006.

Franklin, Simon and Widdis, Emma (eds), *National Identity in Russian Culture*. Cambridge: Cambridge University Press, 2004.

Gauss, Rachel, *Lear's Daughters: The Studios of the Moscow Art Theatre 1902–1927*. Canterbury and New York: Peter Lang, 1999.

Gérin, Annie, *Devastation and Laughter: Satire, Power, and Culture in the Early Soviet State, 1920s–1930s*. London and Toronto: University of Toronto Press, 2018.

Gillespie, David, *Early Soviet Cinema: Innovation, Ideology and Propaganda*. London: Wallflower, 2000.

Ginzburg, Semen, *Kinematografiia dorevolutsionnoi Rossii*. 1963. Reprinted Moscow: Agraf, 2007.

Goodwin, James, *Eisenstein, Cinema, and History*. Urbana, IL: University of Illinois Press, 1993.

Gough, Maria, '*Faktura*: The Making of the Russian Avant-Garde', *RES: Anthropology and Aesthetics* 36 (1999): 32–59.

Gough, Maria, 'Tarabukin, Spengler, and the Art of Production', *October* 93 (2000): 78–108.

Gough, Maria, *The Artist as Producer: Russian Constructivism in Revolution*. Berkeley, CA: University of California Press, 2005.
Graffy, Julian, *Gogol's The Overcoat*. London: Bristol Classical Press, 2000.
Graffy, Julian, *Bed and Sofa: The Film Companion*. London and New York: Tauris, 2001.
Gray, Camilla, *The Great Experiment: Russian Art, 1863–1922*. London: Thames and Hudson, 1962.
Gray [Blakesley], Rosalind P., *Russian Genre Painting in the Nineteenth Century*. Oxford: Clarendon Press, 2000.
Grieveson, Lee and Krämer, Peter (eds), *The Silent Cinema Reader*. London and New York: Routledge, 2004.
Gromov, Evgenii, *Khudozhnik kino: Vladimir Egorov*. Moscow: Biuro propagandy sovetskogo kinoiskusstva, 1973.
Gromov, Evgenii, *Lev Vladimirovich Kuleshov*. Moscow: Iskusstvo, 1984.
Guerin, Francis, *A Culture of Light: Cinema and Technology in 1920s Germany*. Chicago, IL: University of Chicago Press, 2007.
Hadley, Olga, *Mamontov's Private Opera: The Search for Modernism in Russian Theater*. Bloomington, IN: Indiana University Press, 2010.
Hake, Sabine, *Popular Cinema of the Third Reich*. Austin, TX: University of Texas Press, 2001.
Hansen, Miriam, *Cinema and Experience: Siegfried Kracauer, Walter Benjamin and Theodor W. Adorno*. Berkeley, CA: University of California Press, 2012.
Harte, Tim, *Fast Forward: The Aesthetics and Ideology of Speed in Russian Avant-Garde Culture, 1910–1930*. Madison, WI: University of Wisconsin Press, 2009.
Harvey, Penny and Knox, Hannah, 'The Enchantments of Infrastructure', *Mobilities* 7, no. 4 (2012): 521–36.
Hilton, Alison, *Russian Folk Art*. Bloomington, IN: Indiana University Press, 1995.
Hilton, Alison, 'Folk Art and Social Ritual', in *Picturing Russia: Explorations in Visual Culture*, edited by Valerie A. Kivelson and Joan Neuberger, 96–100. London and New Haven, CT: Yale University Press, 2008.
Hilton, Marjorie L., *Selling to the Masses: Retailing in Russia, 1880–1930*. Pittsburgh, PA: University of Pittsburgh Press, 2012.
Hirsch, Francine, *Empire of Nations: Ethnographic Knowledge and the Making of the Soviet Union*. Ithaca, NY and London: Cornell University Press, 2005.
Horton, Andrew, *Inside Soviet Film Satire: Laughter with a Lash*. Cambridge: Cambridge University Press, 1993.
Howard, Jeremy, *The Union of Youth: An Artists' Society of the Russian Avant-Garde*. Manchester and New York: Manchester University Press, 1992.
Hudson, John, 'Workplaces in the Cinema', *Facilities* 27 (2009): 34–43.
Iampol´skii, Mikhail, 'Razbityi pamiatnik', *Kinovedcheskie zapiski* 1 (1988): 6–11.
Iampolski [Iampol´skii], Mikhail, 'Kuleshov's Experiments and the New Anthropology of the Actor', in *Silent Film*, edited by Richard Abel, 45–67. London: Athlone, 1996.

Iampolski [Iampol´skii], Mikhail, 'Russia: The Cinema of Anti-modernity and Backward Progress', in *Theorising National Cinema*, edited by Valentina Vitali and Paul Willemen, 72–87. London: BFI Publishing, 2006.

Innes, Christopher, *Edward Gordon Craig: A Vision of Theatre*. London and New York: Routledge, 1998.

Ivanova, V., Myl´nikova, V., Skovorodnikova, S., Tsiv´ian, Iu. and Iangirov, R. (eds), *Velikii kinemo: Katalog sokhranivshikhsia igrovykh fil´mov Rossii 1908–1919*. Moscow: Novoe literaturnoe obozrenie, 2002.

Jacobs, Steven, *Framing Pictures: Film and the Visual Arts*. Edinburgh: Edinburgh University Press, 2011.

Jacobson, Brian R., *In the Studio: Visual Creation and Its Material Environments*. Berkeley, CA: University of California Press, 2020.

Kaganovsky, Lilya, 'The Voice of Technology and the End of Soviet Silent Film: Grigorii Kozintsev and Leonid Trauberg's *Alone*', *Studies in Russian and Soviet Cinema* 1, no. 3 (2007): 265–81.

Kaganovsky, Lilya and Salazkina, Masha (eds), *Sound, Speech, Music in Soviet and Post-Soviet Cinema*. Bloomington, IN: Indiana University Press, 2014.

Kelly, Catriona, *Refining Russia: Advice Literature, Polite Culture & Gender from Catherine to Yeltsin*. Oxford: Oxford University Press, 2001.

Kelly, Catriona and Shepherd, David (eds), *Constructing Russian Culture in the Age of Revolution, 1881–1940*. New York and Oxford: Oxford University Press, 1998.

Kenez, Peter, *Cinema and Soviet Society: From the Revolution to the Death of Stalin*. London and New York: I.B. Tauris, 2001.

Kettering, Karen, '"Ever More Cosy and Comfortable": Stalinism and the Soviet Domestic Interior, 1928–1938', *Journal of Design History* 10, no. 2 (1997): 119–35.

Khan-Magomedov, Selim O., *Rodchenko: The Complete Work*. London: Thames and Hudson, 1986.

Khan-Magomedov, Selim O., *Vkhutemas: Vysshie gosudarstvennye khudozhestvenno-tekhnicheskie masterskie, 1920–1930*, 2 vols. Moscow: Izdatel´stvo Lad´ia, 1995.

Khan-Magomedov, Selim O., *Andrei Burov*. Moscow: Fond 'Russkii avangard', 2009.

Kiaer, Christina, 'Boris Arvatov's Socialist Objects', *October* 81 (1997): 105–18.

Kiaer, Christina, *Imagine No Possessions: The Socialist Objects of Russian Constructivism*. Cambridge, MA: MIT Press, 2005.

Kiaer, Christina and Naiman, Eric (eds), *Everyday Life in Early Soviet Russia: Taking the Revolution Inside*. Bloomington, IN: Indiana University Press, 2006.

Kivelson, Valerie A. and Neuberger, Joan (eds), *Picturing Russia: Explorations in Visual Culture*. London and New Haven, CT: Yale University Press, 2008.

Kovalova, Anna, 'World War I and Pre-Revolutionary Russian Cinema', *Studies in Russian and Soviet Cinema* 11, no. 2 (2017): 92–117.

Kovalova, Anna, 'The Picture of Dorian Gray painted by Meyerhold', Studies in Russian and Soviet Cinema 13, no. 1 (2019): 59–90.
Kreimeier, Klaus and Ligensa, Annemone (eds), Film 1900: Technology, Perception, Culture. Bloomington, IN: Indiana University Press, 2015.
Kuman′kov, Evgenii, Vladimir Evgen′evich Egorov. Moscow: Sovetskii khudozhnik, 1965.
Kuznetsova, Valentina, Evgenii Enei. Leningrad and Moscow: Iskusstvo, 1966.
Kuznetsova, Valentina, 'Aleksandr Benua i leningradskaia shkola khudozhnikov kino', in Vek peterburgskogo kino: Sbornik nauchnykh trudov, edited by Aleksandr L. Kazin, 132–51. Saint Petersburg: Rossiiskii institut istorii iskusstv, 2007.
Lamster, Mark (ed.), Architecture and Film. New York: Princeton Architectural Press, 2000.
Lant, Antonia, 'Haptical Cinema', October 74 (1995): 45–73.
Lavrent′ev, Aleksandr, 'Experimental Furniture Design in the 1920s', The Journal of Decorative and Propaganda Arts 11, no. 2 (1989): 142–67.
Lavrent′ev, Aleksandr, Aleksandr Rodchenko. Moscow: Arkhitektura-S, 2007.
Leach, Robert, 'Eisenstein's Theatre Work', in Eisenstein Rediscovered, edited by Ian Christie and Richard Taylor, 105–19. London and New York: Routledge, 1993.
Leyda, Jay, Kino: A History of the Russian and Soviet Film. New Jersey, NJ: Princeton University Press, 1960.
LoBrutto, Vincent, The Filmmaker's Guide to Production Design. London: Faber and Faber, 2006.
Lodder, Christina, Constructive Strands in Russian Art 1914–1937. London: Pindar Press, 2005.
Macheret, Aleksandr (ed.), Sovetskie khudozhestvennye fil′my: Annotirovannyi katalog, vol. 1, Nemye fil′my, 1918–1935. Moscow: Iskusstvo, 1961.
Margolin, Victor, The Struggle for Utopia: Rodchenko, Lissitzky, Moholy-Nagy, 1917–1946. Chicago, IL: University of Chicago Press, 1997.
McCann, Ben, '"A Discreet Character?" Action Spaces and Architectural Specificity in French Poetic Realist Cinema', Screen 45 (2004): 375–82.
McCann, Ben, Ripping Open the Set: French Film Design, 1930–1939. Bern: Peter Lang, 2013.
McDonald, Tracy, Face to the Village: The Riazan Countryside under Soviet Rule, 1921–1930. London and Toronto: University of Toronto Press, 2011.
McManus, Donald, No Kidding: Clown as Protagonist in Twentieth-Century Theater. Newark, DE: University of Delaware Press, 2003.
McReynolds, Louise, 'Home Was Never Where the Heart Was: Domestic Dystopias in Russia's Silent Movie Melodramas', in Imitations of Life: Two Centuries of Melodrama in Russia, edited by Louise McReynolds and Joan Neuberger, 127–51. Durham, NC: Duke University Press, 2002.
McReynolds, Louise, Russia at Play: Leisure Activities at the End of the Tsarist Era. Ithaca, NY: Cornell University Press, 2003.

McReynolds, Louise, 'Demanding Men, Desiring Women and Social Collapse in the Films of Evgenii Bauer, 1913–17', *Studies in Russian and Soviet Cinema* 3, no. 2 (2009): 145–56.

Miasnikov, Gennadii I., *Ocherki istorii russkogo i sovetskogo kinodekoratsionnogo iskusstva, 1908–1917*. Moscow: VGIK, 1973.

Miasnikov, Gennadii I., *Ocherki istorii sovetskogo kinodekoratsionnogo iskusstva, 1918–1930*. Moscow: VGIK, 1975.

Miasnikov, Gennadii I., *Ocherki istorii sovetskogo kinodekoratsionnogo iskusstva, 1931–1945*. Moscow: VGIK, 1979.

Miasnikova, Liudmila, 'Vladimir Egorov: uchenyi risoval´shchik, stavshii "kinoshnikom"', *Dekorativnoe iskusstvo i predmetno-prostranstvennaia sreda*, *Vestnik MGKhPA* (April 2015): 316–36.

Mikhailova, Alla A., *Meierkhol´d i khudozhniki*. Moscow: Bakrushin State Theatre Museum, 1995.

Miller, Jamie, *Soviet Cinema: Politics and Persuasion under Stalin*. London and New York: I.B. Tauris, 2010.

Miller, Jamie, 'Soviet Politics and Mezhrabpom Studios in the Soviet Union during the 1920s and 1930s', *Historical Journal of Film, Radio and Television* 32 (2012): 521–35.

Milner, John, *Vladimir Tatlin and the Russian Avant-Garde*. New Haven, CN: Yale University Press, 1983.

Milner, John, *Rodchenko: Design*. London: Antique Collectors' Club, 2009.

Morley, Rachel, 'Gender Relations in the Films of Evgenii Bauer', *Slavonic and East European Review* 81, no. 1 (2003): 32–69.

Morley, Rachel, '"Crime without Punishment": Reworkings of Nineteenth-Century Russian Literary Sources in Evgenii Bauer's *Child of the Big City*', in *Russian and Soviet Film Adaptations of Literature, 1900–2001: Screening the Word*, edited by Stephen Hutchings and Anat Vernitski, 27–43. London and New York: RoutledgeCurzon, 2005.

Morley, Rachel, 'Zhizn´ za zhizn´/ A Life for a Life', in *The Cinema of Russia and the Former Soviet Union*, edited by Birgit Beumers, 13–22. London and New York: Wallflower Press, 2007.

Morley, Rachel, 'Performing Femininity in an Age of Change: Evgenii Bauer, Ivan Turgenev, and the Legend of Evlaliia Kadmina', in *Turgenev: Art, Ideology, Legacy*, edited by Robert Reid and Joe Andrew, 269–316. Amsterdam and New York: Rodopi, 2010.

Morley, Rachel, *Performing Femininity: Woman as Performer in Early Russian Cinema*. London: I.B. Tauris, 2017.

Morrissey, Susan K., *Suicide and the Body Politic in Imperial Russia*. Cambridge: Cambridge University Press, 2009.

Neirich, Miriam, *When Pigs Could Fly and Bears Could Dance: A History of the Soviet Circus*. Madison, WI: University of Wisconsin Press, 2012.

Nekhoroshev, Iurii I., *Dekorator Khudozhestvennogo teatra Viktor Andreevich Simov*. Moscow: Sovetskii khudozhnik, 1984.

Nesbet, Anne, *Savage Junctures: Sergei Eisenstein and the Shape of Thinking*. London and New York: I.B. Tauris, 2007.

Nesbet, Anne, 'Émile Zola, Kozintsev and Trauberg, and Film as Department Store', *The Russian Review* 68, no. 1 (2009): 102–21.

Olsen, Robert L., *Art Direction for Film and Video*. New York: Focal Press, 1998.

Pack, Susan, *Film Posters of the Russian Avant-Garde*. London: Taschen, 1995.

Pallasmaa, Juhani, *The Architecture of the Image: Existential Space in Cinema*, translated by Michael Wynne-Ellis. Helsinki: Rakennustieto, 2001.

Paperny, Vladimir, *Architecture in the Age of Stalin: Culture Two*, translated by John Hill and Roann Barris. Cambridge: Cambridge University Press, 2002.

Parker, Rozsika, *The Subversive Stitch: Embroidery and the Making of the Feminine*. London: I.B. Tauris, 1984.

Pasholok, Maria, 'Imaginary Interiors: Representing Domestic Spaces in 1910s and 1920s Russian Film and Literature'. PhD diss., University of Oxford, 2015.

Payne, Alina, *From Ornament to Object: Genealogies of Architectural Modernism*. New Haven, CT: Yale University Press, 2012.

Petrić, Vlada, *Constructivism in Film: The Man with the Movie Camera: A Cinematic Analysis*. Cambridge: Cambridge University Press, 2012.

Peucker, Brigitte, *The Material Image: Art and the Real in Film*. Stanford, CA: Stanford University Press, 2007.

Pozharskaia, Miletsa N., *Russkoe teatral'no-dekoratsionnoe iskusstvo, kontsa XIX nachala XX veka*. Moscow: Iskusstvo, 1970.

Preston, Ward, *What an Art Director Does: An Introduction to Motion Picture Production Design*. Los Angeles, CA: Silman-James Press, 1994).

Puchner, Martin, *Poetry of the Revolution: Marx, Manifestos, and Avant-Gardes*. Princeton, NJ: Princeton University Press, 2005.

Rakitina, Elena B., *Anatolii Afanas'evich Arapov*. Moscow: Sovetskii khudozhnik, 1965.

Ramirez, Juan A., *Architecture for the Screen: A Critical Study of Set Design in Hollywood's Golden Age*. London: Jefferson N. C., 2004.

Rees, Eleanor, 'Design, Creativity and Technology: The *Khudozhnik* in Russian Cinema of the Silent Era', *Film History* 32, no. 4 (2020): 60–90.

Rees, Eleanor, 'From the Cinema "Dekorator" to the Cinema "Arkhitektor": Set Design, Medium Specificity and Technology in Russian Cinema of the Silent Era', *Journal of Design History* 34, no. 4 (December 2021): 297–315.

Rees, Eleanor, 'Comfort and the Domestic Interior in Early Soviet Cinema', in *Screen Interiors: From Country House to Cosmic Heterotopias*, edited by Pat Kirkham and Sarah Lichtman, 31–48. London: Bloomsbury Academic, 2021.

Reid, Susan, 'Communist Comfort: Socialist Modernism and the Making of Cosy Homes in the Khrushchev Era', *Gender & History* 21 (2009): 465–98.

Renfrew, Alastair, 'Facts and Life: Osip Brik in the Soviet Film Industry', *Studies in Russian and Soviet Cinema* 7, no. 2 (2013): 165–88.

Rizzo, Michael, *The Art Direction Handbook for Film*. Oxford: Focal Press, 2005.

Romberg, Kristin, *Gan's Constructivism: Aesthetic Theory for an Embedded Modernism*. Berkeley, CA: University of California Press, 2019.

Rudnitsky, Konstantin, *Russian and Soviet Theater, 1905–1932*. New York: Harry N. Abrams, 1988.

Salmond, Wendy, *Arts and Crafts in Late Imperial Russia: Reviving the Kustar Art Industries, 1870–1917*. Cambridge: Cambridge University Press, 1996.

Scholl, Tim, 'Ballet Russe: The Dying Swan', in *From Petipa to Balanchine: Classical Revival and the Modernisation of Ballet*, 37–53. London and New York: Routledge, 1994.

Schönle, Andreas, *Architecture of Oblivion: Ruins and Historical Consciousness in Modern Russia*. DeKalb, IL: Northern Illinois University Press, 2011.

Shulzhenko, Elena, *Reforming the Russian Industrial Workplace*. London and New York: Routledge, 2016.

Siegelbaum, Lewis H., *Cars for Comrades: The Life of the Soviet Automobile*. Ithaca, NY: Cornell University Press, 2008.

Sobolev, Romil, *Liudi i fil'my russkogo dorevoliutsionnogo kino*. Moscow: Iskusstvo, 1961.

Steinberg, Mark D., 'The Urban Landscape in Workers' Imagination', *Russian History* 23 (1996): 47–65.

Steinberg, Mark D., *Proletarian Imagination: Self, Modernity, and the Sacred in Russia, 1910–1925*. Ithaca, NY: Cornell University Press, 2002.

Stephens, Michael L., *Art Directors in Cinema: A Worldwide Biographical Dictionary*. London: McFarland & Co., 1998.

Stites, Richard, *Revolutionary Dreams: Utopian Vision and Experimental Life in the Russian Revolution*. New York and Oxford: Oxford University Press, 1989.

Stites, Richard, *Russian Popular Culture: Entertainment and Society since 1900*. Cambridge: Cambridge University Press, 1992.

Stites, Richard, 'Dusky Images of Tsarist Russia: Prerevolutionary Cinema', *Russian Review* 53, no. 2 (1994): 285–95.

Stoichita, Victor I., *The Self-Aware Image: An Insight into Early Modern Meta-Painting*. London: Harvey Miller Publishers, 2015.

Street, Sarah, 'Sets of the Imagination: Lazare Meerson, Set Design and Performance in *Knight Without Armour* (1937)', *Journal of British Cinema and Television* 2 (2005): 18–35.

Sutton-Mattocks, Julia, 'Cycles of Conflict and Suffering: Aleksandr Dovzhenko's *Arsenal*, and the Influence of Käthe Kollwitz and Willy Jaeckel', *Studies in Russian and Soviet Cinema* 10, no. 1 (2016): 1–32.

Tarasova-Krasina, Tat'iana, *Iosif Shpinel': Put' khudozhnika*. Moscow: Iskusstvo, 1979.

Tashiro, Charles, *Pretty Pictures: Production Design and the History of Film*. Austin, TX: University of Texas Press, 1998.
Taylor, Richard, *The Battleship Potemkin: The Film Companion*. London and New York: I.B. Tauris, 2000.
Taylor, Richard and Christie, Ian (eds), *The Film Factory: Russian and Soviet Cinema in Documents, 1896–1939*. London: Routlegde, 1988.
Taylor, Richard and Christie, Ian, *Inside the Film Factory: New Approaches to Russian and Soviet Cinema*. London: Routledge, 1991.
Titus, Joan, *The Early Film Music of Dmitry Shostakovich*. New York and Oxford: Oxford University Press, 2016.
Thompson, Kristin, 'The Ermolieff Group in Paris: Exile, Impressionism, Internationalism', *Griffithiana* 35, no. 6 (1989): 50–7.
Thompson, Kristin, 'Early Alternatives to the Hollywood Mode of Production: Implications for Europe's Avant-Gardes', in *The Silent Cinema Reader*, edited by Lee Grieveson and Peter Krämer, 349–67. London and New York: Routledge, 2004.
Tolz, Vera, *Russia: Inventing the Nation*. London: Bloomsbury Academic, 2001.
Torre, Michele L., 'Filtering Culture: Symbolism, Modernity and Gender Construction in Evgenii Bauer's Films', in *Screen Culture: History and Textuality*, edited by John Fullerton, 99–112. London: John Libbey Publishing, 2004.
Tsivian, Yuri [Tsiv′ian, Iurii], 'Portraits, Mirrors, Death: On Some Decadent Clichés in Early Russian Films', *Iris* 14–15 (1992): 67–83.
Tsivian, Yuri [Tsiv′ian, Iurii], 'Caligari in Russia: German Expressionism and Soviet Film Culture', in Thomas W. Gaehtgens, *Artistic Exchange: Akten des XXVIII. Internationalen Kongresses für Kunstgeschichte, Berlin, 15–20 July 1992*. Berlin: International Congress of the History of Art, 1993.
Tsivian, Yuri [Tsiv′ian, Iurii], *Early Cinema in Russia and its Cultural Reception*, edited by Richard Taylor, translated by Alan Bodger. London and New York: Routledge, 1994.
Tsivian, Yuri [Tsiv′ian, Iurii], 'Between the Old and the New: Soviet Film Culture in 1918–24', *Griffithiana* 55/56 (1996): 15–64.
Tsivian, Yuri [Tsiv′ian, Iurii], 'Two "Stylists" of the Teens: Franz Hofer and Yevgenii Bauer', in *A Second Life: German Cinema's First Decades*, edited by Thomas Elsaesser and Michael Wedel, 264–76. Amsterdam: Amsterdam University Press, 1996.
Tsivian, Yuri [Tsiv′ian, Iurii], 'Turning Objects, Toppled Pictures: Give and Take between Vertov's Films and Constructivist Art', *October* 121 (2007): 92–110.
Tsivian, Yuri [Tsiv′ian, Iurii], 'The Invisible Novelty: Film Adaptations in the 1910s', in *A Companion to Literature and Film*, edited by Alessandra Raengo and Robert Stam, 92–111. Malden, MA: Blackwell, 2008.
Tupitsyn, Margarita, *The Soviet Photograph, 1924–1937*. New Haven, CT: Yale University Press, 1996.

Tupitsyn, Margarita (ed.), *Aleksandr Rodchenko: The New Moscow: Photographs from the L. and G. Tatunz Collection*. Munich: Schirmer Art Books, 2000.

Tupitsyn, Margarita, *Malevich and Film*, with essays by Kazimir Malevich and Victor Tupitsyn. London and New Haven, CN: Yale University Press, 2002.

Tupitsyn, Margarita, 'The Grid as a Checkpoint of Modernity', *Tate Papers* 12 (Autumn 2009), https://www.tate.org.uk/research/publications/tate-papers/12/the-grid-as-a-checkpoint-of-modernity (accessed 3 February 2019).

Vaingurt, Julia, *Wonderlands of the Avant-Garde: Technology and the Arts in Russia of the 1920s*. Evanston, IL: Northwestern University Press, 2013.

Van Baak, Joost, *The House in Russian Literature: A Mythopoetic Exploration*. Amsterdam and New York: Rodopi, 2009.

Van den Oever, Annie (ed.), *Ostrannenie: On 'Strangeness' and the Moving Image: The History, Reception, and Relevance of a Concept*. Amsterdam: Amsterdam University Press, 2010.

Van Norman Baer, Nancy, *Theatre in Revolution: Russian Avant-Garde Stage Design 1913–1935*. London: Thames and Hudson, 1991.

Vanchu, Anthony, 'Technology as Esoteric Cosmology in Early Soviet Literature', in *The Occult in Russian and Soviet Culture*, edited by Bernice Glatzer Rosenthal, 203–24. Ithaca, NY: Cornell University Press, 1997.

Vishnevskii, Veniamin, *Khudozhestvennye fil′my dorevoliutsionnoi Rossii: Fil′mograficheskoe opisanie*. Moscow: Goskinoizdat, 1945.

Voevodin, Viktor, 'V. Egorov – Khudozhnik fil′ma V. Meierkhol′da Portret Doriana Greia', *Kinovedcheskie zapiski* 13 (1992): 214–24.

Von Geldern, James R. and McReynolds, Louise (eds), *Entertaining Tsarist Russia: Tales, Songs, Plays, Movies, Jokes, Ads and Images from Russian Urban Life 1779–1917*. Bloomington, IN: Indiana University Press, 1998.

Vul′fert, N. V. (ed.), *Sovetskie khudozhniki teatra i kino*. Moscow: Sovetskii khudozhnik, 1977.

Walker, John A., *Art and Artists on Screen*. Manchester: Manchester University Press, 1993.

Waterfeld, Giles (ed.), *The Artist's Studio*. London: Hogarth Arts, 2009.

White, Frederick H., *Degeneration, Decadence and Disease in the Russian Fin de Siècle: Neurasthenia in the Life and Work of Leonid Andreev*. Manchester: Manchester University Press, 2015.

Whitney Kean, Beverly, *French Painters, Russian Collectors: The Merchant Patrons of Modern Art in Pre-Revolutionary Russia*. London: Hodder & Stoughton, 1994.

Widdis, Emma, *Visions of a New Land: Soviet Film from the Revolution to the Second World War*. New Haven, CT: Yale University Press, 2003.

Widdis, Emma, 'Dressing the Part: Clothing Otherness in Soviet Cinema before 1953', in *Insiders and Outsiders in Russian Cinema*, edited by Stephen M. Norris and Zara M. Torlone, 48–67. Bloomington: Indiana University Press, 2008.

Widdis, Emma, 'Faktura: Depth and Surface in Early Soviet Set Design', *Studies in Russian and Soviet Cinema* 3, no. 1 (2009): 5–32.

Widdis, Emma, 'Sew Yourself Soviet: The Pleasure of Textile in the Machine Age', in *Petrified Utopia: Happiness Soviet Style*, edited by Marina Balina and Evgenii Dobrenko, 115–32. London: Anthem Press, 2011.

Widdis, Emma, 'Socialist Senses: Film and the Creation of Soviet Subjectivity', *Slavic Review* 71, no. 3 (2012): 590–618.

Widdis, Emma, 'Cinema and the Art of Being: Towards a History of Early Soviet Set Design', in *A Companion to Russian Cinema*, edited by Birgit Beumers, 314–36. London: Wiley-Blackwell, 2016.

Widdis, Emma, *Socialist Senses: Film, Feeling, and the Soviet Subject, 1917–1940*. Bloomington, IN: Indiana University Press, 2017.

Wilson, Booth, 'From Moscow Art Theatre to Mezhrabpom-Rus´: Stanislavskii and the Archaeology of the Director in Russian Silent Cinema', *Studies in Russian and Soviet Cinema* 11, no. 2 (2017): 118–33.

Witkovsky, Matthew S., Fore, Devin and Gough, Maria (eds), *Revoliutsiia! Demonstratsiia!: Soviet Art Put to the Test*. Chicago, IL: Art Institute of Chicago, 2017.

Wollen, Peter, 'Architecture and Film: Places and Non-Places', in *Paris Hollywood: Writings on Film*, 199–215. London and New York: Verso, 2002.

Worrall, Nick, 'Meyerhold's Production of "The Magnificent Cuckold"', *The Drama Review: TDR* 17, no. 1 (1973): 14–34.

Worrall, Nick, *The Moscow Art Theater*. London: Routledge, 2003.

Youngblood, Denise J., 'The Fiction Film as a Source for Soviet Social History: The *Third Meshchanskaia Street* Affair', *Film and History* 19, no. 3 (1989): 50–60.

Youngblood, Denise J., *Soviet Cinema in the Silent Era, 1918–1935*. Austin, TX: University of Texas Press, 1991.

Youngblood, Denise J., *Movies for the Masses: Popular Cinema and Soviet Society in the 1920s*. Cambridge: Cambridge University Press, 1993.

Youngblood, Denise J., *The Magic Mirror: Moviemaking in Russia, 1908–1918*. Madison, WI: University of Wisconsin Press, 1999.

Zhadova, Larissa, *Tatlin*. London: Thames and Hudson, 1988.

Zorkaia, Neia, *Aleksei Popov*. Moscow: Iskusstvo, 1983.

Zorkaia, Neia, 'Russkii modern i revoliutsionnyi avangard (na materiale kino)'. in *Russkii avangard v krugu evropeiskoi kul'tury*, edited by Viacheslav Ivanov, 232–49. Moscow: Radiks, 1994.

Zorkaia, Neia, 'Sten´ka Razin pod Peterburgom', http://www.portal-slovo.ru/art/35956.php (accessed 15 April 2017).

FILMOGRAPHY

The films listed below have been ordered alphabetically by English title. Each reference includes the following information: translated title, Russian title, year of release, name of studio or production company, production artist, director, camera operator, scenarist and, where applicable, composer. Films that have not survived are identified as non-extant.

Aelita. 1924. Mezhrabpom-Rus´. Production Artists, Sergei Kozlovskii and Viktor Simov with sculptures by Isaak Rabinovich and costumes by Aleksandra Ekster. Director, Iakov Protazanov. Camera Operator, Iurii Zheliabuzhskii. Scenarists, Fedor Otsep and Aleksei Faiko.

The Alarm (Nabat). 1917. A. Khanzhonkov & Co.. Production Artist, Lev Kuleshov. Director and Scenarist, Evgenii Bauer. Camera Operator, Boris Zavelev.

Behind the Drawing Room Doors (Za dveriami gostinoi). 1913. A. Khanzhonkov & Co.. Production Artist, Boris Mikhin. Directors, Ivan Lazarev and Petr Chardynin. Scenarist, unknown. Camera Operator, Aleksandr Ryllo.

Behind the Screen (Kulisy ekrana). 1917. I. Ermol´ev. Production Artist, unknown. Directors and Scenarists, Georgii Azagarov and Aleksandr Volkov. Camera Operator, Nikolai Toporkov.

The Brigand Brothers (Brat´ia-razboiniki). 1912. A. Khanzhonkov & Co.. Production Artist, unknown. Director and Scenarist, Vasilii Goncharov. Camera Operator, Aleksandr Ryllo.

By the Law (Po zakonu). 1926. Goskino (First Factory). Production Artist, Isaak Makhlis. Director, Lev Kuleshov. Camera Operator, Konstantin Kuznetsov. Scenarist, Viktor Shklovskii.

Children of the Age (Deti veka). 1915. A. Khanzhonkov & Co.. Production Artist and Director, Evgenii Bauer. Camera Operator, Boris Zavelev. Scenarist, M. Mikhailov.

The Cigarette Girl from Mossel´prom (Papirosnitsa ot Mossel´proma). 1924. Mezhrabpom-Rus´. Production Artists, Vladimir Balliuzek and Sergei Kozlovskii. Director and Camera Operator, Iurii Zheliabuzhskii. Scenarists, Fedor Otsep and Aleksei Faiko.

Cities and Years (Goroda i gody). 1930. Soiuzkino and the German film studio Derussa. Production Artist, Semen Meinkin. Director, Evgenii Cherviakov. Camera Operators, Sviatoslav Beliaev and Aleksandr Sigaev. Scenarists, Natan Zarkhi, Dmitrii Tolmachev and Evgenii Cherviakov.

The Dashing Merchant (Ukhar´-kupets). 1909. Pathé. Production Artist, Mikhail Kozhin. Costumes, G. Benesh. Director and Scenarist, Vasilii Goncharov. Camera Operators, Georges Meier and Toppi.

The Dying Swan (Umiraiushchii lebed´). 1916. A. Khanzhonkov & Co.. Production Artist and Director, Evgenii Bauer. Camera Operator, Boris Zavelev. Scenarist, Zoia Barantsevich.

Engineer Prait's Project (Proekt inzhenera Praita). 1918. A. Khanzhonkov & Co. Production Artist and Director, Lev Kuleshov. Camera Operator, Mark Naletnyi. Scenarists, Lev Kuleshov and Boris Kuleshov.

Fragment of an Empire (Oblomok imperii). 1929. Sovkino (Leningrad). Production Artist, Evgenii Enei. Director, Fridrikh Ermler. Camera Operator, Evgenii Shneider. Scenarists, Katerina Vinogradskaia and Fridrikh Ermler.

The Girl with a Hatbox (Devushka s korobkoi). 1927. Mezhrabpom-Rus´. Production Artist, Sergei Kozlovskii. Director, Boris Barnet. Camera Operators, Boris Fil´shin and Boris Frantsisson. Scenarists, Valentin Turkin and Vadim Shershenevich.

Golden Mountains (Zlatye gory). 1931. Soiuzkino. Production Artist, Nikolai Suvorov. Director, Sergei Iutkevich. Camera Operators, Zhozef Martov and Vladimir Rapoport. Scenarists, Andrei Mikhailovskii, Vladimir Nedobrovo, Sergei Iutkevich and Aleksei Chapygin. Composer, Dmitrii Shostakovich.

His Eyes (Ego glaza). 1916. *Russkaia zolotaia seriia*. Production Artist, Vladimir Egorov. Director, Viacheslav Viskovskii. Scenarists, Viacheslav Viskovskii and Aleksandr Volkov.

Iurii Nagornyi. 1916. A. Khanzonkov & Co. Production Artist and Director, Evgenii Bauer. Camera Operator, Boris Zavelev. Scenarist, Andrei Gromov.

The Kiss of Mary Pickford (Potselui Meri Pikford). 1927. Mezhrabpom-Rus´. Production Artists, Sergei Kozlovskii and Dmitrii Kolupaev. Director, Sergei Komarov. Camera Operator, Evgenii Alekseev. Scenarists, Sergei Komarov and Vadim Shershenevich.

The Kreutzer Sonata (Kreitserova sonata). 1914. *Russkaia zolotaia seriia*. Production Artist, Boris Mikhin. Director and Scenarist, Vladimir Gardin. Camera Operator, Aleksandr Levitskii.

The Last Act (Poslednii attraktsion). 1929. Sovkino. Production Artist, Aleksei Utkin. Directors, Ol´ga Preobrazhenskaia and Ivan Pravov. Camera Operators, Aleksei Solodkov and Anatolii Solodkov. Scenarist, Viktor Shklovskii.

The Little House in Kolomna (Domik v Kolomne). 1913. A. Khanzhonkov & Co.. Production Artist, Boris Mikhin. Director, Petr Chardynin. Camera Operator, Władysław Starewicz.

The Maidservant Jenny (Gornichnaia Dzhenni). 1918. I. Ermol´ev. Production Artist, Vladimir Balliuzek. Director and Scenarist, Iakov Protazanov. Camera Operator, Fedor Burgasov.

A Major Nuisance (Krupnaia nepriatnost´). 1930. Soiuzkino. Production Artist, Dmitrii Kolupaev. Director, Aleksei Popov. Camera Operator, Vladimir Solodovnikov. Scenarists, Isaak Gordon and Aleksei Popov.

The Old and the New (Staroe i novoe). 1929. Sovkino. Production Artists, Vasilii Kovrigin and Vasilii Rakhal's. Architect of the cooperative dairy farm, Andrei Burov. Directors and Scenarists, Sergei Eizenshtein and Grigorii Aleksandrov. Camera Operator, Eduard Tisse.

The Overcoat, a Film-Play in the Manner of Gogol' (Shinel', kino-p'esa v manere Gogolia). 1926. Leningradkino. Production Artist, Evgenii Enei. Directors, Grigorii Kozintsev and Leonid Trauberg. Camera Operator, Andrei Moskvin. Scenarist, Iurii Tynianov.

Polikushka. 1922. Rus'. Production Artist, Sergei Kozlovskii. Director, Aleksandr Sanin. Camera Operator, Iurii Zheliabuzhskii. Scenarists, Fedor Otsep and Nikolai Efros.

The Portrait of Dorian Gray (Portret Doriana Greia). 1915 [non-extant]. Russkaia zolotaia seriia. Production Artist, Vladimir Egorov. Directors, Vsevolod Meierkhol'd and Mikhail Doronin. Camera Operator, Aleksandr Levitskii. Scenarist, Vsevolod Meierkhol'd.

The Queen of Spades (Pikovaia dama). 1916. I. Ermol'ev. Production Artist, Vladimir Balliuzek. Director Iakov Protazanov. Camera Operator, Evgenii Slavinskii. Scenarists, Iakov Protazanov and Fedor Otsep.

Silent Witnesses (Nemye svideteli). 1914. A. Khanzhonkov & Co.. Production Artist and Director, Evgenii Bauer. Camera Operator, Boris Zavelev. Scenarist, Aleksandr Voznesenskii.

Strike (Stachka). 1925. Goskino. Production Artist, Vasilii Rakhal's. Director, Sergei Eizenshtein. Camera Operator, Eduard Tisse. Scenarists, Grigorii Aleksandrov, Il'ia Kravchunovskii, Sergei Eizenshtein and V. Pletnev.

The Tale of the Fisherman and the Little Fish (Skazka o rybake i rybke). 1911. Pathé. Production Artist and Scenarist, Czesław Sabiński. Director, Kai Hansen. Camera Operator, Georges Meier.

The Traitor (Predatel'). 1926. Goskino. Production Artists, Sergei Iutkevich and Vasilii Rakhal's. Director, Abram Room. Camera Operator, Evgenii Slavinskii. Scenarists, Lev Nikulin and Viktor Shklovskii.

The Two Buldis (2-Bul'di-2). 1929. Mezhrabpomfil'm. Production Artists, Vladimir Balliuzek and Sergei Kozlovskii. Directors, Nina Agadzhanova-Shutko and Lev Kuleshov. Camera Operators, Petr Ermolov and Aleksandr Shelenkov. Scenarist, Osip Brik.

The Virgin Hills (Dev'i gory). 1919. Rus'. Production Artists, Viktor Simov and Sergei Kozlovskii. Director, Aleksandr Sanin. Camera Operator, Iurii Zheliabuzhskii. Scenarist, Evgenii Chirikov.

Who Ruined Her? (Kto zagubil?). 1916. A. Khanzhonkov & Co.. Production Artist, unknown. Director, Nikandr Turkin. Camera Operator, Mikhail Vladimirskii. Scenarist, Zoia Barantsevich.

Your Acquaintance (The Woman Journalist) (Vasha znakomaia (Zhurnalistka)). 1927. Sovkino. Production Artists, Vasilii Rakhal's and Aleksandr Rodchenko. Director, Lev Kuleshov. Camera Operator, Konstantin Kuznetsov. Scenarist, Aleksandr Kurs.

INDEX

acting 27, 55, 67, 184
Aelita 33, 42, 119–27, 129, 142, 175, 185
Affron, Charles and Mirella Jona 7
After Death (Posle smerti) 115, 153
agriculture 48, 68–70, 114, 125
Alarm, The (Nabat) 21, 117–19, 140, 142, 160
Aleinikov, Moisei 27, 39, 67
Arkhitektor 4, 43, 47, 175
artist's studio 145–56, 183
Arvatov, Boris 12, 16, 107–8, 156
authenticity 52–6, 61, 65, 179–80
avant-garde 156, 164, 170

Bagrov, Peter 34
Balázs, Béla 63
ballet 153
Ballets russes 100
Balliuzek, Vladimir 24, 30, 32–5, 37, 39, 98, 100–1, 144, 158–65, 178–9
Barnet, Boris 104
Barsacq, Léon 9
Bauer, Evgen ii, 17, 21, 26, 29, 32–3, 39, 40, 65, 81, 88, 90–101, 114–19, 124, 126, 128–30, 152–6, 178–80, 183, 185
Bed and Sofa (Tret´ia Meshchanskaia) 84, 85, 106, 108, 110, 138 180
Behind the Drawing Room Door (Za dveriami gostinoi) 145–7, 151, 159, 170
Behind the Screen (Kulisy ekrana) 156–8
Benjamin, Walter 105
Benua, Aleksandr 6
Bird, Robert 33, 123, 128
blocking 55, 178
Boris Godunov 14, 50–1
Brigand Brothers, The (Brat´ia-razboiniki) 57–62, 71, 180
Brik, Osip 104, 156, 165
Brown, Bill 75
Buchli, Victor 105–6
Bulgakova, Oksana 138
Burov, Andrei 17, 48, 72–3, 192–3

By the Law (Po zakonu) 63–7, 75, 134, 139

Cabinet of Dr. Caligari, The (Das Cabinet des Dr. Caligari) 42, 120, 121, 129
camera operator 38–9, 47, 159, 176, 183, 184
Cavendish, Philip 4, 34, 35, 63, 67, 82, 84, 96, 97, 98, 128, 129, 148, 176
Chardynin, Petr 81, 145
Chekhov, Anton 25
Cherchi Usai, Paolo 57
Cigarette Girl from Mossel´prom, The (Papirosnitsa ot Mossel´proma) 158–62
Child of the Big City (Ditia bol´shogo goroda) 84, 90, 91, 92, 94, 95, 98, 101, 115, 116, 155
Children of the Age (Deti veka) 84, 90, 91, 93, 94, 95, 97m 101, 115, 116, 155
Christie, Ian 121
cinema auditorium. See also cinema theatre 163
cinematography 126, 129, 141, 185
circus 17, 126, 163–71
Cities and Years (Goroda i gody) 171
Civil War 61, 103, 165–6, 171
clutter 98, 105–6
Constructivism 39, 41–2, 46 129, 185–6
Cultural Revolution 14, 49, 72, 106
curtains 62, 88, 90, 126, 155, 194

dance 154–5
Dashing Merchant, The (Ukhar´ kupets) 53–5
Daydreams (Grezy) 91, 115, 153, 155
DeBlasio, Alyssa 11, 32, 115
decoration 97, 105–6
defamiliarization 111, 142
dekorator 1, 14, 27, 29, 43, 72 172
desk 116, 117, 125–6, 190
dikovinka 94, 153
doorway 84, 86, 88, 90, 92, 96, 97, 152, 160

Drankov, Aleksandr 1, 28, 51, 92, 187
Dubrovskii-Eshke, Boris 23, 179
Dying Swan, The (Umiraiuschchii lebed´) 152-6, 159

Egorov, Vladimir 5, 6, 10, 17, 21, 22-3, 24, 26, 29-35, 28, 45, 147-52, 175, 178-9
Eizenshtein, Sergei 35, 68-70, 72, 73, 129-33, 164, 180, 192
Ekster, Aleksandra 22, 120
enchantment 67, 74-5, 79
Enei, Evgenii 10, 34, 109, 124-5, 127, 141
Engineer Prait's Project (Proekt inzhenera Praita) 127-9, 132
Ermler, Fridrikh 109, 111
ethnography 52-6, 59-62, 69-70, 77, 98, 162, 179
everyday life 133, 136-8, 158-61, 181
excess 93, 95, 104, 178

fabric 94-5, 99
faktura 41-2, 98, 135, 178, 186, 188
fantasy 119-20, 124, 126, 181
FEKs 34-5, 109, 124, 163, 179
fences 59, 69, 70-1, 76, 77, 125
Fester, V. 27, 28
First Five Year Plan 48
Fischer, Lucy 13, 96, 162
folk 53-5
fourth wall 24-5, 89
Fragment of an Empire (Oblomok imperii) 109, 111, 118
fundus 44-6, 87, 145, 160, 175

Gardin, Vladimir 23, 30, 31, 32, 86-7
Girl with a Hatbox, The (Devushka s korobkoi) 85, 103-8, 111
glass 86, 93, 97, 108, 121, 129-30, 132, 135, 136, 138, 139, 157, 159
Gogol´, Nikolai 76, 124, 126, 163
Golden Mountains (Zlatye gory) 133, 139-43
Goncharov, Vasilii 28, 53-4, 58
Goskino 22, 33, 39, 65, 129, 176
Gough, Maria 4, 41, 46
Graffy, Julian 84, 101

haptic 8, 11, 100-1
His Eyes (Ego glaza) 147, 151-2
historical accuracy 55

homelessness 103, 107
housing problem 103
How You Live (Kak ty zhivesh´) 112

imagination 102, 114, 12-21, 123, 126, 154, 162, 181
In Pursuit of Happiness (Za schast´em) 65
INKhUK 41, 46
Iurii Nagornyi 95-101
Iutkevich, Sergei 22, 34, 39, 41-2, 101, 129, 138, 150, 178, 185

Journalist. *See also* journalism 92

Kaplunovskii, Vladimir 172, 179
Khanzhonkov, Aleksandr 32, 50
Khanzhonkov studios 28, 31-2, 36, 38, 50, 54, 57, 59, 60, 81, 87, 92, 95, 101, 114, 127, 129, 145, 178
Khokhlova, Aleksandra 67, 133, 135, 138
khudozhnik/kino-khudozhnik 1, 12-14, 27, 47, 172-3, 183, 185, 190, 193
khudozhnik-arkhitektor 47
khudozhnik-dekorator 1, 12-14, 29, 173
khudozhnik-konstruktor 13-14, 45, 175
khudozhnik-zhivopisets 29, 184
Kiss of Mary Pickford, The (Potselui Meri Pikford) 161-3
Kolin, Nikolai 23, 47, 146
Kollontai, Aleksandra 91
Kolupaev, Dmitrii 16, 24, 77, 144, 162-3, 175, 177, 180
Kovalova, Anna 148
Kovrigin, Vasilii 48, 68-70
Kozhin, Mikhail 21, 53-5, 179
Kozlovskii, Sergei 3, 5, 12-21, 14, 19, 21-2, 23, 33, 35, 37-9, 43-5, 47, 61, 65, 71, 104-5, 144, 146, 158-63, 165, 172, 175, 177, 187-9
Kreutzer Sonata, The (Kreitserova sonata) 25, 86-90, 97, 116, 145
Kuleshov, Lev 3, 5, 17, 26, 31-2, 35, 38, 40, 64-6, 76, 87, 94, 117, 127-9, 132, 133-5, 139, 144, 156, 164-7, 173, 179, 180, 182-5

labour 68, 111, 119, 122-3, 132-3, 137, 169
lace 82, 95, 136, 140

Last Act, The (Poslednii attraktsion) 165, 168, 170
Le Corbusier 72, 105
Left Front of Arts (LEF) 45, 123, 138, 156, 164–5, 167
Lenin, Vladimir 101
Leningrad filmmaking 14, 33–4, 109–10, 139
Life for a Life, A (Zhizn´ za zhizn´) 91, 95, 101, 128
lighting 4, 6, 8, 15, 20, 24, 26, 27, 38, 40, 46, 50, 51, 58, 60, 81, 89, 96, 100–1, 109, 122, 161, 175, 177, 184, 188–9, 190–1, 195
Little House in Kolomna, The (Domik v Kolomne) 81–6, 87, 92, 97, 179
Lukhmanov, Nikolai 48–9, 73, 112, 136
luxury 12, 16, 80, 93, 95

machines 7, 46, 68, 71, 75, 94, 108, 111, 124, 192
Maidservant Jenny, The (Gornichnaia Dzhenni) 82, 98–100, 130, 177
Major Nuisance, A (Krupnaia nepriatnost´) 75–9, 180
Makhlis, Isaak 64, 65, 66, 180
Marx, Karl 123, 132
materialism 94
medium specificity 40–1, 177
Meerson, Lazar 9
Meinkin, Semen 170–1
Mezhrabpom-Rus´ 19, 33, 35, 39, 42, 43, 44, 45, 119, 120–1, 158, 162, 176
Miasnikov, Gennadii 11, 31, 35, 39, 173
Mikhin, Boris 16, 17, 24, 25, 32, 36, 38–9, 50, 81, 86–90, 145–7, 175, 179, 180
mirrors 89–90, 110, 116, 150–1, 157
Mise-en-scène 8, 29, 51, 81, 92, 97, 128, 129, 135, 184
models 57, 122–3, 127
Morley, Rachel 11, 13, 26, 32, 58, 85, 88, 92, 93, 94, 114, 124, 153, 155
Moscow Art Theatre (MKhT) 24–7, 55, 61–2, 76, 81, 87, 89, 148 175
Mozzhukhin, Ivan 157–8
Mur, Leo 102

narrative approaches to set design 7–8
New Economic Policy (NEP) 16, 103
New LEF (Novyi LEF) 45, 167

New Soviet (values; ways of life) 44, 52, 74, 76, 107, 112, 129, 138–9

Old and the New, The (Staroe i novoe) 48–9, 68–75, 78, 79, 126, 180
ornament 81, 95–6, 99, 105, 110, 186
outdoor filming 16, 44, 50, 69, 102, 159
Overcoat, The (Shinel´) 119, 124, 127, 141

painting 46, 53, 59, 62, 95, 97, 100, 117, 126, 133, 145–50, 152–6, 170, 175, 182–3, 185, 186, 191, 194–5
paper 130, 135, 137
Pathé 28, 31, 36, 38, 52–3, 55, 121, 160
pattern 16, 21, 36, 37, 54–5, 60, 77, 82–3, 99, 100–1, 105, 128, 132, 138, 142, 159, 160–1, 177, 178
peasant life 56–7 62, 67, 146
performance 62, 89, 95, 131, 144, 150, 153–5, 167
photogénie 99
Picture of Dorian Gray, The (Portret Doriana Greia) 29, 30–1, 38, 147–52, 157
pleasure 113, 115, 125–6, 127, 139, 156
Polikushka 61–3, 66, 67, 120
Popov, Aleksei 76–7
Preobrazhenskaia, Ol´ga 168
primitive 63, 66
production art 114, 117, 119–20
Protazanov, Iakov 30, 32–3, 35, 98, 120
provinces 15, 56, 61, 69, 71, 76, 77, 79, 98, 104
psychology 26, 63, 65, 140, 180, 185
Pudovkin, Vsevolod 35, 42, 186
Pushkin, Aleksandr 14, 30, 50, 56, 57, 58, 81, 84, 127

Queen of Spades, The (Pikovaia dama) 30, 37, 84, 158

Razumnyi, Aleksandr 15, 37, 38, 39
religion 74, 79
Rembrandtizm 27, 177
Rodchenko, Aleksandr 1, 2, 3, 17, 43, 45, 104, 133, 135, 136–8, 139, 189
Rodin, Auguste 90
Room, Abram 106, 180
Rus´ 27, 33, 39

Russian Golden Series (Russkaia zolotaia seriia) 29, 86, 151
Russkii modern 21, 101

Sabiński, Czesław 24, 28, 31, 36, 38, 39, 55–7, 175, 179
Seagull, The (Chaika) 25
sewing 84–5, 94–5, 108, 111, 124
Shekhtel′, Fedor 21, 54
Shklovskii, Viktor 12, 16, 64, 69, 74, 106, 136, 164
Shpinel′, Iosif 10
Silent Witnesses (Nemye svideteli) 82, 92, 114–17
Simov, Viktor 6, 24–7, 33, 56, 62, 120, 121, 175
Socialist Realism 170, 174
Sovkino 33, 43, 45, 48, 68, 133, 136, 139, 168, 176
Stanislavskii, Konstantin 27, 56, 62
Starewicz, Wladyslaw 81
State Institute for Cinematography (GTK, GIK, VGIK) 23
statues/statuettes 89–91, 116, 124, 127–8, 138, 188
Sten′ka Razin 1, 50, 52, 58, 189
Stepanova, Varvara 45
Strike (Stachka) 34, 42, 118, 127–33, 135, 140, 142, 186
Strogonov Institute for Technical Drawing 21, 54

Tale of the Fisherman and the Little Fish, The (Skazka o rybake i rybke) 55–6, 79
Tarabukin, Nikolai 46
Tashiro, Charles 8

textile 16, 22, 26, 56, 62, 94, 100, 101, 128, 159, 178
Theatre 27, 29–31, 36, 37, 38, 40, 62, 90
Thiemann and Reinhardt 25, 29, 30, 86
Thing Theory 75
threshold 84, 85, 88
Tolstoi, Lev 25, 26, 29, 30, 61, 86, 89
Traitor, The (Predatel′) 22, 34, 101, 102–3
Tsiv′ian, Iurii 11, 32, 55, 83,150
Two Buldis, The (2-Bul′di-2) 165–71

urban environment 59, 63, 81, 93, 121, 159
Utkin, Aleksei 21, 31, 144, 164, 168, 179
utopia 72–3

village 53, 59, 75–9
Virgin Hills, The (Dev′i gory) 27, 62, 67, 120
VKhUTEMAS 123, 137

Wanderers, The (Peredvizhniki) 21, 22, 60, 77
Who Ruined Her? (Kto zagubil?) 59–61
Widdis, Emma 2, 11, 12, 13, 35, 70, 74, 77, 79, 80, 92, 95, 99–100, 102, 104, 106, 111–12, 126, 130, 134, 135, 137, 140, 180
windows 82, 83–6, 88, 89, 94
World of Art (Mir iskusstva) 21, 22, 177

Year 1812, The (God 1812) 28, 37
Youngblood, Denise J. 61, 67, 81, 93
Your Acquaintance (Vasha znakomaia) 133–40, 142, 190
Zheliabuzhskii, Iurii 27, 61, 120, 158, 159
Zorkaia, Neia 11, 58

www.ingramcontent.com/pod-product-compliance
Lightning Source LLC
Chambersburg PA
CBHW052219300426
44115CB00011B/1756